Gothic Tourism

Titles include:

Timothy C. Baker
CONTEMPORARY SCOTTISH GOTHIC
Mourning, Authenticity, and Tradition

Dara Downey
AMERICAN WOMEN'S GHOST STORIES IN THE GILDED AGE

Barry Forshaw
BRITISH GOTHIC CINEMA

Margarita Georgieva
THE GOTHIC CHILD

Derek Johnston
HAUNTED SEASONS
Television Ghost Stories for Christmas and Horror for Halloween

David J. Jones
SEXUALITY AND THE GOTHIC MAGIC LANTERN
Desire, Eroticism and Literary Visibilities from Byron to Bram Stoker

Sian MacArthur
GOTHIC SCIENCE FICTION
1818 to the Present

Emma McEvoy
GOTHIC TOURISM

Lorna Piatti-Farnell and Maria Beville (*editors*)
THE GOTHIC AND THE EVERYDAY
Living Gothic

Aspasia Stephanou
READING VAMPIRE GOTHIC THROUGH BLOOD
Bloodlines

Catherine Wynne
BRAM STOKER, DRACULA AND THE VICTORIAN GOTHIC STAGE

Gothic Tourism

Emma McEvoy
University of Westminster, UK

First published 2016 by
PALGRAVE MACMILLAN

Palgrave Macmillan in the UK is an imprint of Macmillan Publishers Limited,
registered in England, company number 785998, of Houndmills, Basingstoke,
Hampshire RG21 6XS.

Palgrave Macmillan in the US is a division of St Martin's Press LLC,
175 Fifth Avenue, New York, NY 10010.

Palgrave Macmillan is the global academic imprint of the above companies and has
companies and representatives throughout the world.

Palgrave® and Macmillan® are registered trademarks in the United States, the United
Kingdom, Europe and other countries.

ISBN 978-1-349-56220-6 ISBN 978-1-137-39129-2 (eBook)
DOI 10.1057/9781137391292

This book is printed on paper suitable for recycling and made from fully
managed and sustained forest sources. Logging, pulping and manufacturing processes
are expected to conform to the environmental regulations of the country of origin.

A catalogue record for this book is available from the British Library.

Library of Congress Cataloging-in-Publication Data
McEvoy, Emma.
Gothic tourism / Emma McEvoy.
pages cm. — (Palgrave gothic)
Summary: "From Strawberry Hill to the London Dungeon, Alton Towers to Barnageddon,
Gothic tourism is a fascinating and sometimes controversial subject. Emma McEvoy
considers some of the origins of Gothic tourism and discusses Gothic itself as a
touristic mode. Through studies of ghost walks, scare attractions, Dennis Severs' House,
Madame Tussaud's, the Necrobus, castles, prison museums, phantasmagoria shows, the
'Gothick' design of Elizabeth Percy at Alnwick Castle, a party at Fonthill Abbey, and a
poison garden, McEvoy examines Gothic tourism in relation to literature, film, folklore,
heritage management, arts programming, and the 'edutainment' business." – Provided
by publisher.
1. Heritage tourism—England. 2. Haunted places—England. 3. Architecture,
Gothic—England. I. Title.
G155.G7M44 2015
338.4'79142—dc23 2015018583

Typeset by MPS Limited, Chennai, India.

To Robert, with love.

Contents

List of Figures

Acknowledgements

I particularly need to thank Robert Lee, David Short and Catherine Spooner – for incisive commentary, excellent advice and stimulating conversation. To Michelle Geric, I am indebted for invaluable comments – and for her generous enthusiasm. I have had interesting and fruitful discussions with Joseph Coningsby, Ioana Baetica Morpurgo and Steve Barfield, and would like to thank them too. Audrey Lee and David Cunningham also kindly looked over, and made some valuable suggestions for, some chapters. This book was, at many points, a delight to research, and I had numerous interesting conversations with practitioners of Gothic tourism. I particularly would like to thank Charlotte Horne, as well as Dave Allan and Chris Gallarus – and other leaders of ghost walks who do not wish to be named. I thank Herbie Treehead, Matt Barnard, Jonny Croose, Zoe Tautz-Davies, Michelle Hof, Frank Wassink and Dennis van Breukelen, for fascinating and enjoyable conversations about many aspects of Gothic performance. My Devon researches are indebted to the inputs of Pat McEvoy, Andy Littlejohn, Kathleen Romaine and Mike Green. My thanks are also due to the staff at Devon Heritage Services, at Totnes Study Centre and at the West Country Studies Library, in particular, Lucy Browne. Further away from home, Susan Walker and Kristen MacDonald of Yale University Library have been extremely helpful. Charles Kightly of English Heritage, and Professor Pamela Pilbeam were very generous with their time and knowledge, and I thank them both very much. For informative and engrossing conversations about waxworks, I'm indebted to Mike Wade and Louise Baker. Daniel Watkins and Catherine Neil of Alnwick Castle as well as Alison at Berry Pomeroy Castle have also been extremely generous with their time and help. Conversations over the years with Mick Pedroli at Dennis Severs' House were invaluable for the Severs chapter. To Chris Baldick, I am indebted for translation support, and information about Revolutionary France. My thanks also go to my children Rowan Lee McEvoy (who proved to be a useful checker of Terry Pratchett references), Finn Lee McEvoy and May Lee McEvoy (who lent a hand with the index). They have all been patient and helpful. To Finn, extra thanks must go for being such a valuable and never-patronizing technical assistant.

I would like to thank the University of Westminster for giving me a term's sabbatical to work on this book.

Thanks to the journal *Visual Culture in Britain* (available at www.tandfonline.com) for permission to republish part of my article 'Dennis Severs' House: Performance, Psychogeography and the Gothic'.

I am republishing part of my essay '"West End Ghosts and Southwark Horrors": London's Gothic Tourism' by permission of Bloomsbury Publishing PLC. It originally appeared in a volume entitled *London Gothic: Place, Space and the Gothic Imagination*, edited by Lawrence Philips and Anne Witchard, and was published by Continuum in 2010.

My essay '"'Boo!' to Taboo": Gothic Performance at British Festivals' originally appeared in *The Gothic in Contemporary Literature and Popular Culture: Pop Goth* (Routledge, 2012), edited by Justin Edwards and Agnieszka Soltysik Monnet. It is reproduced by permission of Taylor and Francis Group, LLC, a division of Informa plc.

Introduction

Figure I.1 'The Sanctuary', Alton Towers, 2013. Courtesy of Alton Towers

It is May 2013, and I am walking through Alton Towers theme park in the English Midlands. Around me are the park's rides (Oblivion, Sonic Spinball, Thi3teen); to my left are the gardens, and a picturesque lake, its shores dotted with classical statuary, curiously untouched by the theme park around it. Above me is 'the Towers', the destination of my walk. The Towers is a managed ruin with a curiously blank Gothic façade; the windows are glassless, but outlines of delicate tracery are occasionally visible. I have an unimpeded view into empty rooms. Arguably, the

Towers' managed quality gives it more of a sinister feel – this, however, may be because I know the building contains 'The Sanctuary', a scare attraction where I expect to be terrified (see Figure I.1).

Once inside the Towers, my companions and I troop down a sparsely furnished corridor (part of the old conservatory) adorned with dirty tattered sheets. We stop at a checkpoint where actors dressed as nurses, their costumes soiled, accost us. We fall silent as we are harangued, told the rules, and our hands are stamped. To enter The Sanctuary we must travel conga style, our hands on the shoulders of the person in front. Thus are we prepared to enter its fictional world – our individuality stripped down – the communal fun (and solidarity) heightened.

Our journey within The Sanctuary takes us through a series of mocked-up spaces: a tawdry, tattered communal recreation room; a dirty, unattended institution kitchen where flames leap up from stoves; a psychiatric ward, where beds stand unoccupied and cheerless against bare brick walls. There are no windows: this is an enclosed world. The Sanctuary is familiar to us. This is not because we have all been patients in 1960s mental asylums, but because we have seen the right films, or TV series, or read the right kinds of books. Even if we don't know the original texts, they resonate through a variety of allusions that we are familiar with – perhaps through comedy sketches or adverts. The rooms we pass through signify within a contemporary vocabulary of horror. We respond to the atmospheres created – of totalitarian regimes and secret experimentation.

Travelling through these mocked-up spaces, we are not merely on a sightseeing tour of a fictionalized world; the tour has a narrative structure. We go from public rooms to inner depths and secret spaces – from a recreation room, to an underground experiment chamber where, on a slab, lies a highly realistic waxwork of a bloodied, muzzled and tortured corpse. En route, we have been assaulted. The Sanctuary is what is known as a 'high impact scare'. We experience 'marmalization'. We go through a decontamination passage where plastic sheets hang lankly around us, wind machines blast us, leg ticklers alarm us. We breathe in a noisome range of smells – wet dog, Dettol, faeces – all courtesy of the smell pod industry. We are dazzled and confused by strobe machines, and blinded by sudden blackouts. Actors jump out of the darkness and rattle their cages to scare us. The journey has been designed to maximize shock and set our adrenaline racing. In the grand finale, we find ourselves in a room smeared with excrement, choking with the foulness of the smell and deafened by the sounds of distortion and a permeating infrabass, as we run through a maze of false walls. At

the end of the scare, we make our escape, screaming and laughing, into the world outside – a narrow courtyard – it is with a feeling of relief on my part.

What is a scare attraction? The definition is best left to the industry itself, which is a highly self-aware one. 'Scare attractions are live theatrical experiences in which an audience moves through a themed environment populated by sets, props, special effects and, usually, live scareactors.'[1] The scare attraction as we know it, is a phenomenon deriving from the United States, where it is known as the haunted attraction, but it can be found in many places in the world. Indeed, some of the most celebrated examples exist in the same, or roughly similar, format in many different countries. Thus the Pasaje del Terror in Blackpool is a branch of an attraction that may also be found in Spain, Mexico, Italy, Argentina and Japan. The website for the Blackpool branch notes that 'in its 26 year history ... [the Pasaje del Terror] has been visited by more than 14,000,000 people.'[2]

I hadn't realized the scale of the European scare attraction industry until this weekend, when I am attending the industry conference that is being held at Alton Towers over two days, and climaxes with the presentation of the Scare Awards on the final night. At the conference are delegates from all over Britain and from other European countries. There are the 'imagineers' (the creators and devisors of scare attractions), actors, set builders, lighting and sound technicians, makers of masks and prosthetics, health and safety experts, site managers, marketing and sales people, and those involved in the day-to-day tending of a site. A scare attraction, I learn, is an intricate feat of engineering, crowd control, health and safety management, and over the weekend a range of different issues are discussed: from the protection of scare actors, to LED retrofittings, modes of safeguarding children from unsuitable material, policing of the industry and codes of conduct.

The Sanctuary is an example of Gothic tourism. The term is unfamiliar and specialized enough to require explanation. As I use the term, Gothic tourism is the act of visiting, for the purposes of leisure, a location that is presented in terms of the Gothic. Here I am not talking about medieval Gothic, but about the Gothic that came into being in the mid-eighteenth century, the narrative stamp of which came about with the publication of the first Gothic novel, Horace Walpole's *The Castle of Otranto* (1764). Gothic is not only to be found in the form of novels, such as Walpole's *Otranto*, Ann Radcliffe's *The Mysteries of Udolpho* (1794), Matthew Lewis's *The Monk* (1796), Wilkie Collins's *The Woman in White* (1860) or Bram Stoker's *Dracula* (1897). There are Gothic poems

and short stories (such as those of Edgar Allan Poe), Gothic films and television series, Gothic music, Gothic computer games, Gothic clothing, Gothic advertising, Gothic news articles, and, of course, Gothic lifestyle. As Catherine Spooner notes: 'Gothic narratives have escaped the confines of literature and spread across disciplinary boundaries to infect all kinds of media, from fashion and advertising to the way contemporary events are constructed in mass culture.'[3] It is important to note, however, that the earliest Gothic was never just a literary affair. Indeed, right from the outset, Gothic has always been highly intermedial. Walpole's Gothic starts with a house (Strawberry Hill), and comes to fruition by means of that house embedded within a book (Otranto).

Tourism has been integral to the Gothic aesthetic from the very beginning. In *The Rise of Supernatural Fiction* (1995), E J Clery discusses the significance of the Cock Lane ghost – the phenomenon that sent London into a delighted spin early in 1762. At Cock Lane (near Smithfield market and St Bartholomew's Church and Hospital), the ghost of Fanny Lynes was said to be drawing attention, by the means of scratching noises, to the fact that she had been murdered. Fanny's ghost was later found out to be an imposture, but, for some weeks, Cock Lane 'was full of mob',[4] as Walpole wrote, and the house crammed with people waiting to hear the scratching. For Clery, the Cock Lane phenomenon marks the emergence of a new attitude to the supernatural, one that is associated with the rise of Gothic. Clery points out that many of those who went to Cock Lane had a 'hedonistic acceptance of ghosts as a fiction',[5] and were taking themselves to Parson's house, for entertainment, rather than because they believed in the ghost. For Clery, this is the point at which the ghost, '[f]reed from the service of doctrinal', becomes 'caught up in the machine of the economy ... available to be processed, reproduced, packaged, marketed and distributed by the engines of cultural production'.[6]

Walpole's *Otranto* was both popular and influential, a literary groundbreaker. Its significance, however, did not lie only, or even primarily, in its faux medievalism: other novelists of the time were experimenting with medieval settings, and quasi-Shakespearean or medieval romance plots. *Otranto* can be differentiated from such a novel as Thomas Leland's *Longsword, Earl of Salisbury*, which predated it by two years, not by its historicism but by the introduction of a set of attitudes, conventions and tropes, which, as Eve Kosofsky Sedgwick notes in *The Coherence of Gothic Conventions* (1980), possess a remarkable congruency. (Sedgwick also remarks that 'it would be possible to *write* a Gothic novel by the formula that would only be useful for *describing*'[7] another

kind of novel.) Gothic tends to be associated with a particular range of characters (besieged maidens, rather ineffectual heroes, patriarchal tyrants, monsters or vampires, for example), and to resort to certain compelling and recurring tropes – buried manuscripts, the portrait, the veil. Certain kinds of thematics make frequent appearances in Gothic texts – for example, revenance and the vestigial, the monstrous, the nature of the surface, the 'slippage between surface and depth',[8] and doubling. Sedgwick points out that Gothic plots are based on 'counterparts rather than partners ... parallels and correspondences rather than communication ... doubleness where singleness should be.'[9] And, of course, Gothic is interested in *affect*[10] – in what it does to its audiences. Gothic texts might provoke fear, disgust and curiosity; they experiment with terror, horror, repulsion and shock.[11]

Gothic, as Chris Baldick has suggested, in his introduction to the *Oxford Book of Gothic Tales*, has a preoccupation with 'despotisms buried by the modern age'.[12] It is characterized by a specific take on the relation between past and present. In Gothic, the abuses of the past are contrasted with the liberality of the present; Robert Mighall has defined its perspective as Whiggish.[13] As Baldick points out, Gothic combines 'a fearful sense of inheritance in time with a claustrophobic sense of enclosure in space'.[14] At their centre, Gothic texts tend to have imprisoning edifices associated with bygone institutions that still retain power in the time of the text – castles of tyrants, monasteries run by corrupt clergy. As Dale Townshend points out, the Gothic building is a Bakhtinian chronotope: 'in addition to being the site in which much of the narrative action in early Gothic fiction occurs, the ruined Gothic pile is, itself, the spatial embodiment of historical time.'[15]

Gothic tourism is tourism that is intimately connected with Gothic narrative, its associated tropes, discourses and conventions. Scare attractions, with their mocked-up buildings, characters familiar from film and literature, and their attempts to set the adrenaline racing, are very obvious examples of Gothic tourism. However, they are only part of a varied fare. England is awash with Gothic tourism. There are seasonal farm attractions with an endearingly cheesy range of names – 'Farmageddon' in Lancashire and 'Barnageddon' in Yorkshire – which come into existence in the three-week period around Halloween, and typically feature haunted houses and haunted hayrides, other themed rides, consumption of Gothic food and drink, games and street theatre. Other forms of Gothic tourism include Ghost Walks and Ghost Tours, Gothicized waxwork exhibitions (such as the Chamber of Horrors in Madame Tussaud's), and Gothic gardens such as the Forbidden Corner

in North Yorkshire. There are Gothicized theatre tours (such as that of Drury Lane), and Gothicized museums, such as the Clink Prison Museum in London, which specializes in instruments of torture and modes of imprisonment. Some historical monuments make a living from the haunted industry – Bodmin Jail, for example, offers paranormal ghost walks, and an 'Ultimate Paranormal Dining Night'.[16] The haunted industry has proved lucrative for many a business. Whereas at one time, a haunted room in a pub was offered with a price reduction (as happened to a friend of mine travelling in Essex in the 1960s), now a night in a haunted room might very well command a high premium. There are websites that allow people to search for 'Haunted Places to Stay' and to 'find haunted hotels'. As Owen Davies comments, in contrast to 'the historic position where communities desired to be rid of their spirits', the tourist industry has made 'the ghost … a desirable lodger rather than an unwelcome guest.'[17]

Gothic tourism is a substantial, but underacknowleged, part of the tourist scene. It exists cheek by jowl with more conventional attractions, though, frequently, at least in England, it is not allocated much shelf space in tourist offices. Of course, lack of attention from more official channels is not necessarily a bad thing for an industry that, as Philip R. Stone writes (discussing the content of the London Dungeon), 'exists, in content terms at least, on the fringes of conventional leisure attractions and mainstream tourism.'[18] The marketing for Gothic attractions often plays to the idea that it is beyond the pale. Bodmin Jail claims it offers 'the perfect alternative day out'.[19] The Forbidden Corner is 'a day out with a difference'.[20] Gothic tourism is inherently different from other modes of tourism in a number of ways. In particular, it is characterized by very particular different attitudes to place, to affect, to the question of genre, and to the phenomenon of performance.

In this book, I'm going to be looking at some of the Gothic tourism in England today, from the South West to the North East, from mocked-up dungeons to medieval castles, from some of the oldest examples (Strawberry Hill in Twickenham, Madame Tussaud's), to some of the newest (the Necrobus and the Poison Garden at Alnwick Castle). Gothic tourism is, of course, an international phenomenon. North of the border, in Scotland, Gothic tourism is thriving. As Inglis and Holmes point out in 'Highland and other haunts – Ghosts in Scottish Tourism', 'the spectral now figures as a crucial form of selling the country to a global audience.'[21] The Dungeons chain operates not only in England and Scotland, but has branches in Holland and Germany; most recently

one has opened in the United States, in San Francisco. Romania has a Dracula industry, despite the fact that, as Duncan Light points out, Stoker's fictionalization of the historical figure of Vlad Ţepeş was not even translated into Romanian until 1990. Gothic tourism may be found from the Caribbean (in Rose Hall in Montego Bay, Jamaica, for example, haunted by its 'infamous owner, Annee Palmer ... notorious for torturing slaves for her own entertainment')[22] to Japan (where visitors can go, for example on a 'Demons of the Red Light District' walk in Tokyo).[23] In short, it may be found wherever the taste for Gothic exists and wherever sensibilities permit (and sometimes where they don't).

Glennis Byron has called our attention to 'the emergence of cross-cultural and transnational gothics', and the fact that 'in the late twentieth and early twenty-first centuries gothic' is 'progressing far beyond being fixed in terms of any one geographically circumscribed mode.'[24] She points out that these 'developments in the increasingly diverse and problematic genre labelled gothic' are 'intricately connected to historically specific conditions, to the development of an increasingly integrated global economy.'[25] In the face of such a 'globalgothic',[26] it can seem almost bloody-minded to concentrate on Gothic tourism in one country – especially one that has, historically, dominated the attention of scholars. I have, however, concentrated on Gothic tourism in England for a number of reasons – the most important of these is that, though some of its forms are international (the ghost walk, the scare attraction and the haunted house phenomenon, for example), Gothic tourism has much to tell us about particular places and locality. It is bound up with the way in which we think about our past and our surroundings, and with the ways in which we construct our identities. If we want to understand how Gothic tourism operates – in terms of its economics, its politics, or its cultural significance – then it's necessary to frame it, to think about it in relation to its local circumstances. A haunted attraction in the United States will signify differently from a scare attraction in England, where the phenomenon of the Hell House (a performed environment created for the purposes of religious conversion) does not exist. Dracula tourism will be of a very different nature in Romania and in England. Tourism at Whitby is embedded in the culture from which Bram Stoker's novel issued. In Transylvania (and elsewhere in Romania), the imposition of an Anglo-Irish fiction onto sites of national significance, has a very different resonance; the Romanian novelist Ioana Baetica Morpurgo has referred to the 'memory rape' of Bran Castle.[27] I have stuck to England, therefore, for my primary case

studies, though I make reference to examples of international Gothic tourism where relevant. I do, however, consider that the approaches I make use of should prove useful for the study of Gothic tourism elsewhere.

My first chapter looks at Horace Walpole's Gothic house, Strawberry Hill. Here, I consider the origins of Gothic tourism and the Gothic aesthetic more generally, arguing that Gothic tourism both derives from, and played its part in, the development of the Gothic aesthetic that arises in the mid-eighteenth century. I consider the innovative aesthetic at work in Horace Walpole's Strawberry Hill, arguing that the eighteenth century was a time of unprecedented exploration of performance in a variety of art forms, and that the Gothic house, as a piece of 'performed architecture', is indebted to this experimentation. The chapter considers Strawberry through the experience of contemporary visitors, looking in particular at Walpole's comments on visitors whom he considered had failed to understand his house, and asking what his remarks can tell us about Strawberry's singularity. I discuss Strawberry, and, at a later point, William Beckford's Fonthill Abbey, as a kind of masquerade in stone, designed and created in expectation of certain kinds of performance. A house party given by Beckford in 1800 for Lord Nelson, the Hamiltons, and other luminaries, illustrates the extent to which Fonthill can be thought of as performed architecture. The final section takes a look at the first fully commercial piece of Gothic tourism – Robertson's Paris Fantasmagorie – and considers its indebtedness to Walpole's aesthetic experiments, arguing that the Gothic aesthetic itself is indebted to the relation between Strawberry Hill and *Otranto*.

Chapter 2 looks at another seminal example of Gothic tourism: Madame Tussaud's. I will be considering Tussaud's, past and present, paying special attention to the 'pre-history' of the exhibition in eighteenth-century Paris. The chapter will discuss the Gothicization of the waxwork and the waxwork exhibition, focusing on the changing displays in the Chamber of Horrors through the nineteenth century. The (consciously literary) testimony of visitors from Charles Allston Collins to G. R. Sims provides the lynchpin of an analysis of the mode of Tussaud's horror, and of its canny exploitation of the uncanny. The chapter will also look at the relation between history and the Gothic at Tussaud's. With the French Revolutionary period as its defining era, Tussaud's was, as it were, fated to explore the interplay between Gothic and history. It is to Tussaud's, (which, through the nineteenth century always creatively exploited its 'cross-roads' position – somewhere

between museum, theatre and gallery) that we are indebted for the rash of Gothicized museums today.

Chapter 3 comes back to the present day, and looks at a number of attractions in London. It considers London's Gothic tourism in relation to its past, and discusses some of the predominant tropes and modes of contemporary Gothic tourism. The chapter starts with Dennis Severs' House in Spitalfields, and considers its innovative summoning up of the uncanny. It then looks at Drury Lane Theatre's 'Through the Stage Door' tour, and discusses what its ghosts have to tell us about the theatre – and about the West End more generally. The following section takes itself south of the river, and considers some of Tussaud's offspring – the London Dungeons, and the Clink in Bankside – discussing them as examples of contemporary horror. The Necrobus is the final attraction to be considered. Witty, allusive and consummately performed, it is in some ways an exemplary text which illustrates many of the characteristics of contemporary Gothic tourism. Central to the chapter is the question of location. Does the nature of tourist attractions differ in different parts of London? Is it possible to talk of a geography of Gothic tourism?

Chapter 4 is concerned with peripatetic Gothic. It examines four ghost walks in detail – those of Bath, Exeter, Weymouth and Dorchester – asking what the ghost walk tells us about the town or city in which it is performed and thinking about the ghost walk as a contribution to a town's identity. Looking at Bath's ghost walk, it will examine some of the prevalent tropes of the genre and consider some of the commonest structuring motifs. Considering Exeter's council-funded ghost walk, the chapter discusses the ghost walk in relation to place, asking what can be learnt both from where ghosts are to be found, and where they are not to be seen, as well as discussing different modes of narration. The next section looks at Weymouth's Haunted Harbour Tour, and considers Gothic as an excuse for a history lesson. Finally, by means of a discussion of ghost walkers in Dorchester, the chapter will consider the ghost walkers themselves, asking who they are, what they are expecting, and where they come from, as well as examining their part in this immersive theatre of the streets. Throughout the chapter, I am interested in the way that the ghost walk not only has much to say about history and heritage, but is also eloquent on such issues as class and economics, and on the experience of change in the town.

Chapter 5 changes tack and takes a long perspective – one of 230 years. In this chapter, I look at Berry Pomeroy Castle, in South Devon,

which has a reputation of being haunted that neither its owner, the Duke of Somerset, nor its managers, English Heritage, relish. Berry Pomeroy Castle is often described as one of the 'most haunted', to use a phrase drawn from the highly popular television series on which it once appeared. The chapter traces that reputation and looks at the potent mixture of forces that brought it about. I look at tourist writing about the castle from 1788 to the present day and consider some of the many works of literature that have been written about it. I consider changing environmental factors and look at the variety of ghosts that have been said to haunt the building. What emerges is a story characterized by a fascinating interplay of factors, and a network of complicated relations between tourist practice, local publishing, folklore and literary fashion.

Berry Pomeroy Castle reappears in Chapter 6, which looks at the recourse to Gothic in the field of heritage management. The chapter focusses on Gothic tourism at three castles, managed within different economic sectors: Warwick castle (owned and managed by Merlin Entertainments), Alnwick Castle, (part of the estate of the Duke of Northumberland), and Berry Pomeroy, (managed by English Heritage, a government-funded public body, at the time of writing). 'A Tale of Three Castles' looks at the variety of forms of Gothic tourism to be found at these sites – from scare attractions to audio tours, theatrical performances, a ghost room and the Poison Garden – and considers the, sometimes problematic, relation between Gothic and heritage management: from Warwick castle's whole-hearted embrace of Gothic to Berry Pomeroy's wary distrust of it. The section on Alnwick castle, makes an excursion back into the mid-eighteenth century, to look at a form of 'Gothick' design that was a rival to Walpole's. Heritage management has, in recent years, reached more of an equable understanding with the Gothic. This chapter argues that this tendency is indicative of new priorities within the field.

The rapprochement with Gothic that characterizes heritage tourism is typical of cultural tourism more generally. Chapter 7 turns its attention to Gothic at a selection of contemporary arts festivals, two of which are publicly funded, whilst one is notable for its donations to 'Worthy Causes'.[28] The chapter considers the wide range of genres to be encountered at these festivals – films, promenade performances, walkabout acts, sideshows and installations, for instance – and discusses the phenomena of Gothic 'edutainment' and family-friendly Gothic. The example of Showzam!, 'Blackpool's Annual Festival of Circus and Performance',[29] provides an opportunity to look at the role played by Gothic in promoting a town's identity. The chapter considers the

prevalence of disambiguated Gothic (the shearing of Gothic motifs from Gothic narratives) and considers some of the surprising connotations of Gothic in the contemporary world. Pondering the curious case of Gothic respectability, it looks at the cultural and economic underpinnings of a new Gothic, which puts the '"fun" back into "funeral" and says "Boo!" to taboo"'.[30] Such Gothic often has a healthy bank-balance, a productive relationship with Arts Funding and a corporate-friendly image.

1

Strawberry Hill: Performed Architecture, Houses of Fiction and the Gothic Aesthetic

The duc de Nivernais visits Strawberry Hill

In the April of 1763, Louis-Jules-Barbon Mancini-Mazarini, duc de Nivernais, visited Horace Walpole at Strawberry Hill, Walpole's home in Twickenham. Nivernais and Walpole, who were almost exact contemporaries, had much in common. For a start, they were both politicians. Nivernais, an experienced diplomat, was acting in England as ambassador extraordinary, and earlier in the year had been involved in the negotiations for the Peace of Paris, one of the two treaties that concluded the Seven Years War.[1] Walpole was the son of the eminent eighteenth-century first minister, Robert Walpole, and an MP in his own right, with what he called (using an Old English term to refer to parliament) a 'Gothic passion ... for squabbles in the Wittenagemot.'[2] Besides politics, Walpole and Nivernais had many other mutual interests. Walpole was a francophile and Nivernais an anglophile. Both were connoisseurs of art, devotees of the landscape garden, and, above all, men of letters.[3] The two were to remain in contact for many years afterwards (the last surviving letter that passed between them dates from 1792, by which time both men were in their mid-seventies). Nivernais' visit to Twickenham in 1763, however, was not primarily social. His reason for calling was as much to see Strawberry Hill as to see Walpole.

Receiving tourists into one's home, in this period, was certainly not unknown. One has only to think of Elizabeth Bennet touring Darcy's Pemberley with her aunt in Jane Austen's *Pride and Prejudice* (1813). But travellers who made visits to Pemberley, or, in the real world, Chatsworth or Hampton Court (where Nivernais was heading for), did so for reasons different from those of visitors to Strawberry Hill. Not only did the former want to see impressive collections of paintings and

rare and beautiful objects (which Strawberry Hill had in plenty), but they also wanted to see houses that were either brilliant examples of new building or hallowed by age and historic associations. Chatsworth, for example, had been rebuilt in the baroque style at the turn of the century. Hampton Court was famed for its association with the monarchy: Henry VIII had taken the palace from Cardinal Wolsey; Edward VI had been born there; Elizabeth I had been imprisoned there as a young woman by her half-sister Mary I. Strawberry Hill, although it had some exquisite *objets d'art* and historical relics, was neither a celebrated historic house nor a stunning new build. It was not even large. Strawberry Hill was a converted dairy, which had been substantially extended and mocked-up.

Nivernais had a great deal of respect for Walpole's taste in the fields of literature and design. An anecdote of Walpole's shows Nivernais, the following month, at a party given by a mutual friend at Esher, 'absorbed all day and lagging behind, translating [Walpole's] verses'.[4] In 1785, Nivernais was to translate Walpole's 'Essay on Modern Gardening' into French. Despite these promising indications, Nivernais was doomed not to 'get' Strawberry Hill. In a letter to Horace Mann, Walpole notes: 'I cannot say he flattered me much, or was much struck by Strawberry.'[5] The crisis came when the duke walked into the room Walpole called the Tribune, which held many of Walpole's greatest treasures (see Figure 1.1).

What was the Tribune like? Fortunately for scholars of Strawberry Hill, Walpole left a very detailed description of the room and its many contents in a catalogue *A Description of the Villa of Horace Walpole, Youngest Son of Sir Robert Walpole Earl of Orford, at Strawberry-Hill, Near Twickenham: With an Inventory of the Furniture, Pictures, Curiosities, &c* (1774). In this work, we learn that the Tribune (or 'the Cabinet' as it was also known) featured windows from the 'great church at saint Alban's',[6] that its roof was taken from the chapter house at York and was 'terminated by a star of yellow glass that throws a golden gloom all over the room',[7] and that the room contained an 'altar of black and gold, with a marble slab of the same colours'.[8] Not all the objects in the Tribune had religious associations. The Tribune was a 'cabinet' in the eighteenth-century sense in that it contained many and varied objects. There were secular portraits and statues, many of them of historical figures, including kings and queens of England and of France, and some of the Walpole family past and present. There were various *objets d'art* ('a fine old enamelled watch-case, after Raphael and Dominichino',[9] for example); a substantial number of objects from the classical world (examples include a 'small bust in bronze of Caligula, with silver eyes'[10]

found at Herculaneum; an antique cameo of a 'sleeping hermaphrodite with two satyrs';[11] 'Two phalli ... two sacrificing instruments'[12]); and treasures from as far away as China.

As he entered the Tribune, the duke removed his hat. He did this because he thought he was entering a chapel. A number of factors had wrong-footed him, not just the number of religious objects in the room, but the fact that the Tribune was, as Walpole admits, 'formed upon the idea of a Catholic chapel'[13] and had been intended to have 'all the air of a Catholic chapel – bar consecration!'[14] In removing his hat, Nivernais (an aristocratic Frenchman who would not have been surprised to

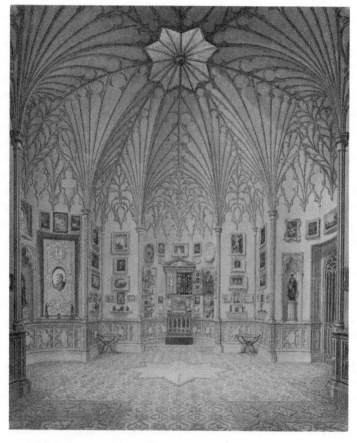

Figure 1.1 Carter, John c. 1789 'The tribune at Strawberry Hill'. Courtesy of the Lewis Walpole Library, Yale University

find a richly endowed Catholic chapel in a private house) had reacted automatically. He had, however, failed to take into account Walpole's Protestant upbringing, and the fact that Walpole liked to call himself an 'infidel'.[15] He quickly collected himself. A glance at the sleeping hermaphrodite, the 'naked Venus' or the antique phallus charms would have been enough to dispel his illusion. Although Nivernais could hardly be faulted for his mistake, he was evidently annoyed at his faux pas. He commented *'Ce n'est pas une chapelle pourtant'* ('It's not a chapel, though' italics in the original), and Walpole remarked that he 'seemed a little displeased'.[16]

The anecdote is, for me, exemplary. It shows a new kind of tourism – and an old style of tourist. It recounts a faulty response, which is in itself illuminating, and hints at a new aesthetic for which a new set of sensibilities is required. It conveys both Walpole's amusement and the fact that Strawberry Hill in 1763 was a singular phenomenon that involved a new type of visitor experience.

In this chapter, I will be looking at Strawberry Hill as a piece of proto-Gothic tourism. In the first section, I will be thinking about Strawberry predominantly through the lens of visitor experience, considering the reactions of visitors – or at least their imputed reactions – and the kinds of responses Strawberry elicited. Most of the anecdotes I'll be looking at are drawn from Walpole's letters and come accompanied by his comments. Walpole's comments give us a sense of how Strawberry wasn't to be approached, what was not to be expected of it, and what it wasn't, as well as suggest the skills and sensibilities he considered necessary for a proper appreciation of it. In the following section, taking as my cue Walpole's phrase 'liberty of taste', I will be thinking about some of Walpole's pronouncements on 'Gothic', and some of the contemporary connotations of the style. My focus throughout the chapter is on the question of what made Strawberry such a new phenomenon. I will be thinking about its experimental aesthetics, and its indebtedness to the landscape garden, as well as considering it as a piece of performed architecture. I will be discussing some of the parties that took place at Strawberry, and comparing them with a more fully Gothic party at William Beckford's work of literary architecture, Fonthill Abbey in Wiltshire.

The aesthetic at work at Strawberry was in a constant state of development. From the mid-1760s, Strawberry Hill started to become a different phenomenon. Not just a piece of performed architecture, but one that was intimately related to a literary text that was, like Strawberry itself, *sui generis*. Strawberry became a different house by means of, and because of its relationship to, Walpole's novel *The Castle of Otranto*

(1764). I consider the relation between Strawberry and *Otranto* by means of an account of a visit made by the novelist, Frances Burney, later in the century.

The chapter concludes by looking at an example of fully commercialized Gothic tourism in the late 1790s: Robertson's Parisian phantasmagoria. The Fantasmagorie was a popular attraction that ran for four years, and spawned many rivals and tributes. Immersive, mocked-up, using a perambulating audience and scare actors, it is demonstrably akin to the scare attractions of today. It was, I argue, indebted to the aesthetic experiments essayed by Walpole earlier in the century.

I make no apologies for my concentration on Walpole in this chapter. Although I take a brief look at one of Strawberry Hill's successors, Fonthill Abbey, regarding it too as a piece of performed architecture, and finish with Robertson's Paris Fantasmagorie, my main focus has been on Strawberry Hill. My reason for this is twofold. First, it was an extraordinary aesthetic experiment in its own right, with lasting effects on both architecture and tourism. Second, through its relation with *Otranto*, it gave birth to the Gothic aesthetic, to which all later Gothic – touristic or otherwise – is indebted.

Strawberry Hill: 'puppet-show of the times'

Walpole had acquired the lease of Strawberry Hill in 1747 from a Mrs Chenevix who had a toyshop and china shops at Charing Cross. His recorded comments about the house play upon the idea of toys, knick-knacks and treasures. Walpole joked in a letter to his cousin Conway that it is 'a little play-thing-house that I got out of Mrs Chenevix's shop, and is the prettiest bauble you ever saw.'[17] To his friend Horace Mann, in June 1747, Walpole wrote: 'This little rural bijou was Mrs Chenevix's, the toy woman à la mode'.[18] As these words suggest, his house was in an area that was both rural and fashionable. The patch of five acres that Walpole acquired was, as Michael Snodin notes, 'the last piece of undeveloped Thames-side land'[19] in the fashionable area of Twickenham. Twickenham was full of wealthy titled widows ('Dowagers as plenty as flounders'[20] Walpole commented) and noblemen with fantastical design ideas. One of his neighbours, Lord Radnor, had a Chinese pagoda in his grounds, which were to become known to Walpole and his friends as 'Mabland'.

Strawberry was not called Strawberry Hill when Walpole acquired it. Walpole 'rescued' this romantic name from history. He tells us that its previous name was Chopped-Straw-Hall, supposedly because local

people believed that its owner, the Earl of Bradford's coachman, had been able to afford to build it by feeding his master's horses chopped straw rather than hay.[21] As Walpole noted in 1764, after having had to spend substantial amounts of money entertaining some tourists from the top end of the social scale ('representative majesties of France and Spain'), Strawberry Hill 'was no royal foundation'.[22] It was a building of humble origins, history and associations. When Walpole showed Strawberry to his friend Etheldreda, Lady Townshend, she 'cried out "Lord God! Jesus! what a house! It is just such a house as a parson's, where the children lie at the feet of the bed!"'[23]

Walpole, a man of means, had more than one home. During the season, he could be generally found at his London address, in Arlington Street, in the district of St. James, conveniently near to the House of Commons, but from 1748 he was increasingly to be found at Strawberry Hill. His first references to Strawberry, show that he conceived it in classical terms. He describes it to Horace Mann in 1748 as a 'villa' and refers to the Thames as the Brenta.[24] By 1750 though, he is declaring 'I am going to build a little Gothic castle at Strawberry Hill.'[25] In 1763, Walpole had just completed a second phase of work on the house. Strawberry now had battlements, ogee windows, a round tower, a new hall and stairs and an armoury (in 'an open vestibule of three gothic arches, lighted by a window entirely of painted glass').[26] There was a Great Parlour, the Holbein Chamber, a long gallery ('Fifty-six feet long, seventeen high, and thirteen wide without the five recesses. The cieling [sic] is taken from one of the side isles of Henry 7's chapel'),[27] a library (the books 'ranged within gothic arches'),[28] a cloister and the 'Tribune' or 'Cabinet'. By the time Nivernais visited, Strawberry looked (from the outside at least) like a little white castle.

Following this extensive work, Strawberry Hill, in 1763, became a tourist destination. In the August, Walpole wrote to his cousin, Henry Conway, about the Gallery, 'Why, all the earth is begging to come to see it'.[29] By September, he was complaining to George Montagu:

I have but a minute's time for answering your letter, my house is full of people and has been so from the instant I breakfasted, and more are coming – in short, I keep an inn; the sign, the Gothic Castle – since my gallery was finished, I have not been in it a quarter of an hour together; my whole time is passed in giving tickets for seeing it, and hiding myself while it is seen – take my advice, never build a charming house for yourself between London and Hampton Court, everybody will live in it but you.[30]

As Walpole noted eight years before, after a visit during which 'Princess Emily' (George II's daughter, Amelia Sophia Eleanora) had not kept within the bounds expected of visitors, but had been 'prying into the very offices and servants' rooms', 'Strawberry Hill is the puppet-show of the times'.[31]

Interest in Strawberry Hill was not merely because of its use of Gothic. Indeed, the turn to Gothic as a design style was not in itself particularly radical or inventive. Although Walpole is sometimes credited for introducing a taste for Gothic design in architecture, there had been a wave of interest in Gothic for a while. As Robert Wyndham Ketton-Cremer points out: by '1750 a variety of Gothic designs was accessible to every ambitious citizen'.[32] Ketton-Cremer even suggests that, by the time Strawberry was built, Gothic 'had become so prevalent a craze as to be already unfashionable and middle-class.'[33] At Strawberry Hill, Walpole was not merely bestowing a few graceful Gothic touches. He was introducing a much more pervasive and inventive aesthetic. Strawberry Hill was a tourist attraction that was quite unlike anything that had gone before it. It was no mere house, but, as the term 'puppet-show' suggests, a new kind of entertainment – more specifically, dramatic entertainment.[34] Strawberry Hill was, and is, a dramatized building for which audience response and interaction were essential.

Strawberry Hill, Madame de Boufflers and solidity

The duc de Nivernais' experience, if we judge by Walpole's letters, does not seem to have been an isolated one, but was mirrored by those of other visitors, particularly French visitors. Walpole recurs to the French experience of Strawberry a number of times and his comments about the French inability to 'get' the house tell us much about the sensibilities required in order to appreciate it. An anecdote relating to a visit in May 1763 shows Walpole frustrated by the indifference of a party of visitors:

> The French do not come hither to see. A l'Anglaise happened to be the word in fashion; and half a dozen of the most fashionable people have been the dupes of it. I take for granted that their next mode will be à l'iroquoise, that they may be under no obligation of realizing their pretensions. Madame de Boufflers I think will die a martyr to a taste which she fancied she had, and finds she has not.[35]

Claiming that the French only come to see Strawberry because there is a fashion for things English in France at the moment, Walpole implies

that the French sense of fashion (as opposed to true taste) gets in the way of their ability to 'see'. Wryly, he suggests that if there had been a fashion for things Iroquois, the French would not have felt obliged to carry their efforts so far. The reference to the Iroquois is topical and loaded with significance. The Iroquois had fought with the British against the French in the Seven Years War, during which the French had lost many of their global possessions, including most of those in North America. Walpole's allusion marshals English taste and Native American tradition into their battlelines, positioning them against French sophistication and 'pretensions'. The subtext, I think, conflates Iroquois culture with what Walpole thought of as Strawberry's 'venerable barbarism'.[36] The British and the Iroquois are, ultimately, the winning combination – part of the new world order when it comes to matters of taste.

For Walpole, the response of the French party who visited in May, and of Nivernais, who had visited the previous month, is hobbled by their understanding of religion. They are unable to liberate their taste and sensibility from their religious backgrounds. He uses a language of over-earnest religious practice and self-imposed martyrdom to figure Madame de Boufflers' struggles to understand Strawberry. The image picks up on a reference that Walpole had made earlier to 'the popery of my house, which was not serious enough for Madame de Boufflers, who is Montmorency ... and too serious for Madame Dusson, who is a Dutch Calvinist'.[37] Whether or not Walpole was correct in interpreting his visitors' reactions, he was wrong about Madame de Boufflers' religion, as the notes in the Yale edition of Walpole's Correspondence point out.[38] The comment, however, underlines the fact that the Tribune was not to be responded to as a religious space.

Strawberry Gothic was premised upon a radical degree of divorce between style and function. Despite looking like a little castle from the outside, and having an armoury, it had no defensive functions. Although it had a cloister and a room that resembled a chapel, Strawberry had no religious functions. Rather, it drew on the styles of castle and monastery in order to create certain kinds of ambience. Walpole coined the word 'gloomth'[39] to refer to the atmosphere he worked so hard and well to create. The fact that 'gloomth' is a coined word, a truncated portmanteau, both new and archaic sounding, is itself telling. It is a compound of a noun ('gloom') and an ending associated with abstract nouns associated with spatial measurement ('breadth', 'width', 'length', etc.). 'Gloomth' is a composite; atmosphere achieved through things; old and new at the same time. In Strawberry, Walpole wished not to achieve a copy of a monastery or a church, but to relocate, into a modern, secular, non-military context, an atmosphere.

In a letter written to Horace Mann in December 1764, Walpole takes up the issue of Madame de Boufflers' response to Strawberry again. He refers to her visit of the year before, noting that she was 'extremely infected with the *anglomanie*, though I believe pretty well cured by her journey.' He is at pains to point out his liking for Madame de Boufflers, who, he notes:

> is past forty, and does not appear ever to have been handsome, but is one of the most agreeable and sensible women I ever saw; yet I must tell you a trait of her that will not prove my assertion. Lady Holland asked her how she liked Strawberry Hill? She owned she did not approve of it, and that it was not *digne de la solidité anglaise*. It made me laugh for a quarter of an hour.[40]

According to Walpole's account, Boufflers considers Strawberry not to be worthy of, nor to have the dignity or solidity that she associates with, the English character. The reference to Strawberry's (lack of) 'solidity' is illuminating. At one level, the comment may be taken to refer to Strawberry's flimsiness. Strawberry might have looked like a castle but there was very little that was solid about it. Strawberry's crenellations were fashioned out of wood, its walls constructed from pasteboard. By the time Walpole died, his friend, Williams, quipped that 'he had outlived three sets of his own battlements'.[41] At another level, 'solidity' signifies the earnestness that Boufflers considers Strawberry so singularly to lack. Walpole examines Boufflers' expectations, dismissing her ideas about Englishness, before posing an idea about Frenchness, and, in particular, about French approaches to architecture:

> They allot us a character we have not, and then draw consequences from that idea, which would be absurd even if the idea was just. One must not build a Gothic house because the nation is *solide*. Perhaps as everything now in France must be *à la grecque*, she would have liked a hovel if it pretended to be built after Epictetus's – but Heaven forbid that I should be taken for a philosopher! Is not it amazing that the most sensible people in France can never help being domineered by sounds and general ideas?[42]

For Walpole, not only do the French (or at least those French smitten with Anglomania) credit the English with a seriousness that they do not have (a kind of philosophical aspect to the 'rosbif' character), but they also demand a certain kind of congruency between national character

and architecture because of their own primarily theoretical cast of mind. Walpole finds the idea absurd and restricting, asking if France's passion for the Grecian style means that even a hovel would be appealing if built in the style of Epictetus (the Greek philosopher of stoicism who was also a Roman slave).

Strawberry could not and did not appeal to Madame de Boufflers and many others because it was far from being 'domineered' by a general idea and certainly not possessed of philosophical congruency. It did not have the stylistic congruence, the purity that might be expected of someone working in a classical style. Walpole freely mixed and matched, drawing upon classical 'grace'[43] and Gothic features at Strawberry Hill. Strawberry's very 'Gloomth', as Michael Snodin notes, was not necessarily gloomy.[44] The building was characterized by what Walpole calls, in a letter to Mann in 1758, 'the irregular lightness and solemnity of Gothic.'[45] Strawberry too was notably lacking in historical cohesion. Despite being a keen and knowledgeable historian who went regularly on 'Gothic pilgrimages'[46] with his friend Chute, visiting old churches, country houses and castles and returning with plunder destined for Strawberry, Walpole did not feel obliged to work only in Gothic, or to adhere to the style of any particular period. In his designs for Strawberry, Walpole refused to confuse his academic expertise and his aesthetic sense. As Marion Harney puts it: 'Authenticity was not his concern'.[47] Walpole had no problem with combining genuine artefacts with copies, or with examples of contemporary design based on ancient items, or illustrations from books, or ideas drawn from other historical artefacts.[48] Indeed, as Kevin Rogers notes of the house as it stood in 1756, 'the strongest influences on the overall design of the house ... were not in fact ancient structures but modern Gothic buildings.'[49] Furthermore, Walpole was happy to sit medieval pieces beside pieces from classical antiquity. In the Tribune, the display was disparate enough to include 'a Chinese incense box of bronze', an 'Egyptian duck; antique cameo, on agate', Elizabethan miniatures and 'the Great seal of Theodore king of Corsica':[50] the element that was to provide cohesion was Walpole's taste. The phrase 'creative anachronism' might have been invented for Horace Walpole.[51]

Walpole finishes his meditation on Boufflers' reported comments by posing a contrast between sense and nonsense.

So the moment it is settled at Paris that the English are solid, every Englishman must be wise, and if he has a good understanding, he

must not be allowed to play the fool! As I happen to like both sense and nonsense, and the latter better than what generally passes for the former, I shall disclaim even at Paris the *profondeur* for which they admire us.[52]

Disclaiming 'depth', Walpole seems to position Strawberry as 'nonsense'. Rather, however, I think that it is positioned within a fourth (unmentioned but implied) category. Strawberry is neither sense, nor nonsense, nor nonsense passing as sense. It is sense passing as nonsense – or what Walpole terms a few lines later 'the genuine nonsense that I honour'.[53] This is one of the reasons why the nature of response to Strawberry tended to be so complex.

Modern Gothic: 'liberty of taste'

Working in 'Gothic' in the 1750s, Walpole sensed a degree of disdain from some of his friends, and felt the need to justify his stylistic choices. His efforts to convince various of his correspondents to value his style choice are informative. Walpole had to perform some interesting sleights of hand (metaphorically) in order to gain some acceptance for the Gothic. Thus, in a letter of 27 April 1753, he writes to his friend Horace Mann, who was resident in Florence:

thank you a thousand times for thinking of procuring me some Gothic remains from Rome; but I believe there is no such thing there: I scarce remember any morsel in the true taste of it in Italy. Indeed, my dear Sir, kind as you are about it, I perceive you have no idea what Gothic is; you have lived too long amidst true taste, to understand venerable barbarism.[54]

Walpole's strategies in his re-education of Mann are interesting. His first recourse is to a muddying of the waters. Although he makes conventional obeisance to the 'true taste' of the classical, juxtaposing it with the barbaric, en route he highjacks the word 'venerable', applying it to Gothic 'barbarism'. His grounds for doing so are impressively sure-footed. 'Venerable', as a word of Latin derivation, might be expected to be applied to Italy, however, yoking the term with 'barbarism' works well – particularly as the word was associated with the English early medieval writer, the Venerable Bede. Significantly, the phrase 'true taste' is used twice: once for Gothic remains and the other for Roman remains. To complete Mann's re-education in his new aesthetic,

Walpole adroitly realigns classical 'true taste' with ignorance (a characteristic traditionally assigned to the Goths themselves), declaring 'you have no idea what Gothic is'.

Walpole's correspondence with Mann reveals some further interesting associations for the Gothic. In a letter written to Mann three years earlier, he states:

> I am sure whenever you come to England, you will be pleased with the liberty of taste into which we are struck, and of which you can have no idea.[55]

Robert Miles points out that the term 'Gothic' had a wide variety of significations within this period, but that it was becoming ever more entangled with concepts of liberty and 'Englishness'.[56] What is interesting in Walpole's usage, however, is that Gothic is not so much a style that alludes to, or allegorizes, ancient liberty, as a style whose use signifies contemporary liberties. An article in *The World* (22 March 1753) shows that Walpole was not alone in thinking of the use of Gothic in this way. Significantly, the terms at play are very similar. The writer considers the contemporary fashion for Gothic, remarking sardonically:

> There is something, they say, in it congenial to our old Gothic constitution; I should rather think to our modern idea of liberty, which allows every one the privilege of playing the fool, and of making himself ridiculous in whatever way he pleases.[57]

This bundle of associations – liberty, privilege, modernity, pleasure, 'playing the fool' and self-expression – is relevant to Strawberry Hill.

In his letter to Mann about the 'liberty of taste' Walpole makes an interesting alignment of Gothic with chinoiserie, writing:

> I am almost as fond of the Sharawaggi, or Chinese want of symmetry, in buildings, as in grounds or gardens.[58]

As David Porter writes: 'the spirit of the Gothic is for Walpole in this letter unmistakably Chinese.'[59] Gothic and chinoiserie represent and showcase the creative liberty that characterizes English building but is absent from French and Italian architecture both of which, for Walpole, are over-restrained by notions of the correct. Walpole's willingness to link Gothic and chinoiserie at this juncture (he later was to repudiate chinoiserie) is linked to the creative possibilities of a new Gothic, where

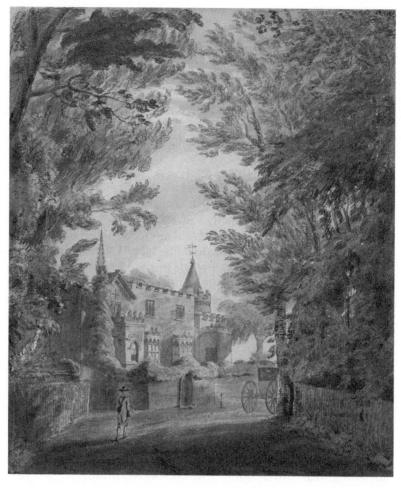

Figure 1.2 Joseph Charles Barrow, 'View of the North Front of Strawberry Hill from the Road', 1789. Courtesy of the Lewis Walpole Library, Yale University

styles fuse with each other. Mixed and matched styles were a sign of liberty and confidence, wealth and privilege – a result and reflection of Britain's status as the trade centre and emporium of the world. As in London, anything from anywhere, so it seemed, could be bought, sampled or sold; in British building, classicism, chinoiserie and Gothic could be found. Walpole himself obliquely refers to the relation between his styling of Strawberry and Britain's new imperial riches when he jokes:

though my castle is built of paper, and though our empire should vanish as rapidly as it has advanced, I still object to peach-colour – [60]

Walpole's use of Gothic, his confidence that it could be disentangled from its cumbersome old world connotations, signified luxury at a variety of levels. The very ability to choose Gothic signified liberation from the contexts that had traditionally gone with it. Strawberry could be as it was, precisely because the days when Catholicism was the state religion were centuries away, Walpole was freed from religious practice, and the house was on a little peaceful country lane in ever more fashionable Twickenham (see Figure 1.2). Strawberry demonstrated the luxury of being able to detach the sign from its significations. It was also, in itself, luxurious. The breakfast room, for example, is described thus by Walpole, in a letter of 12 June 1753 to Mann:

hung with a blue and white paper in stripes adorned with festoons, and a thousand plump chairs, couches and luxurious settees covered with linen of the same pattern.[61]

As Walpole noted in the 1784 edition of the *Description*: 'In truth, I did not mean to make my house so Gothic as to exclude convenience, and modern refinements in luxury.'[62]

The association of the new Gothic with pleasure was paramount and Walpole emphasizes the point through contrast with classical rigour. 'Grecian' taste, as evinced by the reference to Epictetus, is figured as an aesthetics of endurance and pain. The fact that Walpole's example of French building is a classically appropriate hovel says it all. In Walpole's writing about Strawberry, on the other hand, Gothic is associated with liberty, modernity and pleasure.

The wording of *The World*'s critique of Gothic is instructive about the particular nature of the liberty of Gothic architectural design. *The World* distinguishes between political and individual liberty, between the 'Gothic constitution' and what it terms 'the privilege of playing the fool, and of making himself ridiculous in whatever way he pleases'. Humour, the 'genuine nonsense that I honour', is an essential aspect of Strawberry's Gothic. Walpole was particularly fond of perceptual dissonance and enjoyed exploiting the tensions between what was and what one might expect. Pleasure was to be had in Walpole's use of lowly modern materials to imitate old treasures: ingenious pretence, and the recognition of it, was essential to Walpole's design aesthetic. The disparity between the domestic and the martial world of the castle

was a particularly fruitful source of pleasure, as was incongruity relating to scale. Though a castle, Strawberry was small. Walpole writes of his delight in its 'diminutiveness'[63] from the start, telling Mann in June 1747 'The house is so small, that I can send it you in a letter to look at',[64] and writing, in a similar vein, in March 1753, of 'a Gothic staircase, which is so pretty and so small, that I am inclined to wrap it up and send it you in my letter.'[65] Both comments play on Strawberry's literary qualities.

The criticism of Gothic in *The World* associates the style with the display of individual taste. This too is relevant to Strawberry. In Strawberry, Walpole was not only declaring his right to freedom in matters of taste, he was also creating a house that was to be intimately associated with its creator. As Catherine Spooner notes, Strawberry 'inaugurated ... a tradition of Gothic interior design as expression of unique personal taste, a means of curating the self.'[66] Strawberry demanded an understanding of the eccentric and singular intentions of its creator. It was to be read in terms of the character of a possibly rather wayward individual, which is why Walpole refers to it in 1784 as a 'capricious house'.[67] Its humour is conspiratorial. It plays to those clever and delighted enough to be able to detect and appreciate its felicities, its making-do, its fabrications. Failure to appreciate Strawberry's humour, results in Walpole's laughter – 15 minutes of it in the case of Boufflers. The level of identification between Walpole and Strawberry accounts for the tension in Walpole's letter between his liking of Madame de Boufflers and her failure to like his house. Because of the degree of identification between the two, it should be a case of 'like me, like my house' – only, she is French, so it isn't.

Rather than making demands upon the taste associated with an aristocratic education, Strawberry required new responses. As Snodin writes, in Walpole's opinion, 'Gothic had a unique ability to summon up ideas and emotions'.[68] To appreciate Strawberry, it was necessary to be able to feel it. Strawberry addressed itself to those who were sympathetic, who 'understood'; it celebrated the possession of shared sensibilities. The question of the right sensibilities for Strawberry is best illustrated by recourse to the disastrous visit of May 1763. As Walpole tells it, his French visitors are virtually unmoved by Strawberry – apart from when they visit the Tribune. Here their apathy is conquered by the effects of light, and by the response of an English woman in their party – the Duchess of Grafton – who is much more receptive to the spirit of Strawberry:

the cabinet, and the glory of yellow glass at top, which had a charming sun for a foil, did surmount their indifference, especially as they were animated by the Duchess of Grafton, who had never happened to be here before, and who perfectly entered into the air of enchantment and fairyism, which is the tone of the place.[69]

The Duchess of Grafton's response is exemplary, and Walpole's wording informative. He refers to her animation of the French visitors, stresses the qualities of movement, life and soul, on her part, in opposition to the initial coolness of the French response. With the phrase 'entered into', Walpole conveys the degree of sympathetic response and imaginative leap necessary to appreciate Strawberry. Walpole's terminology of 'enchantment and fairyism' links Strawberry with the world of *A Midsummer Night's Dream*, and suggests the act of transformation that takes place within the spectator who is willing to 'enter' into 'the tone of the place'.

Strawberry, the landscape garden and intermediality

Commenting on Nivernais' failure to congratulate him, Walpole grumbled to Horace Mann: 'the most sensible French never have eyes to see anything, unless they see it every day, and see it in fashion'.[70] Despite the pique implicit in the comment, there is an element of truth to the assertion that French visitors were less well equipped than Walpole's British (and particularly English) visitors to understand the aesthetic at work in Strawberry. For a start, Walpole's French visitors did not have the familiarity with the new Gothic that his English visitors had. Nor did they have the same cultural contexts by which to understand what Walpole was doing with his material. There was, I would argue, a further sense in which some of Walpole's French visitors were ill equipped to understand Strawberry Hill, and that was that the aesthetics at work in Strawberry Gothic were very much indebted to another art form, one that, as John Dixon Hunt writes, was 'thought of variously yet unanimously as "the English landscape garden", "le jardin anglais" or "der englische Garten"'.[71]

Walpole was a keen student of the landscape garden, and, through his 'Essay on Modern Gardening', one of its most important theorists. He was a keen landscape designer himself, indeed, he set about landscaping Strawberry Hill in 1748 before he embarked on his Gothic improvements.[72] In *Place-Making for the Imagination: Horace Walpole and Strawberry Hill*, Marion Harney points out some of the ways Strawberry

Hill draws on the theory of the landscape garden. She writes of its use of a 'series of sensory effects and moods ... [which] create a background to Walpole's collection of cultural and historical artefacts'.[73] She also argues that 'Walpole used theories of landscape design' in his 'juxtaposing' of 'Classical artefacts with Gothic'.[74] Walpole's indebtedness to the landscape garden goes further. Specifically, I would argue that the fluid and inventive sense of genre to be found at Strawberry Hill is indebted to the landscape garden.

For many people, the filter through which eighteenth-century arts are approached is that of a stifling neo-classicism, a concept of frigid aristocratic norms. When the phrase 'ut pictora poesis' ('As is painting, so is poetry'),[75] a central maxim for creators of the age, is referred to, all too often it is used by present-day commentators merely as a shorthand for invention incapacitated by classical learning, or aesthetic theory hobbled by an over-prescriptive emphasis on representation. By contrast, for eighteenth-century creators, in a variety of spheres, the concept of the 'sister arts' was a licence for experimentation and generic crossover; it signalled the possibility of hybridization and even the creation of new art forms. It was through hybridization that Walpole was best able to demonstrate his 'liberty of taste'.

The theory of the interdependence of the sister arts was particularly significant for the landscape garden, which was an artwork that contained and combined many other art forms. For Walpole, the 'Three Sisters' of 'Poetry, Painting, and Gardening' were 'the Science of Landscape'.[76] The landscape garden not only contained examples of architecture and sculpture but was a kind of sculpture in itself. In the landscape garden, hills might be flattened, or created. Streams might be diverted, valleys flooded. ('The expence [sic]' Walpole commented 'is only suited to the opulence of a free country.'[77]) More significantly, the landscape garden was specifically modelled on examples drawn from other media. It was indebted to painting. As John Dixon Hunt and Peter Willis point out, the owners of the gardens 'collected from Italy examples of the "best of Landskip painters"... These pictures and engravings were destined for English walls and cabinets, while outside the grounds steadily assumed the forms the paintings had suggested.'[78] Such was the influence of painting on the creation of scenes within the landscape garden, that Walpole commented: 'every journey is made through a succession of pictures'.[79] The creators of landscape gardens also thought of the landscape in relation to poetry, freely drawing on literary sources, either directly, or in subtextual allusion. Landscape gardens referenced classical pastoral, and made use of an ever-increasing vocabulary of national liberties and native architecture. As critics such as John Barrell, John Dixon Hunt

and Peter Willis have demonstrated with reference to such gardens as Stowe or Rousham, these are not merely gardens fashioned in the terms of specific landscape paintings but gardens that ask to be read.[80] Strawberry Hill took cues from the landscape garden when it came to the relation between the sister arts. It is an artwork that combines many others – literature, painting, sculpture and architecture amongst them. Not only does it contain works of art, but it also ingeniously combines and blends them. That is, it has a specifically intermedial aesthetic. References in Walpole's letters, such as the one quoted above (about the 'Gothic staircase' that Walpole is 'inclined to... send in my letter'), or to being able to send the whole of Strawberry in a letter, suggest as much. Strawberry was never only seen as a piece of architecture; it was always seen in terms of other media too. Walpole enjoyed breaking the frames, exploring what happened when art works spilled over traditional generic boundaries. Not only did visitors see paintings, they were also invited to walk into a painting. Strawberry Hill can be thought of as a series of pictures created in actual space. Parts of the house were fashioned from representations – illustrations from books, paintings and prints; Walpole and his Committee of Taste then recreated what had been two-dimensional in three dimensions. The phenenomenon became even more apparent when Walpole employed artists to represent Strawberry Hill. From 1755 until 1759, Johann Heinrich Müntz, the resident artist, painted a series of views of the house to hang inside it.

Literature was also a significant part of Strawberry's conception and central to its understanding. Not only did the house contain busts and portraits of writers such as Voltaire, Dryden and Colley Cibber (who himself had lived in the house, and had written *The Refusal or The Lady's Philosophy* (1721) there)[81] and a painting of Eleanora d'Este with whom, Walpole notes, Tasso was in love, but it built in allusion to, and drew inspiration from specific lines and literary texts. As Kenneth Clark in *The Gothic Revival* (1928) declares, 'Gothic was from the first a literary style with an appeal which was purely associative',[82] though, strangely, he made an exception for Strawberry Hill.[83] There were particular literary references that can be seen to work their way through a variety of different media at Strawberry. For example, in the Tribune there was a drawing by Richard Bentley, which depicted 'two lovers in a church looking at the tombs of Abelard and Eloisa'.[84] In the *Description*, Walpole points out that the lines, 'If ever chance two wand'ring lovers brings/To Paraclete's white walls and silver springs, etc.'[85] were the inspiration for the artwork. Pope's lines function at a variety of levels, and bring together visual, literary, architectural and historical domains. They inspire not only the drawing, but the room in which it is situated.

The same visual/literary/historical/architectural knot can be seen in the construction of the hall. Walpole points out in a letter to Mann of 1753, long before the tower or the Tribune was built:

> I was going to tell you that my house is so monastic that I have a little hall decked with long saints in lean arched windows and with taper columns, which we call the Paraclete, in memory of Eloisa's cloister.[86]

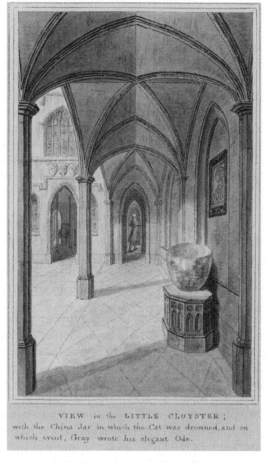

VIEW in the LITTLE CLOYSTER;
with the China Jar in which the Cat was drowned, and on
which event, Gray wrote his elegant Ode.

Figure 1.3 John Carter 'View in the Little Cloyster' from *A Description of the Villa of Horace Walpole* (Strawberry Hill, 1784) (Extra-illustrated, owned by Richard Bull). Courtesy of the Lewis Walpole Library, Yale University

Literary and historical allusions also pertained to other parts of the house. In the small cloister, they were less weighty. Here stood the very same porcelain vase in which, in 1747, Walpole's cat, Selima, had drowned (see Figure 1.3). The vase had achieved fame when Walpole's friend, the poet Thomas Gray, wrote about the event in his celebrated poem 'Ode on the Death of a Favourite Cat Drowned in a Tub of Goldfishes', first published[87] in 1748. Again, however, it was not enough for the association to be merely felt. Walpole made sure that the visitor's attention was drawn to the fact by a label (written by Walpole himself) that, adapting the first line of the poem, read 'Twas on THIS lofty vase's side'.

Strawberry was an immersive art environment with a strong sense of the proximity and continuities between neighbouring media. The point is made best with reference to Walpole's account of a party that he held in May 1769. Strawberry, he writes:

> has been in great glory – I have given a festino there that will almost mortgage it. Last Tuesday all France dined there. Monsieur and Madame du Chatelet, the Duc de Liancourt, three more French ladies whose names you will find in the enclosed paper, eight other Frenchmen, the Spanish and Portuguese minsters, the Holdernesses, Fitzroys, in short we were four and twenty.[88]

The guests arrived at two in the afternoon, and after being received by Walpole, were given a tour of Strawberry. After this, Walpole took them to his printing house:

> where I had prepared the enclosed verses, with translations by Monsieur de Lisle, one of the company. The moment they were printed off, I gave a private signal and French horns and clarinets accompanied the compliment. We then went to see Pope's grotto and garden, and returned to a magnificent dinner in the refectory.[89]

The anecdote conveys the extent to which Strawberry was an all-enveloping artwork that even included some of the means of production (the printing press). Here the arts are to be found and experienced in a fluid continuum. Here poetry is created, produced and sampled. Here music is played, triggered by the moment of printing. From here, guests may tour Pope's celebrated garden, which bordered on Walpole's.

The decision to visit 'Pope's grotto and garden' was not merely a result of Walpole's need to entertain his visitors with a nearby attraction. Nor is it solely an example of literary pilgrimage. Alexander Pope was an

essential part of Strawberry Hill. Walpole makes the significance of Pope clear from the beginning. In 1747, describing Strawberry's environs, he comments to Conway:

> Dowagers as plenty as flounders inhabit all around, and Pope's ghost is just now skimming under my window by a most poetical moonight.[90]

Walpole was interested in Pope for a number of reasons: as the foremost classical poet of the century; as one of the early practitioners of the art of the landscape garden; and also, as the reference to Pope's ghost hints at, as one of the earliest experimenters in a new Gothic aesthetic, in the form of his renowned poem 'Eloisa to Abelard'. Just as significant, for Walpole, as Pope's ability to work within different aesthetic systems, and within different media, was Pope's interrelating of his spheres of creative interest. Pope's grotto was a particularly good example of this phenomenon. Not only was it an attractive piece of garden sculpture, a faux-medieval structure decorated with twinkly stones, where visitors could shelter, rest and meditate, but it was also a materialization of one of the locales associated with the medieval world in which Pope had set his influential poem.

Strawberry was, undoubtedly, in a literary locale. It was also a locale shaped by literature. Pope was the ghost under the window, the fashioner of the land, an inspiration for Walpole. He was also present at Strawberry in other ways. Walpole chose not only to reference Pope, but to draw him in, to frame him, and to use Pope to frame his visitors' experience. Tracing the presence of Pope at Strawberry Hill helps us understand some of the ingenious modes of intermediality that operate at the house – particularly the contagious properties of literature. Thus, the lines from 'Eloisa to Abelard', discussed earlier, were felt at various points within the house, their influence spanning drawing, architecture and the creation of atmosphere – not merely the atmosphere of the medieval, but the atmosphere of being in a poem. At Strawberry, visitors are not only within another's artworld, but art spills over boundaries, migrating, for example from the world of ideas to become a material object, or from one medium to another. The phenomenon can again be illustrated by recourse to Pope. At Strawberry was Pope's own copy of the edition of Homer that he had used to make his celebrated translation. Not only did it have Pope's signature, and an inscription that marked the date of his completion of the translation, but, on the flyleaf, Pope had drawn the church at Twickenham. Pope's drawing

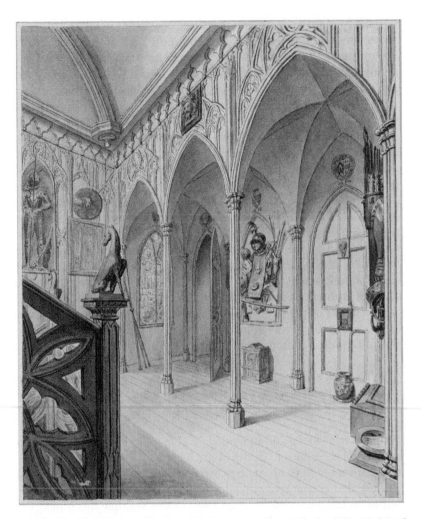

Figure 1.4 John Carter, 'Hall' (not dated), from Horace Walpole, *A Description of the Villa at Strawberry-Hill* (Strawberry Hill, 1784). Courtesy of the Lewis Walpole Library, Yale University

(of Twickenham) lay within Pope's Homer, within Walpole's building, within Pope's landscape. The example of Pope's Homer at Strawberry shows Walpole's interest in arranging artworks so that different art forms formed a pleasing – and often teasing – continuum. It is a kind of Russian doll principle crossed with a kind of teasing ekphrasis. One artwork frames another, in a series of constantly changing perspectives.

Strawberry is above all, as Snodin points out, 'a house full of stories'[91]. As Stephen Bann points out: 'For the most part, it was not artistic quality that validated an object's presence at Strawberry Hill, but the richness of its associations, historical or personal.'[92] Walpole positioned and presented his objects so that even if they hadn't arrived with a story (and his record-keeping, as regards provenance, was impeccable) they would receive one. There was of course what Kevin Rogers calls its 'elaborate fictive history',[93] the overriding fiction that visitors were encouraged to embrace (and to recognize as a fiction), of Strawberry as ancestral home, 'an ancient seat developed and extended over generations.'[94] Thus, Walpole says of some 'trumpery' he has purchased at 'Mrs Kennon the midwife's' sale, 'it is all to be called the personal estate and moveables of my great-great-grandmother'[95]. Likewise, he describes the contents of his armoury, 'niches full of trophies of old coats of mail, Indian shields made of rhinoceros's hides, broadswords, quivers, long bows, arrows and spears' and notes that it is all '*supposed*' to be the war spoils of the crusader Sir Terry Robsart[96] (see Figure 1.4). Of an 'immense cargo of painted glass from Flanders', Walpole wrote, 'I call them the achievements of the old Counts of Strawberry.'[97] There were other stories too. Strawberry was awash with them. As the historian Macaulay, was to comment – disapprovingly – many years later:

> In his villa, every apartment is a museum, every piece of furniture is a curiosity; there is something strange in the form of the shovel; there is a long story belonging to the bell-rope.[98]

Walpole was above all interested in the power of objects to tell stories, whether those stories were histories, legends, romances or newly invented fictions. At Strawberry everything spoke. It was, and is, a house that encouraged polyphony. As Alicia Weisberg-Roberts points out in an essay entitled 'Singular Objects and Multiple Meanings', the 'objects in Walpole's collection exceed discursive boundaries by simultaneously inhabiting more than one physical or narrative context'.[99] Walpole positioned – and labelled – his objects in ways that encourage interesting dialogues. Walpole would position the invaluable beside the practically valueless, the relic beside the artefact, the genuine beside the fake. What was common to all these objects was their power of voicing a narrative. At Strawberry, however, not only did stories emerge from objects, but story spawned objects. The house itself was not immune to the generative power of stories. The most notable example of this is the case of one of the works produced by the Strawberry Press, Walpole's

scandalous play, the verse drama *The Mysterious Mother* (1768), which Frances Burney described as:

> a tragedy that seems written upon a plan as revolting to probability as to nature; and that violates good taste as forcibly as good feeling. It seems written, indeed, as if in epigrammatic scorn of the horrors of the Greek drama, by giving birth to conceptions equally terrific, and yet more appalling.[100]

The Mysterious Mother, which Walpole started writing in 1766, was printed in an extremely limited edition of 50 copies, and Walpole kept firm control over who received these copies. Limited in its spread in the outside world, however, it permeated Strawberry Hill itself at many levels, eventually making its way into the very fabric of the building. Walpole's friend Lady Diana Beauclerk drew some of the scenes from the play, then, in 1776, appeared a new tower with a room – the Beauclerk closet – both 'built on purpose to receive seven incomparable drawings of Lady Diana Beauclerc for Mr Walpole's tragedy of The Mysterious Mother.'[101]

Strawberry as masquerade

Performance was an integral part of the aesthetic at work in Strawberry Hill. In this, Strawberry was not atypical of its age: eighteenth-century culture was performance-orientated, and performance in the eighteenth century was not then confined to those spaces where we expect to find it now (not least because the lines between leisure and high art were much more fluid than they were subsequently to become). Patrons of the arts not only expected professionals to perform, but they frequently expected to perform themselves – at pleasure gardens such as Vauxhall and Ranelagh, at masquerades, at private parties, for example. Tourists going on picturesque tours expected the landscape to be performed for them – by musicians placed round lakes, for example. The landscape garden was characterized by a high degree of performance. Place itself performed: areas became wildernesses or Arcadian meadows. Like a stage set, the landscape garden was littered with fake medieval grottoes, recently constructed ruins, Greek temples and hermitages. Queen Caroline's garden at Richmond Lodge had a building called Merlin's Cave ('something like an old haystack, thatch'd over,' wrote the correspondent of the *The Craftsman* dismissively),[102] as well as a hermitage that contained a library (staffed by the poet Stephen Duck). The performance of place was sometimes supplemented by paid performances

by faux-medieval hermits, for example, or rural milkmaids. The hermit was the most usual, but also the most difficult to retain, on account of the job conditions.

Performance saturated Strawberry Hill – the house itself, its contents and, on occasion, the inhabitants performed. The house performed – as a castle and a monastery. Its 'chapel' was pretty convincing, as we have seen in the case of Nivernais. Even the décor was performing. Strawberry is full of materials that are posing as something other than themselves. Paper is the most obvious example. In a letter to Horace Mann of June 1753, Walpole revels in the effects he has managed to create with 'stone-colour Gothic paper' and 'paper painted in perspective to represent ... Gothic fretwork'. Paper was also used 'to imitate Dutch tiles' in the 'cool little hall'.[103] The very painting pretended to be ancient:

> We are just now practicing and have succeeded surprisingly in a new method of painting, discovered at Paris by Count Caylus, and intended to be the encaustic method of the ancients.[104]

Objects in Walpole's collection posed as things they were not. Walpole positioned objects in ways that explored dramatic possibilities. As we have seen, he cheerfully invented fictional provenance, and he was interested in the extent to which objects can be passed off as other things. In the letter of June 1753 to Mann, quoted above, Walpole marvels at the fact that some 'Venetian prints, which I could never endure while they pretended, infamous as they are, to be after Titian' can be resituated and re-presented as fifth-century artworks:

> when I gave them this air of barbarous bas-reliefs, they succeeded to a miracle: it is impossible at first sight not to conclude that they contain the history of Attila or Tottila, done about the very era.[105]

As Judith Chalcraft and Anna Viscardi argue in *Visiting Strawberry Hill*, theatricality was a significant aspect of the house. They note that: 'Walpole's interest in theatre influenced the way in which Strawberry Hill was prepared for visitors, who became, through their application for tickets, the audience to his play.'[106] They also apply the idea of theatricality to some of the objects in Walpole's collection, writing of the 'possibility of a theatre in which the Holbein drawings of the Tudor courtiers become the actors'.[107] In many ways, Strawberry was more like the immersive site-specific theatre of our time than the proscenium

arch drama of his own. Visitors to Strawberry did not remain outside it, but were required to 'enter in' both metaphorically and literally (though there were rooms, as Chalcraft and Viscardi point out, that ticketed visitors would not enter, but could only look upon through the doorway).[108] Strawberry did not stage a single narrative, but presented a multiplicity of stories, which were experienced within the diverse time frames of the tourists themselves, rather than within one communal chronology. The metaphor of the masquerade is perhaps more appropriate to Strawberry than that of the theatre as understood in the eighteenth century.

Walpole was a keen masquerader. 'Well, West', he writes from Italy in August 1740, 'I have found a little unmasked moment to write to you ... I have done nothing but slip out of my domino into bed, and out of bed into my domino.'[109] His letters show him enthusiastically attending masquerades throughout his life. Masquerade could be a rich experience for Walpole, not only involving dressing up and adopting temporary identities, but also creating the possibility for an elaborate human theatre. A letter of 1743 shows Walpole at a friend's house, 'in an Indian dress',[110] about to depart, with the rest of the party, for a masquerade. He has written, for the occasion, a fictional text, a letter 'wrapped in Persian silk'. The letter purports to be from the 'seraglio of Ispahan', and is addressed to his friend, Henry Clinton, Earl of Lincoln, shortly to be married, in tones humorous, parodic and verging on blasphemy, as 'Highly favoured *among women*'. Approaching Clinton, Walpole bows three times and kneels. He then takes the letter, which is written on 'a long sheet of red Indian paper', from his 'bosom', and places it on his head. Masquerade provides Walpole with an opportunity not merely for fun, but for self-expression and a demonstration of wit, the chance to give political and moral commentary and to indulge in literary excursion and parody. It is particularly interesting to note the positioning of the literary text in this anecdote. Text is born from, and enriches, masquerade – the letter itself emerges from within the masquerade costume. Significantly, Walpole has the text close to his body. Moving it from bosom to head, he emphasizes its emotional and cerebral value.

Strawberry is a house in masquerade, where the culture of the masquerade is embedded in the very walls and décor. Walpole went so far as to commission works of art that showed himself, his family and friends participating in the masquerade of the house. Eckhardt, the Swiss painter employed at Strawberry, had to work in what Michael Snodin has called 'antiquarian make-believe'.[111] The sitters are painted

in the style and costume of the time of Van Dyck, which as Snodin points out was 'an established form of dress at masquerades and also in portraiture.'[112] An incident from the festino of 1769 shows Walpole appearing as if in masquerade, much to the bemusement (or so he says) of his guests' servants. Walpole relates how he receives his guests at 'the gates of the castle':

> dressed in the cravat of Gibbins's [sic] carving, and a pair of gloves embroidered up to the elbows that had belonged to James I. The French servants stared and firmly believed this was the dress of English country gentlemen.[113]

Walpole emerges dressed in an artwork (in the form of a cravat carved out of wood, an example, by Grinling Gibbons, of the technique known as fretwork) and a historical artefact (an elaborate pair of gloves more than a century and a half old). The anecdote reveals the fluid continuum between art, craft, performance, partying and antiquarianism at Strawberry. It also shows the extent to which masquerading complemented – and even *realized* – Strawberry Hill.

Fonthill Abbey: performed architecture

If Strawberry Hill can be considered as a building that is both performed and built for performance, the same may be said of another building constructed by another writer, William Beckford's Fonthill Abbey. Fonthill Abbey (which, unlike Strawberry Hill, no longer survives)[114] lay in the county of Wiltshire. Beckford had started work on it in 1795, employing James Wyatt as the main architect. Wyatt had first achieved fame more than 20 years earlier for his design of the Pantheon, the ultimate masquerading venue, on Oxford Street. The house was to show none of Walpole's delight in the miniature (for Beckford, Strawberry Hill was a 'species of Gothic mousetrap')[115] but was a conspicuous display of grandiosity. It was a huge building with a central tower designed to be taller than the spire of Salisbury Cathedral, 14 miles away. Fonthill Abbey was the creation of one of the wealthiest men in England and its eventual running costs were reputedly £35,000 a year.

Walpole and Beckford were unlike in very many respects, as were their works. Beckford took pleasure in distancing himself from Walpole. He claimed that Walpole 'hated me', and was reported to have said of Walpole's collection: 'Some things I might have wished to possess – a good deal I would not have have taken as a gift.'[116] The insults perhaps

derive from Beckford's sense that, despite many dissimilarities, there was much in common between Strawberry Hill and Fonthill Abbey. And at no point was this more apparent than at a party given by Beckford in December 1800.

The party, which was given in honour of Lord Nelson, was written up in two instalments in *The Gentleman's Magazine* in 1801.[117] Guests included Nelson himself, the celebrated antiquarian Sir William Hamilton, British Envoy to Naples, and his equally celebrated wife, Emma, who was having a very public affair with Nelson, and was pregnant with their child. There were also James Wyatt, as well as the President of the Royal Academy, a 'distinguished musical party... and some prominent characters of the literary world'. As the correspondent comments, they 'formed altogether a combination of talents and genius, not often meeting at the same place.'

After Nelson, the 'hero of the Nile',[118] had been rapturously welcomed at Salisbury, Beckford's guests were entertained at Fonthill Splendens for some days. On 23 December, 'the festivities were transferred from the Mansion-house to the Abbey':[119]

> The company being assembled by five o'clock, a number of carriages waited before the house to receive them. The several parties, as arranged for each, took their places. Lord Nelson was loudly huzzaed by the multitude as he entered the first coach.[120]

The timing was significant. The party left Fonthill Splendens (the mansion house) for Fonthill Abbey 'as the dusk of the evening was growing into darkness.'

> In about three quarters of an hour, soon after having entered the great wall which incloses the abbey-woods, the procession passed a noble Gothic arch. At this point the company were supposed to enter the Abbot's domain; and hence, upon a road winding through thick woods of pine and fir, brightly illuminated by innumerable lamps hung in the trees, and by flambeaus moving with the carriages, they proceeded betwixt two divisions of the Fonthill volunteers, accompanied by their band playing solemn marches, the effect of which was much heightened by the continued roll of drums placed at different distances on the hills.[121]

The whole affair was designed as a Gothic experience (see Figure 1.5). The party pass the Gothic arch, and at that moment, the land they

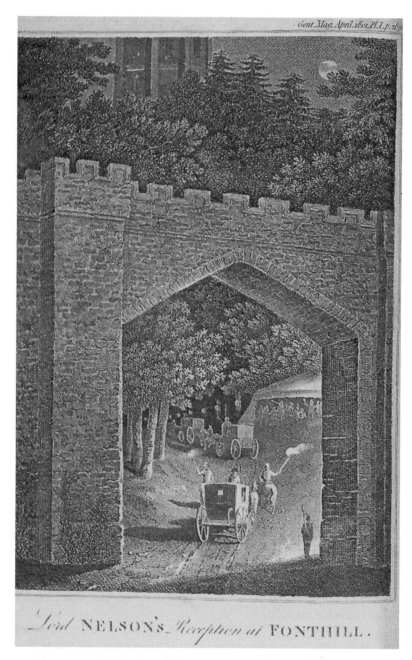

Gent. Mag. April.1801.Pl.1.p.289.

Lord NELSON's *Reception at* FONTHILL.

Figure 1.5 'Lord Nelson's Reception at Fonthill' from *Gentleman's Magazine*, April 1801. Courtesy of Senate House Library, University of London

traverse is re-imagined as belonging to the fictionalized Abbey they are about to visit. This is a performed landscape, the very lights (the 'flambeaus') are in archaic fashion, music is not only performed around them by the 'Fonthill volunteers' but is also made to seem to emanate from the hills. 'What impression ... this ensemble of light, sound, and motion, must have made on those who could quietly contemplate it all at a distance, may be left to imagination without any attempt to describe it' comments the writer.[122]

When they reach Fonthill, Beckford's guests enter 'a groined Gothic hall' and are:

> received into the great saloon, called the Cardinal's parlour, fur-
> nished with rich tapestries, long curtains of purple damask before
> the arched windows, ebony tables and chairs studded with ivory, of
> various but antique fashion; the whole room in the noblest style of
> monastic ornament, and illuminated by lights on silver sconces.[123]

The effect is reminiscent of Strawberry Hill, with its mixture of a 'monastic' style and modern luxury. The level of splendour, however, surpasses anything that Walpole had (or, I suspect, would have desired) at Strawberry. The long table measures 53 feet and occupies 'nearly the whole length of the room'.[124] As at Strawberry, the house and décor are performing. There are named rooms which play at being the dwelling places of the fictional former inhabitants; the furniture is of 'various but antique fashion'.[125] At Fonthill, even the food is performing. The guests sit down:

> to a superb dinner, served in one long line of enormous silver dishes,
> in the substantial costume of the antient abbeys, unmixed with the
> refinements of modern cookery.[126]

As the anonymous writer notes: 'It is needless to say the highest satisfaction and good-humour prevailed, mingled with sentiment of admiration at the grandeur and originality of the entertainment.'[127]

After dinner 'the company removed up stairs to the other finished apartments of the abbey' (Fonthill was of course, at this time, incomplete):

> The staircase was lighted by certain mysterious living figures at dif-
> ferent intervals, dressed in hooded gowns, and standing with large
> wax-torches in their hands.[128]

The company are shown the splendours of some of the completed rooms on the upper floor, and then enter the half-completed gallery, which is done up in what the writer calls 'the most impressively monastyc stile'[129] (by which is not meant bare simplicity, for this was a room of splendours centring on a marvellous statue of St Anthony). As the guests entered, 'solemn music' which 'suggested ideas of a religious service' played, to recall, as the writer puts it, 'our antient Catholic times'.[130] To complete the evening's entertainment, Emma, Lady Hamilton, delivered an affecting, if anachronistic, performance as Agrippina bearing the ashes of Germanicus in a golden urn.

The account concludes:

> The company delighted and charmed broke up, and departed at 11 o'clock, to sup at the Mansion-house. On leaving this strange nocturnal scene of vast buildings and extensive forest, now rendered dimly and partially visible by the declining light of lamps and torches, and the twinkling of a few scattered stars in a clouded sky, the company seemed, as soon as they had passed the sacred boundary of the great wall, as if waking from a dream, or just freed from the influence of some magic spell. And at this moment that I am recapitulating in my mind the particulars of the description I have been writing you, I can scarcely help doubting whether the whole of the last evening's entertainment were a reality, or only the visionary coinage of fancy.[131]

The party at Fonthill is an example of Gothic performed architecture played out at the most lavish level that I have encountered. Fonthill is performed within 'the sacred boundary of the great wall'. Within it, landscape, house, décor, comestibles, musicians, servants and even some of the guests perform. Music plays an important part in the act of transformation and acts both as entertainment and a powerful indicator that the building and surrounding landscape are being performed.

Beckford's party is, in some important respects, very different from Walpole's. At Walpole's party of 1769, guests play 'at whist and loo till midnight', drink lemonade, and are 'saluted by fifty nightingales'.[132] The atmosphere at Beckford's party is very different – certainly not that of a 'festino'. This is not merely a Gothic occasion because the party takes place in a Gothic-designed mock Abbey, with mock-Gothic food and attendants in fancy dress. Instead, there is a conscious attempt to create what would we understand as a Gothic atmosphere. This is not merely Gothic as pre-Classical style, as barbarity, or even a renovated

'gloomth'. Gothic is intimately associated with a quality belonging to narrative: mystery.

The account of Beckford's party is characterized by a high degree of codification of the Gothic aesthetic. There is a conscious recourse to Gothic tropes – mysterious monks, music lost in forests, distraught women, luxury and ruin – and there is also a high degree of congruence of Gothic effect. The language used to describe the event, and the picture that accompanied the article, are both within a recognizably Gothic idiom. The language is in a style that its readers would have associated with the novels of Ann Radcliffe and her imitators. The 'awful gloom' of the summit of the tower, the splendid lights, and the contrast between the lights and 'the deep shades which fell on the walls, battlements, and turrets'[133] are all reminiscent of the Radcliffe's Gothicized architectural sublime set in vividly described landscape. The accompanying image is in a style associated with a Gothicized picturesque. The article *in toto* is testament to both the codification of Gothic in the last part of the eighteenth century, and to the extent to which it was dispersed across a variety of media.

The differences between the parties of Walpole and Beckford – and the ways in which those parties are described – tell us about a cultural shift and a consolidated sense of Gothic that took place during the 1780s and the 1790s. By the 1790s, Gothic had become a popular and potent cultural force, with its own repertoire. This sense of Gothic (though it didn't affect his taste for parties) is not something, however, that post-dates Walpole, but is very much associated with him and his works.

House of fiction: fictionalized house

From the moment in 1765, when Walpole's authorship of *Otranto* was revealed, Strawberry Hill changed. It had, as we have seen, always had a literary dimension, but now the building's literariness lay not only in its witty allusions to the works of other writers, or in the fact that it was a house associated with an author, nor in the number of stories that Walpole associated with his collection, but in the fact that it was associated with Walpole's seminal novel. There was a high degree of identification between Strawberry Hill and *Otranto* as a result of which the house and the book entered into an interestingly symbiotic relationship. From this point Strawberry was not merely Strawberry Hill, it was also something else too: a house associated with a specific piece of fiction. Walpole's

visitors were entering not just a literary space, but a fictionalized one, a building that could be, and often was, interpreted in terms of a book.[134]

Walpole made no secret of the relation between Strawberry and *Otranto*. In letters to friends, he flagged it up. To William Cole, he wrote in 1765:

> Your partiality to me and Strawberry have I hope inclined you to excuse the wildness of the story. You will even have found some traits to put you in mind of this place. When you read of the picture quitting its panel, did not you recollect the portrait of Lord Falkland all in white in my gallery?[135]

The relation between the portrait and *Otranto* was also announced to a wider public. Walpole ends the preface to the 1784 edition of the *Description*, by referring to Strawberry as 'a very proper habitation of, as it was the scene that inspired, the author of the Castle of Otranto.'[136] A footnote in the *Description* draws attention to the Falkland painting 'The idea of the picture walking out of its frame in The Castle of Otranto, was suggested by this portrait.'[137] The identification between the house and the book lay at deeper levels too. Not only was Walpole's home a mock castle, but *Otranto* could be mapped onto Strawberry, as W. S. Lewis pointed out in 1934.[138] As summarized by Ketton-Cremer, 'many of the rooms in Walpole's castle – the Gallery, the Chapel, the Blue Bedchamber, the Holbein Chamber, and half a dozen more – occupied precisely the same relative positions in the castle of his imagination'.[139]

Visitor experience at Strawberry changed with the publication of *Otranto*. The house gained a dimension. If before it had been haunted and shaped by Pope's ghost gliding outside its windows, now it was haunted and transformed by *Otranto*. Strawberry became a materialized house of fiction, a kind of achronological prequel, retrospectively fictionalized. The spaces of Strawberry became the spaces of *Otranto*. The magnificent portraits, the suits of armour, the statues, were no mere historical curiosities, but had received another life from Walpole's Gothic text. Visitors became novelistic perceivers, walking along the gallery and through its rooms, under the eye of watchful portraits from the past, confused by detail, and lost in a welter of things. Their very movements recalled the shape of a Gothic narrative, which is predicated on patterns of flight and exploration. If this seems fanciful, it is worth looking at the account of some later visitors.

In September 1785,[140] Dr Charles Burney, the celebrated musicologist, and his daughter, Frances, the acclaimed novelist, visited

Strawberry Hill. Frances in her *Memoirs of Doctor Burney* (1832) notes that 'Mr. Walpole paid them the high and well understood compliment of receiving them without other company'.[141] Her portrait of Walpole is lively: she talks of his 'fund of anecdote'[142] and declares him to be:

> scrupulously, and even elaborately well bred; fearing, perhaps, from his conscious turn to sarcasm, that if he suffered himself to be unguarded, he might utter expressions more amusing to be recounted aside, than agreeable to be received in front. He was a witty, sarcastic, ingenious, deeply-thinking, highly-cultivated, quaint, though ever-more gallant and romantic, though very mundane, old bachelor of other days.[143]

Frances Burney writes of the treasures they see, noting:

> All that was peculiar, especially the most valuable of his pictures, he had the politeness to point out to his guests himself; and not unfrequently, from the deep shade in which some of his antique portraits were placed; and the lone sort of look of the unusually shaped apartments in which they were hung, striking recollections were brought to their minds of his Gothic story of the Castle of Otranto.[144]

The terms Burney uses are interesting, and point up the extent to which she is encountering Strawberry through *Otranto*. This is apparent, not merely in the manner in which she recounts the way in which *Otranto* is 'brought to their minds', but in the way that the ambience of the novel has communicated itself to the house ('the deep shade' 'the lone sort of look of the unusually shaped apartments'). Not only is Strawberry Hill depicted in terms that suggest *Otranto*, the whole visit has been Gothicized. The tendency becomes even more apparent as the passage develops.

> Horace Walpole was amongst those whose character, as far as it was apparent, had contradictory qualities so difficult to reconcile one with another, as to make its development, from mere general observation, superficial and unsatisfactory. And Strawberry Hill itself, with all its chequered and interesting varieties of detail, had a something in its whole of monotony, that cast, insensibly, over its visitors, an indefinable species of secret constraint; and made cheerfulness rather the effect of effort than the spring of pleasure; by keeping more within bounds than belongs to their buoyant love of liberty, those

light, airy, darting, bursts of unsought gaiety, ycelpt [sic] animal spirits.[145]

The atmosphere of Strawberry is the atmosphere of a house from a Gothic novel (and, arguably, one of a later date than *Otranto*). Strawberry itself, manages to have, despite its interesting variety, a 'monotony' of atmosphere that casts an 'indefinable species of constraint'. Strawberry becomes a place where youth and 'animal spirits' are kept within 'bounds' and Burney's use of the archaic 'yclept' associates those bounds with a literary Gothic. Burney's is the language of Gothic imprisonment, atmosphere – and of difficult protagonists. Walpole himself is Gothicized. Rather than being merely an old man with the manners of a different era, which are uncongenial to the young Burney, Walpole becomes possessed of 'contradictory qualities'. There is a sense that the atmosphere of the house derives from the man himself. Given this portrait, it is somewhat surprising when she tells the reader: 'Nevertheless, the evenings of this visit were spent delightfully'.[146] Even Burney's account of the delightful evenings, however, is written in a Gothic tenor:

> In the evening, Mr. Walpole favoured them with producing several, and opening some of his numerous repositories of hoarded manuscripts; and he pointed to a peculiar caravan, or strong box, that he meant to leave to his great nephew, Lord Waldegrave; with an injunction that it should not be unlocked for a certain number of years ...[147]

Burney picks up on the tropes of the Gothic manuscripts, the hoard, the Gothic strongbox, and Gothic inheritance, the box to be passed on to the next generation, and Gothic prohibition.

For the finale of the account, Burney ventures into comic Gothic. Walpole has unsuccessfully tried to persuade the exceptionally busy and sociable Dr Burney to stay for longer – and failed.

> Mr. Walpole looked seriously surprised as well as chagrined at the failure of his eloquence and his temptations: though soon recovering his usual tone, he turned off his vexation with his characteristic pleasantry, by uncovering a large portfolio, and telling them that it contained a collection of all the portraits that were extant, of every person mentioned in the Letters of Madame de Sevigné; 'and if you will not stay at least another day,' he said, patting the portfolio with an air of menace, 'you shan't see one drop of them!'[148]

Burney has turned Walpole into a comic version of a Gothic villain, displeased but managing to manage his countenance as perhaps Radcliffe's Montoni might have done. His menace however is limited.

Robertson's Fantasmagorie

There are problems, of course, with claiming Strawberry or Fonthill as the ancestors of contemporary Gothic tourism. Tourism played no part at Fonthill Abbey. Even had Beckford wished for it (and this is practically unthinkable, possessing, as he did, a haughty contempt for the lower orders), it would not have been possible. Beckford had become socially *persona non grata* in 1784 and, despite attempts to re-establish himself, was never to be rehabilitated. The 1800 party was the only major social event to take place at Fonthill. Strawberry Hill, on the other hand was, a noted tourist destination of the day. Walpole was 'ready to oblige any curious Persons with the Sight of his House and Collection'.[149] He issued tickets, which could be applied for one or two days in advance, and had to start issuing house rules: only one party per day; maximum four visitors per party; no children. The tours operated within certain hours ('between the Hours of Twelve and Three before Dinner') and in certain months of the year ('from the First of May to the First of October').[150] However, Strawberry was not a commercial attraction. Walpole made no money out of it (though visitors were encouraged to tip Margaret the housekeeper if she was the one guiding them round the apartments); indeed, he most certainly lost by it, financially. An anecdote of 1791 shows Walpole's exasperation at the behaviour of some of his visitors who had broken off the end of a beak of a Roman statue of an eagle, and then 'pocketed' it.[151]

By the late 1790s, however, there was a commercial Gothic tourist attraction in operation. It was the Fantasmagorie of the Belgian showman and scientist, Etienne-Gaspard Robertson, and it played at the Convent des Capucines in the place Vendôme, Paris, from 1799 to 1803. Robertson's Fantasmagorie is recognizably of the same ilk as the scare attractions of today.

Between them, Mervyn Heard in *Phantasmagoria: The Secret Life of the Magic Lantern* and David J. Jones, in a chapter on the Fantasmagorie and Hoffmann, in *Gothic Machine* have provided excellent and fulsome accounts of Robertson's Fantasmagorie. As Heard points out:

the first performance took place on 3 January 1799 at 7.30pm. Newspaper advertisements promised a feast of spectres which would

manifest themselves by various methods attributable to such diverse authorities as the magicians of Memphis, as well as the fictional witches of Macbeth.[152]

The show had also been advertised by means of fliers and a poster with an image of the Witch of Endor raising the spirit of Samuel. After assembling in the courtyard, the audience was greeted by a figure who took them into the attraction, as Jones notes, 'through the passageways and cloisters of the convent'.[153] As Jones points out, it would have been dark and disorientating.

The show lasted, according to one report, an hour and a half. The principal attraction was a spectacular magic lantern show, but there were many other elements, including a room for consultation of the invisible woman. The audience's first destination was the 'Cabinet de Physique', a room devoted to scientific experiments in such fields as Galvanism and optical illusion. As Jones comments: 'This was a scientific display which made viewers mistrust their everyday field of vision and awareness.'[154] After the scientific display, the audience heard the mysterious sounds of a glass harmonica and were then led through an Egyptian door into the Salle Phantasmagorique, the Chapel of Isis. The key turned loudly in the lock. Robertson then commenced speaking. This was a superior version of showman's patter. As Jones comments, it was 'highly polished, carefully orchestrated for greatest effect, and consisted mainly of smoothly dovetailed quotations from well-known sources.'[155] When Robertson had finished speaking, a funerary lamp that hung from the ceiling was extinguished; the room was plunged into darkness and the magic lantern show began.

The content of Robertson's phantasmagoria show was diverse. It referenced art, literature, religion, folklore and anecdote, from many countries (Britain was well represented) and a variety of epochs. It included classical imagery, images drawn from the works of Voltaire and Rousseau, and depictions of thrilling anecdotes (such as that relating to Lord Littleton, a serial seducer, who received premonitions of his death from a white bird and a woman in white clothing). It had a significant strand of content that was positioned culturally as Gothic. One of the slides showed Fuseli's celebrated picture 'The Nightmare', for instance; another showed an illustration of the bleeding nun from Matthew Lewis's novel *The Monk* (1796). There were *memento mori* images (beautiful living figures that changed into skeletons, a skeletal Death that hovered over the audience), and visual representations of literary material that had recently found itself re-categorized as part

of the Gothic aesthetic – Shakespeare's *Macbeth* and Young's graveyard poetry, for example.

The Fantasmagorie was as Jones points out, the 'first totally self-contained entertainment'.[156] It was also the first piece of fully commercial Gothic tourism. Robertson's Fantasmasgorie was a mocked-up, dramatized and performed building that specifically took up on the tropes of the Gothic novel. The very building, which was in a bad state of repair, can be seen as a materialization of the houses of the Gothic novel. As Jones writes, it was a 'site linked both with Revolutionary dread and Gothic conventual associations'.[157] It was covered in 'fantastical paintings';[158] it had a 'crypt' (which, as Jones has shown, was actually on the ground floor), and an Egyptian room. Inside, strange voices called, and figures that we might think of as low-level scare actors, emerged from the shadows. Materializing some of the most evocative tropes of the Gothic novel, Robertson's Fantasmagorie featured diaphanous curtains, and mirrors. It sought to establish Gothic atmosphere, employing sound effects that belonged to the world of Gothic (thunder, rain and wind) and conjuring up the kind of strange music associated with the aural worlds of the Gothic novel. The Fantasmagorie employed a glass harmonica, a celeste and tamtan chinois (or gong) to achieve the desired 'monotony of sound'.[159]

Not only was the Fantasmagorie a three-dimensional Gothic mise en scène, it also attempted to recreate Gothic affect by exploiting the subject positions that popular Gothic authors of the 1790s were exploring. The Fantasmagorie sought to imbue its audiences with a sense of mystery, to play to ideas of mortality, and to create sensations of fear, confusion, wonder. It was a novelized entertainment, with emphasis on modes of perception and exploration that had been carved out by Gothic novelists, chief amongst them radical uncertainty, fear and curiosity.[160] The Fantasmagorie placed its audience in the subject position of the Gothic protagonist – scared, assailed, confused but curious – impelled through the Gothic house that is a world in itself.

Jones convincingly argues for the significance of Robertson's Paris phantasmagoria, not just in the history of the magic lantern show, but also in terms of the development of the Gothic. He writes that Robertson 'gatherered [sic] together very many of the varied constituents and assemblages from previous shows, introduced new ideas and components, convened these elements under one roof and thereby initiated the machine stage of the collective Gothic genre.'[161] Jones refers to Robertson's 'syncretic imagination'[162] and writes that the 'siting of Robertson's lantern show at the Capuchin convent was an event

of intense trans-medial and cultural fusion'.[163] Whilst I would not deny this, nor indeed Jones's argument that the Gothic itself draws from the Fantasmagorie, referencing, and employing the language of, visual technologies, I would argue that, as a performance, the Fantasmagorie was able to function as it did, because it drew on an aesthetic that by this point was already well-codified, and had already shown itself to be intermedial to an almost virtuosic degree. What Jones calls the 'intense trans-medial and cultural fusion' of Robertson's Fantasmagorie, is ultimately indebted to Walpole's experimentation at Strawberry Hill.

Conclusion: The Strawberry/*Otranto* nexus and the Gothic aesthetic

Strawberry's influence on later Gothic tourism was at two levels. First, it was an influential building in its own right. Second, it was influential in that it formed part of a nexus that gave birth to one of the most enduring aesthetics of the eighteenth century: the Gothic. The Gothic aesthetic springs not, as it were, fully formed, from *Otranto* alone, but emerges from the relation between Strawberry and *Otranto*, and from the extent to which Strawberry and its modes of aesthetic experimentation are embedded in *Otranto*.

If Alexander Pope had been an inspiration for Strawberry, and incorporated within it at a variety of levels, the same may be said of Strawberry in relation to *Otranto*. Strawberry is not only the site of writing for *Otranto* and one of the inspirations behind it. It can also be said to be embedded within it: Strawberry's artefacts are written into the literary text; its room layout is mapped onto the novel. The ramifications of Strawberry within *Otranto*, or the Strawberry/*Otranto* nexus, are many. As Walpole writes, in the preface to the first edition of the novel, 'The scene is undoubtedly laid in some real castle.'[164] The relation between *Otranto* and Strawberry, between the novel and the house, is responsible for the high degree of visuality that characterizes both *Otranto* and the Gothic novel (which typically requires of its readers a great deal of visualization – of historical prints, actual buildings, celebrated landscape painting, of imaginary house interiors, for example) more generally.

Otranto came into the world accompanied by the sense that it referred to something outside itself, that it was not merely an invented world. The relation between *Otranto* and Strawberry was responsible for a degree of vraisemblance that was acutely felt by early readers of the novel. One reader told Walpole that she'd been there. There is a bizarre anecdote in which Walpole himself experiences the effects of *Otranto*'s

'realseemingness'. Writing to Madame du Deffand, he tells of visiting his old college, Trinity, Cambridge, two or three years after having written *Otranto*. Writing in French, he notes 'I found myself exactly in the courtyard of my castle ... The towers, the gates, the chapel, the hall, all matched it with the greatest exactness ... I fully believed I had entered into that of [ie the castle of] Otranto.'[165] The hyper-real quality of literary Gothic, and the degree of affectivity associated with it, are the concomitant features of Gothic vraisemblance.

Otranto's embedding of Strawberry has had other legacies for the Gothic. Just as *Otranto* is a novel in which architecture is of overriding significance, and narrative is fused with space, Gothic, typically, possesses an interdependence of place and action: there is nothing accidental or interchangeable about relation of plot to locale. Gothic novels, more than novels of any other genres, are characterized by their insistence on action that can only happen in specific places – whether flights along corridors, sieges in bedrooms, immolation in crypts, or the arrival of outsize armour in courtyards. To Strawberry is owed the pre-eminence of the house as a trope in the Gothic, as well as the idea that architecture is to be read in terms of character. Strawberry's imprint is also to be felt in the attitude to 'things' in the Gothic novel. Alicia Weisberg-Roberts reads various incidents in *Otranto* in terms of Walpole's 'complex act of self-representation as a collector'.[166] *Otranto* is a collector's novel. The treasured objects of Strawberry – paintings, armour, clothes, manuscripts – are the tropes of Gothic, and, as at Strawberry, in the Gothic, not only manuscripts, but lockets and items of clothing have tales to tell. *Otranto*, like Strawberry, is filled with objects that are to be scrutinized, decoded, read. Gothic, as Strawberry, is packed with multiple stories. Objects tell tales, and the tales they tell are of interest not only for themselves, but also influence the main narrative of the work. The springs of narrative in Gothic fiction lie within the primacy of the object.

The legacies of the Strawberry/*Otranto* nexus to the traits, tropes and conventions of the Gothic aesthetic are many. To it are owed the interest in the culture of masquerade and dressing up, as well as the radically intermedial nature of the Gothic aesthetic. The touristic aspect of many Gothic novels, particularly pronounced in novels such as Radcliffe's, but also to be found in other texts where protagonists venture to strange and exotic lands, may also be traced back to the Strawberry/*Otranto* nexus. There is a strong case to be made for much Gothic as vicarious tourism for readers; much of the description in Gothic texts overlaps with the language of travel writing. The Strawberry/*Otranto* nexus was also to

bequeath a characteristic set of structures to the Gothic. Walpole's interest in frames, in stories within stories, has, of course, become a characteristic feature of Gothic texts within a variety of media.[167] The relation between Strawberry and *Otranto* marks Gothic at an even deeper level. By the time it was written, *Otranto* already had its prequel. It is not difficult to see the relation of Strawberry to *Otranto*, an already-standing house encountered within a text that is in the process of being written, as an allegory of the modes of temporality with the Gothic.

As I stated at the beginning of the chapter, I make no apology for my concentration on Walpole. Not only is he the author of the first properly Gothic novel, and, as Spooner has pointed out, the inventor of Gothic lifestyle, he was also a radical experimenter in a new mode of conceiving and approaching architecture. Strawberry, as we have seen was something of an experiment, not so much in terms of design, as in the modes of encounter it encouraged. Springing from a Gothic that Walpole associated, with modernity, liberty and pleasure, it is a witty, irreverent building that embodies a decidedly pragmatic (rather than ideological) approach to style. Strawberry is a self-consciously ingenious mock-up that affronted expectations of authenticity and earnestness. It is an example of a building in masquerade and for masquerade, designed and created in expectation of certain kinds of immersive performance, where the stories and temporalities were plural. It encouraged the idea that architecture could be performative, and established a new set of parameters within which architecture may be read. Strawberry is a house of fiction in which visitors become the protagonists of novels. It is fictionalized architecture that inspired architecturalized fiction. Strawberry is also an example of early Gothic tourism, whose influences are still felt today.

The rise of the Gothic aesthetic in the eighteenth century is linked both to the invention of new narratives for architecture, and new architectures for narrative. It is indebted to the complex sense of intermediality that was born at Strawberry – a building that was also conceived as a picture, a place of story, and a performance. Strawberry's radically intermedial aesthetic was to have influence not only on Walpole's novel, but on a cultural tradition which itself spans a variety of media. Indeed, the very intermediality of the Strawberry/*Otranto* experiment has been one of the reasons why the Gothic has been so successful in pervading a diversity of media.

2
Madame Tussaud's Chamber of Horrors: Wounded Spectators, Perverse Appetites and Gothic History

On the Marylebone Road in London, a short distance from Regent's Park and Baker Street, is Madame Tussaud's.[1] Tussaud's today is an international phenomenon, with branches from Blackpool to Beijing, San Francisco to Sydney. It is one of the most famous, and one of tourist attractions in the world – and the London branch is the original Madame Tussaud's. It arrived at its present location in 1884, but had been based round the corner, at the Baker Street Bazaar, for almost 50 years before that. Its history extends even further back. Before it became a fixed-site tourist attraction in London, it had been a touring exhibition since 1803. And the touring show that Marie Tussaud brought to London in 1802, had its origins in a French exhibition that dated from the late 1760s.

Like the other Tussaud's that have mushroomed round the globe, the London branch has a strong focus on 'celebrities' – film stars, sports people, television characters, and royalty. Unlike most of the other Tussaud's, it also has a very Gothic aspect. Its Gothic is not merely confined to the Chamber of Horrors, but is to be found at many other points in the exhibition. Indeed, as I will argue, the whole geography of the London Tussaud's is premised on a Gothic aesthetic. Tussaud's Gothic is not a retrofit, but something that has characterized the display since at least the mid-nineteenth century, and, very sensibly, the current management have retained it at the London branch, even if Gothic has not been taken up as a style choice elsewhere. Tussaud's Gothic derives from a complicated blend of tradition, historical circumstance and choice: from the fairground waxwork show, Tussaud's own astounding history, and the decisions and choices made in the display of the material since the beginning of the nineteenth century.

In this chapter, I will be thinking about Tussaud's past and present. I will be looking at the London branch of today, and considering Tussaud's pre-history in Revolutionary France, before investigating the changing displays of the Chamber of Horrors in the nineteenth century. I am particularly interested in what nineteenth-century visitors have to say about the terrors of the waxwork, and the ways in which they figure the waxwork's effect upon themselves and fellow visitors. Tussaud's commentators, and they are many, constantly return to what is to become a highly codified language of the victimizing gaze, temporal distortion, and weakened subjectivity; its dominant mode is that of 'contagion', (to use Eve Kosofsky Sedgwick's term).[2] Throughout the nineteenth century, Tussaud's pioneered new modes of display, and new relations between the waxwork and the spectator. It became an innovator in the relation between spatiality and content, and, by the mid-century, had invented a Gothic geography for its exhibition. Tussaud's was instrumental in cementing the association between waxworks and the Gothic. Through its invention of the Gothic museum, it has been at least as influential in the propagation of Gothic as an educational mode.

Tussaud's today

Tussaud's, in present-day London, is gargantuan in its size and complexity, taking in not only numerous waxwork exhibitions, but also a scare attraction; the 'Spirit of London' ride; and the 'Marvel Superheroes 4D experience'. Gothic is integral to the Tussaud's experience, though you do not hit full-blown Gothic for a little while – somewhere around the middle of the labyrinthine complex. The most obvious example of Tussaud's Gothic is the Chamber of Horrors, an attraction already so famous that it barely appears on the marketing. At the time of writing, the front page of the section of the Tussaud's website devoted to the London branch featured images of the waxworks of the Royal Family, the Marvel Superheroes and Benedict Cumberbatch,[3] but there was no reference to the Chamber (or indeed any other of the more Gothic displays). The Chamber doesn't need front-page attention, however. It can rely on something more long lasting – deep cultural memory.

The Chamber of Horrors is a mocked-up Gothic space, small, dark, enclosed and crypt-like, populated by various tableaux. Each depicts pain (or the prospect of it) dressed up in the fashions of a bygone (and not regretted) age. A splendidly dressed waxwork of

Vlad the Impaler occupies one niche, a model of Guy Fawkes being hanged, drawn and quartered is in another. There is a waxwork of someone being garotted, with a sign that tells you that the last official garotting took place in Spain in the 1970s. Another tableau shows someone being broken on the wheel. The treatment of the figures, and the way they are presented to spectators, recall the dynamics of a Romantic period Gothic text, such as *Melmoth the Wanderer* (1820). At many points in Maturin's multi-framed novel, hapless protagonists find themselves unwilling spectators of horror. All too often, the horror is perpetrated against a chillingly incongruous backdrop: the splendour of Catholic Spain, for example, with the flames of the auto-da-fé and the splendid costumes of bishops. In one such scene, one of the protagonists, Monçada, watches a parricide being torn to death by a mob. The passages focuses on his riven spectatorship:

> witnessing this horrible execution, I felt all the effects vulgarly ascribed to fascination ... I echoed the wild shouts of the multitude with a kind of savage instinct ... then I echoed the screams of the thing that seemed no longer to live, but still could scream; and I screamed aloud and wildly for life – life – and mercy![4]

Monçada expresses a sense of unwilling witness, and confusing sympathies. He gazes in silence and horror at an image of bodily suffering. His responses are divided by contradictory impulses: he sympathizes both with the suffering of the victim's body, and with the mob's desire for revenge upon the heinous sinner. Monçada is forced to 'gaze'. Significantly, he uses the language of psychology ('fascination'), and references the concept of the automaton (he declares in the same passage, that his 'existence was so purely mechanical').[5] The account of the complex nature of such spectatorship is capped with a reference drawn from theatre: 'The drama of terror has the irresistible power of converting its audience into its victims.'[6] The unwilling but fascinated spectator is caught in a moment of sado-masochistic quandary, aware of the justice of retribution, and horrified by the degree of bodily suffering. Monçada experiences both a terrible bodily sympathy, premised on unbearable pain, and a horrifying emotional sympathy – with the passions that drive the mob. Positioned as a witness to a 'drama', he is caught within a dynamic of overactive thought, and passivity. The experience is couched in the language of art even as the spectator is

confronted with the sight of the body reduced to material. The spectator position in the Chamber of Horrors, I would argue, is consonant with this example of Romantic period Gothic.

Leaving the Chamber, you do not leave the Gothic. Instead, what had been behind glass has been turned into the mise en scène that surrounds you. With the cobbles now under your feet, rather than within a tableau, and gibbets dangling over your head, you approach 'Scream', Tussaud's twenty-first-century Gothic: a scare attraction. The time zone of the approach is only temporary – the subject matter of 'Scream' is much more up to date. As we queued to enter, listening to the screams emerging from the attraction, a loud Australian, with a totally unnecessary microphone, gave us our instructions and established the narrative premise: 'a maximum security prison has been taken over by its inmates'.[7] Once inside, we bustled through a maze-like series of false walls, occasionally startled by sudden illuminations, sprays and squirts, while actors playing deranged patients jumped out at us from the shadows. Over everything was an amplified heartbeat.

When you leave 'Scream', the Gothic still has not let up, though it has changed mode. Visitors find themselves in another dark and enclosed space. This is France at the end of the eighteenth century – in the form of a narrow and dimly lit corridor, whose atmosphere recalls subterranean depths. Behind glass are a series of waxworks that, unlike those of the entrance halls, convey not the freshness of vigour but the yellowness of age and, seemingly, a concept of living itself that is tarnished. There is a waxwork of Marat, assassinated, in his bath, the accompanying note telling us that Marie Tussaud herself did his death mask. There are original waxworks of guillotined heads of the French royal family and of Revolutionary leaders who fell foul of the Terror. There is a tableau of Marie Tussaud, searching amongst corpses for the head of Marie-Antoinette. Further along the corridor is the guillotine blade that decapitated the queen (no fake we are informed, but an original purchased from the executioner) and a waxwork of a sans-culotte – with moving eyes.

So accustomed are we nowadays to the Gothicization of the waxwork and the waxwork display, that to comment on Tussaud's Gothic can seem almost pointless. After all, waxworks have been shown as objects of terror, horror and the uncanny, in texts ranging from Ann Radcliffe's *The Mysteries of Udolpho* (1794) to Angela Carter's *The Passion of New Eve* (1977). The seal was put, as it were, on the idea of the waxwork as an uncanny object by Ernst Jentsch and Sigmund Freud. In his essay on 'The "Uncanny"' (1919), Freud notes that 'Jentsch has taken as a

very good instance "doubts whether an apparently animate being is really alive; or conversely, whether a lifeless object might not be in fact animate"'.[8] The history of the waxwork and the waxwork exhibition, however, shows us that its uncanniness is not a given, and neither is the positing of the waxwork as an object of horror or terror. As Pamela Pilbeam has pointed out, the waxwork has had a varied history. In the second half of the eighteenth century, for example, it was used in religious practice, in the fields of science and medicine, funereal display, and as expensive pornography. In addition, it served as a form of news reporting, and provided a form of popular entertainment in sideshows at fairs.[9] Tussaud's exhibition itself, or rather the exhibition from which it derived, 'Curtius's Cabinet of Curiosities', which first came to these shores even before Marie Tussaud herself did, had not had a Gothic cast. Advertising material for the exhibition that Tussaud sent off on a tour of England in 1795, suggests an eclectic mix. Waxworks were only some of the attractions. A poster advertising its stop-off in Birmingham lists: a 'glass ship' nearly three foot high, 'a precious collection of figures in rice paste' (including Cleopatra, Voltaire and 'Flora with a rake and a basket of flowers'), and a 'model of the Temple of Paris' where the royal family had been confined.[10] There are also 'several Pieces of curious Writing', 'Profiles of the King and Queen of France, made of Hair', 'Turner's Works in Ivory' and a model of the Guillotine. The waxworks by Curtius are advertised below those of 'Mr Monstevens, Modeller to the Prince of Wales'. This 'Choice Collection of Models from Nature' includes models of members of the British Royal Family and the aristocracy. Tussaud's, in the next century, however, was to become an attraction that embedded and exploited the Gothic.

From Paris to London

The pre-history of Tussaud's lies in France and in the waxwork exhibitions of Philippe Curtius. Curtius was a German-speaking Swiss, who had trained as a physician. He was a man of many and varied interests, an intellectual whose friends included Voltaire, Rousseau and Benjamin Franklin – all of whose heads he modelled. He was also a supporter of Revolutionary politics: the journalist Marat was another friend. In her memoirs, Tussaud claims that Curtius was her uncle, though Pilbeam suggests that she might have been Curtius's illegitimate daughter.[11] Whatever the relationship between the two, Tussaud (or Grosholz, as she was then) lived, with her mother, in Curtius's household and he

trained her as a wax modeller, leaving her his business and collection in his will.

Between the late 1760s and the 1790s, Curtius had a number of establishments. There was a wax salon at the St Laurent fair, followed by an establishment on the Boulevard du Temple. The latter was in two sections. While one part showed wax figures of the famous – royalty, writers and politicians, for example – the other, the 'Caverne des Grands Voleurs', contained waxworks of some of the most notorious criminal figures of the time. The Caverne, as Pamela Pilbeam points out, was in the tradition of the wax sideshow at a fairground, which often featured waxworks of murderers and other criminals.[12] A new venture, the Salon de Cire, aimed at a more upmarket clientele, was receiving visitors by 1784. It was based at the Palais Royal – not a royal residence, but a commercial site, with shops, theatres and cafés, as well as public promenades. The Salon was a brilliantly lit space: Curtius didn't spare on the candles, and the walls were hung with mirrors. Paintings and works of sculpture were on display, as well as wax models – both full-length figures, which stood around the sides of the room, and busts, which were displayed on short columns. The room's celebrated centrepiece was the royal family at dinner. The exhibition, as Pilbeam notes, was well regarded and popular with both Parisians and foreign tourists.[13] Both Curtius and Tussaud had cachet. In the 1780s, their relations with the royal court were both commercial and professional. They were modelling royalty and the aristocracy, and Tussaud was employed at the palace, teaching female members of the royal family the art of making wax flowers.

Curtius and Tussaud's habits of employment, and the nature of their displays, were to be radically revised by the French Revolution. One of the traditional functions of the waxwork was to provide a record, to act as a reporter of what we call 'news'. The kind of 'news' to be reported on, from 1789 onwards was horribly suited to the nature of Curtius and Tussaud's work. Waxwork modellers in the eighteenth century modelled hands and heads. (Bodies were made of wood – and were usually used for more than one figure.) From the earliest days of the Revolution, Curtius and Tussaud found themselves reporting on its activities by modelling heads that had already been severed from their bodies. After the governor of the Bastille, de Launay, was beaten to death by the crowd, and de Flesselles, the prevôt des marchands, was shot, their heads were taken off, put on pikes, and paraded round by the crowd. Pilbeam notes that:

According to Madame Tussaud and Philip Astley, the owner of the circus next door, when the severed heads of de Launay and de Flesselles were pulled from the pikes, they were rushed to her at the salon for modelling. In her memoirs she claimed that she sat on the steps of the exhibition, with the bloody heads on her knees, taking the impressions of their features.[14]

Many of Curtius and Tussaud's subsequent heads were those of victims of the guillotine – Hébert, Robespierre, Fouquier-Tinville, Louis XVI and Marie-Antoinette, amongst them. Pilbeam points out that: 'Because Curtius was frequently involved in national guard business, Marie usually undertook the gruesome labour of modelling the severed heads of enemies of the Revolution for the Convention.'[15] The Convention ordered the wax modelling of the heads for the purposes both of propaganda and record-keeping. Orders came thick and fast. Curtius and Tussaud could find themselves modelling the heads of people they had known – as was the case when Tussaud did the head of the princesse de Lamballe, or when Curtius modelled the decapitated head of Madame du Barry in 1793. He had, in the 1760s, modelled her as the Sleeping Beauty.[16] The ways in which Tussaud and Curtius were associated with the Revolution were marked by terrible ironies, as their relation with many of their clients became a post-mortem one, associated with abjection – best illustrated by the image of Marie Tussaud scrabbling around at the foot of the guillotine.

The economic climate of Revolutionary Paris was not good for wax-work exhibitors. Attendances dwindled, and eight years after Curtius's death, Tussaud took the opportunity of a cessation of war between Britain and France to travel to Britain with Joseph, one of her two sons.[17] She arrived in London in 1802, and was never to return to France. Significantly, in terms of the ecology of early nineteenth-century London Gothic, Tussaud shared premises with Paul de Philipsthal, aka Philidor, the magic lanternist.[18] Philidor, who had invited Tussaud, was himself newly arrived from France. His phantasmagoria show, replete with ghostly images, automata and scientific experiments, played at the Lyceum Theatre in London. Philidor's permanent exhibition occupied the main space, and Tussaud took the upper floor for a while, before leaving for Edinburgh in 1803, because she was dissatisfied with the contract with Philidor and the meagre profits she was making. She spent the next years touring the British Isles, and only adopted the Baker Street Bazaar venue as a fixed site for the exhibition in 1835, aged 74.

'*What* a horrible place!'

Tussaud's show was unlike any to be seen anywhere else.[19] Although it contained a variety of figures of the sort that might be found in other waxwork exhibitions – politicians, royalty, writers and musicians, for example – its central attraction was the collection of heads and figures from the Revolutionary period. In terms of its modes of display (if not its politics), the show could have been called revolutionary. Lela Graybill points out, that 'nineteenth-century waxworks displays were frequently concerned with bringing their subjects to life' and that even Curtius's Caverne des Grands Voleurs had presented criminals in 'lifelike states, shown as they had appeared before their execution.'[20] Tussaud's Revolutionary display, on the other hand, 'presented little more than the fact of violent death'.[21] Tussaud's bleeding heads were spectacles of mortality, records of a very bloody, and very recent history. In the case of such Revolutionary leaders as Robespierre, they traced a compelling narrative – from power and fame, to the guillotine. Tussaud did not present this narrative in the mode of tragedy, but in the mode of horror – the reduction to pulped flesh. Thus, the model of Robespierre showed not only the severed head, but the bloodied broken jaw, result of a gun-shot wound, that had him screaming at the guillotine. Significantly, Tussaud refused to show the decapitated heads of the king and queen.[22]

From the moment of Tussaud's arrival, she made sure to keep her waxwork exhibition up to date and newsworthy. A poster of 1812 mentions models of Colonel Edward Despard (would-be assassin of George III), members of the British royal family, Nelson, Washington, Wesley, Fox and Pitt, as well as such historical figures as Mary, Queen of Scots and John Knox.[23] The figures, in the early days, were all presented in one big room. Later, Tussaud divided her exhibition into two rooms. This development meant that celebrities could be divided from criminals, and criminals found themselves in the company of the Revolutionary displays. The second room had different names at different points in its history, including the 'Separate Room', the 'Adjoining Room', the 'Other Room', the 'Dead Room' and the 'Black Room'. Such names, compared with Curtius's 'Caverne des Grands Voleurs', are suggestive of a different attitude to the content (reminiscent of the shift in literary sensibilities when it came to the Gothic) away from the brigandish and towards a more domesticated, quieter and sinister approach. This is the room that was later to become known as the 'Chamber of Horrors'.[24]

The management, which from 1850 comprised Tussaud's two sons, Joseph and François, claimed that the Chamber of Horrors was morally instructive. Contemporary accounts of the Chamber do not bear up this claim. Inevitably, they focus on its horrors rather than its moral effects. Visitor thrill was central to its operation: the Chamber of Horrors was the scare attraction of its day. In 1849, 'Mr Pips' in the magazine *Punch*, declared that his wife said 'she should dream of the Chamber of Horrors'.[25] An article by Charles Allston Collins, entitled 'Our Eye-witness in Great Company', which appeared in Dickens's journal *All the Year Round* in 1860, takes it upon itself to investigate the particular nature of these horrors:

> To enter the Chamber of Horrors rather late in the afternoon, before the gas is lighted, requires courage. To penetrate through a dark passage under the guillotine scaffold, to the mouth of a dimly-lighted cell, through whose bars a figure in a black serge dress is faintly visible, requires courage. Your Eye-witness entered, on the principle which causes judicious persons to jump headlong into the sea from a bathing-machine instead of gradually and timidly emersing themselves from the ankle upwards. Let the visitor enter this very terrible apartment at a swift pace and without pausing for an instant, let him turn sharply to the right, and scamper under the scaffold, taking care that this structure – which is very low – does not act after the manner of the guillotine it sustains, and take his head off. Let him thoroughly master all the circumstances of the Count de Lorge's [sic] imprisonment, the serge dress, the rats, the brown loaf – let him then hasten up the steps of the guillotine and saturate his mind with the blood upon the decapitated heads of the sufferers in the French Revolution – this done, the worst is over.[26]

The Eye-witness's language gives no room for doubt that the experience is a Gothic one. He positions himself as the protagonist of a Gothic novel, adventuring in a liminal period 'before the gas is lighted'. The tone is foreboding: the visit 'requires courage' that might not be forthcoming. There is a panicked attention to geography – as experienced by the subject, not from a bird's-eye perspective. The passage makes use of particular registers related to Gothic spectatorship, contagion and the spiritual reduced to the material. The Eye-witness insists on scripting his readers into the experience, navigating by remote control the passive 'visitor' of the future – 'Let him' do this, that and the other – advising on route, speed and safety. The passage is notable for

its series of overlapping identifications – between the Eye-witness, the models and the reader/visitor. Not only does the Eye-witness project the experience of the visitor/reader in terms of his own experience, but what he projects is an experience that is strangely close to the subject of the waxworks: the visitor must be careful not to be beheaded by the model of the guillotine, but he must hurry up its steps. The sufferings of the victims of the Revolution are conveyed in a phrase that both binds the visitor and the victim, and combines the meditative and the visceral: 'let him ... saturate his mind with the blood upon the decapitated heads'.

Despite the Eye-witness's claim, at the end of the passage quoted above, that 'the worst is over', it becomes clear, as the account continues, that it is not. Indeed, the Eye-witness, like a harried Gothic protagonist, is only to emerge from one set of horrors to encounter another. He next deals with the displays relating to modern crime, where all the malefactors are depicted alive, and at the dock of the Old Bailey. These have their own peculiar, and very different, kind of horror:

> But, *what* a horrible place! There is horror in the dull cold light descending from above upon those figures in the Old Bailey dock, all with the same expression on their faces, upturned, inquisitive, bewildered. There is Horror in the unpicturesqueness of this aspect of crime – crime in coats and trousers being more horrible (because nearer to us) than crime in doublets and trunk-hose. There is Horror in the inflated smiling heads, cast after death by hanging. There is Horror in the basket by the side of the guillotine – a basket just the length of a body without the head, and filled with blood-drinking sawdust. There is Horror in the straps and buckles which hold the victim on the plank till the broad edge descends and does its work. There is Horror in the smell of the wax figures, in the folds of the empty clothes, in the clicking of machinery behind the scenes, and in the faces of most of the visitors to the place.[27]

This is a horror of 'dull cold light' rather than darkness, a horror of the mundane – of 'coats and trousers' rather than 'doublets and trunk-hose'. It is a horror not of grim tortures, but of the failure of transcendence. Light does not comfort. Upturned expressions do not connote understanding or prayer, but simply 'bewilderment'. Expression is divorced from sense. Heads that have suffered painful execution smile. There is a terrible sameness of expression. The Eye-witness plays not

only on the idea of the human become material, as also on the idea of the material object with agency. The sawdust is invested with grotesque animation. It is described, in terms that suggest the vampire, as 'blood-drinking'.

The Eye-witness has recourse to a Gothic rhetoric of emptiness; he constantly recurs to what Eve Kosofsky Sedgwick has called the 'imagery of the surface'.[28] Significantly, the Eye-witness is insistent that the horror of the waxwork exhibition lies not so much in its realistic representation of horror, but in the horrid relation it bears to the human. He draws attention not to the figures so much as the surrounding machinery of signification. The waxwork exhibition is horrible in its accoutrements – a basket, the straps and buckles, the 'clicking of machinery'. The basket is horrid in the way it sketches the human form – without the head. The straps and buckles are a source of horror, rather than the hapless victim they contain. Horror is located too in the 'folds of empty clothes'. The Eye-witness draws our attention to the trope of the surface, but identifies himself as someone not fixated by the surface. His sensibility lurks in the 'folds'.

At the end of the passage quoted above, the Eye-witness's feeling of horror overcomes any sense of discrimination between the different kinds of content – he conflates his accounts of the criminal and Revolutionary displays. Then he moves on to analysing the horror anew. First he locates horror in the waxwork itself – the very 'smell of the wax figures' – but he is not done. He then makes a *volte-face*, turning from the waxworks to the spectators. The horror of the experience, he says, is to be found in the 'faces of most of the visitors to the place'. At this point, it is unclear whether the Eye-witness is talking of the horror inscribed on their countenances, or of his own sense of horror at the sight of these. Such uncertainty, however, is resolved by the end of the passage, when he launches an attack on a pie eater.

By the end of the Eye-witness's account, horror is located in Tussaud's clientele, and the Chamber's attraction is specifically associated with depraved male appetite. The Eye-witness has neatly prepared the way for this rhetorical tour de force from the very beginning of the two-part article. Part One, 'Our Eye-witness in Baker Street' (which had appeared in the previous issue) records the Eye-witness's visit to a cattle show, where he deplores the conditions that the pigs are kept in, and notes the 'morbid excess' to which an ox's 'appetite had been cultivated'. '[B]ecoming anxious to change the scene', he goes by means of 'a door

leading to an obscure passage, dimly lighted with gas' into a 'gorgeous apartment of vast size, and with the oddest looking people, in the oddest looking dresses, and in the strangest attitudes, standing round about it.'[29] The Eye-witness has arrived at Tussaud's, and the preamble has slyly established what will become a retrospective link between the pigs, morbid appetites, the necessity of escape – and the Tussaud's experience.

When the Chamber of Horrors is finally introduced in Part Two, it is through the commentary of a large man:

> 'And every one of these here has been hung,' said a powerfully-built gentleman in top-boots, speaking to himself aloud with immense relish. 'Every one of 'em hung,' he said again, smacking his lips.[30]

Taste for the Chamber is conveyed in terms of perverse appetites. The gentleman is fat, and his pleasure is displayed by his smacking his lips. The language is adroitly doubled – the term 'relish' can be understood both as an emotion and as a condiment – and insinuates the lack of distinction between the gentleman's aesthetic appreciation and his physical appetite. The motif of literalized taste (a revivification of a dead metaphor) is continued at the end of the piece. The Eye-witness is sent scarpering by the horrors of insensitivity, in a passage that, by recalling the poor pigs of Part One, forms the final part of a rondo.

> What shall be said of the man who could stand at the door of the Chamber of Horrors *eating a pork pie*? Yet such a man there was – your Eye-witness saw him; a young man from the provinces; a young man with light hair, a bright blue neckcloth, and a red and beefy neck. His eye was on the model of Marat, assassinated in a bath, and with this before him he could eat an underdone pork pie.
>
> It is the last straw that breaks the laden camel's back; it was this last horror that sent your Eye-witness out of Madame Tussaud's, as fast as his legs would carry him.[31]

The young man's pie-eating is related to his moral and aesthetic tastes – not only to *his* tastes even, for with light hair, and beefy neck, he represents a particular type of young Englishman. Standing there eating, he also stands for English blunted sensibility and depraved appetite. Taste for the Chamber is explored through a language of

Gothic doubling and contagion. The young man's 'red and beefy neck' is a contemporary-dress, daylight version of the more traditionally Gothic spectacle that he is surveying: the dead Marat in his bath. Marat was in his bath, of course, not waiting to be murdered by Charlotte Corday but because he suffered from a debilitating skin condition. Marat and the pie eater are linked, in terms of their red skins. Furthermore, both men are linked, via this trope of the Gothic surface, to the 'underdone pork pie'. The account associates the tastes of the Chamber's spectators (though 'consumers' seems a more apt term here) with cannibalism – and even a horrific sort of autosarcophagy (or consumption of the self). The association is cemented, I think, by an implied allusion to Mrs Lovett's meat pies in *Sweeney Todd or The String of Pearls* (1846–1847).[32]

'I'm a model man': the uncanny waxwork

In 1891, the journalist G. R. Sims sat for Marie Tussaud's great-grandson, John Theodore Tussaud. After the sitting, Tussaud requested an autograph – and was to receive this punning response:

> DEAR TUSSAUD,
> I'm a model man.
> You're a modeller.
> Yours truly,
> G. R. SIMS.[33]

Sims, sitting as a model, plays on the idea of the 'model man' – the exemplary man – much of the humour deriving from the fact that he was not known for living within the strait norms of respectability. During his time at Tussaud's, Sims was to explore other kinds of exchange between man and model:

> I have been penetrating the secrets of Tussaud's lately, and had a specially quiet half-hour alone with the murderers in the Chamber of Horrors, just to see what it was like.

> The idea came to me one night when I had been sitting late to Mr. John Tussaud. I wanted to see what it would feel like to be all alone with those awful people with only one dim jet of gas lighting up their fearful features.

After the door was shut I walked about and whistled, and stared defi-
antly at William Corder and James Bloomfield [sic] Rush, and even
went so far as to address M. Eyraud in French. But wandering about
in the semi-darkness I stumbled and fell, and when I got up and
looked around me I found I was in Mrs. Pearcey's kitchen.

Then I made one wild rush at the closed door, and hammered at it
until the kindly watchman came and let me out. I never want to be
shut up alone at night in the Chamber of Horrors again as long as
I live.[34]

In this account, which appears in John Theodore Tussaud's *The Romance
of Madame Tussaud's* (1919), Sims deploys the rhetoric of terror, modu-
lated into a comic register. He starts with a mock-Gothic language of
penetration of secrets, before reverting to the easy informality of the
assured man about town, at ease both in public and in private. Sims,
however, traces a trajectory from the adventurous man, upright, whis-
tling, to the terrified creature lying in the kitchen of the murderer,
Mrs Pearcey. The account is structured in terms of the classic chiasmus
of the uncanny – the inanimate seeming animate: the animate seeming
inanimate.

Despite the differences in tone, visiting the Chamber invokes some
similar responses from the Eye-witness and Sims. Both stress alone-
ness. The Eye-witness feels alienated from his fellow visitors – the
'powerfully-built gentleman' and the pie eater – each of whom is
pictured in isolation. (In comparison, when the Eye-witness describes
the Grand Hall, he focuses on groups of observers, in particular a
female family group, who, of course, are also having a bad time.) Sims
is literally alone ('all alone with these awful people'), a privileged
spectator daring to outface the exhibits in the Chamber. In both pas-
sages, a waxwork spectator is figured as someone talking to himself.
In the Eye-witness's account, it is the 'powerfully-built gentleman'
who is talking to himself: 'And every one of these here has been
hung'. In Sims's acccount, Sims himself addresses the murderer Eyraud
in French. The encounter with the waxwork, it seems, necessitates
speech. Why?

Speech in both these accounts acts both to mitigate the loneliness
of the experience, and to put the waxwork in its place. Speaking to
the waxwork positions it as an inarticulate thing, and helps to allay
the fear that the waxwork is alive – or could come to life. Speaking
has a further function in both passages – it serves to reinforce the self.

Jentsch locates the Uncanny both in the doubt that a 'lifeless object' 'might not be in fact animate', and the doubt 'whether an apparently animate being is really alive'. In the Tussaud's experience, what is significant is not so much doubt that other observers are alive (though, as we have seen, they tend to be tainted with the qualities of the wax-work), but the draining of life from the observer. The concomitant of the potentially animate waxwork is a weakened sense of self. At the moment of spectatorship, the self becomes particularly passive and vulnerable. This is so in the case of the Eye-witness (who, faced with the wax figure of the comte de Lorges, becomes confused, his account losing its logical ordering), and with Sims – who stares until he collapses. Sims plays on the idea of transferred identities, the idea that when watching the waxwork, one becomes as powerless, as inhuman as the waxwork itself.

The same trope may be found in an account written by John Theodore Tussaud himself. Towards the end of his *The Romance of Madame Tussaud's* (1919), John Theodore writes of being alone one night in the exhibition, and seeing a waxwork move:

> I looked at it again, carefully this time. I was not mistaken. The figure did move, and, what was more, it moved distinctly towards me. It appeared to bend slowly forward, as though in preparation for a sudden bound, and I thought it looked at me with a fixed and malignant stare.

> Just as I was expecting it to raise its arms and seize me by the throat, it stopped dead, and remained at a grotesque and ludicrous angle, apparently looking for something on the floor.[35]

John Theodore's language is that of a breathless first-person Gothic, reminiscent of the Victorian adventure narrative. His account takes up all the familar tropes of the encounter with the waxwork – the gaze ('I looked at it again'), and the reversed gaze ('I thought it looked at me with a fixed and malignant stare'); the statement of intent; the movement of the waxwork and the concomitant stillness of the observer. Sims found himself prostrate; John Theodore is approached by a bending waxwork. At the moment of climax, when the waxwork should be throttling him, the account retreats into the 'ludicrous'. The waxwork comes to a halt. John Theodore Tussaud's wording is significant. The threat from the animate waxwork is not over until it is confirmed that the waxwork has 'stopped *dead*' (my italics).

Mrs Pearcey's kitchen

It is significant that John Theodore Tussaud uses the term 'uncanny' when he gives 'the explanation of this thrilling experience'[36] (which is that vibrations from a train 'had shaken the figure off its balance, and the iron which fasted it to the floor permitted it to move').[37] By the end of the nineteenth century, Tussaud's was doing its best to engineer modes of presentation that made the experience of the Chamber of Horrors an uncanny and terrifying one. They were highly successful. Such were the terrors of the Chamber that, as John Theodore Tussaud explains, Tussaud's had to write to the army requesting that they dissuade soldiers from trying to prove their courage by attempting to spend the night there.[38] What was so terrifying about the Chamber, that the idea of someone driven mad by an overnight stay was considered a suitable premise for a story such as E. Nesbit's 'The Power of Darkness' (1905)?[39]

The Chamber today is, for the most part, what Charles Allston Collins might have called a 'doublets and trunk-hose' display. It features villains and victims from 'history' – or something that approximates to it.[40] The Chamber in the nineteenth century was a rather different kettle of fish. After having sampled the Revolutionary displays, visitors encountered 'crime in coats and trousers'. Some of this crime was imagined (an early twentieth-century catalogue refers to an Opium Den display – a 'GRAPHIC RECORD OF A DOWNWARD CAREER DEPICTED IN A SERIES OF TABLEAUX' sub-divided into 'THE SIX STAGES OF WRONG').[41] Most of the crime, however, was real-life, recent and sensational. Tussaud's followed all the most notorious murder trials, with the aim of taking accurate likenesses of convicted murderers, depicted as close to the time of murder as possible, and displaying them in the Chamber of Horrors. At the end of the century, John Theodore Tussaud was sitting in courtrooms sketching the accused, with a camera concealed in his hat. After a guilty verdict, a waxwork would be modelled, dressed and displayed as quickly as was possible without the sacrifice of quality. As with other waxworks in the exhibition, those of murderers in the Chamber were clothed in garments that were either copies of those worn by the subject, or the subject's actual clothes. Some murderers, as Pilbeam points out, 'donated their own clothes for their models before their execution'.[42]

Patterns of display in the Chamber changed significantly through the nineteenth century. Lela Graybill describes the presentation of the Revolutionary displays at the beginning of the century:

Severed heads were staged to highlight the violence of the victims' death, blood often added to heighten the gruesome effect. A model of the guillotine was also displayed, but Tussaud did not stage it with a model executioner and victim; it stood at the ready, open to the viewer's imaginative projection into the scene.[43]

Graybill compares Tussaud's Revolutionary display with a 'den of thieves' style waxwork show seen by Thomas Holcroft in Paris in 1804:

The malefactors were put in different attitudes: sitting, standing, and lying, each in straw ... And loaded with chains ... As I entered, these chains were clanked with a din that might inspire horror: the exhibitor, with a gloomy terror in his voice, recounted their individual crimes; their grand robberies, rapes, and assassinations; appearing to value himself most upon him who had been the most wicked; and ending with their execution, and their blasphemies, after having been racked, while expiring on the wheel.[44]

In this show seen by Holcroft, the 'malefactors' are presented, as it were, *in situ*, sound effects are used (the clanking of chains) and a barker mediates the experience. Tussaud's earliest displays differed in many important respects. For a start, Tussaud never used a barker, preferring instead to leave the spectators to work out their experience for themselves – with the aid of a written catalogue. As Graybill notes: 'In the absence of barkers, visitors were free to engage the exhibition space at their own pace and according to individual curiosity and desire.'[45] Graybill also notes that, despite the presence of a model guillotine, the early displays of the French Revolutionary victims didn't provide the kind of 'theatrical contextualization for her figures'[46] that may be seen in the show that Holcroft attended. Even in the mid-century, such 'theatrical contextualization' was minimal. Richard Doyle's *Punch* cartoon of 1849,[47] which accompanied the text referred to earlier, shows little evidence of the kind of immersive environment that was to emerge later in the century, though John Theodore Tussaud notes that 'the walls were constructed and draped in imitation of the interior of the Bastille'.[48] The Revolutionary heads line the wall; the criminals, all in one dock, are ranged against another wall, and overlook Marat, in his bath in the middle of the room. There are models – of the farm where Rush lived, and of Stanfield Hall, where his victims lived – but these are small. Visitors can be seen bending over to inspect them.

As the century wore on, Tussaud's began to experiment with other forms of display in the Chamber of Horrors. The tableau became the dominant mode. There were tableaux throughout Tussaud's exhibition, of course,[49] and there had been since Curtius's day. For example, in the first hall, there was a tableau depicting the coronation of George IV, the monarch wearing the regalia (purchased by Tussaud's in 1840) actually used at that event. Here, however, the separate groups were not partitioned off, or enclosed within radically different environments, but shared the same overall space – the 'Grand Hall' provided the environment for all of its tableaux and figures. This could lead to some strange, or even comical, blurrings of context. The Eye-witness writes of George IV 'smiling in an insulting manner at his father, who is not allowed to be on the dais at all, but is placed aloof at a respectful distance.'[50] The modes of display in the Grand Hall were not particularly dramatic, but, rather, emblematic, the occasions often ceremonial. Collins writes of members of the peerage 'with their coronets fixed more or less uncomfortably on the tops of their heads, and their ermine right to a tuft.'[51] In the Chamber, by contrast, the theatrical, narrative, and immersive qualities of the tableau were stepped up. Tableaux in the Chamber were intended to provide a disconcertingly Gothic experience.

Whereas, in the mid-century, malefactors in the Chamber of Horrors were placed side by side at the dock, those at the end of the century were placed within separate tableaux. These tableaux were three-dimensional affairs. Spectators could either adopt positions which gave them the sight angles of proscenium arch theatre, or move around the displays. They were within an immersive environment. The Chamber's bare walls and dim lighting were designed to make visitors feel themselves to be within the same atmospheric world as the horrors themselves. Tussaud's exploited to the full the fact that visitors had to descend to reach this area, creating a dungeon-like ambience. The tableaux themselves, three-dimensional mock-ups that contained real furniture and furnishings, were real-seeming in the extreme. Their powers to terrify were enhanced by the fact that they were not just contextualizations; tableaux in the Chamber were mise en scènes, and waxworks were positioned in a way that implied narrative. Typically, tableaux in the Chamber of Horrors conveyed the sense of a pivotal moment – of imminent danger, perhaps, or discovery, or imminent execution.[52] This can be seen in exhibit '74. THE HAMPSTEAD TRAGEDY',[53] the tableau that so alarmed G. R. Sims.

Exhibit 74 featured Mrs Pearcey in her sitting room. Mary Eleanor Pearcey was a 24-year old woman who was the lover of a married man by the name of Hogg. In 1890, she invited Mrs Hogg, with her 18-month old daughter, to her house in Kentish Town. She murdered the pair of them, and disposed of their bodies on waste ground, wheeling the corpses in a perambulator. She was caught, tried and hanged, and was the main attraction at Tussaud's that Christmas. No images of the late Victorian tableau have been discovered yet, however, Pearcey was still in the Chamber 60 years later. A 1950s image of the tableau shows Mrs Pearcey in her sitting room. In the tableau Mrs Pearcey is making an ominous entrance upstage. The visitor is, as it were, being greeted. The room is cluttered and detailed, tucked into an alcove, and full of things – innocent seeming, but all claustrophically close.[54]

For Sims, the nadir of his experience in the Chamber of Horrors is his collapse in what he calls Mrs Pearcey's 'kitchen'. Significantly, it is not the waxwork of Mrs Pearcey that is the source of Sims's terror, so much as her kitchen/sitting room – and the fact that he has literally, and not only imaginatively, entered it. What made the room so terrifying was not merely its verisimilitude, but the fact that, though a mock-up, much of it was real – and had been purchased by Tussaud's.

From its earliest days (and before), Tussaud's had exhibited what it called 'relics'. Curtius's exhibition had contained the bloodstained shirt that Henri IV had been wearing when he was assassinated (Tussaud's still possesses it), and an Egyptian Mummy. The Napoleon Rooms, opened in the 1840s, were full of relics. The first Napoleon Room was a prime example of a secular shrine, containing, by the end of the century, not only one of Napoleon's teeth and some of his hair, but 'A PIECE OF THE CELEBRATED WILLOW TREE under which Napoleon used to sit, and under which he was afterwards buried';[55] his military travelling carriage; and his son's cradle.[56] (There was of course also Napoleon's head, modelled by Marie Tussaud herself, when the HMS *Northumberland*, the vessel on which Napoleon was being taken to St Helena, was moored in Torbay.) The second Napoleon Room contained, as well as the severed heads, 'THE MOST EXTRAORDINARY RELIC IN THE WORLD – A melancholy relic of the first French Revolution. The original Knife and Lunette, the identical instrument that decapitated 20,000 persons'.[57]

The Chamber of Horrors too contained relics. There were British equivalents of some of the relics in the Napoleon Rooms. For example,

the Napoleon Rooms had the key of the principal gate of Bastille, and the Chamber had 'THE ORIGINAL CELL in which Lord George Gordon died from jail fever'[58] and 'THE ORIGINAL IRON GRILL GATE of the cell from which Jack Sheppard escaped', both 'Removed from Old Newgate Prison.'[59] It also contained relics of a different sort: relics from recent crime scenes. Such items were disturbingly more contemporary, and belonged to crime that was 'nearer to us', as the Eye-witness put it. Tussaud's had, for example, 'the knife ... that was used by [James] Greenacre to cut up his victim'.[60]

It was not only murder weapons that Tussaud's collected. The company adopted the practice of stepping in and buying up movable property from crime scenes. Sometimes, as Pilbeam points out, 'Tussaud's bought the entire contents of a room where a particularly memorable murder had occurred.'[61] Whole crime scenes could be recreated in chilling detail, using objects that had been silent witness to murder. Thus, Tussaud's model of Mrs Pearcey's sitting room contained 'the identical Furniture and Fixtures', including the Piano 'on which Mrs Pearcey played while the Police were searching her house.'[62] Also on display were the piece of toffee chewed by the murdered toddler, and the 'actual perambulator'[63] in which Mrs Pearcey had wheeled the two corpses.

Tableaux in the Chamber exploited spectator unease in a myriad of ways. They were mock-ups with real-life props; they lay unsettlingly on the boundary between the real and the fake. Tableaux such as exhibit 74 were perhaps more horrifying because they were intimate, associated with private dramas, and with the contemporary domestic setting (which is why Sims uses the language of the cosy chat at the beginning of his account). Such tableaux were transposed interiors, rooms within a room. The accoutrements of the private space, the home, had been imported into the spaces of commercial spectatorship. Tableaux in the Chamber thrived on the blurring of boundaries: between fiction and the real; private and public space; moral inculcation and horrid fascination. They also derived power from their liminal generic placing. Populated by waxworks, rather than people, they were not *tableaux vivants*. They were both dramatic and actorless. They bore some relation to the Jacobean dumbshow (the Opium Den tableaux are each accompanied by a quotation from Shakespeare in the catalogue), but could perhaps better be defined by the term 'shrine'. The tableau in the Chamber was a kind of perverted shrine, receptacle for macabre 'relics', subject to avid pilgrimage.

Tableaux in the Chamber were notable for their Gothic psychologiz-
ing. Viewers were invited into the displays, through the negotiation
of empty space in relation to the implied narrative. Tussaud's tableaux
encouraged imaginative placing. Sometimes the visitor was put in place
of the victim. Mrs Pearcey loomed over the visitor to her sitting room.
In other modes of display, visitors were encouraged to turn detective,
as was the case in the 'MODEL OF THE KITCHEN where Mr. Patrick
O'Connor was murdered by the Mannings.'[64] This was a space with a
seemingly absent object, where the viewer was required to do a little
detective work, like the policeman who discovered the real corpse by
noticing the difference in the stones of the kitchen floor. The viewer
was invited to imagine the absent object. Such invitations to imagina-
tive and intellectual participation served to draw the viewer in closer. It
had been a tactic from Tussaud's earliest days.

As Mark B. Sandberg reminds us in *Living Pictures, Missing Persons:
Mannequins, Museums, and Modernity*, the 'wax figure had always relied
on a combination of iconicity (its powers of resemblance) and indexi-
cality (its physical connection to a source) for its realistic effect'.[65] The
wax figures in the Chamber had 'physical connection[s]' to their sources
that were potentially troublesome. As noted earlier, some murderers left
their clothes to Tussaud's for their models to be clothed. Pearcey, from
her prison cell, had sold all her furniture and furnishing to Tussaud's
(the payment was to cover her legal fees). Many of the models were
based on sittings that had taken place in the cell of the accused.
Inevitably, in the Chamber, knotty questions about the relation of the
viewer to the murderer were raised. There were issues of will and desire
to be fathomed. As Percival Leigh notes, writing as Mr Pips in *Punch*, (in
a style that deliberately pastiches Pepys's):

> Methinks it is of ill Consequence that there should be a Murderer's
> Corner, wherein a Villain may look to have his Figure put more cer-
> tainly than a Poet can to a Statue in the Abbey.[66]

The Chamber was a strange hall of glory. One murderer had been seen
patrolling the Chamber of Horrors the day before he was arrested, try-
ing, so it was thought, to work out where he might be placed. In the
1940s, the last wishes of the acid bath murderer, Haigh, related to the
disposal of his belongings at Tussaud's. What did this mean in terms
not only of the morality of Tussaud's, but of the relation of the specta-
tor to the murderer? Was the spectator, positioned before the model,

succumbing to the murderer's will, a willing accessory to his or her vanity?

Gothic history, Gothic geography

By the Edwardian period, the Tussaud experience was a journey through a series of differently set-up and modulated displays. The visitor entered the four Grand Halls, where the emphasis was on contemporary celebrity, the figures of the great and the good. Here (as nowadays), the emphasis was primarily on stand-alone figures, though some of the figures had a collective identity (there was a group of well-known suffragettes, for example), and some, like George IV, were placed within a context. The Edwardian visitor to Tussaud's went on a journey towards the Gothic – and (never quite) away from it. (It is no accident that each of the accounts covered in this chapter finishes with a description of the Chamber, even though the Chamber was not the last room in the exhibition.) The journey began with the living, and continued through the illustrious dead. When it reached the Napoleon Rooms, the second of which was dedicated to the Revolutionary displays, there was a greater coherence of theme and narrative, an emphasis on groups and connections, contextual material and the relic. The Chamber of Horrors followed the Napoleon Rooms. Its contents and their layout were further explorations on the modes of display to be found in the second Napoleon Room: the tableau was the main form of display, the relic was central, and the immersive mode reigned.[67] After the Chamber came the room devoted to Historical Tableaux, where there were mock-ups of such scenes as King Harold at the Battle of Hastings, the death of Nelson and the murder of the princes in the tower. The mode of the Gothic tableau left its imprint on that which came after it.

Many of the same points may be made about the geography of Tussauds today, despite the altered room layout. First are the opening halls with their focus on contemporary celebrity culture, where you may stand beside the Beckhams, and where there are teenagers photographing themselves happily towering over Daniel Radcliffe. Then come the rooms dedicated to some of the celebrities of yesteryear, the rooms relating to the British royal family, and the hall of the twentieth-century political giants: Churchill, Gandhi, Hitler. After these relatively large well-lit spaces, one descends into the fully Gothicized part of the exhibition: the Chamber, 'Scream' and the French Revolutionary displays. Gothic at Tussaud's today is not left behind when one leaves

the Chamber of Horrors, rather it is a mode that continues and permeates what is after it. Leaving the French Revolution, one climbs some stairs and emerges into an area dedicated to history and the making of waxworks. There are full-size models of the French royal family, living, elegantly clothed, but all, as it were, retrospectively presented in the light of their ultimate fates. Further down the line is a waxwork of Marie Tussaud herself. Tussaud is shown not as the sweet, rosebud-lipped young woman who adorns the pages of the *Memoirs and Reminiscences of France* of 1838, but as a little old woman, bespectacled, covered, witchlike, in a long black hooded cloak. It was self-modelled. Gothic at the London Tussaud's is only really escaped in the Marvel Superheroes finale.

Tussaud's, over the last two centuries, has adopted the habit of embedding its own history. Its roots are woven into its texture. Its habits of fossilization have engendered a very particular kind of geography. Journeying through Tussauds is to take a trip through its former incarnations. The habit of thinking about the past in relation to space permeates contemporary Tussaud's and dictates its forms. History is thought of in terms of geography. Round the corner from the main red carpet area of the entrance hall, are smaller rooms, with celebrities of a few years ago – demoted and re-positioned. At Tussaud's, the further you go, the further back into cultural memory you explore. As celebrities fade away into darker and smaller rooms, there is a strange equivalence between space, time and status.

Conclusions

As the Eye-witness noted in 1860, Madame Tussaud's is 'something more than an exhibition; it is an institution.'[68] Tussaud's has been embedded in British life since the beginning of the nineteenth century. It has negotiated its way through a variety of changes of taste, reinventing itself, and trying out new modes, positioning itself somewhere between exhibition, museum, gallery, concert hall and theatre – and partaking of the characteristics of all of these.[69] Throughout the nineteenth century, Tussaud's was experimenting with new modes of display, and new relations between observer and exhibit. The accession of Marie's two sons, Joseph and Francis, to the management, after she died in 1850, saw a move away from the more respectable portrait-based mode that she had presided over, and towards a more immersive and dramatic mode. The move to Marylebone Road, with its larger exhibition rooms and greater storage capacity, created the

possibility of staging grander tableaux and acquiring more relics.[70] Tussaud's became ever more adept at encoding the waxwork as a site of horror and of terror in the Chamber, and displayed a disturbing ability to manipulate feelings of unease related to liminality, developing immersive contexts and importing macabre relics. It developed a Gothic geography. The Chamber itself, the Dead Room, with its severed heads and criminals, became as it were the centre of the display, the place to which the rest flowed, and from which it ebbed away. For the Eye-witness, the Chamber of Horrors was the ultimate Tussaud's experience – the room that succeeds in defining the nature of the waxwork.

Gothic is not a necessary element in Tussaud's internationally. Las Vegas Tussaud's concentrates on American movie and music stars. Washington's Tussaud's presents US presidents. Shanghai's offers 'Shanghai Glamour' and 'Science and Best of Britain'. In most of the other branches, Tussaud's history is replayed within the 'Authentic History' section, rather than played out through Gothic. As far as the London branch is concerned, however, Gothic is a motivating force and has been for a long time. The very waxwork of Tussaud herself, on display at the London branch, bears witness to the Tussaud's trajectory into Gothicization. (Significantly, at other branches, the model of Marie Tussaud on display is one that was retrospectively modelled, and shows her as a lovely young woman, at the period when she was working in France.)

The responses of Collins and Sims to the Chamber tell us much about the particular horror of the waxwork. The Eye-witness's account is characterized by its sense of inadequate boundaries – between spectators and waxworks – and the possibility of contagious fates. As in *Melmoth the Wanderer*, when Monçada witnesses the death of the parricide, the encounter with the waxwork is an act of riven spectatorship, characterized by what Eve Kosofsky Sedgwick refers to as the 'insidious displacement of the boundaries of the self'.[71] The spectator becomes victim, and is also implicated in the violence. (Indeed, in the early days, Tussaud's attitude to the Revolution was that it was somewhat of a necessary evil.) The Chamber appeals to visitors' sympathies, but, as the Eye-witness notes, these sympathies have nowhere to go. The language of his account is suffused with the failure of transcendence, with the idea that the waxwork can teach and express nothing but the reality of the body. The phrase 'saturate his mind with the blood' perfectly expresses the tension between the metaphorical and the literal,

the material and the spiritual, that becomes a source of agony in the Eye-witness's account. For the Eye-witness, the Chamber of Horrors produces a cannibalistic, self-consuming kind of spectatorship. This he leaves to others (unsavoury men) and flees the building. In Sims's account, the threat posed by the waxwork is discussed in terms of the uncanny. The tension in Sims's account is between the animate and the inanimate – and the threatened exchange of identities. The encounter with the waxwork is responsible for a weakened sense of self. The Tussaud's visitor is written of in terms of the gaze. Through the eye, the self is wounded. Strength, the power of thought, and individuality are drained away.

Unsurprisingly, the waxwork has had a fairly distinguished career in English literature. There are, as Kelly Hager writes, 'scattered references to waxworks throughout Dickens's[72] – she notes references in *Nicholas Nickleby, David Copperfield* and *Great Expectations,* and discusses their figurative use in Dickens's portrayals of 'monstrous' marriages.[73] The waxwork, providing as it does an image of a person, in an object that is devoid of agency, has had a special attraction for writers depicting characters subject to abuse (indeed such, it could be argued, is the case in Radcliffe's *Udolpho*). The waxwork has become a dominant trope in Gothic, and Gothicized, fiction. Waxwork exhibitions feature in Dickens's *The Old Curiosity Shop* (1841) and *David Copperfield* (1850), and several short stories have been devoted to the terrors of a Chamber of Horrors experience.[74]

W. L. George's 'Waxworks: A Mystery', which appeared in *The Strand Magazine* of 1922, picks up on many of the features examined in this chapter. The two main characters, Henry and Ivy, are recognizably of the same kind of class as Sims's fellow visitors of 60 years before (George goes so far as to emphasize their class-related lack of height – 'neither of them was quite five-foot-six').[75] On an afternoon off, the courting couple go into a deserted house, which hosts Mrs Groby's waxworks. They are soon spooked. Typically, it is a feeling that something is missing, a feeling of lack, that is most disturbing. 'The sense that here was emptiness made emptiness frightful.'[76] As at Tussaud's, it is the tableaux that affect them the most: 'the single figures were less terrifying than two groups represented in action'.[77] In George's story, the experience in the Chamber is linked to temporal disruption and to questions of agency. We are told that 'things stood so still, but sure of themselves, as if they had always stood in the dust and twilight.'[78] The effect on the visitors is to dislocate their

own sense of time (they are 'half-conscious that they had been here a long time, though little more than a minute had passed').[79] Henry and Ivy are also prompted to displays of physical attention that seem to point up some rather unhealthy aspects of their relationship. George, of course, focuses on the act of spectatorship – the gaze and the returned gaze:

> Ivy did not want to see, but she could not look away. It was as if she must meet material, human eyes. It was always the eyes she looked at. There was a challenge in them. It was the defiance of the dead which she must meet.[80]

As in the narrative of Monçada in *Melmoth*, the gaze is forced. The moment of the gaze is written of in terms of materiality, 'challenge', and the dead. When Henry and Ivy do flee, they have been transformed – or rather she is transformed. Ivy gives a cry 'like that of a beast in pain',[81] and is no longer capable of sight 'for her eyes were so retroverted that only the whites showed under the falling lids'.[82] Moreover, she is figured as deathly: 'As they stumbled together down the stairs, he thought that it was like being held by bones.'[83] The story's twist plays on the 'dead' qualities of the waxwork, and on the interchange between human agents and depicted characters, between flesh and waxwork (significantly the word 'dummy' is used both of one of the story's protagonists and the waxworks). The tableau that depicts a murder actually contains the body of the murdered Mrs Groby. When the rescuing policeman brings his hammer down on the figure of the 'murderer' though, it flies into waxen fragments. The penultimate line, delivered by the policeman,[84] points up the mystery: '"Dead – still warm." His voice rose high: "Killed – by what?"'[85]

Tussaud's relationship with the Gothic was a two-way one. The Chamber of Horrors both contributed to the Gothic (lending its tropes, and its model of stricken spectatorship, to literature and later to film), and took its cues from it. An essay of 1892, by George-Augustus Sala, for *Madame Tussaud's Exhibition Guide*, illustrates the very conscious Gothicization of the Revolutionary part of Tussaud's narrative that had taken place by the end of the nineteenth century. Sala points out that 'with the scenes and personages of [the French] Revolution, equally with the scenes and characters of the Consulate and the Empire, the Exhibition must ever be indissolubly associated.'[86] The narrative Sala produces is curious in the extreme. At one point he explores the

potentially fatal effects of associating with Madame Tussaud (the 'young niece of the Bernese physician'):

> Marie was sent for to Versailles to give lessons in modelling to Madame Elizabeth, the sister of the King. The royal pupil and her brother were both guillotined. The heads of scores of the Court beauties, whose nimble fingers had fashioned, under the tuition of the young niece of the Bernese physician, flowers as lovely as themselves, were destined to fall on the scaffold.[87]

As if by a process of Gothic contagion, contact with Marie means death for her pupils. In recounting another celebrated anecdote of the Tussaud/Curtius story, Sala again produces a Gothicized narrative with an almost nightmarish version of causality at work:

> It is worth curious remark that almost the first blood shed in anger in the Revolution flowed in consequence of a broil engendered by two figures modelled by Curtius. On the 12th of July, 1789 – *only two days before the storming of the Bastille* – a crowd of well-dressed persons obtained from the 'Cabinet de Cire,' in the Palais Royal, the waxen busts of the recently disgraced minister, Necker, and of Philippe Duke of Orleans. These busts, veiled with black crape to symbolise the popular mourning for the minister's downfall, were paraded through the streets of Paris in the midst (it was Sunday) of an immense crowd. While crossing the Place Vendôme the procession was attacked by the Regiment of Royal Allemand, and a detachment of dragoons, sword in hand. Necker's effigy was cloven in twain by a sabre cut; and the unlucky individual carrying the bust, a linendraper's assistant, received a musket-ball in one leg and a sword-thrust in the chest. The bust of the Duke of Orleans escaped destruction; but several persons lost their lives in defending the inoffensive waxen image from the fury of the troopers.[88]

Sala's phrasing emphasizes Gothic tropes. The waxwork itself is conscripted into political action and becomes central to political change. Its parodic mimicry (of the death of ministers) brings about violence. The person holding the waxwork is killed as a result. The phrase 'inoffensive waxen image' comes to seem ironically chosen. The tone of Curtius's original account is characterized by a rather flamboyant boasting: his work, his popular craft, inspires revolution. Curtius

moreover does not mention the black crêpe on the 'effigy', nor does he provide the detail that the person who receives this violence, is himself someone who works with cloth: 'a linendraper's assistant'. Sala's account, by contrast, focuses on the veil and cloth. His central figure is a waxwork, possessed with uncanny agency, and contagiously spreading violence.

As argued earlier, Gothicization was not the only mode of treatment available for the waxwork, and, indeed for many it might seem undesirable and tasteless. Tussaud's recourse to the Gothic was perhaps influenced by the fact that the defining period of history for Tussaud's (the 1790s) was concurrent with the decade of the greatest popularity of the Gothic novel, and that some of the leading Gothic novels of that period were interested in the wax figure (most notably Radcliffe's *Udolpho*). Tussaud's Gothicization of the waxwork, though ultimately a matter of choice, could, however, also be said to have been foisted on it by the peculiar nature of the history through which Tussaud and Curtius had lived. The waxwork display was caught up with, corroborated and transformed by events. Rather than thinking about Tussaud's purely in terms of the textual Gothic, wondering whether it was Gothicized, or responsible for Gothicization (both statements are true), it is worth taking a step back and thinking about the relation between Tussuad's, the Gothic, and the French Revolution more generally.

As Ronald Paulson argues in *Representations of Revolution: 1789–1820* (1983), the French Revolution was not only an epoch politically, it was also a paradigm maker in terms of the arts, and, in particular, a crucible for new narrative modes. In a chapter on 'The Gothic: Ambrosio to Frankenstein', Paulson looks at how the Revolution left its imprint on Gothic texts from the mid-1790s onwards. He discusses Lewis's *The Monk* (1796) as a text that illustrates the 'general pattern Burke at once detected in the French Revolution: first destroy the father and then of necessity become more repressive than he was.'[89] Paulson notes both the 'bursting out of his bonds' of Ambrosio, and 'the bloodthirsty mob that lynches – literally grinds into a bloody pulp',[90] Mother St Agatha of the convent of St Clare, discussing them as 'cases of justification followed by horrible excess'.[91] Maturin's *Melmoth* contains some very similar incidents of violent encounter. There is the fate of the parricide (discussed earlier), and an accompanying reference in a footnote to the 'unfortunate Dr. Hamilton', victim of revolutionary violence in Ireland, transformed into a 'heap of mud at [a] horse's feet'.[92] This is the mode

of horror. The texts dwell on the moment of the violent end, and focus on the reduction of a thinking being to pulp – to 'a mangled lump of flesh'.[93] Frequently, though not always, the authority figures involved are tyrannical, and the minions are possessed of vicious propensities that have been encouraged and sheltered by corrupt power. During the process, the corrupt figure has been represented as a suffering being. The body becomes the site both of sympathy and of debasement. Such incidents, as we saw in *Melmoth*, are frequently associated with emotional confusion and divided sympathies. In this mode of depiction of the relation between spectator, sufferer, body and mind, the Revolutionary imprint is to be found.

Paulson discusses the responses to the French Revolution of a selection of writers and visual artists, amongst them: Burke, Gillray, Rowlandson, Wollstonecraft, Goya and Wordsworth. Both Philippe Curtius and Marie Tussaud could productively be added to this list. They stood in a unique relation to their age: both artists and artisans of the Revolution, its recorders and its narrators. When Tussaud arrived in England, it was with a collection of objects that were unlike anything to be seen elsewhere in the world. These objects stood in direct relation to the events of the Terror. They were both art objects and relics. They acted as a record of recent history, and they told a story. Like the miniature guillotines produced as souvenirs in Revolutionary Paris, these were also objects wrought for public consumption. Moreover, Tussaud's bloody relics were waxwork copies. Unlike the real object, the head of a king or a traitor, which could be hoisted up to public display, and would then rot away, the waxwork copy was a thing that lasted. When this copy wore out, there could be another and another (as long as the original mould was still in existence) to take its place. The French Revolutionary heads were objects cast in the mode of horror (not to mention the uncanny).[94] These were copies, never to wear out, whose subjects were mere drops in the ocean when it came to the scale of bloodshed, they were records of bloody fates that were not cast in the individualizing mode of tragedy, but instead of the more universal reduction to flesh (and, moreover, the flesh was bloodied, severed and not-whole). They bore a macabrely ironic relation to the portrait head as a genre. The fact that some of the soon-to-be-decapitated subjects welcomed the prospect of their posthumous wax sculpting made the issue of portraiture (and the relation of spectator to the heads) even more complex. In addition, Tussaud's artefacts were produced within the public sphere, and spanned both political and

commercial contexts. Visitors paid to see them – and they paid to see them specifically, this part of the exhibition cost an extra sixpence. Tussaud's Revolutionary heads gave to literary horror, a new vocabulary – a new way of thinking about corporeal existence and conceiving of spectatorship.

The peculiar circumstances of Tussaud's development ask us to rethink the relation between Gothic and history. David Jones, writing in *Gothic Machine* of Robertson's Fantasmagorie, points out that the building in which the Fantasmagorie was performed had previously been a convent but more recently had seen service as a revolutionary headquarters. Indeed, it was where Robertson himself had suffered interrogation. The examples of both the Fantasmagorie and Tussaud's warn us to beware the polarization between Gothicization and history, and to resist the temptation to think of Gothic tourism as sensationalist fictionalizing with no real relation to politics. As Curtius and Tussaud knew very well, there was no definite line that could be drawn between politics and entertainment. As Pilbeam points out, Curtius's show changed many times during the Revolutionary period, as the narrative of the Revolution itself changed: martyrs (such as Marat), heroes and villains, gave way (after the execution of Robespierre) to the Revolution's victims. Pilbeam notes:

> As the Revolution later escalated the different stages of the Revolution could be followed by a glance at the grand couvert, which previously had shown the king and queen at dinner in Versailles ... It was an endlessly adaptable dinner table, where only the wax fruits, table and chairs remained constant.[95]

Models of Necker and Madame de Staël (his daughter) were succeeded by those of the Girondins, the 'popular military commander Dumouriez', the Committee of Public Safety, Danton, Robespierre and the Public Prosecutor, Fouquier-Tinville. Figures that had fallen from favour had to be removed quickly; to retain them was to seem to show sympathy. Curtius, despite his Revolutionary sympathies, and despite the fact that he was a member of the National Guard, found himself in trouble for displaying, at different times, the models of the generals Lafayette, Dumouriez and Custine when they were no longer men of the hour but traitors to the nation. In August 1792, in order to demonstrate loyalty to the sensibilities of the Revolution, Curtius was required, after he had apologized to the Convention, to decapitate the model of

General Lafayette publicly. Curtius's sense of the political significance of the waxwork led him to claim in 1790, in relation to the fact that the wax heads of Necker and Orleans had become flash-points for revolutionary fervour in the previous year: 'Ainsi je puis me glorifier que le premier acte de la Révolution a commencé chez moi.'[96] ('Thus I may pride myself on having played host to the opening scene of the Revolution.')

Tussaud's was, and still is, associated with celebrity, newness and absolute contemporaneity. As Pilbeam notes, what put Tussaud's ahead of its competitors in the nineteenth century was the ruthlessness with which it kept up to date, boiling down its models.[97] As well as focusing on contemporaneity, Tussaud's, through the nineteenth century, made a definite bid to pitch themselves not merely as a waxwork show, a poor relation of the art gallery, but as a museum – a place through which history may be understood. Since those days, David Brett has suggested that: 'The changing display [at Tussaud's] shows a slow progress away from popular history, towards contemporary record and "celebrity".[98] However, rather than moving away from history, Tussaud's, at least in London, has stuck with it. Arguably, through its renowned Revolutionary displays, it bears responsibility for a popular understanding of history as Gothic. Because of the exceptional circumstances surrounding the creation of its exhibitions, the line between Gothic and history was, and still is, blurred at Tussaud's. Some of its most Gothicized sections are labelled 'history'. Arguably, in the London branch, by virtue of its Gothic geography, all its waxworks occupy a line on what might be called the Gothic spectrum. Some of its waxworks have always been Gothic; some only come to discover their Gothic condition, through the operations of time. As I noted earlier, Tussaud's Gothicization is not a 'retrofit' – it has been there almost since the beginning. And it is to Tussaud's Gothicization of the past that we owe a long line of Gothic museums, Gothic dungeons and Gothic gaols.

The Eye-witness referred to Tussaud's: 'profound and awful misery ... which provides the Englishman with an entertainment which does not make him happy'.[99] It is important to remember, however, that, as both Sims's and Tussaud's accounts show, the Chamber has also proved to be a fertile site for what Avril Horner and Sue Zlosnik call comic Gothic.[100] John Theodore Tussaud's account (first published in 1919), through its very succinctness, shows that the trope of the uncanny waxwork was becoming a worn-out joke. George's 'The Waxworks'

appeared in the 1920s, but then so did Richmal Crompton's 'William and the Waxwork Prince' (1929) in which William, posing as one of the princes in the tower, at a fairground waxworks, becomes bored and comes to life, to the horror of his schoolboy enemies, who, 'were yet not too paralysed by fear to turn to flee'.[101] G. R. Sims, playing on the 'model man' trope, notes:

> that so long as the public only stuck pins into him, or stamped on his toes, he did not mind; but he should feel it very much if they were to bang him about the head with an umbrella, or take him by the collar and shake him.[102]

The humour is not a million miles away from that of the film *Carry on Screaming* (1966).[103]

3
London's Gothic Tourism: West End Ghosts, Southwark Horrors and an Unheimlich Home

London has had Gothic tourism for a long time. Indeed, as the example of Madame Tussaud's shows, some of its oldest purpose-devised tourist attractions are Gothic. In the last half century, the amount of Gothic tourism in London has increased substantially. London's latest acquisitions include: the Clink in Bankside (which announces itself as the London prison museum); the London Dungeon; the London Bridge Experience; the Ghost Bus Tours (the Necrobus); Dennis Severs' house in Folgate, Spitalfields; Simon Drake's House of Magic ('hidden away at a secret Central London location')[1]; as well as numerous ghost tours and Ripper walks. In this chapter, I'm going to be taking a tour of some of London's contemporary Gothic tourism as a means of exploring contemporary Gothic tourism more generally. I will be starting with an example that is perhaps the most akin to Walpole's house – Dennis Severs' House in Spitalfields – before taking myself to Drury Lane Theatre in the West End, considering its 'Through the Stage Door' tour. After this, I will be going south of the river – to the Clink in Bankside, and the London Dungeon. Finally, I will be touring the city (or rather cities – Westminster and the City) on the Necrobus. En route, I will be discussing some of the dominant tropes and modes of the attractions. I will be thinking about these contemporary examples in relation to the past of Gothic tourism, and asking what literary and cinematic texts they draw on. I will also be thinking about the relation of Gothic tourism to its environment, asking where London's Gothic tourism is situated, whether the nature of the attractions differs in different parts of London, and whether it is possible to talk about a geography of Gothic tourism.

Dennis Severs' Unheimlich home

18 Folgate Street, Spitalfields, is Dennis Severs' House (see Figure 3.1). The building itself is one of a terrace of early eighteenth-century houses that were originally occupied by prosperous silk weavers, though thereafter they went into a period of seemingly terminal decline. Severs was

Figure 3.1 Door of Dennis Severs' House, Spitalfields. Photograph by Roelof Bakker

an American who came to London in the 1960s, seeing in the 'Old World' a chance to create a haven away from the twentieth century. He looked onto an unwelcome and already-present futurity, and when he acquired the house in Folgate Street, he determined to use place as an anchor to the past. From 1979 at 18 Folgate Street, he created the history and home of an imaginary eighteenth-century family: the Jervises. Severs' House, he informs us, provides 'his visitors with a rare moment in which to become as lost in Another Time as they appear to be in their own'.[2] Over the years, he collected objects – written texts, pieces of crockery, dresses, furniture – with which, Miss Havisham-like, he surrounded himself, for he was resident within his own artwork. Each room in the house is meant to feel as if its eighteenth- or nineteenth-century inhabitants have just left it (and for this effect Severs sometimes had recourse to more recent technology: there are hidden tape recorders playing recordings of cries and whispered voices, a master giving orders, gun shots). In the bedroom of 1780 a dangling mechanical monkey is swinging from the four-poster bed. The smell of the orange punch and the sweets on the landing is almost overpowering. Whilst Severs was alive (he died in 1999), the house was open to visitors at certain restricted times, when he would perform to select audiences during a three-hour tour through the various rooms of the house. The house is still open to visitors who are now greeted and launched on their tour by Mick Pedroli, friend of Severs and house manager.[3]

Once in the house the visitor is asked to try and read its narrative: the story of the rise and fall of the fictional Jervis family. The rooms are to be experienced in a certain order and each supposedly exists at a different period of the house's history. There is the dining room of 1724, the smoking room of 1780, the Dickensian attic at the precise moment of William IV's death, you can hear the bells ringing out the monarch's knell and the guns sounding for Victoria's accession. You travel from the Reception room down to the cellars, then up through the house to the decaying attic and back down to the Victorian parlour. As you go, you smell, hear, see and wander *in* the narrative that elusively haunts the rooms, and you are supposed to feel the ghosts. Dennis Severs' irascible notes wait along the way, telling you 'You either see it or you don't' and rebuking the worldly and insensitive for their bad behaviour. 'Forgive the shallow who must chatter. Silence brings to the fore deeper sensations with which many are unacquainted and ill at ease. They fear a loss of control: They talk.'[4]

Dennis Severs' House is a direct descendant of Walpole's, and Beckford's, performed architectures. As Walpole did at Strawberry Hill,

Severs offers the pastness of the past through a considered mixture of collector's items, *objets d'art* and fakery. Strawberry Hill's pasteboard walls are echoed in Severs' rococo ceiling, constructed with plastic fruit, bought from Brick Lane market[5] and covered in scrim, or in the bed he made from market crates, which was so convincing that, after Severs' death, the agent from Christie's valued it at £3,500.[6] Like Beckford, Severs has house, host, visitors and even food, performing. What Raphael Samuel calls the camp side of 'retrochic' that 'makes a plaything of the past'[7] is to some extent shared by all three literary architects. Severs' House, like its eighteenth-century precursors, is intimately linked with its creator, and with a book. (As in Walpole's case, the book – *18 Folgate Street: The Tale of a House in Spitalfields* – post-dates the house.) Like them too it plays on a range of media and genres, and tells its stories through carefully placed objects.

Despite this kinship with earlier examples of Gothic tourism, and despite the fact that Strawberry Hill is mentioned in *18 Folgate Street* as a place where the Jervises go on an excursion, Severs' House is not usually thought of as Gothic. Commentary on the house reveals a certain kind of cultural amnesia, as regards the traditions of Gothic tourism. Indeed, the debate about what the Severs House is, proves nothing so much as how the history of Gothic tourism has been lost, and how popular notions of Gothic tend not to attach themselves to attractions so rareified. The London events magazine *Time Out* lists the house under 'Museums and Attractions' but then proceeds to describe it as 'a unique form of theatre',[8] David Hockney called it one of the 'world's five great "opera" experiences'.[9] Severs himself didn't refer to the house as Gothic (though commentary on the house, from Iain Sinclair to Dan Cruickshank, is permeated with references to its spectrality).

Severs' House is characterized by generic indeterminacy and inventiveness. Severs himself was proud that his house confounded traditional generic categories. He recalled that as a child he longed to be able to enter the paintings he saw on the wall and wrote of his house, in words that strongly recall Strawberry's intermediality: 'To enter its door is to pass through a frame into a painting: one with a time and a life of its own'. Severs plays with the expectations associated with twentieth-century museum experience, and with detective and time-travel narratives; the house's diffuse allusiveness includes cartoons, television, novels, performance and installation art. Severs effected a wholesale narrativizing of the architecture and contents of 18 Folgate Street. His is not merely a Gothic house of fiction materialized, but a house that embodies and brings into being a narrative. Severs' House and his

narrative are completely inter-reliant: the whole house and almost all the objects in the house have become the bearers of narrative and been made to perform.

In his lifetime, Severs would sit as artist in residence, not only the author of his house but the curator, insisting that visitors processed the right way, sometimes asking those who spoke too loudly or giggled to leave. Now, as you enter the house you are given a sheet of paper to persuade you into the right sensibility. The house encourages imagination but also demands an ideal spectatorship. Severs' notes instruct you: 'The experience is conducted in silence, and its level is poetic; and like anything so – works best on those who are endowed, willing and able to meet it halfway.' You are told that the experience is not to be that of a museum, but, conversely, that a 'visit requires the same style of concentration as does an Old Masters exhibition'.[10] Visitors are expected to exert their imagination, but within certain limits: to have neither too little nor too much imagination. The imagination is told not only to work but also to work it out. In the section 'A Balancing Act' from Chapter 13 of his book, Severs specifies:

> In this house – a visitor without imagination can be dangerous in the same way that they might be in a kitchen or in bed: in politics such people are lethal. However, more dangerous are those with unstructured imaginations who will employ fancy to imagine absolutely anything, and often make themselves the centre. That simply will not do and those seen 'glorying' here have also been seen tumbling down its stairs. Now that our thoughts are aligned to the same template as our bodies, and our imaginations bounded in harmony, what we imagine here should be just right; we can have a little fun.[11]

Despite, or perhaps even because of, Severs' use of a mannered eighteenth-century language of harmony, balance and correct alignment, his relation to his house, both before and after his death, may be described as *unheimlich* or uncanny. Of course, the uncanny is intimately linked with the home. For Freud: '*Unheimlich* is in some way or other a subspecies of *heimlich*.'[12] As Anthony Vidler points out in *The Architectural Uncanny*, the uncanny is 'the quintessential bourgeois kind of fear',[13] 'a domesticated version of absolute terror, to be experienced in the comfort of the home'.[14] For Vidler, the uncanny 'has, not unnaturally, found its metaphorical home in architecture ... in the house, haunted or not, that pretends to afford the utmost security while opening itself to the

secret intrusion of terror'.[15] Although Vidler notes that 'no one building can be guaranteed to provoke an uncanny feeling',[16] I would argue that this is precisely what Severs' House does. The most significant difference between Severs and his forebears, is the fact that the keynote of Severs' House, and its characteristic trope, is the uncanny. Severs' House problematizes materiality, blurs the boundaries between past and present, and encourages feelings of ghostliness and undermined subjectivity.

Severs' House animates the inanimate and materializes the phantasmatic. It elides the markers between the real and the phantasmatic, and positions the visitor in the world of Severs' phantasms. It is as if the Freudian concept of the 'omnipotence of thoughts',[17] has been displaced from the experiencing individual onto a sinister neighbour. It is a house of inversions, where Severs succeeds in Gothicizing the Age of Reason and such un-Gothic figures as Hogarth, through his summoning up of his visitors as spectral presences, pallid observers of ghostly eighteenth-century revelry. The house is a museum whose curator pissed in the fireplaces. It is a house where fantasy becomes public property; a locale where the spaces of imagination are commandeered; where the material is spiritualized and the spiritual is materialized. It is a house that, according to Mick Pedroli, refracts various elements of its creator's mind. Severs' House is haunted by Severs.

The house embalms its author, positioning him inside his text, becoming his auto-icon, as if he were an aesthetic Jeremy Bentham going for immortality through mummification. The house was already an over-determined text within Severs' lifetime, but the kind of narrative control exerted over the material of experience *after* Severs' death is suggestive of that of an impresario, a Svengali operating now from beyond the grave. The experience of the house is oppressively pre-constructed: the visitor has been 'authored'. The house enshrines authorial control in a way that echoes the claustrophobic atmosphere characteristic of texts such as J. Sheridan Le Fanu's *Uncle Silas* (1865) or George du Maurier's *Trilby* (1894), where the victimized protagonists feel themselves to be scripted. The words 'Thus, and this was Mr. Severs' intention, *what you imagine* is his art' emphasize the dual nature of Severs' relation to your experience – not only that he has stimulated the imagination but that he controls it.

The visitor to the house is made the subject of a bewildering narrative as Severs sets up a strange line between obedience and transgression. This tendency is even more pronounced in Severs' book. A picture shows a door marked 'private' but the text exhorts us 'Open-up ...'[18] The door is, however, already ajar, and the extent of the transgression thus already bounded. There is an astounding moment in the chapter

'A Balancing Act', in a section called '*Our Sin*', when Severs, addressing his reader in the second person on the recreated tour that runs through the book, encourages his reader/visitor in a conspiratorial whisper, to steal a silver patch box which belongs to Mrs Jervis. You are invited to transgress; Severs pre-empts your acquiescence and tells you '*Boom, boom, boom,* your pulse quickens, blood pressure rises, nerves may make you sweat; there is a desire to smoke or – dare I say it – even chew gum. Guilt will, with time, begin to rearrange and harden your features to appear defensive.'[19] Inside the box is a scrap of paper – a buried manuscript. '*From Harmony you have stolen: watch what happens to you now.*'[20] The reader/virtual visitor is lost in a vertiginous temporality where the past rebukes the present, and constructs the future. Severs sets himself up as predeterminer of your features (Gothically inscribing your visage) and your fate (that of being found out). He constructs himself as god and devil of his house: moral educator and tempter.

The over-determining marks of the houses's absent author, confer an impotent subject-position on visitors. Indeed the experience of the house encourages a state of ghostliness in the visitor. A feeling of unease is compounded by an insistent blurring of boundaries between that which is animate and that which is inanimate, reminiscent of Ernst Jentsch's discussion of the uncanny.[21] In Severs' House, the visitor is a protagonist in a labyrinth of temporalities and virtual presences. The more real the ghostly reality of the Jervises becomes, the more visitors become what Iain Sinclair calls, 'spooks of the future'.[22] You are expected to find that which is not materially present, moving as Sinclair writes 'Through rooms that never were, moved by false histories (heavily documented) of families that never existed.'[23] The fleshly is reduced to the two-dimensional and to Gothic tropes of the veil, the mask, and the figure at the window. Turning a corner, visitors are greeted with the cardboard silhouette of a child, or make contact with the past in the form of a discarded and thinning wig. One of the most bizarrely spectralizing effects occurred when I caught sight of a figure, pale and immobile, through the internal window on the ground floor and realized that it was no 'ghost' or waxwork, but a fellow visitor.

Perhaps the most notable triumph for Severs' House as an essay in the uncanny, is its treatment of the world of physical artefacts. Despite Severs' insistence that the house is what he calls 'Post-materialist' – 'it seeks to remind a visitor of a scientific thing: that *what we cannot see* is *essential* to *what we do*'[24] – his summoning up of the past is done with utter reliance on the material realm. He materializes the supposedly immaterial. For Sinclair, 'Severs is an ether broker, a man dedicated to creating "atmosphere", sculpting rococo fantasies out of his own

ectoplasm'[25] The running metaphor linking the house to nineteenth-century spiritualism is very apt.

Severs stressed the liminal nature of his house: his explanatory texts tell us that: 'It's about what you have just missed': the 'space between'. Severs' House blurs the boundaries between art and life and between temporalities. Things from both the past and present are placed side by side. The smell of rot that pervades the larger attic room, is not just pretend rot, a prop, a narrative device, a literary description. It exists here and now, as supposedly it did in the 1830s at the time of Victoria's coronation. The ceiling has fallen in; the place is decaying. Despite Raphael Samuel's comment on Severs' House as 'a magical mystery tour'[26] and his belief in its ability to convey a sense of history, Severs' House is more Gothic than historical. Although Severs, like Walpole and Beckford, collected and assembled a collection, his *objets d'art* move 'history into private time' and restore not an '"authentic", that is, a native context of origin but an imaginary context of origin',[27] to adopt Susan Stewart's description of the properties of 'the souvenir'.[28] If, for Raphael Samuel, here paraphrased by Caroline Evans, 'objects are emotion holders, traces of the past, and carriers of discourse from other times into the present',[29] the problem in the Severs House is that these objects are all borrowed, displaced, repositioned. The 'genuine' artefact lies beside the fake, and, more significantly, is divorced from its own history. More than this – the artefacts are positioned in a temporal realm that is neither past nor present. The house is littered with that which is past, but which is also here, now, and supposedly untouchable. At one end of the spectrum, there are letters, supposedly just written, brittle with age, on discoloured paper; or a child's shoe of impossibly stiff leather; at the other are the foodstuffs just bought from the market. Somewhere confusingly in between are the 'eighteenth-century' notes written by the characters of the house on antique-seeming paper by a modern hand.

The photographs in *18 Folgate Street* taken by Severs' niece, Stacey Shaffer, present the house with the luminescence of the Dutch interior. In actuality, the house is dim and many of the artefacts are crumbling, yellowing in the here and now. As for the artefacts of the present – the carefully arranged displays of sweets on the first floor landing, the punch with the overpowering scent of oranges – like Walpole's gigantic helmet, there is something too overpoweringly physical about them to fit into the aesthetic of haunting. The dizzying odour of oranges becomes the smell of the living posing as the dead, and the dead trying to break through to the present. The house is a monument to decay, history turned yellow and cracked. All is smell, touch, decomposition.

Severs' House is not so much a study in the 'post-Materialist', as an essay in the perversity of the physical artefact. Severs' achievement is to make objects Gothic, to make an installation, a performance piece, that does not recognize temporal parameters or his own death.

West End ghosts

Severs' House lies in an area that, recently, by means of a number of influential texts, could almost be said to have become consecrated to the Gothic. Iain Sinclair, in *Lud Heat* (1975), conjures up a Spitalfields that is a centre of occult power. Sinclair's conceit is hijacked by Peter Ackroyd, who, in *Hawksmoor* (1985), produces a Gothicized Spitalfields that is a site of murder and time travel. More recently, Alan Moore and Eddie Campbell's graphic novel *From Hell* (1991–6), and the subsequent film version (dir. Albert and Allen Hughes, 2001),[30] have created a Victorian Gothic Spitalfields, a site of rancid privilege, corrupt social and sexual relations, bad medicine and terrifying freemasonry. The Gothicization of Spitalfields in the late twentieth and early twentieth centuries is indebted to a number of factors. It draws upon the area's construction in the Victorian novelistic tradition and the penny dreadfuls, as well as its association with the Ripper murders. It is also indebted to the peculiar circumstances of modern day Spitalfields. Over the last 40 years Spitalfields has undergone a remarkable, and still-continuing, 'make-over'. Colin Ward, here paraphrased by Patrick Wright, described the area in 1975 'as a classic inner-city "zone of transition", a densely populated "service centre for the metropolis" where wave after wave of immigrants had struggled to gain a foothold on the urban economy'.[31] Since then, Spitalfields has experienced gentrification, which coexists with urban poverty and soaring property prices. Spitalfields is currently an ultra-fashionable place of residence with more than its fair share of artists, actors, directors and musicians. Indeed, David I Cunningham argues that a 'certain gothicised heritage',[32] in particular the mythologization of the Ripper, Rodinsky and the Krays, has become 'valuable capital'[33] in the 'promotion of the area as desirable real estate'.[34] Spitalfields is also closely associated with heritage groups – the Society for the Protection of Ancient Buildings, which has its headquarters there, and the Spitalfields Trust[35] – and has been the subject of much contestation, vigorously fought over by developers, and various people and societies interested in preserving its Georgian and Victorian fabric. It has a complex and embattled position both in relation to its surroundings, and within itself. It possesses a peculiar blend of wealth and poverty. It occupies

a 'vestigial' position, to use Robert Mighall's term, in relation to the hypermodernity of the City, which it borders.[36] The very narratives of contemporary Spitalfields have a strangely liminal character. The defining narratives of its eighteenth-century streets are those of the nineteenth century, and, more recently, the neo-Victorian.

The West End is a different kettle of fish. It is not so rich in terms of Gothic literary tradition, neither is it particularly amenable to Gothic tourism in terms of economics. Dennis Severs was able to create his house because he bought it very cheaply in the 1970s, at a time when Spitalfields was run-down. The West End, by contrast, is theatreland, a land of valuable properties, home to some of the most famous museums and galleries in the world. Despite these inauspicious circumstances, the West End does have some Gothic tourism, though, unsurprisingly, its examples are not permanent fixed-site examples. There are a number of ghost walks operating in the area, and there is, at Theatre Royal Drury Lane, an interactive theatre tour entitled 'Through the Stage Door'.

Twice daily on most days punters, advised to don 'sensible foot-wear,'[37] are met in front of the box office and conducted on a guided walk of Drury Lane, from front of house to underneath the stage. In the course of the walk they encounter 'three professional actors', and 'the history of the Theatre Royal Drury Lane is brought to vivid life as key characters, writers and actors from the theatre's 300-year old past take you back through time as you look around this famous theatre'.[38] The tour, though it doesn't announce itself as such, is constructed as a Gothic experience. It is peripatetic, multi-temporal Gothic, and it offers a proliferation of hauntings from a variety of time zones. The theatre itself, for the duration of the tour, is constructed as a Gothic building, the mise en scène of a series of Gothic narratives. The beginning of the tour presents a story of warring royals and an acrimonious father/son relationship (that of George III and the Prince of Wales), which the very architecture of the theatre bears witness to, in that there are separate King's and Prince's entrances. The erotic, subterranean strands of Gothic are touched on in stories of Charles II visiting Nell Gwynne by secret underground passages. The split character of the theatre is stressed as the tour moves from the sumptuous public spaces to the relatively depauperate backstage areas.

The Alice in Wonderland-sounding title of the tour, 'Through the Stage Door', with its contorted, mock-historic subtitle ('A tragical comical-magical Historie of The Oldest Operating Playhouse in the World'), suggests the kind of gleeful generic trespass that has character-ized Gothic tourism since Walpole. 'Through the Stage Door' is a strange

mixture of guided tour, promenade performance, and site-specific work performed not only by 'three professional actors' but by ghosts. It is both displacement and reinvention of the theatre experience. It experiments with audience trespass onto the areas associated with actors and theatre staff, and it relies on actors who are dead. It draws our attention to the palimpsestic nature of the theatre – its rebuildings, the re-sitings of the stage, the plenitude of different time zones and significant spaces that coexist and co-haunt. At one point, tourists are informed that the tunnel they are in is part of the seventeenth-century theatre, which was supposedly constructed on the site of an earlier nuns' burial ground, and is currently haunted by the ghost of Dan Leno. As the tourists/audience pass through an arch, they are told that this is where a corpse was found bricked up in a wall in the nineteenth century – and that the ghost of this man in grey has walked here ever since that discovery. They are told of another ghost who appears where a stage was, but is no more, on his way to finish the performance during which he died. The very spaces of the theatre are shown to be liminal. Ghosts walk across spaces that, because of the many re-sitings of the stage are no longer there. In this palimpsestic theatre, space has become haunted – not just by ghosts of humans, but by traces of former spaces.

The Gothic quality of Drury Lane's construction, is, I would argue, elicited by the problematics of a history/heritage dichotomy. The theatre's website conveys the point somewhat elliptically. It stresses the long history of the theatre, going back to the early seventeenth century. It mentions its design by Wren, its occupation by Garrick, but has to point out: 'The present Theatre Royal in Drury Lane, designed by Benjamin Wyatt, opened on October 10, 1812 The interior has been substantially redesigned and overhauled many times since then'.[39] In other words, Drury Lane's impressive history is not visible in its architectural remains. The theatre that stands is not the one built by Wren or commanded by Garrick. It is not even, strictly speaking, the one that opened in 1812. The Theatre Royal, Drury Lane is a prime example of an institution, a site even, possessed of a celebrated history that it cannot display.

Drury Lane's predicament is that of much of the West End. The West End has its history, but all too often the material remains are lacking, because the district has been relentlessly built-over and updated. The phenomenon leaves the tourist market with some pressing challenges. Where marketable heritage proves elusive, however, Gothic tourism has stepped in and supplemented the heritage industry. The West End is awash with peripatetic Gothic tourism. Cleverly planned ghost walks

make a virtue of the area's irrepressible modernity, and the relentless Victorian development. The relative lack of pre-Victorian material, of heritage of the kind that characterizes a city such as York, for example, becomes the structuring principle of the walk. For Robert Mighall, Gothic fiction 'depicts the anachronistic survival of vestigial customs into the enlightened present'.[40] The 'Apparitions, Alleyways and Ale' walk that I went on in 2009, was planned around the vestigial survival of traces of the past in an otherwise modern city. Our guide, Russell, took his walkers from the busy streets of the Strand, through to 'crepuscular, crooked little alleyways'.[41] The relative scarcity of these places, their uncharacteristic nature, their status as 'backwater', was the premise of the tour. Every night, such walks circulate through the streets of the West End, pencilling in historical detail that has left precious little in the way of traces.

Southwark horrors: the Clink and the London Dungeon

If the West End is predominantly constructed as a site of haunting, just south of the river, horror is flourishing. Amongst the many examples of Southwark horror is the Clink, London's Prison Museum. The Clink is situated on Bankside, within spitting distance of the remaining walls of the Bishop of Winchester's palace (under whose jurisdiction the area once lay), and cheek by jowl with the Victorian-restored Southwark Cathedral, the replica of Francis Drake's Golden Hind and Sam Wanamaker's rebuilt Globe. It is in an area that is in the process of reinventing itself. Its predominant fabric is Victorian but, of all its many and varied pasts, its Victorian period seems, at the moment, to be the last it wants to reference. Instead, Bankside rebuilding summons up a renovated Elizabethan age, sandblasted into an ultra-clean hypermodernity. The nineteenth-century industrial buildings have been scrubbed up, and carry no trace of smoke-blackening. Expensive restaurants, with window walls of clean glass that look onto minimalist 'artisan' interiors and sparkling table settings, have taken up residence in and around Southwark market. The Clink's defiantly black exterior is almost a relief.

The Clink's sign is a gibbet suspended over the pavement. Its entrance is down a flight of steps, above which hangs a luridly painted skeleton, flanked by two burning torches. The entrance is both barred and adorned with a coat of arms. The Clink is the museum as Gothic Theatre with all the apparatus of set, lighting and sound. The ticket office, tellingly, has 'box office' written over it. The whole building is done out as a self-contained world: to enter the Clink is like wandering onto a stage set of a rather tongue-in-cheek horror film. It is a world of artexed ceilings and walls, false flames,

coloured lights of yellow, red, white, green. In the opening room, visitors are positioned as spectators of talking, spotlit waxworks as they listen to a looped recording of a scripted encounter between a blacksmith and the prisoner he is fettering. The Clink is conceived of as a journey through a series of spaces, some of which are mock-ups of the prison at different stages in its past, and some of which are display areas in a more traditional museum style. Its various exhibits include authentic artefacts and comically gruesome figures. There are Victorian whipping posts and Tudor torture equipment; severed heads on pikes; starving figures that sit beside wretched, comfortless beds, and in front of bare tables

The Clink presents a history of imprisonment through centuries, drawing on a Gothic sense of the unenlightened past, characterized by pain and tyranny. According to the accompanying booklet:

THE CLINK

The prison that gave its name to all others – was owned by the Bishop of Winchester within his Palace on the Bankside. From the 12th century, his prison was used for, amongst others, the prostitutes and customers who broke his rules of 1161 in his 22 licenced [sic] brothels along the Bankside. Later, during the 16th century, the Clink was used almost exclusively by so called heretics who disagreed with the Bishop's views and during the 17th century, it was used almost exclusively for debtors.[42]

The world of the Clink has no mundanity. It is populated by whore-mongering clerics, tyrannical kings, suffering poor. Henry VIII, with his introduction of the punishment of boiling in oil, and the death sentence for sodomy, features as the one of the foremost tyrants, as do the profiteering Bishops of Winchester (written of in the quotation above, as if they were one very long-lived and implacable character). The Clink is Old England as tarts and bishops. Crime is committed by oppressors from on high. Women fared particularly badly in the world according to the Clink. As the booklet has it: 'many women would gamble their clothes away leaving them stark naked'[43]. Female madness is presented as seemingly unavoidable: 'CLOSE CONFINEMENT AND harsh treatment brutalised females, often driving them to madness.'[44]

If Tussaud's could be said to play on a sense of uncanny spectatorship and uncomfortable proximities, keeping, for the most part, its Gothic at a distance,[45] the Clink brings the Gothic out to its public – or rather it coyly invites them in. On a visit in 2011, I turned a corner to find two young women at the whipping post, one photographing the other

in a sexualized pose. If the invitation to sneak into the displays was more or less unspoken in 2011, it has, in the years since, become a selling point. 'Torture your friends' reads a poster at the window. Do an internet search for the Clink, and image after image appears of visitors sitting in torture chairs, bending over execution blocks or peering up from oubliettes. At the Clink, the horrors of the past are offered as a platform for salacious performance, and a means of titillation for the present.

The Clink is in many ways, the progeny of Tussaud's, which was collecting prison 'relics' through the nineteenth century, and by the 1870s had released a special catalogue of their 'Collection of Instruments of Torture.' The Clink, despite the fact that it declares itself to be a 'prison museum', is even more generically mixed than Tussaud's, and creates much of its effect through its precarious generic positioning. It is museum, radio play, waxwork exhibition and site-specific theatre. It has a curiously literary dimension too. The tone of E. J. Burford's 'A Short history of The Clink Prison' ('this less than orthodox story' as he puts it on the title page of the booklet), its learnedness, its prejudices and prurience, communicate themsleves to the place. The Clink derives much of its tone from that individuality. Displays at the Clink are characterized by a peculiar relish, a somewhat off-hand sense of mock-up, a macabre sensibility, and a sly sense of humour. Moreover, the Clink is deliberately out of touch. Both the content of its displays, and the display itself are dated. Its technologies – waxworks, old-fashioned sound reproduction techniques – are themselves presented as antiquated, even Gothic. This has become one of its attractions. The Clink's very cheesiness is one of its selling points.

If some of the perverse charm of the Clink lies in its individuality, the same can't be said for the London Dungeon, which now has branches in Amsterdam, Hamburg, Edinburgh and York. The Dungeons chain employs a highly successful formula that it uses with slight variation in each of these places; its current guidebook contains pictures from different branches. Buy a guidebook in London, and you'll get Berlin's weiße Frau along with Jack the Ripper and Sweeney Todd. There is much in common, however, between the London Dungeon, and the Clink. Both are theatrical events and both foreground participation, but where the pleasures of the Clink are private and furtive, the Dungeon's are noisy and communal. The London Dungeon is Gothic pantomime crossed with the fairground and promenade theatre, and delivered within registers associated with Hammer Horror. Like the Clink, the Dungeon

features disembodied voices (though they tend to be more Hammer than Radio Four), flickering lights and waxworks. The Dungeon is more self-avowedly theatrical than the Clink. It uses a variety of theatrical forms – monologues, shadow theatre, promenade and pantomime. Within the site-specific promenade theatre of the Dungeon visitors are not just bemused spectators, but become participants in the piece. In a court scene they are incorporated into a Kafka-esque parody of the eighteenth-century judicial system as a bewigged judge condemns to the gallows a non-English-speaking tourist, unable to defend him or herself. The Dungeon first commissioned waxworks with sophisticated mechanisms, to deliver its thrills, but quickly discovered that the use of actors was far more effective. The actors at the Dungeon are mostly young, and enthusiastically throw themselves into their parts, hamming up their performances, trilling their 'r's, raising corpses to life, throwing mad fits, using a vernacular that much of the audience will not understand. The theatrical experience has become one of the attraction's main selling points. As the guidebook has it:

> The Dungeons brings together an amazing cast of theatrical actors, special effects, stages, scenes and rides in a truly unique and exciting walkthrough experience that you – surrounded – see, hear, touch, smell and feel. It's hilarious fun and it's sometimes a bit scary.[46]

In the pre-2013 guidebook for the Dungeon,[47] in a characteristic show of bravura, the opening of the attraction becomes part of a paradigm shift in a time-line of pain and torture: '1969 Capital punishment is abolished 1975 The London Dungeon opens'.[48] The point at which certain histories are offered up for consumption is framed as the point of discontinuity with the past. At the Dungeon, and at the Clink, the gruesomeness of the past is presented for the delectation of the present.

Both the Dungeon and the Clink mark their separation from a Gothicized past through their proclamation of attitudes towards the body. As the sales pitch quoted above illustrates, the Dungeon is a 'walkthrough' that plays to all the senses. The Dungeon emphasizes the physicality of the consumers themselves. Indeed, attitudes towards the body become the means of distinguishing between past and present. The Dungeon provides a take on the past that constructs the historic body as the site of abuse/terror/injustice as it engages in the business of moving and assaulting the contemporary body for fun. Visitors are positioned as passive victims of an ordeal of gruesome surprise, as they

are assaulted by ghastly sights, sudden noises and noisome smells. They become lost in a maze; take a boat journey, as traitors, to the Tower of London (with special booming, courtesy of 'much loved actor Brian Blessed starring as Henry VIII');[49] are treated as one of the plague-infected, and experience Gothic contagion as they are splattered by the droplets of a plague victim's sneeze. Audience seats suddenly tip back in Sweeney Todd's darkened barber's shop. The Dungeon is designed as a journey. It commences by positioning visitors as spectators of the horrors perpetrated on other bodies, and finishes by treating them to the fun that can be experienced by our own. The Dungeon offers fun in the fairground tradition. It is an extended ghost train ride, which takes in a maze of mirrors, a boat ride, and a 'vertical free fall drop ride'[50] en route.

The Necrobus

London's Necrobus (see Figure 3.2) departs from Northumberland Avenue every night at 7.30 and 9 pm. Tourists are welcomed, in somewhat unnerving fashion, onto the black doubledecker by a guide. They then make their way through an interior decked out in suburban chintz, to seats 'arranged in "railway style" for comfort, and so that passengers

Figure 3.2 London's Necrobus. Courtesy of the Ghost Bus Tours

can grieve openly and offer condolences to each other'.[51] There are little lamps on the tabletops, and curtains at the windows. The vehicle is supposed to have belonged to the 'Necropolis Bus Company', which:

> began in the 19th century as a private funeral bus service. The Necropolis vehicles or 'Carcass Coaches' as they were known to Londoners were able to convey the deceased, pall bearers and up to 50 mourners (no standing) to the final resting place.[52]

This bus is said to be the last of the fleet, following a 'tragic fire' at the depot in 'South Dulstead'. It becomes clear that this is a narrative that will be explored further.

Of all the tourist attractions looked at in this chapter so far, the Necrobus is the one that most firmly meets the prerequisites of the tour, in that it does actually ferry passengers round London, and it points out famous sites – the Tower of London and St Paul's Cathedral, for example. Tourists, however, are shown not only some of the most celebrated landmarks, but also some that are decidedly less famous, Cock Lane, near Smithfield, for example, where we are told about 'Scratching Fanny the Cock Lane Ghost'. Nowhere were the idiosyncrasies of the Ghost Bus Tours as a tourist mode, more apparent than at the moment when we were passing a particularly beautiful stretch of the Thames on a lovely evening in July 2012. Suddenly, the guide announced: 'This is part of the sightseeing tour where you don't see the sights' and demanded that we draw the curtains. It was a cheeky rhetorical gesture that served to remind us that the Ghost Bus Tours privilege the theatrical over the sightseeing experience.

As the website puts it, the Necrobus is:

> a theatrical sightseeing tour, showing you the darker side of London while providing a piece of comedy horror theatre onboard a classic 1960s Routemaster bus. A guided London bus tour combined with a spooky and funny experience you'll never forget.[53]

Its visitors board the Necrobus specifically because they want a theatrical experience. They get a form of site-specific theatre. Indeed, the Necrobus could be said to be site-specific theatre twice over, with the roads and landmarks of London constituting one site, and the bus itself the other. The performance on board the Necrobus investigates both the city and the theatre space. If at Drury Lane, the audience trespassed onto the acting space, the reverse is true of the Necrobus. The

actors (particularly the unhinged Mr Hinge) continually trespass onto the audience area (or what the audience thought would be their area), frequently breaching the etiquettes related to personal space in the process. Mr Hinge further tests the limits of the acting space when, at one point, he flees the bus, and draws the outside streets directly into the action. Creating a short mini-narrative outside, he ensures that, briefly, the bus's passengers become the actors for an audience constituted of passers-by.

The Necrobus is a witty and savvy, affair, very aware of its niche as Gothic tourism, with a strong sense of its forebears in the tourist business – as the reference to the Cock Lane ghost shows. It is allusive and self-referential, and cleverly plays on a range of Gothic tropes and texts. The bus is constructed as the Gothic building, the cursed locale associated with a horrible history that troubles the present; the tour guide becomes the Gothic narrator. Audiences are presented with a classic framed Gothic narrative, where one story encloses another, and frames are unexpectedly punctured. The Necrobus relies heavily on its audience's interpretative expertise, its ability to pitch with exactness the different kinds of Gothic narrative being offered. The only person not following the cues on the journey I went on, was a five-year old boy, who worriedly asked 'When do we see the ghosts?', moments after we took our seats. The rest of us were well able to respond to the different texts and media being referenced: *The Blair Witch Project* black and white, hand-held style of footage, wittily delivered over the 'CCTV'; the *Most Haunted* style disturbances of that 'CCTV'; and the wheezy accordion soundtrack that occasionally appeared to let us know, if we hadn't already guessed, that this wasn't to be taken too seriously.

Conclusions

London has an impressive array of Gothic tourism – from ghost walks, to Gothic tours, Gothic museums, waxwork exhibitions, scare attractions – and performed houses of other kinds. Some of these attractions may be found in other cities – the Dungeons and the Necrobus, for instance – some, Severs' House, for example, are not transferable in the same way (though, as we will see later in the book, Severs' House has been influential). The range of London's Gothic tourism is impressive – but it is not definitive, or encyclopaedic. It has, for example, no equivalent to Edinburgh's Mary King's Close, nor has it, at the time of writing, any Gothic gardens.

The examples discussed in this chapter are a specific breed of tourist attraction, generic hybrids, all performance-based, sitting on the boundaries between fiction and history, amusement and edification, mock-up and historical site. Despite these broad-based similarities, they operate very differently from each other. Where Dennis Severs' House demands quiet, and Severs insisted that 'a commonly made error is to assume that [his house] might be either amusing or appropriate for children',[54] the Dungeon is permeated by screams, and announces itself as suitable family entertainment.[55] Where Severs' House does not breathe the word Gothic, and, moreover, is based round a narrative which, in itself, is not necessarily Gothic (its themes of social mobility, decline and fall, could be those of a classic realist text), The Dungeon goes for the jugular, referencing *Sweeney Todd* and a host of other gruesome murderers and histories. Whilst some attractions – the Dungeon, the Necrobus, and the Clink – happily cite film, others are more literature-inclined. As a general rule, the more literary the tourist attraction is, the more highbrow it is perceived to be. The more populist attractions tend not to play to literary texts so much. This was manifest even in terms of the catalogues. The London Dungeons currently sells a catalogue that mainly comprises glossy photographs of actors. Its current catalogue (as opposed to the pre-2013 catalogue, which was more wittily wordy) is primarily focused on visuality. By contrast, the Clink, provides not so much a catalogue, as a booklet, a history, which sets a tone for the attraction itself, exploiting a feeling of literariness. The book, or the written word more generally (this includes the numerous labels in the Clink and in Severs' House), tends to be associated with individuality and characterization. From its booklet and labels, the Clink derives a patina associated with the crusty antiquarian. Both Severs' House and the Clink rely to some extent on the feeling of being inside someone's psyche, being the toy of a somewhat contrary sensibility.

The Necrobus is in many ways exemplary, and points up many characteristics of contemporary Gothic tourism – the dominance of performance, for example, and the sense that, even indirectly, the experiencing self is the subject of the attraction. There are no unselfconscious tourists in Gothic tourism. In the Dungeons, we are plunged into the darkness of Sweeney Todd's parlour, our seats tilting, our throats at risk; on the Necrobus, we become the means of the plot denouement. Even in attractions like Severs' House, where the contemporary supposedly has no place in the narrative, the tourist is harangued, suspected and even accused (by means of Severs' notes). In such examples, Gothic tourists are not only vicarious participants in a fictionalized environment (as

we are when wandering through mocked-up Tudor cells in the Clink, or winding our way through haunted passages in the Drury Lane Tour), but fictionalized subjects. Often we even play at being audiences.

Contemporary Gothic tourism relies on shared knowledge. It often has a strong sense of its tourist precursors, and it riffs convincingly on an array of Gothic texts, drawing on the narratives and tropes of a tradition that is now 250 years old. Gothic tourism positions tourists within a community defined by knowledge and sensibility. It exploits intertexuality. As in the eighteenth century, Gothic tourism nowadays is highly intermedial. Each of the examples discussed in this chapter has been characterized by its inventiveness in transposing effects associated with one media to another. Severs' House, with its 'unique spectator sport "Still-life Drama"',[56] its detective and time-travel fictions, and its rooms framed like Gothicized Hogarth prints, is perhaps the most prolific in terms of its generic questing, but the habits of remediation and intermedial pleasures belong to each of the examples looked at in this chapter: 'Through the Stage Door' and the Necrobus as theatricalized tours, the Clink as performed museum, the Dungeon as immersive pantomime. Much of the pleasure of contemporary Gothic tourism is derived from such intermedial leaps. The cinema/theatre crossover proves particularly attractive. It is not only the Pasaje del Terror scare attractions which bring characters from horror film into the immersive theatre set; the Clink, and the Dungeon draw on a vocabulary drawn from cinema – in this case the very British Hammer Horror. The Necrobus too explores the area where cinema and theatre cross over. Audiences are placed within immersive sets, experiencing subject matter more commonly associated with Gothic film, but delivered by actors whose delivery is very much that of theatre. It is a source of a very particular set of thrills that cannot be found elsewhere.

There are, of course, examples of Gothic tourism in London that I have not discussed here. There are places where people go as an act of Gothic tourism, but which have not been consciously framed as Gothic tourism – graveyard tours, for example, such as those in Highgate or Nunhead. Sir John Soane's House, in Lincoln's Inn Fields, is another example, though for rather different reasons. Though it is now open to the general public, free of charge, it was never designed as a tourist site: Soane's House, which was established as a museum by Act of Parliament in 1833, was both his home and the repository of his collection of architectural remains, drawings, paintings and sculpture, all of which he used in his teaching. Soane's House does, however, have much in common with other texts discussed in this work so far. Like Severs'

and Walpole's houses, it is associated with a fiction, and even, as Nicole Reynolds has shown, with a book (the Gothic novel written by his son). The house, which Soane himself designed,[57] has a fictive monk in residence at the lowest level: Brother Giovanni, a fictionalized aspect of Soane himself, with his somewhat monkish habits. As Reynolds writes 'Soane built Gothic novels and ruined literary manuscripts, emplotted his interiors and made monuments to the fiction that shaped his life'.[58] Soane's House proves that once a 'Brother Giovanni' has been invited in, he cannot be confined to a certain area – in this case, the lower regions of the house. The aesthetic associated with Brother Giovanni, visible in both his plush over-decorated room, and the mediaeval ruins in the courtyard, infects what is presented around and above it. Even Classical ruins become Gothicized when placed in close proximity to Gothic ruins. Artefacts become Romantic fragments. Gothic knocks up against other modes of viewing, and, ultimately, comes to change them.

It is certainly possible in London to talk of Gothicized locales. Spitalfields is one (spectacular, almost over-determined) example, but there are others: Highgate, for example, where different kinds of tourism battle it out. Highgate Cemetery, site of the 'bloofer lady' incidents in Stoker's *Dracula*, has, for some years, had a vampire tour outside its gates, competing with the more respectable Highgate Cemetery tour inside them.[59] The Highgate Cemetery Tour, though it might not present itself as Gothic, is definitely perceived as such by many of the tourists. It has even inspired its own Gothic fiction, in the form of Audrey Niffenegger's novel *Her Fearful Symmetry* (2009), which tells of two young Americans, Julia and Valentina, who become involved with Robert, a British guide to the cemetery. Niffenegger worked as a guide in the cemetery as part of her research for the novel.[60] Perhaps because of the resistance of the Highgate tour to more downmarket Gothic, the title of Niffenegger's book pitches the novel, via a neat pun, within a more respectable Romantic/Blakean realm.

Gothic tourism is not merely restricted to those areas that have already received Gothicization in literature, film or television. It can be found almost anywhere. The kinds of Gothic tourism that are adopted in various places, however, will depend on a variety of factors. The reasons why certain locales are Gothicized in particular ways are always complicated. The kind of Gothicization might relate to the current economic profile of an area, its architectural and social history, specific social and political circumstances, and to historical events, as well as to literary, televisual and cinematic texts. Certain circumstances make certain kinds of Gothicization more suitable than others. Prohibitive

property prices, for example, as in the West End, are more likely to result in a peripatetic Gothic.

In terms of London, at least at the present moment, it is, I think, possible to talk of a geography of Gothic tourism. There is a striking dichotomy between the kinds of Gothic tourism to be found in Southwark and the West End. Southwark has horror. It has more than its fair share of scare attractions. Its tourism, at least at the moment, is characterized by mock-up. The Dungeon and the Clink both privilege the body. They call attention to the body-as-fun as the mark of modernity, and characterize the past through the trope of the body-as-pain. Southwark narratives are the grand narratives, the story of England, the story of the medieval – this is History with a capital 'H'. West End Gothic, by contrast, is more upmarket. In contrast to the 'low' Gothic of Southwark (with its emphasis on the body, its noise and sense of fun), West End Gothic is quieter, and more discreet. Rather than 'History' with a capital 'H', it prefers to summon up histories – individual stories of people and places. Rather than the material, it conjures up the spectral. West End Gothic focuses on ghosts. There are the variety of ghost walks plying its streets, as well as the ghostly theatre tour at Drury Lane. And it is to ghost walks, and their particular relation to place, that I will be turning my attention in the next chapter.

4
Ghost Walking

Ghost walks have become a very popular phenomenon internationally. Examples in the United States are numerous – from the 'French Quarter Phantoms' ghost tours of New Orleans to the 'Ghosts of Gettysburg' tours. Examples in the Czech Republic include the 'Mysterium Tour', and the 'Ghosts and Legends Tour' by 'Haunted Prague'. Paris has the 'Mysteries of Paris Ghosts and Vampire Tour'. Significantly, these last three examples are English-language tours, aimed at English speaking tourists. In Scotland, Edinburgh's ghost tours are big business. A number of different companies compete with each other for visitors' custom: walk down the Royal Mile in summer and you end up with a fistful of flyers for a variety of walks. The largest of the companies, Mercat, offers ghost tours daily, all year round, and they don't just run in English – there is a 'Misterios de Ultratumba' tour for Spanish-speaking tourists. Ghost walks are popular in England too. The London Walks Company offers several: 'Ghosts, Gaslight and Guinness' (starting at Holborn Tube station, its blurb influenced by an Ackroydian discourse of occult geometries), 'Ghosts of the Old City', 'Haunted London' and 'The West End Ghost Walk' amongst them.[1] The website boasts that, barring Christmas Eve and Christmas Day, the company hosts a ghost walk every day of the year.[2] Manchester hosts the 'Haunted Underworld' tour by Jonathan Schofield and Flecky Bennett's Manchester Ghost Walk. York has at least five ghost walks. Derby's ghost walks company is run by Richard Felix of TV's *Most Haunted*.

Ghost walks are not only to be found in large cities, however, and they are not only run by big companies with multiple employees. At the time of writing, it seems as if there is hardly a small town in England without its ghost walk. In smaller places the walks are usually seasonal, running once, sometimes twice a week, to catch the summer

tourist trade. Sometimes they are so sporadic as to fade very quickly into non-existence. I have waited in a Tourist Information Office on a rainy Wednesday afternoon for a tour that never materialized and which no one seemed to know very much about. The guides of many seasonal walks are part-time. For many it is a labour of love. Often, there is a surprising lack of profit involved: though some guides are making money, others are working as unpaid volunteers.

In this chapter, I will be focusing on four ghost walks from the South West of England – those of Bath, Exeter, Weymouth and Dorchester. I'll not only be thinking about the ways in which these walks are structured, and examining some of their commonest tropes and their generic allegiances, but I'll also be considering what the ghost walk has to say about the town or city where it takes place. Every ghost walk that I have come across, however much it might play to generic expectations, or provide thrills in common with those at other sites, has never failed to leave me with the sense that it is somehow intrinsic and special to town. To this end, I'll be thinking about the logistics of the hauntings as well as considering the kinds of ghosts said to haunt places, and the ways they are talked about. I'll be asking such questions as: Where are the ghosts seen? Who sees them? How much of a ghost tour isn't about ghosts? How directly is the ghost linked to the town? Are its ghosts showing off – or showing up – a place? As Catherine Spooner, in an essay on Hilary Mantel's *Beyond Black*, writes: 'Ghosts, in common with other kinds of folklore, are ... both a means of interpreting a place, and a source of identity ... Ghosts are both defined by place and define places.'[3] The same may be said of ghost walks, which are eloquent, if indirectly, not only about history and heritage, but also class and economics, and the way a place may have changed over time.

This chapter will also be discussing the ghost walk as a place in which contemporary folklore is rehearsed and produced. I'll be considering the ghost walks in the light of Owen Davies's discussion of modern ghosts in *The Haunted*, asking what kinds of ghosts are seen and what contemporary ghosts do. Do they appear in the same kinds of places as ghosts of previous centuries? Ghost walks have as much to say about people as about places, and, in the final part of the chapter, I'll be considering the ghost walkers themselves, asking questions that are more familiar to students of tourism: Who are the ghost tourists? Where do they come from? How do they behave? What kind of experience are they expecting? What kind of experience do they get? Why is the ghost walk such a successful and popular form?

Outside Garrick's Head: Bath

It is an evening in April 2013. The weather is changeable but it seems as if the rain will hold off. I am one of 19 people who have met outside the 'Garrick's Head' pub, for the celebrated Bath ghost walk. The small crowd is mostly composed of families and groups of friends. I have arrived without either, and am the only one with a notebook.

The Bath ghost walk was established in 1974 and runs every Thursday, Friday and Saturday night all year round. Like many ghost walks, it is designed to last approximately 90 minutes. We meet at the Garrick's Head but will be left at another location. This is typical of the ghost walk: a group meets at one place, but is dropped off at another, very close to it, and given directions to get back to where they started. The event, after all, is not only a walk, but a journey – and ghost walks, like narratives, tend not to be completely circular. The pub or inn is a common starting-point for a variety of reasons. Walkers can arrive early and have a drink, and the tour leader can establish a mutually beneficial arrangement with the landlord or landlady. In addition to this, the pub in the ghost walk very often stands for Chestertonian conviviality, community and continuity. It is not only a place of entertainment and common resort, but also a point of contact with the past, a survivor – but perhaps only just, for, at the time of writing, pubs in Britain are closing at the rate of 28 a week.[4] Increasingly, pubs are also being perceived as haunted. In recent years, many ghosts have supposedly been caught on CCTV: the seventeenth-century James Stanley, seventh Earl of Derby, has made a number of headlines in the last few years (on account of his appearances at Bolton's Ye Olde Man and Scythe pub),[5] as have a surprising number of black-eyed child ghosts.[6]

The Garrick's Head is busy, and there are people bustling round the entrance to the Theatre Royal, which is just round the corner. Our guide informs us 'I don't like starting here. It has absolutely no atmosphere at all, but the reason is this building'. Immediately we are plunged into the series of transformations effected and demanded by the ghost walk. The guide points out that what is now two buildings was once one. The pub was once part of the house of the celebrated Beau Nash; here a lover was stabbed to death by a jealous husband, after which the adulterous wife leapt to her death. In the ghost walk we are asked to see the joins, to see beyond present divisions. Its business is to change perceptions. The ghost walk asks us to superimpose, to imagine, and it encourages an emotional and conceptual openness. 'Don't think that nothing will

happen. Think that something might happen,' says our guide, skilfully encouraging us by negatives. Five minutes later we are grouped outside what was once the splendid front entrance of the theatre (it is now the back). The street it fronted was, we are told, even in the eighteenth century, a one-way street, so busy was it with carriage traffic. Dusk is drawing in. 'Don't be frightened' says our guide in his sedate but convivial fashion, but of course we must be a little frightened, and this is what he wants.

Ghost walks tend not to be whistle-stop tours or to cover much physical ground (though there are exceptions). In the main, they will take in no more than a mile or so. Much care will have gone into the choice of route and suitable stopping places where stories can be told. If stories are to be told to large groups, then a space both big enough and quiet enough is needed. A ghost walk tends to take its walkers from a relatively central place, and lead them to and from a series of quiet spots: typically the stopping points on ghost walks are by-ways, quiet alleys, gravel walks, not-quite roads or what-were-once roads. Ghost walks are conducive to moments of quiet and rapt congregation under street lights (not usually of the neon kind), and will often take in parkland. The Bath walk stopped at a variety of well-chosen places, many of them liminal: thresholds (entrances/exits to pubs, theatres and grand houses), some parkland once used as a duelling ground, a street corner.

Our guide is adept at conjuring up frisson. At the beginning, he encourages us to communicate any experience of the paranormal we may have had. One woman introduces her companion to the group as a ghost seer: 'she's weird' she claims. Later we are given the chance to 'experience the strange power of an amazing paranormal bush'.[7] Our guide suggests the kind of sensations that might befall us – a feeling of cold, pins and needles – if we walk round the tree in a certain direction. There is a pleasant jitteriness in the air. Torches are switched on, and suddenly the stray branches look very Blair Witch. Those of us clustering within the branches of the tree, searching the trunk for the hidden face, can hear the others processing around, exclaiming 'Oh my God! My right shoulder's tingling!' and 'That bottom corner is absolutely cold. Icy cold.'

'Outside Garrick's Head' is, as well as a meeting point, also a fitting metaphor for the ghost walk. The ghost walk is 'Outside Garrick's Head' in that it is a form of performance that situates itself outside the traditional sites of drama, both literally and metaphorically. The ghost walk goes beyond conventional theatre in that it is performance not limited to the stage. Our guide points out (outside the theatre again) that we are 'walking down a film set'. At one level this is true, Bath has been

the setting for period dramas time and time again. At another level his remark reminds us that on the ghost walk everything is performed: the guide performs, the guide makes the place perform, and we, as tourists, perform. The ghost walk is also 'Outside Garrick's Head' in that it encompasses the personages of David Garrick, actor, Beau Nash, the leader of fashion, and John Wood, architect, but it is also beyond their imaginings, for the Bath walk is a take on eighteenth-century and Regency culture that is indebted to later patterns of ghost story telling – predominantly those of the later nineteenth and early twentieth centuries.

The template our guide uses is that of the literary ghost story. Such devices as the reporting of third-hand evidence, and the witness of sceptical observers are built into the narrative of the tour. The moment of proof is set up as narrative climax. Figures similar to the ghost walkers themselves are incorporated into the narration, and observers from the New World (so often associated in Victorian fiction with modernity) are frequently used to give credence to tales of haunting. Our guide makes a speciality of the contemporary American witness, who, strangely enough, is usually male. (On this walk the last example of an American female witness appears to have been in 1939). One story starts by introducing four contemporary tourists, two Americans and two British people but our guide tells us to 'Ignore the Brits'. In another story, the Mayor of Miami is the expert witness. One particularly luckless American is clawed by a tree. Occasionally science is called in to lend authority to the story, but on the Bath tour this is in the relatively cosy form of Tony Robinson and the Time Team television programme.[8] As in the ghost story, we are told of ghosts revealed through, or in spite of, the investigations of modern media: there are eighteenth-century duellists who appear to newspaper photographers, but cannot be photographed.

Outside the Theatre Royal, our guide delivers a series of interrelated stories all bound up with the theatre, performance and a curse. Typically the narratives have delayed or staggered climaxes. They might also be said to be contagious: when our guide in Bath stops and tells a story, it usually leads on to another and yet another. The effect is akin to that of the Gothic frame. Our guide constantly knits the ghosts and their stories into the fabric of everyday life. It is a device found in M. R. James's work, but here it has been somewhat democratized, the mutual culture invoked is not that of a don's circle but rather of our own. The guide's stories relate to a network of his contacts, friends and acquaintances. We learn about the experience of the residents of specific houses. We are informed that office workers won't walk past the ghost of Fanny Braddock if she appears during their lunch break. To draw us in further we are given stories told by former walkers.

Guides must be good storytellers. Our guide has an impeccably under-stated manner, combining whimsical wit with gentle urbanity, and makes his scary stories all the more effective by telling it with calmness. When he is recounting a particularly entertaining anecdote, there are moments when I glance up at the rest of the group and think that I have never before seen quite such rapt and innocent looks on the faces of a crowd of people.

'Ghosts and Legends': ghost walking in Exeter

Bath's ghost walk takes place, for the most part, within the Georgian parts of the city. Its ghosts predominantly date from the city's Georgian heyday, and include gamblers, lovers, architects, duellists, as well as various unspecific ghosts in late eighteenth- and early nineteenth-century dress, many of the stories told on the walk relate to the busi-ness of preserving Bath's architectural heritage. Our guide tells us that frequently spirits are annoyed when walls or doors are knocked down or flats redecorated; one unnamed ghost announced his/her presence through a sad wailing when some unsympathetic home improvements were undertaken (the owner quickly restored the flat back to its old look). On the Bath walk you run no risk of being led into any discor-dantly modern part of the city. Though this might seem to be obvious (after all this is a ghost tour and one might expect ghosts to be embed-ded in the historic fabric of a city), it is by no means a given. Why should ghosts be confined to an area where the architectural heritage dates from the period of the ghosts' stories? Most towns and cities are not possessed of the Georgian architectural heritage for which Bath is so famous and which features so heavily in its ghost walk. Where do their ghosts appear? What kinds of stories are associated with them? In what periods of their history are these stories set?

In Exeter, the ghosts are granted more latitude than in Bath, and ven-ture into more modern parts of the city. Exeter's ghost walk – 'Ghosts and Legends' – is not a private venture, but one of the Red Coat Guided Tours, run by the city council and free of charge. It starts outside the Royal Clarence Hotel in Cathedral Yard. The choice of venue nods to Exeter's prosperity, manifest through the elegant early nineteenth-century buildings that are part of its architectural heritage. As I stood there on a chilly November evening in 2012, a slight autumnal misti-ness lingered round the no-longer-gas-lights, and Mercedes and BMWs were pulling up outside.

The Exeter tour is very much a 'gas lights' tour. It is divided, and sometimes torn, between providing requisite ghostliness and creating

photo opportunities at impressive or picturesque locations, such as the cathedral, Southernhay or the New Cut in the city wall. The beginning of the tour illustrates this tension well. We are led across the graveyard until we stand outside the west front of the cathedral. I am a little surprised, because the reaction to ancient heritage, and, in particular, churches is often complicated on the ghost walk. Sure enough, though we are told about successive cathedral buildings we are also informed that there are no ghosts here, though the guide gestures to mortality by pointing out that there are up to a quarter of a million people buried in the cathedral's old graveyard. The Exeter walk is as notable for informing us where there are no ghosts as for telling us where they are said to exist; we are shown several impressive sites and then told they are not haunted. Exeter's ghosts, it seems, have a very particular sense of the propriety of haunting. They reveal a marked tendency to absent themselves from the city's most impressive examples of architectural heritage. The Guildhall (which dates from 1160, though the present structure dates from the late fifteenth century) is still in use, but, as the guide informs us, it has no ghosts.

Exeter's ghosts come from specific periods of history. They are predominantly of the nineteenth and twentieth centuries: the eighteenth century is the preferred cut-off point, and medieval heritage is an exclusion zone. When it comes to Exeter's oldest monuments, our guide tells no ghost stories but resorts to other modes – either factual recounting, historical anecdotes (such as the execution of one of its thirteenth-century Mayors for murder) or (another, more specifically literary, mode) legends. The suitable literary mode for the cathedral is felt to be the legend rather than the ghost story. Outside the cathedral's west front, we are treated to a story of the supernatural at second-hand: a medieval Bishop of Exeter had encountered the Devil – but that was over in Tavistock. At another spot on Cathedral Green, we are told a tale of forbidden medieval love, involving monks and nuns and lovers' suicides but it involves no haunting (though the story has an effective coda involving the discovery of the skeletons by the Water Board in the late twentieth century). The cathedral itself remains untainted by Gothic fictionalization. Exeter's ghosts – and potential ghosts – are policed by the fittingness of modes. Gothicization pertains to the more recent past, and anything more ancient is recounted in terms of legend and anecdote.

It is not only ancient architectural heritage that Exeter's ghosts (or at least those on its ghost walk) avoid. They also have more sense than to interfere with those parts of the city that have been devoted to recent

cultural memorialization. The ruins of St Catherine's almshouses on this November night look like archetypal Gothic ruins. These buildings, however, have been preserved in a state of ruination as a memorial to the World War II bombings, and the devastating Blitz experienced by the city in May 1942. Though the transparent information boards are barely visible in the night-time, the guide is wary of turning this poignant memorial into a Gothic locale. The only claim for ghostliness here is in the supposed echo of chanting monks from the site adjoining it – their manner of haunting providing, as it were, a fitting soundtrack to the narrative of loss that predominates at this spot. Exeter's Blitz *is* referenced in the ghost walk, but it is not Gothicized. We are taken past St Stephen's church, which stands oddly out of place, a medieval survivor surrounded by late twentieth-century rebuilding. The guide links the building to the supernatural, but not in the form of ghosts: he quizzically asks whether it was 'God?' who intervened at this site, saving it from the incendiary bombs. However, although the Blitz is not Gothicized, it is responsible for certain patterns of Gothicization. In many respects, it is the unspoken shaper of Exeter's ghost walk.

The sociologist Avery Gordon, notes that 'the ghost is primarily a symptom of what is missing'.[9] Exeter's ghosts constantly gesture to the city's loss. They haunt what is no longer there, rather than what is there. They cluster round monuments long-gone – such as the old Broadgate, taken down in 1823–1825, and now haunted, our guide tells us, by the ghosts of a man, his wife and a horse. Exeter's ghosts flit about vanished buildings, and even lurk under roads, apologizing, as it were, for the 1950s rebuilding. Although our guide tells us that sadly the Guildhall has no ghost, he takes us a few yards further up the road and points out that ghosts proliferate in the shopping centre across the way, haunting Laura Ashley, Marks and Spencer and Costa Coffee. Owen Davies, writing of the 'Geography of Haunting', points out that ghosts are often associated with liminal spaces, both natural (such as rivers) and man-made (such as parish boundaries or bridges).[10] In the case of the Exeter ghost walk, liminality is not so much to do with social function as temporality. Exeter's ghosts are frequently to be found at those points where modernity meets the old fabric of the town: at the Broadgate, for example, where you stand with the cathedral behind you, looking towards a shopping mall, or just up from the Guildhall, where you look over to a shopping centre. Exeter's ghosts patrol the borders between the city's modern and ancient fabric.

Exeter's ghost walk both reflects the city's sense of history, and delivers a narrative of loss. The destruction during the Blitz of much of

Exeter's historic fabric has left the city's remaining historical buildings standing not as grim reminders of a Horrible Histories past, but as a glimpse of an older world before the nightmare of World War II. Exeter's ghosts, rather than gesturing to the ghastliness of the past as happens in many another ghost walk, provide a focus for an appreciation of the city that was. They do not frequent its best heritage sites, instead they linger longingly near to the city's surviving monuments. The implication is that they would prefer to be laid to rest in the serenity of Exeter's remaining architectural splendours rather than doomed to loiter round the shops, cafés and open spaces that are the legacy of later twentieth-century rebuilding of the city.

When is a ghost not a ghost? Weymouth's Haunted Harbour Tour

It is one of the few warm and sunny evenings in July 2012 and I have turned up for Weymouth's 'Haunted Harbour Tour'. Several people are already sitting on benches outside the assigned meeting place, the Boot Inn, where there are neither theatre crowds milling, nor expensive cars pulling up. The Boot is a former tanner's workshop, and it sets the tone of the tour, which is a very different affair from the Bath and Exeter walks. This walk is not constrained by the need to show off photogenic locations or keep to a beaten track that takes walkers to places notable for their aura of gentility. (As the guide on our Exeter walk commented at one point: 'Quite a spooky little place, this, but rather lovely. Rather lovely.') Dave Allan, who leads the walk, arrives dressed in a tricorn hat and a cloak (a kind of seventeenth-century workaday dress) and carries a little leather-bound book. He greets us all, takes our money, gives us tickets and we're off – on what is to be the longest ghost walk I've ever been on. Dave has been expert in finding paths and roads round Weymouth from a variety of historical periods, and his tour, departing from the 90-minute format, lasts a good two and a half hours. It is a journey of discovery, communicating Weymouth's power to surprise, despite the disastrous carve-up of the town resulting from mid- to late twentieth-century road building.

In many respects Weymouth is an unsuitable candidate for a ghost walk. It is remarkably lacking in locales that conjure up a sense of Gothic claustrophobia: modernization here has left little in the way of the alleys so beloved of London tour guides (the one stunning exception is the remains of the Elizabethan High Street that Dave leads us down into, towards the end of the tour), and it is relatively lacking in

the kind of nineteenth-century industrial landscape that might provoke a Gothic frisson. This evening, in particular, Dave has to work with refractory materials. The boats are glistening on the Marina, and Weymouth looks unwontedly glamorous. The status of the 'Haunted Harbour Tour' as ghost walk is complicated further when Dave informs us at the start: 'I don't believe in ghosts'. The insistence is not merely a ploy to lower our defences in order to frighten us more effectively. Dave told me as much, a couple of days earlier, when I phoned to enquire about the possibility of writing up the walk for this book, not wanting to mislead me in my research. However, being a conscientious man, and not wanting to disappoint his walkers, he delivers a series of ghost stories at various points on the walk.

Bath's and Exeter's guides delivered, consummately, polished ghost stories, based on the best literary models. Dave's tales, by contrast, have a more chaotic, random element. He has collected tales from various sources, written and oral, and delivers them laconically and with telling effect, *in situ*. Whereas Exeter's walk sustained a decorum of literary modes and vigilantly kept watch over where ghosts were allowed to haunt, Weymouth's ghosts riot, it seems, wherever they have a will to go, and find themselves in the kind of places that Exeter's and Bath's ghosts wouldn't dream of haunting. They appear to be particularly fond of pubs (perhaps unsurprisingly, people seemed often to have experienced those tell-tale cold shivers whilst in a pub toilet). They are also to be found in carparks, in shops and in ordinary suburban houses. 'Ghosts cling' says Dave at one point. The places where they cling in Weymouth are indicative of the town, its people and their leisure pursuits. Weymouth's ghosts play 'knock down Ginger' on very ordinary streets, and reverse pistol shots in what is now Sharky's Play Zone. Most bizarrely, there is a ghost who occasionally guides tourists round the town's Tudor House Museum.

Why, one might ask, is Dave Allan leading a ghost walk at all? His walk is not devised as a means of vaunting a much-prized architectural heritage; he is not employed by a council whose underlying agenda is to encourage tourism; he does not believe in ghosts, nor does he want to scare his walkers. The answer is simple. Dave's main interest is in history: he organizes living history events for a living, and is co-founder of Pike and Shot Events Limited.[11] At one level, as he is only too willing to confess, ghosts on this tour are merely the peg to hang history on.

Dave is primarily interested in social history – the history of working men, in particular. He has a strong interest in local history, particularly of the Civil War period, and is on a mission to raise awareness of

Weymouth's Crabchurch Conspiracy of 1645. Dave's historical interests influence the kinds of ghosts he presents us with. They tend not to be the individual and eccentric persons that populate fiction, but more anonymous figures, representative of the historical many, living at specific historic junctures: trepanned soldiers, plague doctors, besieged townspeople, and unnamed sailors. They are not 'ghost story ghosts', but figures conjured up by Dave as historian, and given a ghostly gloss when necessary.

Weymouth's 'Haunted Harbour Tour' is primarily concerned not with ghosts, but with mediating Weymouth in relation to its history. Thus, it is fitting that the 'Haunted Harbour Tour' starts off along the higher reaches of Weymouth. As we climb up Love Lane, we are entertained with a story of plague (the position of the ghost indicating the previous topography of the place) and then we are sauntering high above the town. The early part of the walk involves a series of significant exhortations. Dave tells us to 'Look over this wall', or he requires us to step up. 'The step' proves to be a dominant trope. Our attention is drawn to a variety of bizarrely isolated steps: individual steps which were once part of flights of stairs; the remains of a staircase which ran up to the medieval chapel but is now in someone's back garden; a single step projecting from a wall that is the one surviving piece of a demolished Victorian school. One series of steps leads to a wall which is broken – heras fencing is all that protects walkers from falling down a steep hill. Weymouth's steps seem doomed to lead nowhere and act as indications of what once was.

The 'Haunted Harbour' tour bears testimony to change (often profoundly ugly and unimaginative) and redundancy in Weymouth, and indirectly draws attention to its loss of national significance. Dave's ghosts inhabit a townscape whose resonances – domestic, bourgeois, suburban – are very different from those of its medieval and early modern period. What is now the spick and span, new Marina was once the fetid backwaters of the River Wey. Here, Dave tells us, in 787, was where one of the first Viking ships arrived in the South, and where the king's reeve was slain. Here was where the Black Death first entered England in 1348. As we wander through a newly pedestrianized corner of town, Dave points out the Red Lion pub. Here, he tells us, now underneath the road surface, is the pool into which two hundred Irish soldiers of Lord Inchiquin's regiment were driven in the Battle of Weymouth 1645, and where they drowned. The walk articulates Weymouth's neglected history in relation to its altered fabric, and gestures to the town's transformations. It illustrates the near impossibility of mapping past

Weymouth on to the present town. Thus, in stark opposition to most of the other ghost walks I've ever been on, its ghosts flit round some splendidly unpicturesque places: a multi-storey carpark built over an old graveyard, and another town-centre carpark, built on the site of the medieval friary. They have also taken up position on some of those vestigial steps. One ghost 'inhabits' the steps running up to a Victorian church, and has a habit of pushing old gentlemen down them. In her book *Haunted Weymouth*, Alex Woodward points out that access to Chapelhay was re-routed in the 1880s, and suggests that perhaps 'the ghostly pusher is a former resident of one of those houses, still angry that his or her home was pulled down to make way for the new route.'[12]

The finale of a ghost walk is a crucial part of the experience: it consolidates the tone and the overall feeling you walk away with, now unaccompanied by your companionable guide. In Bath, a lamplit moment by a haunted hotel provided the final scene, imparting not the sense of an ending, as much as the sense of unending (it dealt with a surprisingly resumed haunting). In Exeter, the final location was a *pièce de résistance* of claustrophobia. We were led down into the nasty-smelling cellar of a pub where not only was there a stinking well, but also a bizarrely pieced-together skeleton in a glass case, a printed text above it.[13] Our guide uttered some disturbing words about the three steps to death, and the tour was over. In Weymouth, by contrast, Dave chooses to leave us in a car park, which had been, he tells us, the site of a ferocious battle in the Civil War. He throws us the word 'flense' (which refers to the stripping of skin from a body or carcass), using its unfamiliarity to convey something of the shocking, and historically distant, wholesale destruction that has taken place here. At one level he is describing the ability of early modern warfare to obliterate the body – at another, more metaphorical level, he is adverting to the wanton destruction of so much of Weymouth's heritage. Dave's tour has made us constantly aware of the destructive forces of 1950s modernism and 1960s road construction, and perhaps nowhere is this illustrated better than at this carpark. He gestures to a 1950s council building at the far end, pointing out that in order to build it, one of the country's few surviving complete streets of Elizabethan housing was destroyed. By the end of the Haunted Harbour Tour, our predominant feeling is that Weymouth is a ghost of itself.

Dorchester's ghost walk: being a ghost walker

At the top of Dorchester's South Street is an obelisk erected in 1784. According to English Heritage's listing, this was a 'one time town pump' and the tablet it bears 'commemorates its erection in 1784 on the site

of the Cupola or Market House.'[14] In front of the obelisk, in the tourist months, stands a moveable miniature version of it, that functions as a signpost to some rather bizarre tourist attractions. The mini-obelisk points not only to Max Gate (the home Thomas Hardy built for himself) and the Teddy Bear Museum, but also to Hitler's desk, the Tutankhamun Exhibition and the Terracotta Warriors Museum. Dorchester's tourist industry does a nice sideline in homegrown inauthenticity presented in vernacular buildings. One of the reasons, perhaps, why this happens so blatantly, is that, because of the work of Hardy, the line between the real and the fictional is often very thinly drawn here.

Dorchester knows well how to exploit its most famous son. The Gorge café, situated in the building in which Hardy was trained as an architect, advertises itself by playing on Hardy's dourness:

> Freshly cooked meals within 10 minutes
> Even Thomas Hardy would be delighted[15]

The relation with Hardy and the identification of Dorchester with Casterbridge goes further than name-dropping. Dorchester has enthusiastically embraced the identity of its fictional counterpart, Casterbridge. There are Casterbridge dental studios, hotels, and heating show rooms. The frontage of one of the high-street banks even bears a plaque announcing that the elegant Georgian building is none other than the home of Thomas Henchard, the Mayor of Casterbridge, the eponymous and tragic hero of Hardy's famous novel. As Nicola J. Watson points out, the idea of Hardy's Wessex 'overlays the physical reality of Dorchester with the parallel imagined physical reality of Casterbridge.'[16]

To a greater extent even than Weymouth, Dorchester possesses little in the way of Gothic scenery. There is a dearth of industrial building. Most of the older buildings have been genteelly heritaged-up, and many of the public buildings and open spaces have been given functions other than their original (more ghost-promising) ones. The graveyard, where the tour finishes, bears a sign saying 'wildlife friendly habitat'; the church that it surrounds is decommissioned and now functions as the museum's storage facility. What was once the town's theatre[17] is now a restaurant called 'The Horse with the Red Umbrella'. The courtroom in the Antelope Hotel, in which Judge Jeffreys notoriously gave out 251 hanging sentences during the Bloody Assizes, which followed the Monmouth Rebellion of 1688, is now the Judge Jeffreys Restaurant. Even the promisingly named Hangman's Cottage turns out to be impossibly pretty – and much enlarged since the hangman lived there.

Alistair Chisholm and Chris Gallarus, the guides of Dorchester's ghost tour, are not daunted, however, by Dorchester's lack of Gothic glamour. On the evening that I turn up, the walk is led by Alistair's deputy, Chris Gallarus. Instead of going for chills and thrills, Chris takes his cues from Dorchester's long-ingrained habits of fictionalization and comfortable inauthenticities. He demands very little in the way of credence from his audience, and instead deliberately and knowingly embarks on a campaign of (often arch and sometimes preposterous) storytelling. The result is the most (enjoyably) complacent and cosy ghost walk that I've ever been on.

Significantly, our meeting point for 'Dorchester's famous ghost walk' is inside rather than outside. We are gathered in the reception room of the King's Arms, on the High Street, when Chris enters expansively. He is in classic actor/storyteller garb – long black coat, red scarf and broad-brimmed hat – and carries a stick with a brass knob. He could be introducing Anglia Television's *Tales of the Unexpected*.[18] We begin with a reference to Hardy – we are told that our meeting place is the house of Lucetta in *The Mayor of Casterbridge* (1886). This is not the last Hardy reference we will receive; Chris later mentions *Tess of the D'Urbervilles* (1891), and the short story 'The Withered Arm' (1888), and says to me afterwards that he's considered inventing a Hardy tour. Chris's tone is one of engaging urbanity. We are all made to feel interested, entertained and knowingly superior to the tales we are being told. It is a difficult balancing act, which Chris manages perfectly. I am impressed by the inventiveness that makes the most out of a semi-rural environment. Along the pretty riverside walk, we hear of a haunted tree (the leaves on one side paler than those on the other), and strange scratching noises under the boardwalk (which Chris, somewhat hopefully, says may be echoes of Celtic sacrificial practices). The patch of water just up from Hangman's Cottage is a haunted pond, though Chris freely volunteers the interpretation that the strange bubbles are the result of gaseous rather than ghostly action.

The emphasis in Chris's walk is on conviviality and even on comedy; the fear factor is negligible. In the stylishly preserved ruins of Dorchester's Roman House, we are told the silliest ghost story ever – of Maximus Profitus. It is given no ghostly gloss, and we are thrown many laugh lines as we sit on the wall. Most of the ghosts are far from threatening. Judge Jeffreys has been neutralized, and makes do with haunting a café, occasionally appearing before opening hours to staff in the Oak Room. They, apparently, may easily placate him with a 'Good Morning, George'. A surprising number of the ghosts, seemingly aware that they

are now heritage attractions, are said to haunt the museum, which has never been anything other than a handsome, nineteenth-century purpose-built museum. There was even a rather half-hearted attempt to co-opt Mary Anning, the geologist (really the property of Lyme Regis), and Judge Jeffreys onto the museum's ghost board.

Despite the fact that we received very little in the way of thrills and chills, it was a very contented group of people who went their separate ways at the end of Dorchester's ghost walk. Chris's tour demonstrated that it is possible to have a ghost walk without any attempt to generate fear, and even without many 'verifiable' ghost stories. I raised the issue of the 'authenticity' of his stories with him at the end of the tour. With a knowing look he declared: 'What I usually say is: And every word is true. Well, mostly true, for a given value of true'. For which, he added, he was indebted to Terry Pratchett.[19] In what ways then were we, as ghost walkers, satisfied with the Dorchester walk? What were we expecting? What did we receive that made us feel that we'd got our money's worth?

As Chris's tour illustrated so well, we were not expecting truth so much as performance – more specifically, live performance in the context of a communal experience. As Kristine Keller points out, in an online essay that focuses on ghost tours in the United States, ghost walks are 'immersive' and the tourists are 'participants in a dramatic experience'.[20] Performance is inherent in the ghost walk and it takes place at many levels. Some of the most successful ghost tour guides, including Chris, are actors, but all are acting, whether or not this is their profession. Ghost walk guides turn up in costume and they adopt a persona. They encourage performance from the walkers themselves, making use of audience participation techniques within their storytelling. On the Bath tour, a young woman is chosen to stand on the same spot that the ill-fated Fanny Braddock used to stand, waiting for her love to return, and where she stood last before taking her own life. On the Exeter tour, I am the one to end up standing on the well cover under which, many feet down, lie the skeletons of two mediaeval illicit lovers. Sometimes, as is the case with the Bath walk, a guide encourages a whole group to interact with the environment – and with each other. As ghost walkers, we expect performance by guides, we expect the town itself to perform, and we understand that we must perform too as walkers. Following a bizarrely dressed actor, processing through streets, walkers are participants in a vast open-air, site-specific, immersive performance.

Conclusions

The Bath, Exeter, Weymouth and Dorchester tours illustrate the sheer variety that characterizes the ghost walk in contemporary England. Some of the walks were comic, some more, some less, scary. Some paraded round and about magnificent heritage sites, some gravitated towards carparks. One of the guides told us about poltergeists in his house, whilst another declared his lack of belief in the supernatural. Although I limited my examples to a certain geographical area – the South West – I am pretty confident that I would have found as varied and eclectic a mix of ghost tours in other regions. The ghost walk is not a one-size-fits-all phenomenon, but a flourishing form, characterized by ingenuity, inventiveness and wit.

The study of ghost walks gives an opportunity to consider the range of ghosts said to be flitting about our towns and cities today. On these four tours, there was an impressive variety: ghosts, harbingers and poltergeists; ghosts that were both named and unnamed; eighteenth- and nineteenth-century ghosts in plenty, but also ghosts from the Civil War period, the Middle Ages and even pre-historic times. There were multiple examples of what Owen Davies calls 'heritage hauntings'[21] – the kind of ghost such as the Roman legionnaire, which, as Davies points out, was virtually unknown before the twentieth century, and is indebted to 'the advent of compulsory mass education in the second half of the nineteenth century'.[22] Many of the ghosts belong to Davies' 'silent memorial' category.[23] There were, by contrast, very few examples of what Davies has called the traditional or 'purposeful'[24] ghost[s], who points out murderers, or gestures to buried treasure. The few examples included Exeter's two Roman soldiers who appear at a site where archaeologists subsequently discovered gold and silver coins, and, arguably a contemporary variant, the ghosts who get angry about unsympathetic home improvement or the destruction of houses. It was only in Dorchester, in the haunted pool, that there was an example of the kind of West Country 'folk ghosts' identified by Theo Brown, that 'betake themselves to or are laid in pools or marshes'.[25]

The 'Geography of Haunting', to use Owen Davies's phrase, on these ghost walks was instructive. These ghosts took up their residence in carparks, riversides, suburban streets, pubs, museums, high-street shops, parkland, hotels. Such traditional areas as graveyards, disused houses, or crossroads, hardly featured – except on the Dorchester walk, where we visited both the riverside and the old (now transformed) churchyard. Significantly though, this was the least scary walk, a fact that is

indicative perhaps of the lack of power of more traditional ghost stories to scare us now.

Creators of ghost walks draw on a variety of sources. Some of these are contemporary oral sources – research from family, friends, neighbours and hearsay. The ghost walk, however, as a phenomenon owes at least as much to the written word. Ghost walk creators read and research in libraries. Significantly, they also feed such material back into the folkloric loop. Stories that may have come from research into arcane written sources (nineteenth-century books of regional ghosts, for example, or formerly long-forgotten books of folklore) are told orally, and pass into contemporary word-of-mouth circulation. Perhaps one of the most interesting points to be made is the extent to which so many of the tales told by ghost guides take their bearing from literary modes, in particular following the now-classic patterns of the M. R. James ghost story. There is, I think, a strong case to be made that the patterns of the Jamesian ghost story have become those of modern folklore. This is perhaps linked to the fact that James' stories themselves are characterized by a strong sense of place, and often make a feature of supposed local folklore. They are also cemented in the popular consciousness by the BBC's 'Ghost Story for Christmas' adaptations.[26]

A ghost walk is no mere assemblage of all the ghost stories that are associated with a place (whether pre-existing or invented for the walk itself). It is a sculpted and crafted phenomenon, not merely a walk plus stories, but a journey that creates a narrative in its own right. As I have been arguing through the chapter, ghost walks have much to tell us about the places where they are performed, and they do this through a variety of means. The kinds of ghosts said to haunt a town tell us about a place, as do revelations of what annoys them, what assuages them and *how* they are talked about (what oral or literary modes are suitable for discussing them). A clever, well-constructed ghost walk will convey something not only about that town but may well act as a contribution to a town's sense of identity, or indeed its aspirational qualities. The meta-narrative of the ghost walk is that of the town itself.

The ghost walk provides an interesting and provocative way of mediating history and expressing the anachronism that is the modern English town. It is no accident that the period in which the ghost walk came into existence is the period that saw a massive rise in interest in local history. The ghost walk is both a mediation and a meditation. It reflects on change and transformation, and offers a way of thinking about a locale as something multiple and palimpsestic. In recounting the examples of the Weymouth and Exeter walks, I emphasized the

sense of loss. In many cases, however, I think it is possible to see the ghost walk as resisting and countering a sense of loss. Though it seems a strange claim to make, ghost walks are a form of celebration of the places in which they operate.

There is a sense in which the ghost walk performs similar cultural work to the explorations of the psychogeographer. Both are staged in relation to the messy temporalities of the modern city/town, and the tropes they have recourse to are sometimes strikingly similar. Both rehearse the sense of absent presence and both may flourish in the least promising locales. In the ghost walk and the psychogeographical walk, the question of change and its relation to the living fabric of the town predominates – perhaps more so in the ghost walk. I don't want to suggest that the ghost walk is best viewed as a kind of middlebrow alternative to psychogeography. Rather it is a skilled and popular performance mode, an immersive, site-specific theatre of the streets. It is proof that storytelling as a popular form (as opposed to a genre revived within specific educational contexts or cultural subgroups) is still very much alive and kicking in modern England. The ghost walk is also a crucible for modern folklore.

In comparison with some of the international examples cited at the very beginning of this chapter, which were clearly pitched at tourists, many of the examples I have been considering here, were not primarily directed towards tourists. Indeed, on some of the tours I was surprised by how few tourists there were. On my way to the King's Arms, for the Dorchester walk, I tried to anticipate the company I would be in. I expected to join a crowd of early holidaymakers; the kind not dependent on the school calendar (the summer holidays were still a few weeks away). I was expecting some Midlanders, some Northerners, perhaps even a few European or American visitors. I was to be surprised. Only one person in the group was not from Dorchester or the surrounding area (he was from the North East). The rest of us all lived in the vicinity. This proved to be true not only of the Dorchester walk. The Weymouth walk also contained a large proportion of local people, though there were a few more holidaymakers in the mix there. On the Exeter tour there was a substantial proportion of tourists, national and international, though again also many local people. When I asked the guide of the Bath walk about the kinds of people he tended to have on the tour, he said that they were predominantly tourists, but could include hen parties, children's parties and, students at the beginning or end of their degree courses. I do not intend to give any statistical evidence as to the composition of the groups (that is a task that would be far better done

by people in the field of Tourism Studies, and doesn't really serve my needs here), the point I want to make is that a surprisingly large number of us on all these walks were not there to investigate a new place, as to explore one we knew.

In David Lodge's novel *Paradise News* (1991), the dodgy tourist studies lecturer, on an expenses-paid trip to Hawaii, expounds the concept of the 'sightseeing tour as secular pilgrimage'.[27] I don't want to play into parody myself, but I think that there is a case for the ghost walk to be considered as a ritual form. It is a profoundly communal event, and profoundly oral – I felt that I needed to be very discreet when taking notes. People attend in peer groups, most often with family and friends. On the Weymouth walk, Dave introduced a second figure, a local man, Ken, who pointed out, amongst other things, the now-destroyed school he had attended as a boy, and some graffiti engraved by his father. In the ghost walk, sometimes the storytelling merges seamlessly with learning about ancestor-heritage. Thinking of the ghost walk as a ritual helps to explain why it is a popular choice for students finishing degrees, or for hen or birthday parties. The ghost walk's concern with temporal liminality, with people who once were, and who are almost lost to an ongoing world, certainly chimes in well with people at turning points in their lives.

In 'Legend-tripping in spooky spaces: ghost tourism and infrastructures of enchantment', Julian Holloway notes that in the ghost walk, 'an awareness of contingent and provisional meaning allows enchantment to flourish in modernity: one is entertained and thrilled through being given a chance to wonder and revel in a mixture of indeterminate meaning and possibility.'[28] There are many kinds of enchantment to be had on the ghost walk. The ghost walk is a performative act in which other versions of the town are conjured into being. We are walking as people might have used to walk, and trying to see what people might have seen. The ghost walk tells us about people and places, but it also encourages an openness and a perceptual shift. It is a journey through place that seeks to stimulate contact with the past. We are asked to participate by means of our imaginations. The ghost walk makes us more aware of the streets and buildings around us, but also asks us to see them in another way, to see through them, and ultimately to see more than them.

Place and fiction become wedded in the ghost walk. Constantly we are made to feel that we are within a story, but it is a story that might transgress the boundaries of its telling, and walkers start to read the possibilities of their surrounding with new eyes. On the Bath walk,

standing with the Royal Crescent in front of us, some of the girls start to giggle with relief when they realize the approaching presence is merely a dog. Even on Dave Allan's defiantly non-believing walk, on a lovely, sunny evening in a resolutely mundane 1940s street, we all start at a sudden bark.

Ghost walks do not just draw our attention to the past, but they revive some of the forms of pedestrianism of the past. The ghost walk is experienced as a kind of archaic form. For most of us, walking quietly, in a large group, behind a quaintly dressed person is not a usual occurrence. For some, it is reminiscent of religious processions. The ghost walk, I suggest, can be seen in terms of the ritual of 'Beating the Bounds', which derives from Anglo-Saxon times. Beating the Bounds involved a group of boys walking behind a priest, and other church officials, along the boundaries of a parish. The boys would beat the boundary stones with green boughs – though, in some cases, it was the boys' heads that were bashed against the stones. The practice was devised to ensure that knowledge of the bounds of the parish continued into the next generation. It had a religious dimension, and was an occasion for feasting. The ritual of the ghost walk does not demonstrate, and reinscribe, the physical boundaries of a parish, neither does it have a religious dimension (though it is sometimes an occasion for feasting). It is, however, a communal, celebratory act, that asserts an act of imaginative possession, and imposes on the place where it is performed, a complex, multi-temporal identity.

5
Becoming a Haunted Castle: Literature, Tourism and Folklore at Berry Pomeroy

> What a luxury thus to muse away a not unprofitable hour, among such Scenes of grandeur, solemnity, and solitude! longer much longer could I have sat, and indulg'd the penseroso sensations amid these charming Ruins had the time permitted – but I had eight miles to ride – I had seen the Evening star arise.
>
> The Reverend John Swete, writing of his visit to Berry Pomeroy Castle in his *Devon Tour* of 1793[1]

> As a child I used to have nightmares about an unknown castle and this remained unidentified for 40 years. And then one day I visited Berry Pomeroy in South Devon. I don't believe in reincarnation and therefore can't explain why this place is so familiar and so horrible to me.
>
> Robert Graves, 15 July 1953, introducing his poem 'The Devil at Berry Pomeroy'.[2]

Berry Pomeroy Castle, in South Devon, has been a ruin since the early eighteenth century, and a tourist destination for over 200 years. Coming upon it is always a surprise. It is, as the English Heritage website states: 'Tucked away in a deep wooded valley'.[3] The main approach winds through woodland that suddenly opens into level and cleared ground where the castle sits. Before you are the gatehouse and the curtain wall. Within the walls are the remains of its towers (in varying degrees of preservation), the shell of a Tudor mansion, and (only relatively recently revealed) the remains of a colonnaded loggia, dating

from around the year 1600. The back wall overlooks a steep bluff along the bottom of which runs the Gatcombe brook.

One hundred and sixty years separate the two, very different, reactions to Berry Pomeroy Castle given at the beginning of this chapter. For the Reverend John Swete writing in 1793, Berry Pomeroy Castle is 'charming'. Whilst there he almost forgets time, until reminded of the necessity to continue his journey by the rising of the 'Evening star'. Swete's experience is mirrored by other travellers of his day. William George Maton, travelling in 'Dorsetshire Devonshire and Cornwall' in 1794 with the Reverend J. Rackett (who sketched and painted the sites they visited), declares in his journal that Berry Pomeroy 'afforded us more delight than anything of a similar nature we had seen in the course of our journey'.[4] Like Swete's, Maton's experience of the castle is phrased in terms that suggest it almost – but not quite – removes him from mundane time and tourist business: 'We were lavish of our time in contemplating the beauty of Berry Pomeroy Castle and were so amused that we had almost forgotten the object of this day's journey was Torquay.'[5]

By contrast, for Robert Graves speaking in the 1950s, the castle is a site of the uncanny – both 'horrible' and 'familiar'. It is haunted and hag-ridden, a scene of witchery and monstrosity. The words quoted above preface his reading of his poem 'The Devil at Berry Pomeroy', the 42 lines of which are dense with menacing supernatural figures – imps, the devil, ghosts, hags, a weeping lady. Graves depicts the castle as a place of sexual menace and perversity, making reference to incest, rape and a woman leading an ape by a string. The only part of Graves' response that corresponds to Swete's and Maton's is that he finds himself, when at Berry Pomeroy, outside mundane time. In this case, however, it is because Berry Pomeroy is a kind of evil archetype, untied from linear time, which has been occupying his nightmares before he has ever visited the place.

By the late twentieth century, Berry Pomeroy Castle had a fearsome reputation. A picture of its Tudor portion and ruined north-east tower standing gauntly against the twilight is on the cover of Keith Poole's *Britain's Haunted Heritage* (1988). Poole, referring to himself in the third person, writes of an atmosphere so terrible as to repel the would-be visitor: 'So strong are these impressions that he has twice found himself unable to cross through the gatehouse.'[6] In March 2003, Berry Pomeroy Castle featured on the British television programme *Most Haunted*. A quick Internet search for Berry Pomeroy Castle will reveal not just English Heritage, Wikipedia and South Devon tourism web pages but a succession of sites with 'haunted', 'haunting', 'ghosts' and 'mysterious' in their titles.[7] YouTube has innumerable videos related to Berry

Pomeroy Castle: most of them concerned with the paranormal. In *The Ghosts of Berry Pomeroy Castle* (1990), Deryck Seymour describes some of the 'evil forces which from time to time make themselves felt at Berry':

> There is the feeling of unreasonable fear, that sudden physical disability, the going back in time, shadows and aromas – none of these can be dismissed as mere impressions on the atmosphere. They are phenomena far more unpleasant which can impress themselves on receptive individuals at any moment in time and completely upset their mental poise. The usual result with such visitors is that they leave the castle as quickly as possible, resolving never to go there again.[8]

How do we square these very different responses to Berry Pomeroy Castle? Is it possible to reconcile such shrill insistence on its evil and menacing atmosphere with the 'delight' of Maton and Swete, and their sense that its ambiance (or 'local circumstances' in Swete's terminology) is entirely felicitous?

In this chapter, I want to chart some of the reactions to and representations of Berry Pomeroy Castle over the last 230 years. I will be looking at changing patterns of tourism, and the changing image of the castle from the 1780s onwards. I will be taking my cues from travel writing, guidebooks, photographs and the numerous eighteenth- and nineteenth-century prints of the castle, as well as considering some of the substantial body of fiction and poetry inspired by Berry Pomeroy Castle. En route, I will be thinking about some of the processes by which it acquired a reputation as one of the (innumerable) 'most haunted' castles in England.

In a later chapter, I will return to Berry Pomeroy Castle to examine the vexed problem of what happens when ghost tourism and heritage management collide.

Berry Pomeroy and the picturesque tourist

Swete found Berry Pomeroy Castle conducive to delightful meditation, a suitable spot for musing on fallen grandeur (see Figure 5.1). Paying compliment to the classical concept of the *genius loci*, he writes: 'if local circumstances have any influence in the leading the mind to contemplation No spot could be better adapted to the exciting such impressions, than that on which I now stood'.[9] Swete's language in describing Berry Pomeroy shows an interesting breadth of response. As a gentleman and scholar, he, of course, draws on classical literature. He quotes from Virgil's first and second Eclogues, and twice (appropriately, considering that many eighteenth-century writers assumed that

Figure 5.1 The Reverend John Swete 'North East View of Berry Castle', in *Sketches in Devon* 1788. Ref. Z.19/2-12. ('Than this scene nothing can well be more picturesque!'). Reproduced with the kind permission of Devon Heritage Services

Berry Pomeroy was ruined during the Civil War) from Lucan's *Civil War*. 'Every thing around me wore the face of desolation "etiam periere ruinae"' writes Swete[10] ('even the ruins are ruined' or 'even the ruins themselves have collapsed').[11] The classical register infects his own style at this point for it abounds in gerunds – 'the leading' 'the exciting', etc. His sense of the literature appropriate to the place also includes Milton (the reference to 'penseroso') and, with that conjunction of musing and the word 'unprofitable', Shakespeare.

According to Swete: 'there are few places more grand or venerable, or that more deserve the Travellers attention.'[12] A visit to Berry Pomeroy was to become a must for the late eighteenth-century tourist of Devon in the know. It was acknowledged to be beautifully situated; Swete comments on the castle 'rising in high magnificence from the rich bosom of the encircling woods'.[13] More than this, Berry Pomeroy was found to conform exquisitely to the picturesque aesthetic. 'Than this scene nothing can well be more picturesque!'[14] declared Swete of the north east perspective on a visit in 1788, which is doubtless one of the reasons

why he returned five years later. The 1788 visit produced four watercolours and the 1793 visit a further two.[15] Swete was amongst the first to consider Berry Pomeroy in relation to the picturesque, but he was to be followed by many others. Maton, in the published version of his travels, declares that the remains are 'so finely overhung with the branches of trees and shrubs that grow close to the walls, so beautifully mantled with ivy, and so richly incrusted with moss, that they constitute the most picturesque objects that can be imagined.'[16] In a text of 1800, turning off to Berry Pomeroy, despite the threat of rain, the Reverend Richard Warner of Bath notes: 'The spot, indeed, was worth the risk of a soaking, being a more picturesque ruin than any I have yet seen.'[17]

So picturesque did Warner find Berry Pomeroy, that an image of it is chosen as the frontispiece for his *Walk through some of the Western Counties of England* (1800). (In order to gain some sense of the significance of this choice, it is worth noting that the frontispiece for Warner's *A Walk through Wales, in August 1797* (1798) is an image of Tintern Abbey.) Warner gives a thorough account of Berry Pomeroy's picturesque credentials. He describes it from the characteristic low viewpoint, and presents it as only half visible – parts are hidden, only to be revealed by an 'occasional peep':

> Nothing can· be more romantick or sequestered than these ruins, which stand on the summit of a bold rising ground, surrounded by distant elevations of still greater height. The deep gloom of venerable woods spreads itself over hill and dale on every side, concealing these solemn remains from the common eye, and reserving them for the investigation of curiosity, and the contemplation of taste. ... A rich vest of ivy spreads itself over [the double gate]; lofty trees conceal the broad faces of the walls, and only permit an occasional peep at the broken turrets, and dismantled windows; and various shrubs, artlessly scattered by the hand of Nature over the interior area, and around the Gothick entrance, complete the magical beauty of the scene.[18]

Warner notes the interplay of the human artefact and nature, and displays a keen appreciation of the beauties resulting from the ageing process. In fact, Berry Pomeroy was a relatively recent ruin. Despite the surmises of eighteenth-century historians, it had been neither destroyed by fire following a lightning strike, nor ruined in the Civil War period. Rather, it had, at the turn of the eighteenth century, been deliberately stripped by its owner, and its fabric used for salvage, before it had even been finished; earlier building plans had been too ambitious and money wasn't forthcoming. Much was still standing, however, and these

remains were not obscured and rendered dangerous by vegetation, as they were to be 50 years later, but picturesquely adorned. Berry Pomeroy Castle had, rather felicitously, become picturesque as the picturesque aesthetic was invented.

Such is the association of Berry Pomeroy with tranquillity and meditation, that the discrepancy between the Gothic narrative and the castle's reputation is one of the first issues to be resolved in the novel *The Castle of Berry Pomeroy* (1806), the first of many works of literature to be inspired by the castle. The writer could almost be replying to Swete when writing:

> Strange and horrible it is to tell, that this place, so fitted to calm contending passions, and convey a soothing serenity to the mind, should have been the spot where foul murder, hatred and envy, deceit, and every base passion of the mind, instigated by the fell demons of darkness, held their dread abode.[19]

The Gothic narrative, the writer makes clear, is highly unsuitable for the place it describes. On the previous page, the reader had been told that: 'The bountiful hand of nature has adorned this spot with all that can please the sight, and animate the mind to the adoration of Him under whose masterly direction the creation rose.'[20] It is perhaps because of the grotesque incongruity between the picturesque locale and the Gothic narrative, that the writer feels the need to superimpose Greek furies onto the Devon landscape, who 'lash' with serpents 'the shrieking shade of the Lady Elinor, and then lay her beside the murdered Sir Ethelred, on sharp quick-piercing brambles.'[21]

As Michael Pidgley notes, 'Berry Pomeroy Castle was among the most illustrated of all Devon's picturesque sites'.[22] The sheer number of prints made of Berry Pomeroy is testimony to its enduring popularity. The kind of picturesque, however, modulated with the times. Many of the images of the late eighteenth century focus on the umbrageous aspect of the castle.[23] Those from the first decades of the nineteenth century infuse the picturesque with a dose of the sublime: the view point is usually further away so that surrounding rocks and the river are drawn into the picture.[24] Many of these later images exaggerate the proportions, so that the close woodland and the small, rolling hills of the South Hams resemble the grand landscapes of the Scottish highlands. In images of the 1840s in particular, Berry Pomeroy Castle itself becomes impossibly large, a Scott-influenced castle in the manner of the chivalric sublime.[25]

As the eighteenth century gave way to the nineteenth, Berry Pomeroy occupied an important place within a well-organized local tourist economy. It is in this period that we see the first guidebooks produced, as the South Devon coast became a popular destination for those who wished to visit watering places. These visitors were in search of mild climates, bracing air, beautiful scenes and stimulating waters; they demanded convenient facilities and they also wanted amusement. As well appreciating the new and the novel (contemporary guides are full of choice examples of fashionable contemporary architecture in the newly developed seaside towns) these tourists also had an interest in the picturesque and the ancient. Berry Pomeroy Castle, being inland, picturesque and of historical interest, provided a welcome contrast from the pleasures of sea bathing, and was an almost inevitable inclusion in guidebooks of the period. The *Guide to the Watering Places between the Exe and the Dart including Teignmouth, Dawlish and Torquay* of 1817, for example, features Berry Pomeroy Castle under the 'Rides' section for Torquay, describing it as a 'romantic ruin',[26] and tells readers that 'the spectator is riveted to the spot by the grandeur of its appearance.'[27] Berry Pomeroy holds its own after the coming of the railway to the area (in the late 1840s). Its attractions are still enumerated as those of the picturesque (indeed many of the guidebooks shamelessly plagiarize descriptions of the castle that had been published half a century earlier).[28] Murray's *Handbook for Devon and Cornwall* (1851) suggests visiting Berry Pomeroy on day 3 of a fortnight's tour that starts from Exeter, or on day 18 of 'A three weeks tour in South Devon'. Black's *Guide* of 1862 recommends it as part of Route VIII (Plymouth to Exeter by South Devon Railway)[29] and includes it in the 'Hints for Rambles' from Torquay.[30] It was a well-known destination for picnics; as Worth's *Tourist's Guide to South Devon* (1878) notes, a 'small gratuity has to be paid to the keeper, who will make provision for picnic parties.'[31] *Bentley's Miscellany* of 1867, features an account of one such picnic. The writer (who is making a seven weeks' tour in Devon, Cornwall and the Scillies) goes to the castle '[u]nder the pleasant guidance of an intelligent Sunday-school maiden'[32] who gives a 'lively account of a school treat that had taken place amid these ruins in the previous summer. Tea and cakes had been taken, and the water, obtained at the lodge, had been made to boil over a fire of wood collected by the happy children'.[33]

Swete admitted that the 'inner view [of the castle] was not to be compared to that without – either in magnificence or picturesque appearance' but, he added, it was 'not without its peculiar beauties'.[34] Although the more strictly picturesque views of the castle were those of the outside, Swete himself (and a number of other artists) also showed

Figure 5.2 The Reverend John Swete 'Inside of the Gateway at Berry Castle' in *Devon Tour* 1793. Ref. 564M/F5. Reproduced with the kind permission of Devon Heritage Services

figures inside the castle. I would argue that these images act as testimony to the experience of Berry Pomeroy as a soft, rather than *schauer* (horror) Romantic locale. Swete's image, with its range of soft greens, is particularly cosy (see Figure 5.2). The horse is grazing, the inevitable figure, included to give an idea of size (not very lofty, as we can see), is leaning casually. There is no attempt to provide the winding path that teases the viewer's sight out beyond the confines of the picture, so beloved in picturesque images. Instead, there is a sense of containment and contentment. The same sense of a sheltered locale is present in Stockdale and Storer's print of 1823 (see Figure 5.3), which shows a typical picturesque ruin (not particularly identifiable as Berry Pomeroy), with ecclesiastical looking arches and feathery trees growing inside, being visited by a man, a woman and a child. Berry Pomeroy in this image is pictured as suitable for family tourism. A lithograph from 1840, 'In the Guard Room' (by W. Gauci after C. F. Williams), shows a man on a night-time visit, dreaming by the light of the moon, in the gatehouse (see Figure 5.4). The diminutive figure (if considered in terms of the actual dimensions of the place) is lost in peaceful reverie stimulated by the soft sheen of

Drawn for the Port Folio by J.W.L. Stockdale, & Eng.ᵈ by J. & H.S.Storer.

Pub.ᵈ by Sherwood & Cᵒ Sep.ᵗ 1.1823.

BERRY POMEROY CASTLE.
(Devonshire.)

Figure 5.3 J. W. L. Stockdale 'Berry Pomeroy Castle' 1823, engraved by Storer. Ref. SC0130. Reproduced with the kind permission of Devon Heritage Services

Figure 5.4 'In the guard room, Berry Pomeroy Castle', c. 1840, lithograph engraved by W. Gauci after C. F. Williams. Ref. SC0139. Reproduced with the kind permission of Devon Heritage Services

Figure 5.5 Mid-nineteenth-century note paper from Torquay hotel. Ref. 2078 M/2 1–4. Reproduced with the kind permission of Devon Heritage Services

the moon playing around the romantic ruins. This is the same spot that Keith Poole, in the late twentieth century, finds himself incapable of crossing, so strong are the ghostly forces there. The extent and manner of Berry Pomeroy's commodification for the tourist industry are perhaps best illustrated by Figure 5.5, which dates from the mid-century. It is a sheet of note paper from a local hotel, surmounted by a vignette of the castle pictured as a stately, benign-looking ivy-clad ruin.[35]

'Not a relic of the dead past': Berry Pomeroy castle in literature

For a castle tucked away in South Devon woodland, Berry Pomeroy has given rise to more than its fair share of literature. There is a rich vein of work dedicated to the castle. As well as the Gothic novel of 1806, *The Castle of Berry Pomeroy*, and Anna Bray's three volume *Henry de Pomeroy; or, the Eve of St. John, a legend of Cornwall and Devon* (1842), there is Luke M. Combes' *Berry Pomeroy: A Poem* (1872), Frederick J. Whishaw's *A Secret of Berry Pomeroy* (1902), Elizabeth Goudge's *The Castle on the Hill* (1942), Robert Graves' short poem 'The Devil at Berry Pomeroy' and, most recently, a collection of contemporary short stories and poems edited by Bob Mann, *A Most Haunting Castle: Writings from the Ruins at Berry Pomeroy* (2012). Some of these texts are unexpectedly eloquent on the subject of tourist practice at the site, and all of them are interesting to the reader who wants to investigate not only Berry Pomeroy Castle, but the development of the idea of 'the castle' more generally.

Anna Bray's three-decker *Henry de Pomeroy* (1842) is a Scott-inspired historical novel based in the West Country. The West Country novel was Bray's speciality, and her work had some popularity.[36] It starts with an introduction that features Bray and her companion as modern-day tourists of the ruined castle. Fifty years after Swete and Maton enjoyed its delights, the castle was considerably more overgrown. In the 'Preliminary Observations', Bray tells us that the remains are 'so encumbered with brambles and trees, that in many places you can see nothing else'.[37] Not only had the ruin changed, but so had the 'visitor experience'. The eighteenth-century tourists arrived and mused alone but the mid-nineteenth-century visitors, in this case Bray and her companion, are taken round the castle by a guide, a 'nice little girl' who accompanies them 'from a cottage near the entrance of the wood, with the keys of the castle'.[38] The novel proper starts '[a]bout the latter part of the twelfth century',[39] at the time of the strife between

Richard I and his brother John, in which the Pomeroys played a part. Like Scott's work, Bray's is leisurely: 192 pages pass before Henry de Pomeroy enters, and the heroine doesn't make an entrance until the second volume. Bray also shares Scott's prolixity. The novel's medieval set pieces – monastery meals, a procession, the attempted wooing of a rosy-cheeked miller's daughter by a corrupt cleric, the quaint conversations between Patch the fool and jovial well-fed monks – are couched amidst pages of historical explanation, mostly descriptions of dress, pageantry and customs. Its action combines Henry's rebellion with a doomed romance and an inheritance plot, and it is couched within the knotty questions of the Saxon versus Norman question (it has a noble young stripling named Caedmon whose inheritance has been wrested from his family as a result of the Norman Conquest), medieval anti-semitism and the power of the medieval church.

In Bray's novel, not only the appearance, but the *idea* of the castle has noticeably changed. For many in the late eighteenth century, the image of the castle instantly set off ideas of feudal tyranny. Maton suggests that at Berry Pomeroy: 'When he [the spectator] perceives frowning turrets however, massy walls, and gloomy dungeons, his imagination will be wholly at variance with the beauty and serenity of the spot, and he will think only of sieges, chains, torture and death'.[40] Likewise, in the Gothic novel *The Castle of Berry Pomeroy*, the castle is an embodiment of feudal tyranny, its layout the topography of injustice that has no recourse in law. In Bray's novel however, the associations of the castle are rather different: Berry Pomeroy is pictured through a lens provided by Scott. It is the romanticized site of misplaced chivalry and, rather than suggesting bodily torture, it is possessed of an atmosphere of spiritual beauty.

As Black's *Guide* to the area puts it, describing the attractions of Route VII 'Plymouth to Exeter by South Devon Railway' 20 years later: 'There is always a picturesqueness about the Past.'[41] What is perhaps remarkable is the switch that has occurred in the relation between the picturesque and history. Instead of age potentially conferring picturesqueness on a building, the past itself is seen through the lens of the picturesque. Apart from its appearance in the introduction, Berry Pomeroy Castle is depicted only in the final chapters of *Henry de Pomeroy*, and when it appears it is presented as a place of contemplation and meditation:

> altogether, its profound silence, its solitude, and gloom seemed to the eye of a stranger more suited to the contemplative spirit of the monks, than to the fierce, stirring, and warlike character of those who were now the inhabitants of its walls.[42]

In the midst of this stillness, a ghostly horn blows and the family's harbinger of doom – the ghost of the family's Norman founder Sir Ralph de Pomeroy, with hawk and silver spurs – makes an entrance before his beleaguered descendant, Sir Henry. The novel then enters a moonlit phase, reminiscent of the moon radiance in the Gauci lithograph 'In the Guard Room'.[43]

> No lamp was there burning; but the moon, for it was a most beautiful moonlight, fell in mild and cold radiance through the long, narrow, and shafted windows of the apartment ...

> The moon was high in the heavens; only a few fleecy clouds, edged and touched with her silvery light, floated above the woods, now partially illumined by her beams, whilst the surrounding shadows were softened and mellowed into harmony. The little river brawled along the woods at the foot of the precipice on the eastern side of the castle: it was now gleaming with the radiance of the moonlight that trembled on the long line of its musical and flowing waters. The towers of Berry Pomeroy stood erect on the summit of the hill, in the solemnity of silence and of night.[44]

The appearance of the family ghost initiates the moment in which Bray imaginatively rebuilds Berry Pomeroy. Bray's description does not merely summon up a picturesque image, it also conveys a moment of hypostatization. The castle is more than castle, more than stage set, and becomes an exquisite figure of the loveliness of the past. Berry Pomeroy Castle, which is presented in a ruined state in the novel's introduction, is resurrected in a moment that is not particularly dramatic, and certainly not meant to induce fear, but is possessed of a still perfection. The text creates a parallel between the ghost and the building. Both castle and ghost are emblematic; both are buried deep in time; both possess a hypnotic, entrancing power; both are associated with stillness, illumination and brightness and, finally, death.

If Bray's Berry Pomeroy is 'a spiritualized version' of the castle of feudal tyranny at the centre of the Gothic novel, Elizabeth Goudge's novel of 1942 presents a castle that is both spiritualized and a symbol of hope for a Britain under attack. Goudge's *The Castle on the Hill* opens during the London Blitz, but very quickly the characters that start off in London find themselves in Torbay – and at Berry Pomeroy Castle. They include evacuees, a Jewish refugee, and others, of different ages and classes, who are struggling not only to survive, but also to come to terms with the devastation of the old world, and to make sense of

the new world that is emerging. At the beginning of the text, somewhat startlingly, Berry Pomeroy is not in ruins. The castle is supposed to have been partially destroyed in the Civil War period, but rebuilt in the late eighteenth century, courtesy of the revival of the family fortunes in the service of the East India Company. The restored castle, as described by Goudge, tallies with the visible remains of the castle in the 1940s. '"A Tudor manor house is built within the Norman walls," said Mr Birley ... "It is a strange and very lovely combination."'[45] Whereas the castles of the Gothic novel and of Bray's novel were dead, their life only to be sampled by a journey of the imagination, Berry Pomeroy, in Goudge's text, is not only 'still lived in' but 'still alive, not a relic of the dead past but a vital part of the living present.'[46] It is almost numinous ('Its walls, above the vivid green of the grass, glowed in the sun with a warmth that seemed to strike outward from within, as though the heart of the place still burned with valorous fire')[47] and possessed of a beauty and spirit that occasions an allusion to Keats's 'Ode on a Grecian Urn': 'Its beauty banished time and teased one out of thought.'[48]

Throughout Goudge's novel, Berry Pomeroy Castle is called only 'the Castle', though the name of the village 'Applegarth' alludes to the etymology of 'Pomeroy'. As the castle, it stands for a version of traditional England:

> The Norman walls, the Tudor house, the brilliant little formal garden, the wide view across acres of glorious woodlands, made a whole so perfect that one was not conscious of the many centuries that had gone to the making of it.[49]

Goudge's Berry Pomeroy is a long way from the castle of the Gothic novel. In the century and a half that have passed, the idea of the castle has come to stand for an image of England itself: a country with a past that does not so much stand in sharp antithesis to the present (as it does in the other two novels), as form a vital component of the country's present identity. In Goudge's novel, 'The Castle' (always with a capital 'C') comes to stand for a country with a varied and turbulent past that has been resolved (the Tudor house occupies the Norman walls), whose culture and cultural expressions sit happily within the national landscape. In Goudge's description, landscape and architecture are one: 'a whole so perfect'. This interpretation of the castle, as an image of England – its traditions, history and people – threatened with destruction, is foregrounded within the text itself. The elderly Mr Birley, uncle to the two

young Birleys, and a historian himself, introduces Miss Brown to the castle, and in so doing, delivers a long narrative that relates its building and rebuilding to his own family history and to national history. He finishes bleakly with:

> For every family, for every nation, for every civilization, there must come, at last, the end.

> 'Please God not yet,' said Miss Brown, for once managing to say what she wanted to say with surprising fluency. 'Not yet for England, and not yet for this heavenly place. England, now, is like this place. A castle set on a hill for all the world to watch.'[50]

Goudge's vision of the castle is a long way from that pervading the most recent fictional production associated with Berry Pomeroy Castle – the collection of short stories and poems edited by Bob Mann: *A Most Haunting Castle: Writings from the Ruins at Berry Pomeroy*. As the title indicates, its focus is very different from those of previous texts. Instead of the concerns that characterized the earlier literary productions – the question of England, the machinations of monks, the nature of chivalry, anti-semitism[51] – the dominant emphasis in the most recent work is on malevolent ghosts stalking the present with evil intent. And, in contrast to the unobtrusive (and predominantly male) spectres of the nineteenth-century novels, those in the most recent volume are predominantly, though not exclusively, female, and, as in Robert Graves' poem, sexually predatory, a danger not just to Pomeroys but to the casual visitor. In the poems and short stories of Bob Mann's collection, men are seduced by White and Blue Ladies who want to lead them to their doom off castle walls, whilst women tend to identify with the female ghosts (though one is lured to death by the ghost of a knight). These are identifiably the ghosts that have dominated the folklore of the castle in the twentieth century.

The ghosts

Who are the main named ghosts of Berry Pomeroy Castle? S. M. Ellis, in *The Ghosts and Legends of Berry Pomeroy Castle* (mid-twentieth century; undated) tells of a woman who has smothered her illegitimate child, a girl who is slain because of her relationship with a boy of a feuding family, and the White Lady, Berry Pomeroy's most celebrated spectre. The story runs that the White Lady is Lady Margaret, a Norman

noblewoman, imprisoned in a dungeon by her sister, because of rivalry over a suitor. Her appearances have been frequent and alarming: she is dressed in white, and has been seen carrying her head under her arm. By the time Deryck Seymour's *The Ghosts of Berry Pomeroy Castle* appeared in 1990, the ghosts had proliferated. As Seymour himself notes: the 'intriguing variety' of supernatural phenomena to be experienced at the castle 'is nothing short of amazing.'[52] Seymour tells of sightings of the Bloody Hound, a cavalier, the ghost of an old man, and a child Isabelle who is murdered whilst seeing her mother gang-raped. He gives more detail about the child smotherer: she is the 'Blue Lady' 'the daughter of a former baron of Berry Pomeroy, who had borne a child to her own father and strangled it in the room above'.[53]

Those who have sought for historical testimony of the named female ghosts have been disappointed. There is no record of a Lady Margaret, sister of a Lady Elinor. Not only that, but, when English Heritage undertook extensive excavations in the early 1980s, it was found that, despite the Norman name, Berry Pomeroy Castle was not a Norman castle at all; the earliest finds dated from the second half of the fifteenth century. The Pomeroys (who had come over with William the Conqueror) had resided in their manor house in Berry Pomeroy village until the late fifteenth century, at which point (probably, as Charles Kightly suggests, as a result of the turmoil in the area during the Wars of the Roses)[54] they started on the construction of Berry Pomeroy Castle. As Kightly, author of the most recent English Heritage guide to the castle, notes: the '"historical explanations" given for Berry's principal spectres' are 'without foundation' and rely on 'the mistaken belief that Berry was a Norman castle occupied by generations of Pomeroys'.[55] Lady Margaret, even had she existed, would not have been living at the present site of the castle and besides, as Kightly points out, her dungeon is actually a 'late medieval gun emplacement, lit by large gun-ports communicating directly with the castle's exterior'.[56] Norman knights could not have leapt to a suicidal death from castle walls that only came into being in the late fifteenth century. Kightly also notes the implausibility of the story of the Blue Lady, supposedly told by Sir Walter Farquhar who 'encountered her in a panelled room with a stained-glass window within the castle at some unspecified date in the late 18th century.'[57] He points out that a print of 1734 shows the castle as 'already a roofless and tree-grown ruin four years before Farquhar was born.'[58]

If not derived from the history of the castle, then where did these stories come from? Kightly suggests that Berry Pomeroy's ghosts are linked to '19th-century works of fiction written as the ruins became

increasingly popular with visitors.'[59] At first glance there seems not to be a *direct* match between the literature and the castle's present-day folkloric ghosts, rather there is a surprising mismatch. The ghosts in the Berry Pomeroy-inspired literature, up until the point of Goudge's *The Castle on the Hill*, bear very little resemblance to the ghosts that inspired *A Most Haunting Castle*. Many of these earlier texts are without ghosts. *Berry Pomeroy: A Poem* and *A Secret of Berry Pomeroy* have no ghosts, and the latter makes no secret of its explained supernatural. Although *A Secret of Berry Pomeroy* has chapters with titles like 'The Ghosts' (Chapter 4), 'More Ghosts' (Chapter 7), and 'A Noisy Ghost' (Chapter 26), the ghosts are merely excuses for illicit activities: any 'ghosts' in the text turn out to be smugglers or Jacobite sympathizers. The ghost in Bray's *Henry de Pomeroy* only appears to the family and is confined to the Middle Ages. Goudge's novel does have some apparitions, but they are far from the malevolent, seductive harbingers of death that haunt Berry Pomeroy today. In a strange passage in *The Castle on the Hill*, Moppet and Poppet, the evacuees, follow two little girls (who are familiar to the reader as their description tallies with that of two child figures on the family's seventeenth-century tomb in Applegarth church) over a snowy and timeless landscape. Moppet and Poppet play with and follow the girls, Goudge implying a paralleling of past and present character types in a way that overrides time and class, and performs a kind of cohering of past and present. Goudge here, as in some of her other novels (notably *Gentian Hill* (1949) set in the same area), provides what almost amounts to an anti-Gothic: in *The Castle on the Hill* ghosts are comforting presences from the past.

Despite the fact that the literary works feature none of the ghosts that present-day folklore assigns to Berry Pomeroy Castle, the accession of Berry Pomeroy to the 'most haunted category' is, as Kightly suggests, linked to its literary tradition and, in particular, to the early nineteenth-century novel, *The Castle of Berry Pomeroy*. In the following sections I want to add some more detail to the picture.

The Castle of Berry Pomeroy: a novel

The Castle of Berry Pomeroy was published 13 years after Swete's 1793 visit. It is a Gothic novel written in the wake of the popular Gothic novels of the 1790s, and was published by the Minerva Press in one of its characteristic cheap blue paper covers. It has a pacy, convoluted plot with a number of inset narratives and at least one character who appears under a bewildering variety of names. As the editor of the most recent edition, James D. Jenkins, points out, it 'bears signs of having

been written hastily'.[60] Jenkins notes that one of the characters changes name part way through the book.[61] Another character, narrating her past adventures, wrongly counts the number of attempts on her life.[62] *The Castle of Berry Pomeroy* abounds in heinous acts –

> Many are the dark deeds said to have been perpetrated within [the castle's] walls, as the yet blood-stained stones and flitting shades that nightly hover over their sad remains, entombed amongst the ruins, or buried without sepulchral rites, are sad mementos of.[63]

but there is a particular focus on murder and attempted murder. Sister murder, father murder, brother murder, landowner murder, love rival murder and husband murder all feature in the novel. The novel is set at an undefined point in the Middle Ages, and features various thrilling set pieces involving secret passages, gigantic iron chairs and torture. Its characters include banditti, assassins, corsairs and Moors and an evil abbot who ends up, subject to the supposed mores of the medieval church, buried alive.

Somewhat ironically, the 'ghost' which became the novel's legacy to the castle, is a classic example of the Radcliffean 'explained supernatural', that is, it is not a ghost at all. *The Castle of Berry Pomeroy* has a heroine named Matilda who is beautiful and virtuous, and who, for much of the novel, is supposed to have been murdered by her love rival, her jealous younger sister Elinor. Matilda, however, has not been murdered, but merely concealed in a dungeon, though she is allowed to wander out occasionally at night, under oath not to reveal herself. Her lover encounters her twice, dressed in white, sighing and groaning, and thinks that she is a spirit. Rather than the more static figures of Elinor, Ethelred and Abbot Bertrand, the penitent souls of the novel, introduced at the outset, emblematically writhing under brambles, it was Matilda who was to capture the popular imagination: Matilda, enclosed in a dungeon, wandering the castle dressed in white, partially glimpsed, sighing. Or rather, it was a portmanteau version of these sisters – a strange conflation of Matilda's figure and victimhood, and Elinor's jealousy, murderous intentions and overwhelming sexual desires. This portmanteau ghost eventually acquired the name that belonged to one of the castle's towers – St Margaret's Tower.[64] And she became known as the White Lady.

The theory that the White Lady derived ultimately from the novel *The Castle of Berry Pomeroy* is, as noted earlier, not a new one. Kightly suggests as much. Bob Mann too talks of the White Lady story as 'a tale

gradually evolving from many different elements',[65] which for him, are *The Castle of Berry Pomeroy*, Combes' *Berry Pomeroy: A Poem*, folk memories of the legend of St Margaret and 'genuine sightings of ghostly feminine forms'.[66] Of interest to me in the following sections, are not only the origins of the White Lady story, but the processes by which the tale took a hold, and the development of Berry Pomeroy's haunted reputation more generally.

I want to return to a problem stated at the beginning of the chapter. Swete, Maton and other eighteenth-century travellers did not experience Berry Pomeroy as a haunted ruin. Swete, visiting Berry Pomeroy, mentions no ghosts, just a pleasingly melancholy consciousness of the passing of time and the ruin of former glory. At one level, of course, Swete's lack of ghost response is easy to explain away. After all, he is in 1793, a clergyman in his forties whose interests are primarily those of an antiquarian and a searcher after the picturesque. I believe, however, that these early tourists did not present Berry Pomeroy Castle as a haunted ruin because it did not have such a reputation when they were writing and that it only acquired such a reputation many years later.

The early tourists fail to mention any ghost stories or legends attached to the castle and, as we have seen, for Swete, Maton, Warner and generations of nineteenth-century visitors the atmosphere was anything but threatening. Swete lingered into the evening; nineteenth-century prints showed visitors sightseeing at night-time; local hotels provided tours and pictured vignettes of the charming ruins on their note paper. The question is: why did visitors' sense of the atmosphere of Berry Pomeroy Castle change so dramatically? The answer is complicated, but for me two main factors stand out. The first is, very simply, the fact that the castle started to look very different. And the second relates to the fact that its new looks linked it in decisively to a cultural current, gaining in momentum in the later nineteenth century – the ghost tale.

As I stated earlier, Berry Pomeroy looked at its most picturesque just as the picturesque aesthetic came into fashion. By the mid-nineteenth century, however, the castle was significantly more overgrown. Murray's *Handbook for Devon and Cornwall* for 1851 notes that 'the whole is so embedded in ivy, and screened by wood, that little more of it can be seen than the great gateway'.[67] What was of even more importance in terms of visitors' sense of the castle's atmosphere, was that the connotations of the woodland locale had changed. Swete had displayed a keen appreciation of the woodland surroundings – 'by a narrow pathway I proceeded from hence to the castle itself passing under the canopy of

high-arching woods which diffused a thousand sweets, and afforded that "opacum figus"[68] which at the close of a sultry Summer day, is so delightfully refreshing.'[69] The woodland locale in the mid to late nineteenth century, however, set off a chain of sinister assocations. By the late nineteenth century, the castle buried deep in overgrown woodland was increasingly associated with the ghost tale.

Gothic texts had often featured castles. These predominantly were the castles of foreign lands, and, like Radcliffe's castle of Udolpho, they often rose up high, terrifying and powerful against the skyline. With the increasing naturalization of Gothic in the nineteenth century came a new type of Gothic house. The castles, country houses or stately homes of Gothic texts such as J. Sheridan Le Fanu's *Carmilla* (1872) or *Uncle Silas* (1864) or Wilkie Collins's *The Woman in White* (1859–1860) are very firmly embedded in a national landscape[70] – and are very likely to lurk in damp, dank woodland. Berry Pomeroy – buried deep in the woods, away from the main highway, almost invisible until the moment it is finally approached – was just such a castle.

If the suggestion that perceptions of Berry Pomeroy were bound up with the Gothicization of its locality seems too fanciful or facile, it is worth pausing to compare its reputation with that of another castle managed by English Heritage, Farleigh Hungerford in Somerset. Farleigh Hungerford is a 'fortified mansion, occupied for over three centuries by the remarkable Hungerford family.'[71] It is older than Berry Pomeroy, building having been started in the early fourteenth century, though like Berry Pomeroy, much of it was demolished at the beginning of the eighteenth century. Farleigh Hungerford has a rich fund of chilling and well-documented stories associated with its former inhabitants – the sixteenth-century Elizabeth, imprisoned in a tower by the husband who tried to poison then starve her; his execution for treason, witchcraft and homosexuality; the second wife of Sir Edward Hungerford I, Agnes Cotell, executed in 1523 for the murder of her first husband. However, despite its troubled past, its history of violent crimes, and the remarkable human-shaped lead coffins with moulded faces, which lie in the crypt, Farleigh Hungerford has no reputation as a haunted castle. This, I think, is in large part due to its situation. Farleigh Hungerford castle sits at the top of a gentle valley, overlooking a landscape that is pastoral rather than picturesque. It is built of a light-coloured stone and the ruins are almost as open to the observing eye as the cut-away illustrations to be found in the guidebook. Farleigh Hungerford's appearance and situation are inimical to ghost traditions; Berry Pomeroy, on the other hand, situated in a very different locale,

has a host of ghosts despite its lack of a troubled past, and the fact that it is only just medieval.

In the climate of the ghost-tale-loving community of late Victorian Britain, Berry Pomeroy was ripe for population by spectres. Because of its supposed history, the nature of its location, the national love of the ghost tale, and the birth of a more firmly national Gothic (rather than one located in foreign lands), it was eminently the right kind of building to acquire the ghost stories it so singularly lacked (though fairly well-stocked with legends). Some of the earliest references to its ghosts come in the 1860s. The anonymous writer of the account of the seven weeks' tour in *Bentley's Miscellany*, who relayed the anecdote of the merry Sunday school treat quoted above, passes on the 'tale ... that on certain evenings in the year the spirit of the Ladye Margaret, a young daughter of the house of Pomeroy, appears clad in white on these steps, and beckoning to the passers-by, lures them to destruction by a fall into the dungeon ruin beneath them.'[72] The tale is picked up and quoted seven years later by Mrs Henry Pennell Whitcombe in her *Bygone Days in Devonshire and Cornwall* (1874). However, this is very much a generic ghost story.[73] Within a few years, however, Lady Margaret was to acquire her backstory.

The Mortimer brothers, literary tourism and Berry Pomeroy castle

The claim made earlier that *The Castle of Berry Pomeroy* is the ultimate source for the White Lady story is, or seems to be, problematic in that the novel, published in 1806, had no immediate impact in the form of ghost tourism. Decades were to pass before Berry Pomeroy became a celebrated haunted ruin. *The Castle of Berry Pomeroy* was given a helping hand, however, in the late nineteenth century.

By the 1870s, the local guidebook business in the South Hams area had been taken over by the brothers, T. and A. Mortimore. The Mortimores were proprietors of the *Totnes Times* and *Western Guardian,* and they also published a tourist guide to Totnes and to the River Dart. In 1876, they produced a guide devoted to the castle alone: *Berry Pomeroy Castle: An Historical and Descriptive Sketch*. Their guide gives a historical account of the castle, is illustrated (with prints in earlier editions, though by the 1890s the prints have been replaced by photographs), and it addresses what Nicola J. Watson has called the 'reader-tourist'.[74] It assumes that its readers are also readers of literature, and that the very sensibilities that propel the tourist are those of the lover of literature. Thus, it is

written in consciously 'literary' prose and includes a series of legends and anecdotes about the castle, including Henry de Pomeroy's suicide during the reign of Richard I; the Pomeroy knights who leapt to their deaths on their steeds from the castle walls rather than concede defeat; a crock of gold supposed to be hidden at the castle; and the wishing tree. It draws upon suitable accompanying literature, quoting from a variety of poets including Keats. Although there are none of the classical tags beloved of the late eighteenth-century gentleman-scholar tourist, the mode of solemn reverie associated with the passing of time and the ruin of worldly vanities is still conveyed; the Mortimores' guide begins with a quotation from William Lisle Bowles' sonnet 'Pevensey' ('Fallen pile! I ask not what has been thy fate' etc.).[75]

Berry Pomeroy Castle: An Historical and Descriptive Sketch includes a reference to 'the traditionary supposition that in its gloomy basement chamber, the proud Lady Eleanor de Pomeroy, once mistress of the Castle, was confined for a lengthened period, by her fair sister, through a feeling of jealousy.'[76] This is the first reference to this story that I have come across in the tourist literature.[77] The Mortimore Brothers certainly had a copy of *The Castle of Berry Pomeroy* a few years later for they serialized the novel in the *Western Guardian*.[78] Such was the success of the serialization that, in 1892, the brothers, who by now had decided to spell their name 'Mortimer', reprinted the novel (see Figure 5.6).

The Mortimer Brother editions of *The Castle of Berry Pomeroy* aren't easy to come by. I had found references to two editions (dated 1892 and 1906) but it was only through consulting a number of archives that I found that there were (at least) three separate Mortimer editions: there had been *two* editions in 1892 as well as the one in 1906.[79] These were moderately priced volumes, which came in decorated soft covers. The Mortimers' first edition was blue; it bore a print of the castle as a frontispiece, and, to differentiate it from their guidebook (*Berry Pomeroy Castle: An Historical and Descriptive Sketch*), it was presented as *The Castle of Berry-Pomeroy: A Novel*. Their first edition was quickly followed by a second that surpassed the first in magnificence (see Figure 5.6). The colour and the lettering employed were more eye-catching. I have seen one copy in a handsome red binding, with Chinese-influenced lettering picked out in gold, and an image of Berry Pomeroy on the cover, and another copy where the colour scheme was yellow and black.[80] Inside the novel, the print was replaced by a photograph of the castle's gateway. A third Mortimer brothers edition, the 'whole of two editions having been disposed of',[81] appeared in 1906, again in a blue cover.[82] As late as the 1930s, the guidebook to the castle lets its readers know that the novel

Figure 5.6 The second of the Mortimer brothers' 1892 editions of Montague's *The Castle of Berry Pomeroy* (1806). Ref. s823/MON. Reproduced with the kind permission of Devon Heritage Services

is available, at a cost of one shilling. Either the Mortimers' third edition failed to sell as well as its forerunners, or there were further editions.

The preface of the Mortimers brothers' second edition of the novel is enlarged in a way that suggests they had realized that they had discovered a new audience. The tone too has changed, and the language is that of tourism. The preface addresses, and even flatters, the tourist ('the intelligent traveller'); it gives useful walking distances, stresses the appeal of the surroundings in terms of both the ancient and the modern, and uses grandiloquent advertising phrases ('Queen of Watering Places'):

> Few Places in the West of England possess such historic associations as those clustering around the ancient and majestic ruins of 'BERRY-POMEROY CASTLE,' once the stately residence of the lordly Pomeroys, who joined William the Conqueror in the invasion of this country, and who estimated their power as little less than regal ...

> Situate within comparatively easy walking distance (2½ miles) of the picturesque and ancient town of Totnes, accounted the oldest borough in the kingdom, and only about six miles from the delightful 'Queen of Watering Places,' Torquay, the newest corporate borough, it is no wonder that Berry Pomeroy Castle should prove so great an object of interest to the intelligent traveller.[83]

In their preface, the brothers are not merely addressing readers of literature but also, and perhaps predominantly, literary tourists. They are trying to sell the novel not only to their newspaper readership, but also to the people who are buying the guidebook to the castle. The Mortimer brothers were employing a clever marketing strategy that meant that the newspaper, the guidebook and the reprinted novel mutually promoted each other – and promoted the area's tourist industry. It was a well-considered and well-coordinated strategy. The brothers included material from the novel in the guidebook. Somewhat surprisingly, they also did the reverse. The second 1892 edition splices information from the guidebook into the novel! It cuts two paragraphs from the original text (significantly, paragraphs which themselves came from a tourist perspective) and adds a substantial chunk of some more up-to-date tourist information, including some lines on the 'English Rhine'[84] – the River Dart – for which they also sold a guide. The line between guidebook and novel was becoming increasingly blurred. Almost 90 years after its first publication, *The Castle of Berry Pomeroy* had been drawn into the service of a burgeoning local tourist industry.

Becoming folklore

The Mortimer brothers' guidebook was the first to include the story that was to become that of the White Lady, but it is worth noting that their guide does not contain any reference to Lady Eleanor's death, or to any ghosts: this is a reference to a 'traditionary supposition'.[85] Ultimately, however, Lady Eleanor was to climb the ranks and become a ghost. To become the fully-fledged White Lady, Matilda/Elinor/Eleanor/Ellen had to merge with the story-less 'Ladye Margaret' of the 1860s, and then travel between a variety of media – literature, newspaper and guidebook. For me, one of the most interesting (and ultimately untraceable) aspects of her reign is her progress from literature to folklore. This had evidently happened by the 1930s when the Mortimer brothers' guide notes that 'Berry Castle and its grounds are said to be still, haunted'. Recounting the Blue Lady story and the story of the divided lovers, it notes:

> Tales of this description are innumerable, and it is not surprising, therefore, when the shadows of night fall, that ghosts are conjured up in the minds of the imaginative.[86]

Significantly, however, the guide keeps the distinction between legends, ghosts and novel. After all, they have just advised readers to 'procure the novel, entitled "The Castle of Berry Pomeroy," by Edward Montague, price one shilling.'[87]

The Mortimer brothers' editions of *The Castle of Berry Pomeroy* provided the means by which 'Ladye Margaret' could acquire a story. As noted, the text was published three times between 1892 and 1906 and, with the help of an eager and fertile popular imagination, it provided a central character who worked well as a late nineteenth-century ghost. Matilda in the novel is a young, virtuous maiden, unwilling even to ask for help to escape the dungeon in which she has been imprisoned, because she has been put under oath. As a 'ghost' she is a classic example of the explained supernatural: that is, she isn't a ghost at all. The White Lady, on the other hand, is the M R James type of ghost, for which rational explanation is not forthcoming. She shares much of Matilda's narrative but not her character. The White Lady could be said to be a combination of the two sisters of the novel. The result is a ghost who is both villain and victim, doomed, passionate lover and suffering soul. She is glamorous and morally repugnant at the same time, with the ambivalent pull on our sympathies which characterizes,

for example, the vampire seductress of Le Fanu's *Carmilla* (1872), or the werewolf White Fell of Clemence Housman's 'The Were-wolf' (1896).

The White Lady's transmutation from literary text to folklore was helped both by the wide-scale, but very local, dissemination of the novel. The issue of locality – and localness – is a powerful factor in the acceptance of a ghost story, and I suspect that republication of the novel by a London-based publisher would not have been so influential. In the long run the transition from literature to folklore was indebted as much to the *disappearance* as to the *dissemination* of the Mortimer brothers' editions. These were cheap editions, produced for a largely itinerant market. The soft paper covers did nothing to ensure that the books stayed intact – or valued. Tourists bought the books, and I would guess, often left them at their hotels and guest houses. They were read – and discarded (the book does not really reward a second reading – unless you're a literary scholar). While individual copies perished, the story persisted (and persists) and, importantly, changed. It modified with the tastes of the times and with the twists and turns of the popular imagination. That is, it became folklore.[88]

Lady Margaret is not the only ghost attached to Berry Pomeroy Castle; they have proliferated over the years. The White Lady, however, could be described as the castle's signature ghost, and once having gained her, the castle was granted, as it were, a licence to print further ghosts (and not only here, but also over at nearby Dartington where there is a Grey Lady). Berry Pomeroy Castle specializes in female ghosts associated with sexual misdemeanour or suffering, or unruly desire. I would argue that a good many of them – murdered girls, incestuous lovers, unnatural mothers – descended from the White Lady by a process of Gothic contagion. Lady Margaret has spawned many offspring in the past hundred years (and English Heritage's attempts to manage them will form part of the subject matter of the next chapter).

The castle's other main ghost, the Blue Lady, is indebted for her name to the White Lady and is related to her too in the manner in which she came to public attention. Most contemporary accounts of the 'Blue Lady' refer to a first-person testimony published in a work devoted to the history of the Seymour family: *Annals of the Seymours* (1902), which reports the sighting of a 'richly dressed lady' whose face 'exhibited agony and remorse',[89] by a reputable witness, Dr Farquhar. However, the sources and the eyewitness testimony are not as uncomplicated as most contemporary accounts suggest. When I consulted the *Annals of the Seymours* I found the story in one of the many footnotes at the back.[90] And there it gave the source for the story as John H. Ingram's

The Haunted Homes and Family Traditions of Great Britain – a work that was highly popular, and went through many editions in the last decades of the nineteenth century. When consulting the Ingram text, I found that the tale had not originated there either. Ingram notes that 'the story has been told as nearly as possible in Sir Walter's own words',[91] but gives no source for its eyewitness account. After a little digging, I found that the tale had its origins not in a work by Sir Walter Farqhuar (of whom they said in his obituary that it was a pity he hadn't written an account of his medical work, but made no mention of any literary leanings),[92] but in a work of literature. Indeed, the story is first relayed as a classic literary ghost story. It is to be found in an obscure work of 1833, Erskine Neal's *Whychcotte of St John's; or, the Court, the Camp, the Quarterdeck, and the Cloister*, described by the *Monthly Review* as 'a series of rather lively sketches, among which many are very good, but some are but indifferent'.[93] The unfortunate female later to be known as the Blue Lady, makes her entrance in a chapter called 'The Unearthly Tenants of Denton Hall' which is introduced by a quotation from Samuel Johnson 'To sum up the doctrine of supernatural appearances in a single sentence – all tradition is in favour of it, – all reason against it.'[94] It takes as its frame a house party at East Denton Hall (now in the county of Tyne and Wear in the North East of England) in which, '[o]ne Winter's evening',[95] the guests take turns to tell disturbing tales. The Blue Lady story is the first one told and is introduced in the following fashion:

> 'A ghost story! a ghost story!' was echoed round; and at the word the guests drew closer to the blazing fire; while, after two hems and one ha, [the storyteller] drew up her majestic person to its full height and began: – [96]

If the ghosts who started to take possession of Berry Pomeroy at the end of the nineteenth century were relatively harmless – the early twentieth-century photograph republished in the recent English Heritage guidebook, shows a spirit who seems to enjoy playing to the camera – those who appeared later tended to be more alarming. Many of the stories which emerged in the twentieth century are far more graphic and brutal (this tendency is perhaps best exemplified by the gang-rape story mentioned earlier). Berry Pomeroy's trajectory, for much of the twentieth century, has been from haunted castle to a place of unmitigated evil. Such was the castle experienced by Robert Graves, by Keith Poole and Deryck Seymour, and by Bob Mann when he first visited as a child in 1968,[97] and by many another whose testimony can be found on the Internet today.

Figure 5.7 Berry Pomeroy Castle in the mid-twentieth century

Aiding the castle on this trajectory was a new stage in its appearance. By the mid-twentieth century, the woods around the castle had darkened. No longer were they diffusing a thousand sweets; they had been overtaken by rhododendron. Berry Pomeroy's woods resembled nothing so much as the approach to Manderley in that classic twentieth-century Gothic text, Daphne du Maurier's *Rebecca* (1938), also set in the West Country, and also concerned with the effects of unruly female desire. The castle too had changed. The picturesque ivy that can be seen in late Victorian photographs was stripped away in the interests of conservation. What had been romantic ivy-clad ruins suddenly looked grim and bare, whilst, to the front, bits of street furniture, fussy way-markers and trellis added to the de-romanticization of the place. By the mid-century, these denuded ruins were those of Graves' nightmare (see Figure 5.7).

The transition to Berry Pomeroy as a place of evil was due as much to a new taste in ghosts and the Gothic, as to the changing appearance of the castle. As a nation relished reading of the unmentionable evils associated with the occult, in works by novelists such as Arthur Machen at the turn of the century, or Dennis Wheatley in the 1930s, so did the popular imagination oblige by creating a new Berry Pomeroy – characterized as much by its palpable and oppressive atmosphere as by

more ghosts. By the 1940s and 1950s, such was the castle's reputation that local newspapers were reporting findings, associated with night-time seances, of beheaded cockerels at the castle. This was no longer a place where dreamers rhapsodized by the refulgent beams of the full moon.

Conclusions

It is ultimately impossible to work out exactly when the devil took possession of Berry Pomeroy Castle, though I would argue that it was effectively reinvented in the late nineteenth and in the twentieth centuries. The processes involved in the development of Berry Pomeroy's haunted reputation were complex and surprisingly indirect. They have, I think, much to tell us about the relation between haunted buildings, tourism, folklore, and reading habits (at both a national and a local level) from the late nineteenth century onwards. One of the most interesting aspects of the Berry Pomeroy story is the close relation between local tourism initiatives and its haunted reputation. The White Lady is indebted to the *reprinting* of a Gothic novel of 1806 by some savvy local publishers as part of a well-coordinated business strategy aimed at the literary tourist. (As we saw, the first publication of *The Castle of Berry Pomeroy* didn't give birth to stories of a haunted castle in the earlier part of the century.) The local aspect of the re-publishing gave strength to the folklore, and I suspect that the rise in local publishing at the end of the nineteenth century helped to foster many haunted reputations. Although very often the preferred narrative for those considering the relation between the tourist industry and haunted reputations is a kind of reverse Scooby Doo scenario (in that the haunted reputation is supposedly created in order to attract, rather than frighten away, visitors), this was not the case at Berry Pomeroy. The Mortimer brothers themselves, happy with legends and Bowles-ian pensiveness, had not intended, and probably would not have wanted, to be the architects of Berry Pomeroy's spectacular hauntedness. Rather than local interests deliberately promoting a 'ghost' based on a fiction, what we can see happening at Berry Pomeroy is the gradual development of the ghost through a much more protracted, and much more communal, process. This is a narrative of growth and accretion; of stories working their way across media, into and out of print; of happy accident; of books as physical artefacts that were found and lost, forgotten and reworked; of popular desire for a ghost – or at least a sense of the appropriateness of one. It is a process that shows no signs of abating at the present moment.

Berry Pomeroy, with its many and varied supernatural phenomena – glamorous ghosts, ghosts who have suffered depraved levels of violence, an atmosphere which in itself is thick with an evil of which a succession of mere spectres are only inadequate symbols – illustrates the extent to which the ghost stories of popular folklore, from the late nineteenth century onwards, are linked to the literary ghost story. Berry Pomeroy's spectres reflect changing fashions for ghosts in the literature of the last 200 years. There is hardly a traditional (or, as Owen Davies expresses it, 'purposeful')[98] ghost to be found there. The kind of 'folklore' to be found at Berry Pomeroy is not that of a pure folk imagination, passed down orally from folk memory, uncontaminated by modern knowledge and technologies. Instead, it derives from a folk imagination which, as well as operating by word of mouth, has been, for over a hundred years, in full and productive association with literature, newspaper and tourist materials. It is worth stressing, however, that the story of Berry Pomeroy, and many another haunted castle, is not merely one of slavish imitation of popular literature. The story of folklore's indebtedness to literary texts is not a simple one – the communal imagination takes what it wants, jettisons what it doesn't want, combines, improvises and develops.

Literary fashions in themselves don't inevitably result in haunted ruins. The case of Berry Pomeroy illustrates the significance of place – both the extent to which our experience of place is bound up with our literary understanding, and, conversely, the extent to which the stories we tell are reliant upon the changing nature of places. Berry Pomeroy's changing appearance was remarkably in sync with changing fashions – first for the picturesque, and then for the ghost story. In the 1860s, by virtue of its appearance and its situation, Berry Pomeroy came to resemble (or even embody) a certain type of haunted castle made popular by the literature of the day, and, as a result, it became populated by the kinds of ghosts that inhabited that literature. It has been the fortune of some places, like Berry Pomeroy, to change in aspect as fashions have changed. This is one of the reasons that have made it such a fertile site for stories; as the ruin and the locale changed, new stories were added to the old. Perhaps one of the most surprising ingredients in the development of the stories associated with Berry Pomeroy, was the change in conservation practice, which resulted in the ruins being shorn of the softening effect of ivy. Suddenly, this was a building that seemed to be severed from, rather than embosomed in, nature – the castle of Graves' perverse parade. It is interesting to speculate on the extent to which such changes in conservation practice might have affected the ghost/supernatural literature of its time more widely.

Post script

The Mortimers had, I think, a variety of reasons for publishing *The Castle of Berry Pomeroy*, not least amongst them local pride. As Bob Mann writes, more than a century later, Berry Pomeroy has an intensely local significance, and is the kind of place that 'people sit around in pubs or cafés talking about'.[99] As well as their feelings of local pride and the matter of their publishing empire, I think there might be a further and intriguing possibility for the brothers' interest in the novel.

James D. Jenkins in the 2007 Valancourt Press edition notes that the original attribution of the novel to Edward Montague is 'problematic'.[100] He points out that a second novel attributed to Montague on the title page (*Montoni; or, The Confessions of the Monk of St. Benedict*) 'did not appear in print until two years later, in 1808'[101] and when it did appear it was under the name of Edward Mortimer. Jenkins surmises reasonably that the 'cross-attribution of *Montoni*'s authorship, together with the similarity of the two names invites speculation that Montague and Mortimer were one and the same, and although there is no proof of it, both names have the ring of pseudonyms, both names being drawn from the annals of English history.'[102] It is highly probable that the name Edward Montague is, as Jenkins suggests, a *nom de plume*, one of the assumed names used by Minerva Press for the works of several authors. It is also probable that the second name – Mortimer – is also a *nom de plume*, a house name. However, there is, I think, a possibility that the second name – Mortimer – wasn't assumed.

Like many of the works inspired by Berry Pomeroy Castle, the novel *The Castle of Berry Pomeroy* pays detailed attention to the South Devon landscape and the castle itself. Berry Pomeroy Castle and its surrounding are described with fidelity (though, as in many places in the novel, the ability to see the sea from wherever you are in South Devon is over-emphasized):

> The Castle is beautifully situated on a rising ground, its western turrets overlooking the neighbouring wood, and the spacious plains of Dartmoor; to the south is seen afar off, the waves of the great Atlantic ocean, bringing on its agitated bosom the rich treasures of east and western climes.

> The northern and eastern towers hang over a luxuriant vale, the sides of whose steep boundaries are cloathed with hanging oaks and aspiring beech trees; at the bottom is seen a transparent sheet of water,

which loses itself amongst the thick crouding trees, on whose green summits the well-pleased eye reposes with delight, till the sweet windings of the romantic Dart seduces the attention of the enamoured beholder.[103]

Whereas such attention to locality would not be surprising in a work of a later period when local colour was not only fashionable but in some cases *de rigeur*, it is relatively unexpected in a novel of this period. The writer not only describes very exactly Berry Pomeroy Castle, its surroundings and the view from its ruins, but attempts to place them within an imagined historical landscape. It links the castle to buildings thought to be of similar age, and pays detailed attention to the geography of the local landscape. The novelist describes Torbay, Tor Abbey and Ford Abbey (which is presumably Forde House, never an actual abbey, though, as in the novel, it is beside the Teign, and near some woodland).[104]

I would venture that the knowledge displayed in the text was not merely derived from reading published works; the degree of local knowledge exceeds anything that I have been able to find in print at the time. I think that whoever wrote the novel was almost definitely someone who knew Berry Pomeroy Castle and the surrounding area at first hand. I think that there is a distinct possibility that 'Edward Montague' was actually 'Edward Mortimer', one of the local 'Mortimores' and perhaps even an ancestor of the Mortimer brothers.

6

A Tale of Three Castles: Gothic and Heritage Management

In this chapter I will be thinking about Gothic in relation to heritage management, taking for my case studies three castles from different economic sectors. In the first section I will be looking at Warwick Castle, which is owned and managed by the entertainments company Merlin. In the second section, I will be turning my attention to forms of Gothic tourism at Alnwick Castle, which is owned by the Percy family, and is the centrepiece of the family estates and businesses. In the third section I will be returning to Berry Pomeroy Castle, not only because it is managed by English Heritage, the largest of the heritage organizations in England, and, at the time of writing, a state-funded body, but also because it has ghost traditions to manage.[1] I will be considering the way these castles are presented and interpreted, looking at the different kinds of visitor experience they offer, and thinking about the relationship of each with the discourses and tropes of the Gothic.

Traditionally heritage sites have eschewed the Gothic. The kinds of Gothic tourism that will be encountered in this chapter wouldn't have been countenanced a generation ago. As Charles Kightly writes, in an essay entitled 'Interpretation, entertainment, involvement: historic site presentation c 1983–2008':

> In the early 1980s, the typical historic site was either a ruin surrounded by manicured lawns, with interpretation confined to the odd metal wall-label ('The Great Hall'): or a country house viewable only by guided tour, with the visitors reverently shuffling round the state rooms.[2]

Times have changed however. For Kightly it was the Jorvik Viking Centre (a museum and visitor attraction in York) that, in 1984, 'effectively

founded the British heritage interpretation industry'.³ Now, at many places, to greater and lesser degrees, and in a variety of different modes, the Gothic is welcomed in.

Recourse to Gothic tourism can be a risky business for a heritage site, for a variety of reasons. After all, Gothic has famously concerned itself with feudal tyranny, imprisonment, suffering bodies, blood, torture – a rather restricted perspective on the past. It also comes with a particular attitude to history, identified by Robert Mighall as Whiggish, wherein the 'unreasonable, uncivilized ... unprogressive'⁴ characteristics of the past are contrasted with the liberality of the present. Not only this, but Gothic has often (though by no means always) gone hand in hand with a lack of historical specificity. At its crudest, it cares little about history or local detail and functions as a vehicle for bigotry. Gothic in relation to heritage sites thus needs careful negotation because of the risk of blurring histories, superimposing certain narratives whilst ignoring others, and presenting an unnuanced view of a tyrannical past in contrast with an enlightened present.

In this chapter, I will be examining the attractions of Gothic for heritage organizations and thinking about the kinds of tensions that can and often do exist between Gothic tourism and managers of heritage. En route, I will be delving into some forgotten histories of Gothic tourism; thinking about the ways in which Gothic can be used to ward off ghost hunters; and asking what the inclusion of Gothic content can tell us about changing attitudes to, and understanding of, heritage in the twenty-first century.

Warwick Castle – the problem of history

At Easter 2013, I visited Warwick Castle. It was not my first visit; that had taken place many years previously, when I was a child. Then, a friend of the family had been the castle's curator. He welcomed us, leading us across the courtyard into the state rooms. It was out of visiting hours, and all was quiet, dark and solemn. I must admit that I don't remember much else about the experience, apart from my feeling of vague disappointment that the grand state rooms we were going through didn't live up to my idea of a castle – that is they weren't medieval. My second visit was very different. This was a daytime visit in the broad summer sun, and my over-riding impression was of noise. As I approached the castle different sounds echoed all around – birdsong, the screeches of peacocks, a recording of 'Eine Kleine Nachtmusik' overlaid with fart noises and amplified manly grunts. Passing under the portcullis I entered to

a soundtrack – not of medieval music but of stirring tones evocative of chivalry, the kind used during exhilarating battle scenes in films. The track is looped, and plays all day.

Warwick Castle, in the English Midlands, dates back to the Norman conquest. The first buildings were established there in 1068, but most of the remaining fabric dates from the fourteenth to sixteenth centuries. It has had a long history of tourism – the first ticket office was installed there in 1900. Warwick is now part of Merlin Entertainments who have turned it into one of their top attractions. 'Britain's Ultimate Castle'[5] is marketed to the public as a family day out and the emphasis is on fun. As the website puts it: 'Warwick Castle is not your average castle. It is full to the turrets with dramatic shows, interactive experiences, story telling, demonstrations, activities and more.' The castle is awash with themed activities, many of them focused at very specific target groups, conceived of primarily through age and gender. In the Princess Tower, activities centred on storytelling and trying on shoes and tiaras. The Mound, when I visited, was occupied by boys being trained in staff wielding. I discovered that, unless you are a member of one of the targeted groups, certain areas of the castle may well be inaccessible. (It's very difficult to visit the Princess Tower if you are not aged between three and 11 years old and a girl.) Warwick Castle is staged in a variety of ways. There is hardly an area of the castle that isn't subject to a timed performance, whether it be the Dungeon experience, guiding by Gaius's assistants in the Merlin Tower, the telling of stories by princesses, or the firing of the trebuchet in the grounds. Such is the centrality of performance as the castle's dominant mode that earlier examples of tourist performance are featured on the History and Restoration pages of the website; the pages record that the 'Ghosts Alive' attraction (which was based on the murder of Fulke Greville, in 1628) opened in 2004.[6] It could be said that Merlin asserted their own ownership through this dramatization of the murder of one of the castle's former owners.

Unsurprisingly, considering its place within the Merlin group, Gothic plays a major part at Warwick Castle. The best-known example is the Castle Dungeon (one of the Dungeons Group owned, of course, by Merlin), which superseded 'Ghosts Alive' in 2009. Other forms of Gothic tourism at Warwick Castle include, periodically, ghost story telling on the steps at 3 pm, and the Kingmaker waxworks that have been there since 1994. In the evening, Warwick offers, as one of its four kinds of banquet package,[7] 'Dungeons after Dark', advertised as suitable for corporate events and wedding parties. Consumerism is all pervading. 'Kingmaker' ends in

the gift shop, and the map given at the entrance, points to all the shops and restaurants that line the visitor's route.

As well as both daytime and night-time Gothic, Warwick also does seasonal Gothic – at Halloween. In 2013, from 24 October–2 November, doors were open until 9pm for 'The Haunted Castle'.[8] Much of what was on offer was directed at the family and younger children. Some of the usual attractions were modified (the Princess Tower became a witches' tower, for example) and new attractions had been devised – 'The Haunted Hollows', for example, 'a family-friendly trail through an abandoned castle', where a skeleton ball was held. Most of the Halloween attractions were performance-orientated and most, with the exception of the fireballs from the trebuchet as a spectacular finish, were given a Gothic spin. There was a display of Georgian swordsman-ship, for example, entitled 'The Duelling Dead'. The main additions to the Gothic tourism available throughout the year at Warwick were a 'séance' in the gaol (where objects moved inexplicably); a 'Paranormal Investigation' (not live, but a showing of video clips) in a 'secret room' in Guy's Tower; and 'The Revenge of Henry Black', a scare attraction that unfolded a narrative begun in 2012 with 'Séance – The Curse of Mary Black'. The trilogy was completed in 2014.[9]

Warwick's website employs some telltale wording when describing the attractions on offer at the castle:

> We have eleven hundred years of history, but also great battles, ancient myths, spellbinding tales, pampered princesses, heroic knights, Merlin's Dragon, and the dark Castle Dungeon.'[10]

The use of 'but' reveals a certain reservation about the 'eleven hundred years of history', suggesting a tension between 'history' and fun. 'History' at Warwick is a potentially unpalatable concept, and as such, is mediated in a variety of ways. These include Terry Deary's Horrible Histories series,[11] and the popular BBC's children's fantasy drama, *Merlin*.[12] Gothic is only one of the many and varied ways of sweeten-ing the didactic pill, but it works well with the way the castle is pre-sented and interpreted, particularly because it offers a 'take' on history and a set of attitudes that meld seamlessly with those of the Horrible Histories. Gothic at Warwick provides a means of escaping the potential monotony of the history lesson. It fits very well into an interpretative schema that, all too frequently, prefers to offer history as a generalized (rather than localized) narrative. The dominant narratives of the kind of

Gothic employed at Warwick function not so much to relay the castle's history as to provide a diversion from it.

Much of Warwick's Gothic is disconcertingly similar to the Southwark Gothic examined in an earlier chapter. In Southwark, however, the historical fabric was absent and Gothic was, as it were, compensatory. There is no lack of massy heritage at Warwick, yet forms of Gothic tourism that obliterate distinctions between different sites are favoured here. Despite being – or perhaps because it is – an ancient castle of a thousand years old, the mock-up is constantly resorted to. At the very points where the visitor comes face to face with the oldest parts of Warwick's fabric, the castle lays on its most intense pre-scripted entertainments. The waxwork exhibition 'Kingmaker' is situated within what a notice on the wall refers to as 'the heart of Warwick Castle' (the walls date from 1200). Here the visitor is deluged by an immersive experience. There is a disorientating sense of overlap: faux medieval trumpet and drum music overlies the clink of the blacksmith. The music, which feels like an introductory fanfare, does not progress or resolve but constantly returns to the beginning. Phantom children sing cuckoo, and the area reeks of the smells from manufactured historical scent pods.

Alnwick Castle: from Potter to poison

Whereas the tendency at Warwick is to avoid the specifics of local history, at Alnwick Castle these are central to its presentation. Alnwick is presented as the castle of the Percys. The castle's tag line, in February 2014, was 'Where history lives', and Ralph Percy, 12th Duke of Northumberland wrote, on the homepage of the castle's website:

> Welcome to Alnwick Castle. To many people, on their first sight of this glorious medieval castle it can seem foreboding, and certainly its history lacks nothing in drama and intrigue. Yet I am proud that today Alnwick Castle is very much a living castle, at the heart of thriving estates and businesses, and is still our family home, as it has been for over 700 years.[13]

This emphasis on Alnwick as the home of the Percys, as well as the castle's magnificent art collection, does not mean that the entertainments there have no similarities with those on offer at Warwick. Alnwick also offers a 'family day out' with a particular emphasis on the hands-on activities associated with living history. It also makes use of well-known brands. Whereas at Warwick these tend to be drawn

from television, at Alnwick the presentation draws on the Harry Potter films,[14] the castle having featured as Hogwarts in the first two films. Broomstick training takes place regularly in the grounds, and there are magic shows 'featuring characters inspired by Harry and Hagrid'. Some of its visitors arrive in Harry Potter-inspired costume. As I entered the State Rooms in Summer 2013, I heard the guide utter a question I'd never encountered before. 'Are you both Hermione?' There were, it turned out, twin girls standing behind me.

Although Alnwick provides entertainments that can rival those at large commercial sites such as Warwick, it does so in a more individualized fashion, and ensures they are customized to reflect the historical connotations of the site and its locality. Such a strategy is deliberate. Catherine Neil, the Visitor Experience and Interpretation Manager at the castle, explains that, while the emphasis is on hands-on history and entertainment, attractions at Alnwick have to be 'specific to the castle' and 'not generic whenever we could avoid it' ensuring that what is on offer is 'always about reflecting the castle's history, cultural, social or political.'[15] Thus Alnwick's 'Knight's Quest' attraction, whilst offering the chance to dress up in medieval costume, or take part in workshops based on medieval crafts (soap making, or manuscript illumination for example), focuses on the most famous of the Percys, Harry Hotspur (1364–1403), and draws on archival research using the heraldry of Alnwick.

The principle of customizing the attractions in relation to the history of the castle and the locale is extended to the forms of Gothic tourism at the castle. At the entrance to its walk-through haunted-house-style attraction, 'Dragon's Quest', there is a board that has information relating to local lore about dragons – the most celebrated example being the Laidly Worm of Spindleston Heugh.[16] 'The Lost Cellars', which opened in 2012, is also made specific to the history of the castle. Despite the name, it is not an interactive Dungeon-type attraction, based on boo scares, blood, guts and torture. According to Neil, care was taken not to replicate that kind of experience. 'The Lost Cellars' doesn't feature animatronics (though it does have character holograms), mazes or fairground rides. Rather it is scripted for two actors (and a silent third), has a narrative through line, and has more in common with the West End production of *The Woman in Black* than a fun fair.[17] 'The Lost Cellars' is not a transferable attraction. It is site specific. The space itself – a Victorian beer cellar – suggested the nature of the attraction: a dramatized Victorian ghost story. The narrative too is site specific, having been drawn from local stories (in particular those associated with

neighbouring Hulne Priory) such as the Alnwick vampire.[18] At Alnwick, Gothic tourism is bespoke, rather than off-the-peg, individually created rather than mass-produced.

Alnwick's most famous Gothic attraction is the Poison Garden. It was created by the present Duchess of Northumberland, Jane Percy, and opened in 2005 to great media interest. It has remained a subject of media interest ever since, featuring, for example, on BBC Radio 4's 'Woman's Hour' and BBC television's magazine programme 'The One Show' as well as in numerous articles in national newspapers.[19]

Alnwick Gardens are separately ticketed from the Castle. Visitors enter through gates and walk past contemporary buildings of glass and wood, and franchised stalls. The gardens are to a high degree, but not completely, symmetrical: the entrance has a pavilion on either side, and the grand cascade, which immediately greets the eye, is flanked by walks. Much of the area presents itself to the eye at a single glance (though it also contains many enclosed, to-be-explored spaces: a walled ornamental garden, covered walks, bowers, and a bamboo labyrinth). The gardens provide a family experience, *par excellence*. The overall atmosphere is that of a conjoint celebration of nature, fun and science, the informing aesthetic a kind of reborn classicism. On the day I visited, I saw a delighted crowd watching water spiralling down a bright smooth and metallic water feature that was flashing in the sunlight.

The Poison Garden is in many ways a surprising addition to Alnwick Gardens. It is a self-contained area, marked with a skull and cross-bones, and entered through low black gates decorated menacingly with wrought iron poison ivy and spiders. Visitors are not allowed to wander into the Poison Garden at will. They have to congregate outside the gates and wait for a guide to give them a conducted tour. The tour is not merely botanical. The plants are introduced both through information about their habitats, effects and medicinal uses, and through a series of narratives with a familiar Gothic cast. Visitors are told of the many murders committed by the general practitioner Dr Harold Shipman, of a murderous American wife, of wormwood and absinthe, of angel's trumpets and Victorian seducers, of medieval monks and ways to restrain their unruly libidos. The overall emphasis seems more on the negative powers of poison and the stimulating stories associated with them, than on the potentially medicinal effects of the plants. There is canny use of Gothic imagery: some of the plants are housed in black cages and there is a donation box for a drugs charity in the shape of a full-size coffin. Perhaps the collecting box for the drugs charity is a form of apology for the Gothic glamorization.

The Poison Garden is *sui generis*. It has no direct forebears[20] in terms of Gothic tourism, though I suspect that it will have some descendants.[21] It can, however, be seen within the traditions of the landscape garden, in that it draws upon historical events, private histories and literature, as well as wider cultural associations. The Poison Garden is a Gothicized take on the landscape garden – a Gothic fragment, supposedly inspired by the legendary gardens of the Medici, that takes its place within a line of literary gardens such as that of Hawthorne's 'Rappaccini's Daughter' (1844). It is a place where stories are told, and a place from which stories are spawned. There is a series of children's books attached to it. *The Poison Diaries*: 'gothic yet entertaining'[22] reads one Amazon review.

The Poison Garden takes its place within a long tradition of Gothic design. Alnwick Castle has had a history of Gothic presentation for over two hundred and fifty years. For this, it is indebted to Elizabeth Percy, first Duchess of Northumberland.

Elizabeth Percy's Gothick

Elizabeth Percy (née Seymour) (1716–1776) was 'one of the grandest figures in London society, a Lady of the Bedchamber and ... a close friend of Queen Charlotte'.[23] She was a keen traveller, an amateur writer, a prodigious, if indiscrimate, collector, and she acted as patron to Boswell and Goldsmith. Her diaries illustrate both her keen eye for manners and appearance, and a capacity to be thrilled by the delights of the sublime – particularly when it was linked to family history. A diary entry of 1759 shows her enraptured by a visit to the ancient Percy castle at Dunstanburgh:

> Tho almost entirely a Ruin there is from its immense Size (the area of it being 13 acre) & its situation on a high Black perpendicular Rock over the Sea, which washes three sides of it, something stupendous, magnificent in its appearance. The Grandeur of which that day was greatly augmented by a stormy N.E. Wind which made the waves (Mountain High) clash foaming & soaring against its walls & made a scene of glorious Horror and terrible Delight.[24]

In 1766, Elizabeth became first Duchess of Northumberland. She had not expected to become a duchess, or to inherit the Percy estates. The last direct heir to the Percy estates was her grandmother (also named Elizabeth), who had married into the Seymour family in 1682. When

Elizabeth married, it was not into the aristocracy but only into the gentry – much to the chagrin of her grandfather, the sixth Duke of Somerset. Elizabeth's husband was Sir Hugh Smithson, Baronet, who as Richard Lomas points out in *A Power in the Land*, was 'at birth … the son of a younger son destined for London, where he was expected to train and then seek his fortune as an apothecary'.[25] Smithson's 'genealogical luck', however, was, as the *Oxford Dictionary of National Biography* puts it, 'phenomenal.'[26] He unexpectedly succeeded to the baronetcy in 1729 at the age of 17, and five years later he inherited £10,000. Smithson, good-looking with, as Walpole put it, 'an advantageous manner, and much courtesy in his address',[27] had by now become an eligible bachelor. He married Elizabeth Seymour in 1740.

As Richard Lomas points out in *A Power in the Land*, it was a mixture of the quirks of fate, temperament, situation and judicious planning that landed the couple the dukedom.[28] Her father had successfully petitioned to have the Earldom of Northumberland recreated[29] and, in 1750, Elizabeth and her husband, succeeded to the title and the estates, changing their name from 'Smithson' to 'Percy' (the name had disappeared from the family with the death of Elizabeth's grandmother). Hugh, political favours being owed to him, negotiated with the government and was eventually awarded a dukedom. In 1766, the couple became the first Duke and Duchess of Northumberland.

On becoming Earl and Countess of Northumberland, Hugh and Elizabeth made Alnwick Castle their principal country seat. This decision was by no means the obvious one to make. They were wealthy, fashionable people and had other estates to choose from. Moreover, Alnwick Castle was in a 'dilapidated condition'[30] and needed much work. Their sense of history, and what they thought due to the Percy tradition, over-ruled other considerations, however, and Elizabeth and Hugh proceeded to undertake not only restoration and modernization, but what might be described nowadays as a 'radical rethink' of the building.

With the hindsight of history, it seems almost perverse that Robert Adam, the most celebrated neoclassical architect of the age, and James Paine, a Palladian architect, were set to rework Alnwick Castle into a 'Gothick' state. Yet this is what happened, despite the fact that Hugh's tastes (he was a patron of Canaletto, Joseph Wilton and John Linnell) tended towards the contemporary and the classical. This stylistic decision is usually credited to Elizabeth.

Why 'Gothick'? There are many reasons. The design for the castle needed to communicate the couple's contemporary position at the

forefront of fashionable (and political) life; to demonstrate a legitimacy derived from a medieval heritage; to conjure up the manners and ways of ancient times; to reflect on the Percys' medieval greatness; and to show that an earldom and a bloodline were being restored. 'Gothick', as a style, could be seen as both new and old. It referenced history yet signified contemporary fashion. For the Percys it was a gesture to both continuity and renaissance. To some extent, Gothick, in that it was understood as ancient, can be viewed as a defensive measure. Elizabeth and Hugh had something to prove: the legitimacy of their nobility, despite their rapid social ascent. Hugh was occasionally subject to sneers of 'Earl Smithson'. Elizabeth, born a Somerset Seymour, needed to vaunt her northern Percy identity. Gothick helped to tie them into their family history; it acted as an aesthetic legitimization.

What was Elizabeth's Gothick like? We have to imaginatively reconstruct some of it, as much of Alnwick's 'Gothicking' did not survive the nineteenth century. As Colin Shrimpton puts it: 'Algernon, Fourth Duke, chose to replace the 18th century *gothick* with more serious architecture'.[31] However, we know that the work included the rebuilding of parts of the keep, and that a 'series of large *gothick* windows at principal level surmounted by smaller ogee windows in the storey above were a distinguishing architectural feature.'[32] Inside the castle, the staterooms received 'highly decorated fireplaces ... and ceilings with fan-vaults or armorial designs.'[33]

The castle was envisaged as one element in a broader Gothic landscape. As Shrimpton points out, the ruins of medieval Hulne Priory 'became the chief feature to be visited on a coach drive in the park.'[34] Visitors could be taken to neighbouring Warkworth, also a Percy castle, and venture to see its famous medieval hermitage. The sublime delights of Dunstanburgh were only eight miles away. A natural cave in Hulne Park, was made into the 'Nine Year Aud Hole', a supposed hermit's cave, and a drive took visitors right up to it. The 'Nine Year Aud Hole' was, as Laura Mayer points out, 'sufficiently famous to feature as one of the English parkland scenes' on Catherine the Great's Wedgwood Frog service.[35]

Both Elizabeth and Hugh were avidly interested in history. Hugh was a Fellow of the Society of Antiquaries, and acted as trustee of the British Museum from 1753 till his death. For Elizabeth, however, 'Gothick' was more than a mode of framing history. Alnwick's 'Gothick', like Walpole's Gothic, was not to be slavishly tied to verisimilitude and historical accuracy (neither was it to forego contemporary comfort). As Laura Mayer points out:

Adam's light Gothick ... [was] an associational pastiche of classical motifs, battlemented cornices, and pseudo-Gothic Tudor arches.[36]

Gothic, for Elizabeth, was a style associated with creative freedom. Her version of it was pre-eminently literary and performative. It is no accident that the ancestors that Elizabeth chose chiefly to celebrate at Alnwick were those who, as well as being significant historical figures, had been immortalized in literature. Sir Henry Percy (1364–1403) aka Harry Hotspur, is one of the most attractive characters in Shakespeare's *Henry IV, Part I*, and Malcolm III is the Malcolm of Shakespeare's *Macbeth*. Both Malcolm and Hotspur were, as it were, built into the fabric of new Alnwick, in the features of Hotspur's Chair – a bower and viewpoint built into the wall west of the Record Tower, on the site of a former sentry turret – and in the monument to Malcolm, which was erected in the grounds in 1773.

Alnwick was a 'performed' castle. Adorning the battlements, and ranged at different places over the courtyard, were 200 counterfeit soldiers. Having seen the remains of some medieval examples on Alnwick's walls, Elizabeth had employed a local mason, James Johnson of Stamfordham, to create more. It took him over 20 years. These were not the only examples of still-life performance at Alnwick. There was a statue of a hermit at the entrance of the Nine Year Aud Hole; and the Chapter House, built by Adam in the ruins of Hulne Priory, contained statues of friars praying.

For Elizabeth, Gothic was poetic. She and her team, saw the castle and the estate through the lens of poetry – both dramatic poetry and folk poetry. Indeed, Northumberland in the mid-eighteenth century had a good claim to be considered as one of the most 'poetical' counties in England, after the publication of *Reliques of Ancient English Poetry* (1765) by Bishop Thomas Percy, (no blood relation of the family).[37] 'Percy's Reliques' proved to be a seminal text in the development of British Romanticism. It was a collection of traditional ballads, song and poetry, much of which was Northumbrian. The concepts of Gothic, Northumberland and folk poetry were intertwined in the imagination of the British reading public – and inspired the refashioning of Alnwick through poetry. The Gothic refashioning of Alnwick was so literary that it inspired a series of spin-offs. A body of mock-medieval literature was set in the vicinity. In the 1760s, Goldsmith wrote a ballad, 'Edwin and Angelina',[38] which he dedicated to Elizabeth. It is a re-working of the family's recent history within a medieval landscape. In Goldsmith's poem, Edwin, a lower-born youth, takes himself to a hermitage near the Tyne because of his seemingly unrequited love

for the aristocratic Angelina. Angelina, of course eventually falls into his arms, and avows her affection. Bishop Percy, in 1771, added his tuppence with a ballad that was to achieve substantial popularity: 'The Hermit of Warkworth'. The poem draws its inspiration from, and creates a narrative for, the supposed occupant of the medieval hermitage at Warkworth. In the last years of the eighteenth century and the beginning of the nineteenth, the Gothicking of Alnwick and Northumberland inspired a new generation of writers – working in prose this time. Jane Harvey was to write a number of novels whose plots unfolded in this romanticized county. The anonymous *Dellingborough Castle* (1806) describes a 'baronial castle' in Northumberland, situated upon a beautiful and gently-rising hill',[39] with the remains of a hermit's cell in its grounds. It is highly reminiscent of Alnwick and the surrounding landscape.

'Gothick' at Alnwick began as a means of reimagining an ancient title, the house and the domains, in a way that was appropriate for its renaissance. It became an aesthetic triumph: a dramatic and literary affair whose aesthetic mark was the interdependence of place, locality, history, literary heritage and design. To some extent, Elizabeth was interested in the 'Gothick' in the same way that Walpole was. She was fascinated by the refabrication of history, and like Walpole, her understanding of the past was fluid and creative and, for the sake of effect, could happily accommodate anachronism. She, like Walpole was a collector, and both Alnwick and Strawberry Hill can be seen as kinds of display cabinets in themselves. For both Walpole and Elizabeth, 'Gothick' was an aesthetic that delighted in the frame, in literary allusion, in the frisson of the interplay between fiction, history and place.

There are, of course, many points of dissimilarity between the two. Elizabeth, for her part, was interested in the potential Gothicking of the landscape round the castle in a manner that found almost no echo in Walpole's gardens at Strawberry Hill.[40] Walpole was of the opinion that gardens should be 'nothing but *riant*, and the gaiety of nature.'[41] Elizabeth didn't have Walpole's level of interest in the counterfeit. After all, she was working on an authentic medieval castle, and she wanted to insert a crew of (real) medieval ancestors into her building. Working on a much larger scale, she was also not particularly interested in the miniature. The fact that Elizabeth touring Strawberry Hill in 1762 declared she had 'never seen anything as pretty'[42] says much about their different conceptions of scale – and also perhaps partly explains why Walpole might have said some of the rather spiteful things he did say about her.

Ultimately, Elizabeth's contribution to eighteenth-century aesthetics took a different form to Walpole's – one more suited to the appellation

'Gothick' than 'Gothic'. Pope's 'Eloisa to Abelard', with its exploration of love and scholarly enlightenment blighted by the tyranny of medieval culture, in the form of a castrating uncle, gave the tone to much of Strawberry, and, indeed, gives its imprint to the celebrated novel associated with the building. By comparison, Elizabeth at Alnwick celebrated her manly ancestry as realized though Shakespeare. Hers was a Gothick of history and of literary allusion, and as its various literary spin-offs suggest, its predominant associations were with a romance of medieval chivalry.

Many of the present-day tourist attractions at Alnwick are reminiscent of Elizabeth's 'Gothick'. In the courtyard and round about the battlements, some of the Duchess's decoy figures peer down. They have not been in permanent residence since the late eighteenth century, having been consigned to various storerooms at some point in their history. Fifteen figures were found in the late twentieth century, however, and have since been repositioned. This reinstatement of the mock medieval is of a piece with some of the other attractions to be found in this part of the castle. Within the outer curtain wall of today's castle are a series of separate, idiosyncratic and diverse exhibitions. There is the Percy Tenantry Volunteers Exhibition, populated with 1970s wax figures of eighteenth-century militia, illustrating the history of Northumbrian volunteering to counter the Napoleonic threat, and the 'Castle Museum', which presents a history of archaeology at the castle. The Castle Museum is, as it were, a museum of a museum (the original museum was set up in 1826 at the time of the third duke). Each of these offerings to the contemporary tourist operates by an aesthetic consonant with Elizabeth sense of 'Gothick', and involves treating the castle itself as a repository or showcase of histories. In this contemporary version of 'Gothick' tourism, Alnwick re-presents and pays tribute to its past.

Today, Alnwick offers a wide range of Gothic tourism: 'Gothick' as re-presented history; site-specific Gothic theatre; a 'haunted house' style attraction; Harry Potter wizardry; and Gothicized landscape in the form of the Poison Garden. There is, however, one example I have not yet mentioned. In perhaps the most fitting tribute to Elizabeth's 'Gothick' aesthetic, the breakfast room holds what might be called a Gothicized exhibition, designed by Adriano Aymonino. At her London residence, Northumberland House, Elizabeth created her own 'Musaeum'. It took up a whole floor, and was full of curious objects, (knick-knacks relating to historical personages and grotesque porcelain figures, for example) from different periods of history. In the twenty-first century, the Duchess's

'musaeum' has been recreated in the form of 'cabinets of curiosity'.[43] These are outsize chests of drawers, painted black. Each drawer has a glass top under which sit some of the Duchess's treasures – including Cromwell's campaign pillow and nightcap and Mary Queen of Scots' pincushion. The presentation conveys a very twenty-first century sense of the Gothicized artefact. This is Gothic as heritage mode: 'Gothick' inflected with 'Gothic'. In this mode, objects are imbued with talismanic significance and a dark aura, are understood in relation to long-dead owners and unfamiliar aesthetics, and are strangely out of sync with their recontextualized surroundings. It is a potent blend of Gothick as romantic history, with a more contemporary understanding of Gothic – in which the past is framed and given a touch of disturbing alterity.

'My goodness me! Time to move on, I think': ghost management at Berry Pomeroy

Despite startling differences, most notably of scale, there are some strange comparisons to be made between the trajectories of Berry Pomeroy and Warwick castles. Both, for instance, after many years of tourism, came under new management in 1977. In the case of Warwick, the new owner and manager was Tussaud's (later to merge with Merlin). Berry Pomeroy, though still owned by the Duke of Somerset,[44] was given to English Heritage to manage. As far as Gothic tourism is concerned, however, the similarity ends there. At Warwick Castle, a great amount of money has been spent in recent years on creating new attractions and theming particular zones within the building in accordance with the Gothic aesthetic. Berry Pomeroy Castle on the other hand is more likely to discourage Gothic tourism. As English Heritage's web page for the building grudgingly states: 'Even today, perhaps unfortunately, Berry Pomeroy is promoted as 'the most haunted castle in Devon'.'[45]

As noted in the previous chapter, in the years following English Heritage's assumption of the management, new information emerged about the castle. Extensive excavations in the early 1980s indicated that Berry Pomeroy had not been a Norman castle, and that it had once contained what was being described as a 'Renaissance palace'.[46] The remains of a five-arched loggia, 213 feet long, that would have fronted the three-storey building, were revealed, as were the remains of 'life-size plaster caryatids that may have adorned the chimneypiece of the great hall', and decorative plasterwork from a splendid great chamber.[47] As Kightly points out, the long gallery in the Jacobean wing, 34 feet wide and 213 feet long, was 'among the longest ever built in

England – considerably longer, for example, than those surviving at Hardwick Hall or Hampton Court.'[48] For many who knew it, the castle was suffering the opposite of what, in the vocabulary of interior décor is known as being 'distressed'. It was emerging as a fashionable building. The excavations revealed glamour and unexpected modernity. The more that English Heritage dug, the newer the building seemed to become.

The Berry Pomeroy that was emerging did not fit with local folklore, nor with what had become local practices. The castle had long been providing the opportunity for visitors, especially teenagers and young adults, to put their nerves to the test during nocturnal ghost-seeking forays. In fact, the night-time visit to Berry Pomeroy Castle had become a rite of passage. I spoke to someone who recalled a visit he had made in 1971 as one of a party of six teenagers – boys and girls – from a local grammar school. They had gone to the castle after a party. 'Nobody really wanted to be there' he said.[49] And it swiftly became a Scooby Doo affair. The ordeal started with the walk down to the castle, trying to get past the sleeping occupants of the gatehouse. Once at the castle they were all so frightened that they fled, but ran in the wrong direction and didn't reach their homes till dawn. Someone else I spoke to had made a night-time visit as a teenager in the late 1960s and seen Lady Margaret with her head under her arm.

Through much of the twentieth century, the interest in Berry Pomeroy's ghosts was primarily local, but ghost traditions at the castle have had an adrenaline shot in recent years. By such means as the *Most Haunted* programme and the Internet, Berry Pomeroy Castle is firmly on the paranormal map. Ghost tourism at the castle takes a variety of forms. The site manager[50] told me that she received phone calls from people requesting paranormal visits; she said that visitors claimed to have seen ghostly 'fire' on the lawn and cavaliers on the drive. Big groups sometimes congregate outside the castle in the middle of the night. She recounted one such occasion when, as a group was calling out 'Ralph! Ralph!' (requesting the eleventh-century Ralph de Pomeroy to make an appearance), a figure suddenly emerged from the gateway – to shrieks and screams. It turned out to be the security guard.

Berry Pomeroy might well be described, to use Kate Ellis's term, as a 'contested castle'.[51] English Heritage's custodianship was proving to be problematic for some local people, and for others who had been visiting the castle for years. The new discoveries did not accord with local folklore and the local imagination, and altered rights of access had an effect on ghost-hunting traditions. Conversely, visiting habits associated with

the castle's reputation as a haunted locale were to cause problems for English Heritage, who face security and Health and Safety nightmares, if people break in and light fires, or attempt to scale the cliff face. So what does English Heritage do with a castle that is supposed to be haunted? How does it deal with its 'haunted' reputation and the whole vexed question of its ghosts? How has it approached this question in the past – and do its past strategies differ from its present ones? Can it have any use for Gothic tourism?

In preparation for writing this chapter, I visited Berry Pomeroy Castle at Easter 2013. It was a day remarkable for its weather, even by English standards: whilst I was en route it was raining, by the time I arrived, the sun was shining, and as I toured the castle it started hailing. There were primroses on some of the banks within and surrounding the castle. At the ticket office, which is in a neat and unobtrusive one-storey wooden building that also houses the shop, I bought the guidebook and, on this occasion, took the audio guide, which, the site manager told me, had been declared 'excellent' by many visitors.

The Berry Pomeroy visit is a quintessential English Heritage experience: quiet, understated, with room to navigate via the sensibilities and the imagination. Unlike Warwick, its information boards are written for adults rather than children. There are no dressed up actors, and I did not feel that my gender or my age precluded me from visiting any part of the castle. As an experience, it is not accompanied by warring soundtracks. Rather there is a predominating quietness; birdsong from the woods (sometimes disorientatingly supplemented by birdsong from the audio guide) and, periodically, in the distance, the whistle of a steam train (Berry Pomeroy Castle is in the vicinity of the Dart Valley Railway). An appeal, however, to the Gothic sensibility is not absent from English Heritage's presentation of Berry Pomeroy Castle. It is to be found in the audio guide.

Berry Pomeroy's audio guide starts with a burst of medieval music – of the authentic rather than the film soundtrack variety – and proceeds to introduce the castle in a way that kills, as it were, a few birds with one stone. The castle is introduced not only as a historic building, but through a dominant aesthetic filter ('The romantic ruins of Berry Pomeroy Castle')[52] and through its ghost reputation ('also notorious as the most haunted castle in England. We shall find out more about that later on'). Like many other audio guides, Berry Pomeroy's supplements the presentation of historical information with performance. In the terms of the vocabulary of heritage management, this is 'interpretation' as opposed to 'presentation'. There are two main voice actors on the

audio guide, one male and one female, and they play in a variety of modes. They act in the present – as contemporary guides of the kind who are reasonable, helpful and attentive and utter phrases like 'But be careful as the steps are very steep and uneven' in RP English. They also perform in a second mode, as characters from the past: the introduction over, the listener is put into the hands of a fictional character ('now let's meet a member of Lord Seymour's staff'), a steward who becomes the means of recreating some of the past life of the castle. The voice actors are also heard playing in a third mode, which is inflected very differently.

This third mode is that of Gothic. The audio guide features two ghost stories, presented as inset narratives and relayed in quite an ingenious fashion. After the description of the gun-ports in the guard tower, given against a background of footsteps, cannon firing and a soldier barking orders, the listener is told 'But we mustn't leave here yet. Oh no! You still have to find out about the ghost.' The ghost stories are introduced by the Doctor Farquhar, known, as discussed in the last chapter, through the *Whychcotte of St John's/Haunted Houses/Annals of the Seymours* route. 'Good day to you' says a voice with rich, clipped, slightly sinister tones and a tendency towards falling intonation. 'I am Dr Walter Farquhar and I have first-hand experience of the ghostly inhabitants of this castle.' The first ghost to be introduced is the White Lady, Margaret Pomeroy, who speaks with nicely exaggerated pathos. There is plentiful use of sound effects – thunderous noises of dungeon doors, the clanking of chains. At the end, to underline the moving away from the Hammer House of Horror mode, comes a genteel: 'My goodness me! Time to move on, I think.' The second ghost introduced is the Blue Lady, and some of the wording is drawn directly from the account which originated in *Whychcotte*. She is described as 'a beautiful woman ... wearing fine clothes, but looking most distressed and wringing her hands in anguish' and we are told that '[d]riven to a hopeless despair by guilt and shame, she smothered the child, and her anguished figure has been seen on several occasions ever since, walking around the castle.' Farquhar claims 'I give you my word that I do not lie!' Then, back comes the sensible narrator: 'I'm rather glad we won't be here when it's dark, the slightest noise would make me jump out of my skin! Let's move on quickly!'

Within the audio guide, English Heritage has found a way of both introducing and simultaneously *managing* the popular ghost story tradition. This process has involved several decisions: which ghosts to draw upon, how to frame and delimit the stories, how to inflect

the presentation. The ghosts picked are, arguably, the oldest and most respectable. The White Lady has been around longest – and has a literary pedigree; the Blue Lady is mentioned in a respectable source associated with the history of the family who have owned the castle since the sixteenth century. The material is delivered by means of a Hammer pastiche, making use of extravagant sound effects, such as winds, groaning and thunder and employing a deliberately stilted literary style characterized by phrases like 'rack and ruin' or 'save a few rooms'.[53] The pastiche mode and over-blown style not only cater to a sense of irony, campness and fun, but point to the distance of Gothic from the dominant mode of the guide. Care is taken to separate the inset mini-dramas from the more respectable acts of interpretation provided by the steward, and from the main guiding of the present. The scenes are delimited in terms of introductions and conclusions. ('Ah yes, indeed. Dr Farquhar at your service once more'). The presentation of ghost tradition through the Gothic, or rather through Gothic pastiche, means the stories are framed in terms of fictionalization. The use of Gothic here can perhaps be read as a prophylactic. The use of the story-within-a-story framework, the deliberate situating of the narrative within a readily understandable Gothic mode – the Hammer House – has the effect of casting it into the realms of art and fiction. In the audio guide, English Heritage has found a way both to incorporate and demarcate the ghost traditions in relation to the castle – a way that is both discreet and discrete. To read it another way, one might say that English Heritage's framing of the castle's ghost traditions through its audio guide is part of a cunning scheme to use the Gothic to keep ghost hunters at bay.

Conclusions

Gothic tourism in heritage sites is flourishing. It appears in a remarkable variety of forms – from Gothic banquets to audio-tours, Dungeon attractions to site-specific theatre – and new forms (the Poison Garden, for example) are constantly being invented. At Warwick, where the visitor experience is heavily dependent on film and television references, and consumer branding is dominant, Gothic is almost a brand of its own (literally so in the case of the Dungeons), favoured because of the ease with which it can be consumed and because it fits so well into the performance aesthetic that dominates here. Warwick, under the management of Merlin, specializes in the kind of commercial Gothic associated with the body, noise and adrenaline hits. Significantly, it was

the only castle I visited to offer Gothic consumption – in the form of the banquet. Halloween provides an occasion to take the experiential trajectory even further, in the form of participatory performance commissioned from celebrated scare attraction creators. Gothic at Alnwick and Berry Pomeroy is modulated very differently; though 'experiential' tourism is increasingly favoured, raw appeal to the bodies and appetites of visitors is shied away from. Noise, in typically English fashion, is a good indicator of the class of the attraction: away from Warwick, Gothic tourism tended to be quieter.

Gothic is an increasingly popular choice for heritage managers. As marketing teams know: it sells. It provides a way in: a code, a body of knowledge, glamour. However, because of its pre-set narrative arc, its demonizing of the past, its potentially one-sided take on 'history', recourse to Gothic is potentially a dangerous strategy, and heritage organizations in England (and the world over), or at least the academic members of them, have a distrust of it – especially that associated with commercial modes. Thus, many heritage sites court Gothic, using its narratives and imagery to appeal to visitors and potential visitors, but, typically, also seek to contain it. Alnwick's Poison Garden is a good example of this tendency. Its black railings are both a part of its Gothic content (its frame materialized), but also a means of making sure that it doesn't spill over into the rest of the garden. Alnwick's attitude to Gothic can also be read through the tourist geography of the castle. In contradistinction to Warwick, which placed Kingmaker at the oldest part of the castle, Alnwick, for the most part, keeps its Gothic (and Gothick) attractions a distance away.[54] At the centre of the castle are the state rooms with their magnificent art collection. A non-contaminating distance away, in some of the more modern buildings, are the Quest buildings and the Lost Cellars. At its periphery sits its more rareified Gothick.

In recent years, state- and public-funded heritage organizations have become far more willing to deploy Gothic. Their primary recourse has been to the figure of the ghost. Ghosts have become an integral part of the National Trust's tourist strategy.[55] In comparison to the kinds of ghosts that may be found at Warwick, however – malevolent spirits to be experienced (and performed) in the darkness, and designed to make you scream – the Trust's 'ghosts' are quieter, relatively well behaved and much easier to manage. They are the ghosts of story, not embodied, but required to be imagined: a barometer for the visitor's heightened sensibilities and aesthetic feelings. Ghosts and ghost stories make a powerful marketing tool for the Trust. Not only do they have popular

appeal, but they are also intimately tied to their locality and to specific historical incidents. Just as usefully, they come with an established tone and framework – one that is specifically literary – ready wrapped, as it were. Since 2006, the Trust has been publishing its own book of ghost stories: *Ghosts: Spooky Stories and Eerie Encounters*. The National Trust website has a page dedicated to 'Ghostly encounters' on which the reader is told that:

> The many old houses, castles and abbeys that we care for are full of things to look at. But at a number of our places you might also get to see a little bit more than you bargained for.
> Several properties are rumoured to be happy hunting grounds for an assortment of ghost and ghouls.
> Here are a few of our spooky stories.[56]

The language is interesting. The ghost is added value ('a little bit more than you bargained for') but also strategically neutered: the 'happy' in the phrase 'happy hunting grounds' is significant in this respect.

The National Trust has also been experimenting with other forms of ghost tourism, perhaps taking, as historian Dan Cruikshank suggested they should, a cue from Dennis Severs' House. Cruickshank stated that, despite the fact that the National Trust did not take up the opportunity of acquiring the house, the custodians of heritage are learning new practices from it: 'For years, it was seen as no more than a fantastical folly, but now this bizarre house is changing the way we think about the past'.[57] In the crypt of the National Trust property, Dunster Castle, there is a 'ghost room'. The website advises:

> Next visit the ghost room, if you dare. Heed the warning of 'by all means explore, but do explore with care' given to you as you enter. See if you can catch a glimpse of a ghost lurking in the ghost cellar or use the special torch to unearth the castle's ghostly hot spots. If you're brave enough, take a seat and listen to the ghostly tales of the extraordinary ordinary told by volunteers, staff and members of the Luttrell family. Also take this chance to view our ghostly photographs on display.[58]

There is significant overlap in these lines, between the description of the crypt in general and the ghost room. This is because the ghosts of Dunster's ghost room are a kind of conceptual ghost, best understood as manifesting a certain attitude towards heritage: a kind of heritage

fetishization that is profoundly influenced by the discourse of Gothic. The ghost room highlights the tendency within some areas of heritage experience, to think of former occupants as ghosts and to react with objects from the past, as uncanny things. As with the Duchess's 'Musaeum' recreated at Alnwick, this is a marriage of Gothick with Gothic. In such displays, the object in presented in inverted commas, as it were. Objects are understood as Gothic, but it is a Gothic of discourse, without narrative. The past is felt to inhere within such objects, which are associated with the frisson of mortality, displacement and uncanny survival. Objects are presented so that the very air around them, and the shelves on which they rest, become part of their Gothic framing. This is the Gothic of the outmoded museum – or the museum as a Gothic repository of outworn knowledges and technologies. In terms of the National Trust it is a mode that complements its world of tea-shops and chintz and, I suspect, might be seen by many as a welcome antidote to it.

When I started with the idea for this chapter, I had expected to find more clear-cut distinctions between Gothic tourism in different economic sectors. Whilst prepared for the Dungeons at Warwick, I had not expected the Lost Cellars at Alnwick, or Berry Pomeroy's audio guide. Heritage management, I found, was a much more fluid, changeable sector than I had anticipated. Although at the time of my visit in 2013 Berry Pomeroy's only concessions to the Gothic were in its guidebook and audioguide, I discovered that these were not English Heritage's only experiments with specifically Gothic material at Berry Pomeroy Castle. In the early years of this century, there had been at least one Halloween ghost tour as well, of course, as the *Most Haunted* visit. For a few years there were ghosts walks every second Tuesday in May. These have all been discontinued, as indeed have the medieval re-enactments that happened there for a couple of years. Interestingly enough, the reason wasn't so much ideological as economic. Berry Pomeroy is a small castle and the ghost walks, even at £6.50 a head, weren't paying for themselves.

Writing this chapter I found that the terms of reference I wanted to use were inadequate. Although I was set to talk about institutions, often, I realized, I needed to talk about people. Despite being able to write about English Heritage with capital letters, and to refer to 'locals' (with a small 'l') sometimes the two were one and the same. Nowhere does this become more apparent than when the heritage building being discussed is situated in or near a small town. Sometimes, the fluidity of a small town economy is mirrored in extremely porous boundaries

between official heritage management and popular ghost traditions. In one small town I visited, a member of staff of an English Heritage property had an active interest in the paranormal and led the local ghost walk.

Former English Heritage guidebooks to Berry Pomeroy were only concerned with the history of the castle and the families connected with it, and the building of the castle itself. This was in stark contrast to the Mortimer brothers' guidebooks, which were replete with literary quotations and legends. The most recent English Heritage guide by Charles Kightly, however, includes reference to nineteenth-century works of fiction associated with the castle, mentions its ghost traditions (if only to counter them), and has an early twentieth-century photograph of a spectre patrolling the walk.

Referring to ghost traditions ticks a few boxes for heritage managers. Issues of inclusivity, accessibility and engagement are paramount nowadays. As Charles Kightly writes, in English Heritage's *Conservation Bulletin*:

> The principal aim of most recent developments in interpretation is not only to entertain but also to involve visitors, and make historic sites relevant to ordinary people ('hard-to-reach groups', to use current jargon, being an especially sought-after target).[59]

Referencing ghost stories can be a useful strategy in the marketing of a heritage site, particularly as a means of appealing to 'hard-to-reach groups'.

The inclusion of Gothic material at such sites as Berry Pomeroy, and at other English Heritage and National Trust properties, not only reflects the strategies of these organizations' marketing teams, it also gestures to a new set of priorities within heritage management. In the field of heritage studies there has been much recent emphasis on the 'significance' and 'communal value' (defined in a recent English Heritage document on conservation as people's identification with place)[60] of heritage sites. The Ename Charter, ratified by ICOMOS (the International Council on Monuments and Sites) in 2008, stresses the need for engagement with 'living cultural traditions', advising that '[i]nterpretation and presentation should be based on evidence gathered through accepted scientific and scholarly methods as well as from living cultural traditions'.[61] The Charter also advises that '[i]ntangible elements of a site's heritage such as cultural and spiritual traditions, stories, music, dance, theater, literature, visual arts, local customs and culinary heritage should be

considered in its interpretation.'[62] References to ghost traditions in the most recent Berry Pomeroy guidebook, and the incorporation of the ghost stories in the audio guide, are indicative of a new and enlarged idea of what constitutes heritage. Berry Pomeroy's ghost traditions, though they might not be of particular antiquity, are treated as part of the developing history of the place. Official mention of the ghost stories reflects an idea of heritage that is inclusive of popular and local tradition. As a literary critic, I also hope that such presentation strategies gesture to a new – or rather renewed – awareness of the importance of literary and folkloric traditions to heritage sites.

7
'"Boo" to Taboo': Cultural Tourism and the Gothic

In this chapter I will be thinking about Gothic in cultural tourism, look-ing at the Gothic content that was to be found at a sample of English arts festivals between 2009 and February 2015. Of the three festivals I focus on, two are publicly funded: the Norfolk and Norwich Festival and Showzam! ('Blackpool's Annual Festival of Circus, Magic and New Variety').[1] The third, Glastonbury Festival of Contemporary Performing Arts,[2] is not a publicly funded event, though it has a specific remit in terms of charitable giving. I will be considering the kind of content offered at these festivals, the genres favoured and the audiences aimed at. En route, I will be considering the status of certain kinds of Gothic, and its use by the great and the good: charities, educators, arts funders, councils and other spenders of public money. The way these festivals employ Gothic content, I argue, can tell us about the place of Gothic in a wider public psyche, and in the cultural politics of contemporary England (and the UK more generally). In the following sections I will be considering family-friendly Gothic at the Norfolk and Norwich, municipal Gothic at Showzam!, and Gothic consumption (and Gothic redemption) at Glastonbury.

Norfolk and Norwich festival: family-friendly Gothic

The Norfolk and Norwich Festival is a two-week long affair in May, which hosts a 'world-class programme'[3] of theatre, dance, music, literature and the visual arts. Its principal funders are Arts Council England, Norfolk County Council and Norwich City Council. Acts in recent years have included (in no particular order) the Kronos Quartet; rock and classical musician John Cale; jazz musician Hugh Masekela; folk musician Liza Carthy; the Spanish National Ballet; actor John Hurt

in conversation with his teacher, John Granger; poet Wendy Cope; and novelist Will Self. Publicity for the festival focuses on the language of positivity, growth and personal development: 'Norfolk and Norwich Festival aims to use the transformational nature of the arts, culture and creativity to bring about positive change for individuals, communities and the spaces in which they live.'[4] It is not particularly surprising to find that, amongst its many and varied acts, there is little that could be described as Gothic. There is, however, some Gothic content and, significantly, it can almost entirely be found under the 'Family' listings: in the 'Museums at Night' events; in some of the night-time outdoor theatre spectaculars (Basque company Deabru Beltzak's *The Wolves* (2011) and Bad Taste Company's *Faust* (2013), for example); and in some of the walkabout acts based at Chapelfield Gardens (2010).

Gothic is an obvious choice for site-responsive outdoor theatre – especially for those shows designed to be played at night. The spiel for *The Wolves* in the NNF official programme is couched in terms of Gothic affect: '*The Wolves* promises to set your pulses racing and send a shiver down your spine as it weaves its way through the city centre's streets and lanes. Night-time in Norwich may never be the same again.'[5] Outdoor promenade shows like *The Wolves* (or *Arquiem* or *Crowley* from UK-based Periplum) make the town itself perform. They gravitate towards cathedrals and filter through narrow lanes, playing with the sense of the town's temporality and its topography, as well as the spectator's own vulnerabilities and sensitivity to shock and orchestrated obscurity, whether, as Periplum have it, they are 'detailing the delirium of a fevered mind or the vast workings of a social revolution'.[6]

Gothic in outdoor promenade performance is one thing; the deployment of Gothic in entertainment in museums is a rather different kettle of fish. The annual 'Museums at Night' events are not confined to Norwich but are part of a nation-wide (and European) drive to increase attendance at, and interest in, museums and other 'heritage venues'.[7] Many museums host sleepovers which feature the telling of ghost stories. At NNF 2011, the advertising for Museums at Night was particularly Gothic. The main venue was Norwich Castle Museum and Art Gallery, which became 'the spectacular setting for a night of entertainment and discovery.'[8] As the sales pitch for this (free) event ran: 'From chilling tales in the dungeons to tours of the battlements by twilight, this is a chance to explore the nooks and crannies of this fascinating building.'[9] The experience promised to present Gothic thrills grounded in Norwich's real history: its selling point was 'ambience'.[10] The personnel involved included performers (both actors and musicians) but this was also to be

an educational experience – an opportunity to try out 'creative crafts,' talk to curators and handle some of the museum's artefacts.[11]

Increasingly those involved in the marketing of museums have enlisted the Gothic as a mode of mediating history. Like the presence of Gothic in outdoor promenade, this is in some respects an obvious move – after all, many museums themselves are the antiquated location-bound spaces where Gothic narratives have thrived (Norwich Museum, for example, is the old Norman Castle). Gothicization (particularly Gothic inflected as time travel) has become a dominant approach in the 'edutainment' project of selling history to a young audience, despite the fact that Gothic is a potentially difficult mode to negotiate for the historian. A trailer for a film created by Sky Arts for 2011's 'Museums at Night' project is notably Gothicized[12] (see Figure 7.1). Throughout the trailer a Gothic approach is privileged – even at the expense of other content. There is a Gothic sci-fi soundtrack in the style favoured by Murray Gold for BBC's *Doctor Who*. The first shots are of the outside the Old Operating Theatre (Southwark, London) and they are followed by a shot of a skull and the superimposed words 'Museums are the closest we will ever get to time travel'. At this point, passing mention is made to Renaissance painting – still to the Gothic sci-fi soundtrack. Having nodded to the Renaissance, the trailer returns to its Gothic trajectory, and subtitles pose the question 'But what happens … when the museums

Figure 7.1 History as Gothic Spectacle: 'Museums at Night'. Courtesy of Sky Arts

shut their doors...? And the galleries turn off their lights[13]?' The words are rather incongruously placed over shots of the inside of the National Gallery. The approach to purveying history to the young is similar to that shown by the CBBC programme *Relic: Guardians of the Museum*, which employs a gameshow format together with strong elements both of fantasy and Gothic.

The last on the list of the Gothic fare at the NNF is the Gothic walkabout. At NNF 2010, the company Stuff and Things presented two of their walkabout acts: 'Futter's Child' (a 'Walkabout Mime Act With Soundtrack')[14] and 'The Lost Funeral'. Walkabouts are a particularly curious phenomenon in terms of Gothic performance because they are usually performed in daylight and are divorced from a particular place. Indeed, they transfer between locations with impressive ease. At NNF2010 these acts appeared in Chapelfield Gardens; they have also played on Queen Street, Cardiff (at the Cardiff Street Festival); in the theatre field at the Glastonbury Festival; in Chelmsford's Shopping Centre and, in the case of 'The Lost Funeral', on the South Bank as part of the National Theatre's 'Watch this Space' festival, 2014. There is even a picture of Futter, with child in perambulator, walking the Great Wall of China.[15]

'The Lost Funeral' is Stuff and Things' 'head-turning comedy walkabout show' that features 'Ernest Potts & Reginald Fowler – two incompetent, irreverent and yet excessively charming undertakers'.[16] In 'Futter's Child', the Igor-like Futter is 'doing his best to look after a rather challenging baby' ('Horrace, the anatomically-accurate noisy infant ... animated with jiggling arms and beautiful eyes that can be remotely triggered to glow red') with 'a small arsenal of unorthodox paraphernalia ... soft toys impaled on a kebab skewer, a "medieval" rattle and disconcertingly similar bottles of gripe water and embalming fluid!' (see Figure 7.2)

In both acts Gothic imagery and content are refashioned into family-friendly comedy. Even though the narrative of 'The Lost Funeral' is revealed ultimately to be one of attempted murder and live burial, the act, as the website has it, puts the '"fun" back into "funeral" and says "Boo!" to taboo.' The blurb for 'Futter's Child' notes: 'While there's a subtle dark undercurrent to the performance (would you employ him as your nanny?) the emphasis is firmly on comedy, and laughs are plentiful.' Despite the online review of 'Futter's Child' from a 'Teenage Goth' ('Now that's what I call REAL Goth!'),[17] this is not 'Goth' as many would have it, but a 'unique world of love and horror – the quirky world of a misunderstood lovable misfit Connecting with both the parent and

Figure 7.2 Bert Eke as Futter in Stuff and Things' walkabout act 'Futter's Child'. Courtesy of Bert Eke

the child within us all.' An internet image search for 'Futter's Child' brings up a wealth of photographs of delighted punters. This is Gothic that is very largely devoid of traditional Gothic affect: the racing pulse and shivers down the spine as promised by Deabru Beltzak, for example.

The blurb for 'Futter's Child' points up the popular cultural ancestry for 'Gothic slaphead Futter' who appears 'to have evolved from the same gene pool as Uncle Fester from the Addams Family' and whose miming is in itself reminiscent of the age of silent movies. Contemporary Gothic performance interpolates an audience that has a strong sense, not just of the history of the entertainment that they are watching, but of its treatment on the big and small screens. At arts festivals the imagery most frequently adverted to is that of horror in early twentieth-century film. As opposed to contemporary Gothic in cinema, whether terror or horror, which continues to stimulate the required Gothic affects at ever increasing levels, early twentieth-century Gothic has, as it were, become downgraded in terms of the fear factor. The imagery associated with it has thus come to occupy an interesting cultural niche. It can signify fear without being frightening. Much live performance that draws on such

content and imagery has thus come to be seen as suitable for family viewing. This is even so in the case of content that might in other circumstances be considered unsuitable for children. *The Circus of Horrors*, for instance, despite its sexual content and freak show aspects, always has a number of children in its audience. In May 2011, it featured on ITV's *Britain's Got Talent* (making its way to the semi-finals).

For these walkabout acts, and for contemporary culture more generally, the imagery of old-fashioned horror has become a useful common language that embeds both children and adults in a shared history – that of popular culture. Family-friendly Gothic (the walkabouts, the Museums at Night events and the BBC's *Relic*) appropriates a Gothic that has become the mark of a particular kind of cultural literacy. What is more, the history of twentieth-century popular culture has achieved a level of respectability that chimes well with the kind of performances that publicly funded arts festivals want to host: performances that are not only entertaining, but assume and impart a certain level of education. The cultural positioning of Gothic at these events is, in some respects, elitist. Its very status as popular culture has, paradoxically, gained it more than a veneer of respectability.

Showzam! regeneration and the gothic

As the blurb for the Norfolk and Norwich Festival points out, one of the given reasons for a town or a city holding a festival is 'increasing its national and international profile.'[18] A festival is also supposed to communicate something about the identity of the place that hosts it. Thus, the Norfolk and Norwich (less than keen to play up to Norwich's 'white city' cliché) with its many international acts highlights the city's historic openness to the rest of the Continent. The case is somewhat different for Blackpool, a town with a history as a capital of popular entertainment, and an even more recent history of decline. As Kate Burt wrote of public perceptions of Blackpool in *The Independent* in 2008 'the seaside town had an image problem: people were more likely to think of it as a tacky playground for hen and stag parties than a centre of culture.' She also noted that Blackpool 'has a staggering 23,000 theatre seats to fill each day, and was failing to do so.'[19]

Showzam! is part of Blackpool's solution to the problem of the town's decline. It takes place outside the festival season, in cold and rainy February and its date seems to mirror the town's concerns about being outside the mainstream when it comes to the viable modern entertainment industry. The Visit Blackpool website (as might be expected of the

town's official tourism website) is optimistic about the positive effects of Showzam! announcing in March 2011: 'Blackpool's Showzam! Proves To Be Tourism Tonic For Resort.'[20] The words of Councillor Maxine Callow (Cabinet Member for Tourism and Regeneration on Blackpool Council) allude to the thinking behind Showzam! She comments that the success of the festival 'demonstrates that it is possible for Blackpool to attract new audiences without losing touch with it's [sic] much loved cultural traditions for which we are famous the world over.'[21] Showzam! is Blackpool's attempt to raise its present-day profile in terms of its past. It is not only Blackpool's attempt at regeneration but, to use a more Gothic metaphor, revivification.[22]

Showzam! features a variety of acts in genres associated with Blackpool's glory days – it is a 'Festival of Circus, Magic and New Variety'.[23] As might be expected, it has a Gothic component. *Circus of Horrors* played the Grand Theatre in 2011. Spymonkey's *Spookshow* played the Baronial and Renaissance Suite in 2013 and 2015. Each year, there is also, at 'Showzam Central', a range of fairground attractions, some of which are very Gothic in themselves, but all of which, by their very context, are, Gothicized. 'Showzam Central' is situated in Blackpool's Winter Gardens (officially opened in 1878, bought by Blackpool Council in 2010). In February 2011, it hosted Pinball Geoff's collection of slot and pinball machines ('some dating back from the true inception of pinball, through to its golden age in the 50s, 60s and 70s');[24] Mike Diamond's museum of curiosities (the gruesome contents included a shrunken human head); Al Stencell's collection of sideshow banners from American Carnival; the Insect Circus Museum; a contemporary version of Tom Norman's Travelling Palladium Show;[25] and a collection of sideshow acts: 'The Living Half Lady'; 'The Mummy' 'Electra – One Thousand Volts' and 'The Butterfly Girl'.

The sideshow acts, with their technology of lights, mirrors and van der Graaff generators, were originally created in the 1950s by Jon Gresham, and have been recreated by Jon Marshall of Sideshow Illusions from photographs, and in consultation with Pat Gresham (Jon Gresham's widow). 'The Mummy' is a rip-roaring show which has its audience placed in a mock-up of an Egyptian archaeological dig, subjected to overpowering sound and watching a beautiful dancing Egyptian girl – soon to change into a Karloff/Chaney-type frenzied Mummy. 'The Butterfly Girl' chases the lighter side of exotica with another lovely lady situated in a strange land and stranger situation. 'The Living Half-Lady' marries illusion and soap opera comedy. 'Electra' stages the meeting of yet another lovely girl with the 'greatest energy on Earth'.

Figure 7.3 Sideshow Illusions' restoration of Jon Gresham's original 1950s Headless Lady Side-show. Jon Marshall (right) and Tim Cockerill. Courtesy of Jon Marshall and Tim Cockerill

The sideshow performances occupy a multiple-framed cultural niche. 'The Mummy' sits, generically speaking, in a frame established by the Universal Studio's Mummy films. 'Electra' belongs rather to the science-fiction/Gothic crux of 1950s cinema. The spiel for 'Yvette – The Headless Lady' (see Figure 7.3), seen at Showzam! 09, emphasizes this context: 'Twilight Time Thrills and Chills! ... Yvette is kept alive by the miracles of modern medicine. Well, modern as in all those glorious 50s Sci Fi B movies'.[26] Inevitably for modern audiences, the sideshows are situated within a cinematic understanding of the Gothic nature of the fairground itself, and in particular the 1950s fairground. The context of Blackpool's Winter Gardens provides a third frame. Originally designed for the fairground, to be played to paying audiences, outside, these sideshows were now playing inside, for free. This was not just any 'inside' either, but Olympia in the once-fabulous Winter Gardens that had, through this process, been transformed into a museum of entertainment. Curiously, this had the effect of Gothicizing the Winter Gardens, giving them a *Carnival of Souls* atmosphere of the fairground trapped in time. The carpet, where no

carpet should have been, managed to feel slightly damp and musty; where winds should have blown there was a ceiling. As well as being spectators of the illusions before them, the audience was partaking in another illusion. Watching what was a resurrection of an act that had once taken place in a commercial environment, many audience members, watching this free family entertainment, also found themselves acting. They were acting being the kind of 1950s audience who paid money to see the show.

Showzam! knowingly presents not only the Winter Gardens, but also the town itself, as a kind of showcase for a history of popular live entertainment. There is of course a sense in which Gothic texts over a variety of media/genres have often acted as a kind of showcase of old genres, and this is something that makes Gothicization particularly appropriate here. What is happening at Blackpool, however, is not a wholesale Gothicization. Rather, at Showzam Central, and throughout the festival more generally, it is possible to see the way in which Gothic has become an entertainment choice, a mode which has become part of our sense of history rather than a discrete mode of viewing history. Freak shows sit comfortably with pinball machines, comedy and science fiction. Gothic has inextricably become linked to our sense of the history of popular entertainment, not only in terms of content, but also in the way that the whole decline of the fairground and the circus is seen as a narrative with a Gothic trajectory. The far side of this Gothic trajectory is, however, the current resurrection of and fascination with circus and fairground genres. And it is this fact which enables 'entertainment Gothic' to lend to our sense of the past, a glittering dark patina of Gothic stylishness. The Gothic history of live entertainment has become subject to a degree of nostalgia.

Showzam! is the brainchild of Professor Vanessa, aka Dr Vanessa Toulmin, the Director of the National Fairground Archive at the University of Sheffield. In contrast to the NNF, much of the funding coming into the festival is not specially designated arts money but regeneration funding.[27] Showzam! is, or has been, hosted and funded by Blackpool Council, the Northwest Redevelopment Agency, by Blackpool Theatres, various other commercial sponsors, and the University of Sheffield. In fact, Showzam! itself is the product of an Arts and Humanities Research Council funded project – Toulmin's Admission All Classes – set up to 'revitalise the entertainment and cultural industry quarter'[28] of Blackpool. Since Admission All Classes was first set up, it has also been commissioned by Sheffield and Rotherham. Blackpool has co-opted the Gothic in its attempts at constructing its

new civic identity, and is innovatively inventing an Academy-funded Municipal Gothic.

Glastonbury: Gothic consumption

Glastonbury and Gothic seem almost mutually contradictory terms. Glastonbury Festival, the world's biggest music festival, is associated in the popular imagination with its hippie past, with the summer solstice, with mud baths, with vast crowds gathered in front of the Pyramid Stage, and seems to have little do with the Gothic. Indeed, the idea of Gothic at Glastonbury is inherently problematic: at a festival where mind-altering drugs are prevalent, Gothic could mean a very bad trip.

There has, however, been a fair sprinkling of Gothic at Glastonbury in the theatre and cabaret fields. There has been Gothic-themed Circus, Gothic walkabout acts (Futter's Child played in 2008), museums of curiosities (the ubiquitous Insect Circus Museum) and Gothic-inspired dance (most notably the Cholmondeleys and Featherstonehaughs with their *Dancing on your Grave* performed in the Astrolabe in 2008). In recent years, however, Gothic has been thin on the ground in these areas, though, in Bella's Field, the Insect Circus Museum still holds strong, and the Monsters of Schlock, 'Canada's Kings of Extreme Comedy Magic',[29] played on the Sensation Seekers' Stage in 2013. The absence of Gothic in these areas is, arguably, because certain kinds of Gothic have increasingly been colonized/adopted by the middle ground and the middlebrow. As Catherine Spooner points out: 'In the twenty-first century, the prevalence of Gothic-themed products make it easy to select Gothic as a lifestyle choice, with or without the commitment entailed by participating in Goth subculture'.[30] Those performers who, up to a few years ago, still felt they could still legitimately associate Gothic with sub-cultural Goth (despite the incursions of the advertising industry, themed pubs etc.), have more of a problem exploiting sub-cultural cachet in a world full to repletion of teen-romance-Gothic, and where Andrew Lloyd Webber included a Goth number in his West End spectacular, *Love Never Dies* (2010). Significantly, Monsters of Schlock position themselves within a punk-rock tradition. Gothic has not, however, been evicted from Glastonbury; rather, it has been moved and the festival has acquired its own Gothic geography. Somewhat disturbingly, Glastonbury Gothic is associated with the festival's first one-way system.[31]

Glastonbury Gothic is played out in the after-hours areas, which come into their own after the main music stages close for the night: the

Common, Arcadia, Block9, Shangri-La and the Unfairground. These are themed and curated areas designed for partying between 11 pm and 4 am. The Glastonbury 2014 official programme, announces them with the words 'EXCESS ALL AREAS', and introduces them as 'a world of late-night reverie filled with giant mechanical hands, destroyed Tube trains, tomato fights, zombies, people expelled from Heaven, lightning bolts, acid house, cross-dressing DJs, temples and caves, vengeful bored office workers, jump blues combos, bearded kittens, bizarre cocktails and moustaches for hire'.[32] There is a variety of Gothic narratives to be found in these areas. Shangri-La, ('the after-hours pleasure city of the festival. A futuristic and dystopian wonderland, a *Blade Runner*-inspired urban film-set … a brilliant and bizarre alternative world for you to get lost in'),[33] has, since 2008, been the subject of a continuing dystopic narrative. It has 'suffered a corrupt government, a rebel overthrow, a deadly virus and imminent planetary destruction' and experienced both annihilation and the 'Shafterlife' where 'souls make their ways through Shangri-Heaven and Shangri-Hell, encountering a myriad of contemporary sins on the way'.[34] The 'apocalyptic spectacle' of Block9, has been created out of the stuff of urban nightmares of the more recent past. In June 2014, this field in Somerset contained, amongst other installations, a 'sinister, decaying tower block with a life-size, blazing Tube train bursting from the fifth floor,' and a 'replica of a ruined NYC tenement'.[35] In the massive Arcadia field, a 'trusty Bristolian crew sought to transform abandoned military hardware into environments that celebrate the human spirit.[36] It is, unsurprisingly, the stuff of dystopia that creates the most thrills here – the gigantic spider; the 'Hand Of Man, a 26ft-long mechanical hand and forearm built by Christian Ristow', in a 'cyborg glove', which is capable of picking up cars, crushing them and slapping down the Spider if it gets unruly'; and the 'robotic dragon'.[37] The Unfairground features 'twisted fairground side shows and iconic sculptural madness created by legendary scrap pile art and party collective the Mutoid Waste Company'.[38] Shangri-La, Block9, Arcadia and the Unfairground all share a cyber-punk/Mad Max aesthetic of the glamour of the non-glamour of urban ruin.

The Common, billed as 'Un Fabuloso Espectáculo', is rather different. 'Somewhere between Mexico City and Salvador, the mystical world of The Common has been awakened … A sumptuous Latino playground filled with the delights of a vibrant planet of decadence. It's home to twisted voodoo parlours, debauched bordellos and criminal party houses.'[39] The Common in 2014 hosted 'Los Artistas Bohemios' (a mock nineteenth-century life-drawing class); the Totem Gardens Stage ('Enter

Figure 7.4 Copperdollar's Maria de la Muerte from 'The Back of Beyond' at Glastonbury Festival 2014. Photo by Moose Azim

into the Underworld, the hidden gardens inside of one of the world's largest caves. Here you will find the guardian who watches over the last remaining codices, keeping them safe, as they hold a secret that could change this reality in a second')[40]; and 'The Back of Beyond' where the company Copperdollar present 'a visual feast of art, music and interactive performance played out in a venue full of atmosphere. When you meet the ghostly carny folk here, you'll find yourself drawn in to their hypnotic world'[41] (see Figure 7.4). The performance crew at this last venue were dressed and made up as glamorous ghosts, whether serving at the bar, or dancing with customers. In previous years, the Common has also hosted the bull-fight-arena the dance area 'Campo Pequeño'; 'The Lost Picture Show' (a cinema, serving cocktails and popcorn, swathed in red velvet); Ken Fox's uninsurable motor-bike spectacular – the Wall of Death; and 'La Arcada de Adivinos' (a museum of mechanical fortune-telling with some very funny live performance).[42] The theme of the Common, in 2014, was the 'spiritual folklore' of Latin America, a 'lost civilization with a secret'. The Common became a place where 'Magic symbols swirl and ancient codices are brought to life in a fusion of tribal technologies never before witnessed.'[43]

Apart from at the Common, Glastonbury's performed Gothic is in some respects, despite its lavish dressing, pretty denuded. The narrative aspects of Shangri-La, Block9, Arcadia and the Unfairground are practically nil; many of these areas are not even performed. Within the installations, many of the spaces are no more than surfaces; many of the venues that seem to promise labyrinthine exploration, are merely large dark rooms. There is a dominant aesthetic of gigantism – associated with the technological feats involved in erecting massive concrete tower blocks, or moving army tanks around the site – but little is left to obscurity.

Like the Gothic walkabouts, without being quite as family friendly, this is Gothic without traditional Gothic affect. Glastonbury Gothic, rather than a performance mode, is an entertainment mode, a Gothic of consumption. It has been designed for the enjoyable consumption of drink, dance and drugs and even, in the case of one of the installations in Block9, a meal (one serving a day). Despite appearances, often what is being consumed is singularly innocuous. Glastonbury's after-hours Gothic is anything but thoroughgoing, shorn of narrative, affect and hybridized to the point of generic melt-down. It is Gothic as style and Gothic as the excess of consumption. The very choice of Gothic signifies the luxury of abandon and indicates the prevalence of new types of drugs – recreational rather than mind-bending. Glastonbury Gothic is based on the premise that its consumers are not going to commit themselves to anything imaginatively. I have quoted at length from the copywriters' descriptions of these areas because they play a key part in the construction of these Glastonbury Gothic experiences. As regards these after-hours fields, there is a mutually beneficial collaboration between the language of consumerism and the language of installation. The experience of this place has been copywritten beforehand. In fields where film set has replaced performance, it is necessary for spin to supplement experience.

Conclusions

Gothic is very much alive at all these cultural festivals. It has to be certain kinds of Gothic though. Theatrical performance and, to a lesser extent, twentieth-century film are welcomed in. Programmers are not too keen on programming Gothic music: the fare on offer tends to be very different from that at Whitby's Goth Weekend. Arts Festivals have a preference for certain kinds of Gothic content. Zombies are out, for example, and witches aren't particularly in. Such content as the

dystopic, Mad Max-inspired content to be found at Glastonbury, is, in the main, fought shy of by publicly funded arts festivals associated with towns and cities. Mutoid Waste's 'crawling giant sculptures made of scrap metal' did feature, however, at the closing ceremony of the 2012 Paralympics, directed by Kim Gavin. Comic Gothic is heavily represented at arts festivals linked to towns. The Shrewsbury International Street Theatre Festival in 2009, for example, had a 'historical' tour devised by a group of performers[44] who planned their route round suitable locales, such as Butcher's Row and Grope Lane (formerly known as Grope Cunt Lane). Their 'Torture Tour' included men playing medieval female prostitutes, a 'bed of nails' in the churchyard, and a child, who had been buried alive, brought back to life.

The kinds of Gothic courted by arts festivals is subject to fashion. Environmental Gothic is on the up. NNF2015 promises wolves, and a seemingly Angela Carter-influenced Gothic, in a site-specific landscape piece, WildWork's *Wolf's Child*, an 'extraordinary grown-up fairytale of love and betrayal' that 'opens against the magnificent backdrop of Felbrigg Hall'. Bournemouth's Arts by the Sea Festival 2014 featured Zerelda Sinclair's 'gothic spectacular', *Resurrection of the Sea Brides*. ('What fate became the fifty brides of Bournemouth, last seen disappearing over the horizon at 2013's Arts by the Sea Festival?')[45] Interestingly, *Resurrection of the Sea Brides* played in 'the historic Shelley Theatre and grounds' – a venue associated with Percy and Mary Shelley's descendants. The festival's programming illustrates the extent to which towns and cities have been willing to take on, and foster identification with, Gothic writers and texts. *Resurrection of the Sea Brides* was followed by 'a screening of Ken Russell's post-psychedelic horror film *The Lair of the White Worm*' for 'the full Gothic experience'.[46] Certainly, Gothic provides a meeting point between literature, live performance and the film industry, which is exceedingly useful for festival programmers.

Other Gothics that are 'in' at the moment include Day of the Dead Gothic, which has featured at Glastonbury over the last few years, and steampunk. Steampunk and Victoriana are very much in the ascendant. Norfolk's Dragon Hall hosted the steampunk 'The Company of the Curious' as part of the Museums at Night events, for NNF2013. Victoriana was the focus at Blackpool's Winter Gardens at Showzam! 2014, despite the fact that Sooty, the glove puppet was headlining.[47] There was the Victorian magic shop, Tranzient Gallery's 'Perriman-Batty's Travelling Apothecary', and the 'Palace of Curiosities', with its shrunken heads, peepshows, flea circus, Egyptology and dessicated mermaids – 'All the atmosphere, wonderment and macabre family fun

of a Victorian travelling Fairground curiosity sideshow'.[48] Victoriana is especially attractive because it manages to fulfil so many criteria: it is glamorous, indissolubly linked to literature, and, through steampunk, associated both with fantasy and science. Victoriana/steampunk Gothic makes frequent appearances at festivals with educational intent. The 'Travelling Apothecary', for instance, was originally commissioned for a steampunk exhibition at Bradford Industrial Museum, and has since appeared at events ranging from West Yorkshire Playhouse's 'Transform' festival, to Halloween happenings.[49] The outings of the 'Palace of Curiosities' have been even more diverse. 'Palace of Curiosities' has played at events ranging from Victorian days, literature festivals, Christmas markets and English Heritage gigs, to Dark Dark Cabaret Nights.[50] What is notable is the extent to which the cultural industries are taking on niche content that, at one time, might only have played in a much more narrow range of venues. Material that can play at Goth student clubs is also appearing at history and literary festivals, and at corporate events.

For the cultural industries, Gothic is a useful cultural tool, providing a common language. Gothic imagery and tropes have become a kind of common currency. Outmoded or antiquated Gothic, in particular, can act as a useful signifier and perform a number of significant paradoxes. It can signify 'scary' without actually being scary. It can also signify 'popular' whether it has retained its original popularity or not. This is one of the reasons for its attraction for both those involved in selling us something, and those wanting to educate us. Because Gothic has its desirable 'popular culture' cachet, it is seen as possessing the requisite qualities for those engaged in selling what is perceived as less popular: museums and art galleries. For those involved in providing edifying entertainment to the British public, outmoded Gothic has the advantage of being understood as downmarket, whilst remaining in some ways satisfyingly elitist.

Carrying out research for this chapter, what I have found most surprising is the ability of Gothic to be discontiguated: for motifs, discourse, narrative, affect to be dismantled. Not only may Gothic motifs be shorn from Gothic narratives, but so may the traditional affects associated with Gothic. Gothic cachet may be drawn on without necessarily producing a thoroughgoing Gothic text, in fact hybridization is often the norm, whether it be the Gothic/sci-fi gameshow, or, for me, the most incongruous, the reggae sets in Block9. There is a preference for Gothic which has virtually none of the affects traditionally associated with the mode. As can be seen in

the case of Glastonbury Gothic, the whole 'package' is not required. It is perfectly possible, even desirable, to have a Gothic without chills – and even without narrative. Gothic as accessory might be said to have replaced Gothic as discourse.

Embracing Gothic imagery but ignoring Gothic affect can act as an expression of consumer decadence for the music-festival-going public. But Glastonbury's Gothic is not all about consumer decadence. As the years have passed, Glastonbury's Gothic has been increasingly associated with 'Worthy Causes' (there is a pun here, which derives from the fact that the Glastonbury Festival takes place at Worthy Farm): Greenpeace, Oxfam and Wateraid amongst them. Recent Gothic content at the festival has tended to be worded in terms of narratives of redemption. When, in 2014, Joe Rush 'anticipate[d] the Apocalypse and imagine[d] the "Mutoid Rebirth of the Species" in "A Kiss On The Apocalypse" in the heart of Glastonbury's Theatre & Circus Fields in Glebeland', the installation that featured mutants and automats was framed as 'the explosive rock'n'roll rebirth of a new world'.[51] Likewise, the Common, whilst playing with Gothic narratives of ancient codices, and drawing on Day of the Dead type imagery, has a redemptive meta-narrative in which 'tribal technologies' provide the means for the 'ritual undoing' of 'centuries of cultural brainwashing'.[52]

Glastonbury in 1990 featured the cyber-punk spectaculars of Archaos the French new circus company whose spectacles of horror and the decay of civilizations, went hand in hand with their chaotic, and ultimately disastrous, financial arrangements.[53] Much of the Gothic performance that I have been considering in this chapter is founded on a different kind of economy, and benefits from direct and/or indirect (through the public funding of festivals, for example) arts funding; from regeneration funding; and even, in the case of Showzam!, from university funding. Such was the case with Carnesky's Ghost Train, a reinvention of the fairground attraction. As Marisa Carnesky's website tells us, the Ghost Train was 'part ride, part visual theatre and part scare attraction which cleverly combines contemporary attraction technology with age old theatrical illusions'.[54] Comments on the website, attest to both its prestige and popularity. It has received high-profile endorsement from the likes of Derren Brown ('... definitely worth a visit. It's a scary, intelligent, layered, disconcerting experience'), and Libby Purves, who wrote in *The Times* that it combined 'a cultural classy edge with a lot of enjoyable screaming, Carnesky's Ghost Train is a passionate tribute to war scattered refugee ghosts.'[55] It toured between 2004 and 2009, after which it was 'in danger of grinding to a halt'.[56] At this point, 'to Carnesky's great

surprise and joy Blackpool Council suggested that they wanted to take on the art piece as a permanent tourist attraction on the Golden Mile.'[57] In 2011, the website was proud to announce that the Ghost Train was now 'located in it's [sic] true spiritual home in the heartland of the British seaside – Blackpool, situated opposite Sandcastle Waterpark on South Promenade'.[58] Carnesky's Ghost Train over the years has been funded, commissioned and invested in by the Arts Council of England Nesta, Hellhound, European Cultural Foundation, Warwick Arts Centre, Fierce, Mama Cash, Creative Lewisham Agency, Creative London, and London Artists Projects, as well as Blackpool Council.[59] Carnesky herself is currently Arts and Humanities Research Council (AHRC) Creative and Performing Arts Fellow at the National Fairground Archive at the University of Sheffield. This is all well and good, but is curiously at odds with what could be termed an economic aesthetic underlying much of this Gothic live performance. Part of the attraction of Gothicized quasi early twentieth-century entertainment is our sense of the direct economic transactions (and hardships) of the period. In the Gothicized takes on earlier Gothic that I've been looking at, the transfer of hard cash from punter to performer has in many cases been replaced by the economy of funding mechanisms. In the case of the Ghost Train, the mismatch between the different economies forced closure. As Carnesky puts it: 'Commercial realities, unfortunately, mean that we simply aren't able invest [sic] what's needed in the structure and refresh the experience.'[60]

The fortunes of Gothic at these contemporary arts festivals tell us much about the circulation of Gothic in contemporary British society. One of the most surprising aspects is its respectability. It is courted by educationalists in children's television, by Culture24, by towns eager to present their past so as to secure their future. Gothic has been been funded by regional councils, by the Arts Council, by the Arts and Humanities Research Council, by the University of Sheffield, by aid organizations.[61] All are happy to bed down with the Gothic.

Conclusion

Gothic tourism in England in the twenty-first century is flourishing. Ghost walks are ubiquitous; scare attractions (adept at finding and using temporary spaces) pop up by the dozen; the Dungeons are thriving; the Ghost Bus Tours have set up new Necrobuses. A whole host of ancient prisons (and other 'suitable' buildings) are finding a new lease of un-life, in the forms of paranormal events, and other ghost experiences. Even publicly funded heritage managers are finding Gothic to be a fruitful mode when it comes to interpreting and presenting the properties they have charge of. Gothic tourism is the province of very big businesses and tiny ones. It is employed by councils and by charities. It is practised by volunteers, enthusiasts and fans. Researching for this book was a revelation to me. I had not guessed at the size, extent and range of Gothic tourism. I had not expected to find a Gothic that was so respectable and so family friendly – a Gothic that might be associated (as at Showzam!) with civic regeneration, and could even (as at Glastonbury) be enlisted to help save the world.

Despite the prevalence of Gothic tourism, academic attention to it has been thin on the ground – though there have been some notable case studies in the last few years (such as those of Duncan Light in relation to Dracula tourism in Romania), and the phenomenon of the ghost walk is now attracting commentary.[1] With the notable exception of the work of John R. Gold and Margaret M. Gold, whose book on Scottish tourism since 1750 takes a look at the phenomenon of ghost tourism,[2] the greater part of scholars writing in the field of tourist studies take the contemporary, or late twentieth-century, world as their context. As a result, there has been scant attempt to think about the *history* of the cultural practices dominant within Gothic tourism, and little in the way of considering these practices in relation to a literary or wider cultural tradition. Thus, Gothic tourism

has not really been seen for what it is – a distinct subset within tourism. John Lennon and Malcolm Foley's concept of 'dark tourism' (which refers primarily to tourism of death and disaster sites) does not do justice to the phenomenon despite the efforts of Philip Stone to house it within that category. Stone, in an article entitled 'A dark tourism spectrum: towards a typology of death and macabre related tourist sites, attractions and exhibitions', looks at a spectrum of dark tourism from 'Dark Camps of Genocide'[3] to 'Dark Fun Factories' ('the lightest edges of the "dark tourism spectrum"').[4] Gothic tourism, however, is both more and less than dark tourism. Less, in that, though some of Stone's examples are Gothic, others are not (his list, for example, includes tourism to disaster sites, and concentration camps). More, in that there is more to Gothic tourism than 'Dark Fun Factories' of the Dungeons range type, and its concerns and content cannot be contained within a spectrum concerned with death and disaster.

As I hope to have shown in this book, Gothic tourism has a number of defining characteristics. It is immersive and theatricalized, and tends to be highly intermedial. It is indissolubly linked to Gothic fictions, and it is characterized by its emphasis on affect. Strawberry Hill was the product of a Committee of Taste (a group comprising Walpole's friends and employees, as well as Walpole himself), and, since the eighteenth century, when Walpole's French guests bemoaned Strawberry Hill's lack of seriousness, Gothic tourism has always required a special sort of taste. As Charles Allston Collins' piece on Madame Tussaud's showed, this taste is often considered not only to be 'bad taste', but also potentially harmful to the subject who possesses it.

Today's Gothic tourism too relies on a community of taste – though of course its visitors come from a much broader section of the population. It plays to those already in the know, those who are possessed of knowledge – of a specific body of texts, their conventions, narratives and tropes. Madelon Hoedt notes:

> Brophy's concept of horrality, which assumes both a knowing audience and a knowing product, is a perfect way to harness this idea of familiarity and cued responses, as well as a means to approach the playfulness of the genre. Because the film, or book, or play, knows that the audience knows, these media can play with and subsequently subvert expectations.[5]

Hoedt is writing about scare attractions (and other forms of horror performance), but the point applies to Gothic tourism more generally. Gothic Tourism is associated with fictionalization and demands of its visitors a

complex intertextual literacy. This is as true of the kind of Gothic to be found at arts festivals, and on ghost walks, as at scare attractions.

Gothic tourism has been around for a long time. Its roots go back to the mid-eighteenth century, to a culture with a strong interest in performance, and a penchant for hybridity when it came to the 'sister arts'. Contemporary Gothic tourism could be said to date from Walpole's Strawberry Hill, but it has many other lineages too; from the phantasmagoria shows of the close of eighteenth, and the beginning of the nineteenth centuries; to Madame Tussaud's and other Gothicized waxwork exhibitions; to fairground and circus attractions (whether in the form of ghost trains or freak side-shows); as well as to the eighteenth-century 'Gothick' of such buildings as Alnwick Castle. Despite Walpole's comments on the inability of the French to understand Strawberry Hill, Gothic tourism has been an international affair since the 1790s at least. Indeed, at the turn of the nineteenth century, it was particularly associated with France – in the form of the phantasmagoria shows of (the Belgian-born) Robertson and (the German-born) Philidor, for instance, as well as in the waxwork exhibition that Marie Tussaud brought to the British Isles.

The study of Gothic tourism is not only interesting in itself, it is also one that contributes to the study of the Gothic aesthetic more generally. Strawberry Hill was – and is – a building associated with modernity, creative liberty, whimsicality and fun. It is a house that encourages performance and embodies stories: a house in masquerade. It pioneered a new approach to architecture and to tourism. It is also directly implicated in the development of the Gothic aesthetic. Gothic has a claim to be considered a touristic mode, and, indeed, acts of tourism are built into many a Gothic text. Becoming more aware of Gothic tourism, of the past and the present, can make us more aware of certain qualities of the Gothic – the centrality of performance in Gothic novels, for example, or the kinds of vicariousness that are peculiar to all Gothic texts, as well as the preoccupation with artefacts and their stories, the extreme degree of visualization, and the high degree of fusion between narrative and place.

Contemporary Gothic tourism is a performance industry. As at Strawberry Hill, objects perform, and physical spaces are mocked up. Contemporary Gothic tourism, however, to a much greater extent than at Strawberry Hill, is associated with the pleasures of live performance. In terms of the scare attraction industry, the use of actors is a 'no-brainer'. As a participant at the Scare Attractions conference pointed out, it can cost £2,000 to create an animatronic to provide a

scare, but an actor may be had for £500 for a season. Live performance is not only central to scare attractions, with their legions of enthusiastic scare actors, it is also central to ghost walks, ghost tours such as the Necrobus and paranormal events. The only examples I have discussed that were not conceived of in terms of live performance are the waxwork shows and Severs' House – and even this point is moot, when one considers the interpolation of visitors at the latter. Tourism, more generally, of course, is characterized by performance, as has been extensively commented on since the publication of Richard Shechner's influential volume *Essays on Performance Theory* (1978).[6] What characterizes much Gothic tourism is that its performances are not, on the whole, 'transparent'. Its attitude to theatre, and to theatricalization, is self-reflective. Theatre, in Gothic tourism, is not only, on occasion, the means of presentation, but it is also the object of presentation. Gothic tourism presents theatre itself as an archaic mode. It foregrounds those aspects of theatre that are associated with the past, with performance bound to place, played out by physically present bodies. Theatrical performance, in Gothic tourism, is the mode of the past, and it is employed to prompt feelings of alterity.

Tourists take themselves to Gothic tourism for a different type of hit. Affect is central to it. For more than 200 years, visitors have gone to Gothic tourist attractions in order to experience a gamut of sensations and emotions associated with the Gothic aesthetic – from curiosity, fear and wonder, to horror, disgust, and decentredness. My conversations with scare actors and ghost walk leaders were illuminating as to some of the affects aimed at (or perhaps just achieved) in contemporary Gothic tourism. 'Everyone likes to be scared,' I was told by one scare actor who presented fear as something to be desired. Not to have fear was to lack something: 'a lot of people chase the thrill of being scared because they aren't scared.' But fear was not the only affect discussed by scare actors and ghost tour leaders. Certain kinds of catharsis were mentioned. Making 'grown-ups cry' turned out to be a complex source of feelings for one young actor who told me about the first scare she ever did: 'I felt so guilty ... almost weeping ... but also laughing.' Despite such commentators as Charles Allston Collins, who emphasized traditional Gothic affects such as fear, horror and loathing, and focused on the loneliness of the experience, it is important to bear in mind that Gothic tourism, from the eighteenth century to the present day, has been associated with fun and partying. On ghost walks, at scare attractions, at the Dungeons, communality is the norm. Tourists travel with friends and family. Scare actors band together. As a scare actor from one of the

smaller attractions told me: 'It's like a team-build thing: it's amazing ... Basically like summer camp but in one night'.

Scare attractions inhabit a very specific social and cultural niche. They can be seen in terms of Bakhtinian Carnival, where traditional power structures are overthrown. Actors tend to be young, and the genre as a whole seems to be focused on, and feed off, the energy of the young. They are a complex mixture of spontaneity and pre-set narratives. They flourish simultaneously on strict etiquette and flouted prohibition. Scare attractions have strict sets of rules. 'No saying "boo!" No scare stealing. No swearing. No inappropriate touching. No destruction', one scare actor told me – just after she had gleefully announced 'As soon as they say "don't", you do it'. Though scare attractions are communal events, they can provide very individual, and individualizing, effects. Perhaps because they are so generic, the nature of the scares can be very particular. One scare actor reminded me of the degree of responsiveness required for the job: 'scare actors need to interpret the way that people are walking, feed off what information they gather, work on people's reactions and create scares as they go along'. For this scare actor, bodily reaction was a gauge of success. She boasted of the prowess of a colleague who had brought about: 'three defecations, four pukings, seven urinations, two panic attacks, three heart attacks'. If it is tempting to think of the scare attraction as a kind of contemporary Bacchanalia, it's worth remembering the widespread prohibition on touching. The body is worked on indirectly.

The appeal to the body is often the marker of a more 'low-brow' Gothic. At the other end of the spectrum are such attractions as Dennis Severs' House (so highbrow that it is not even usually called Gothic). Here the appeal is couched much more in terms of the erased and castigated self. If 'low-brow' Gothic could be said to curate physical excitement, such examples as Severs' House play to a complex sense of subjectivity through decentring strategies. At such places a visitor is shifted from their observing rational self, to become someone who is both haunted and ghostly. Whether at Severs' House or in the ghost room at Dunster Castle, the observer's place is usurped by the object. Space belongs to the object rather than to the observer, and the latter is rendered spectral by the mise en scène. This is a mode of prohibition and trespass. Alterity is the effect aimed for. Such spectralizing effects have, of course, pertained to Gothic tourism since the phantasmagoria shows of the late eighteenth century, and Madame Tussaud's in the nineteenth century. What is most characteristic about such

examples as Severs' House, or Dunster Castle, is that such spectralizing is summoned up in the interests of 'history'.

Gothic has become part of our sense of history. The use of Gothic performance in the Museum at Night events, and at Blackpool, is a sign of an understanding of history that is not placed in opposition to the fictionality of Gothic, but comprehends it. Instead of Gothic being an attitude towards history, Gothic has become both a part of history and, for many, a style choice in the way it is presented. Jerome de Groot, in *Consuming History: Historians and Heritage in Contemporary Popular Culture*, (2008) reminds us of Raphael Samuel's 'challenge' to historians to 'look at the "unofficial" histories available within popular culture'.[7] Gothic is surely one of these 'unofficial' histories; indeed it may be considered one of the most popular modes of relaying history. It is central to the 'edutainment' business, and used in marketing history – from heritage organizations to the Museums at Night projects.[8] Many a ghost walk has been hijacked by local historians. Gothic is not only a mode of narrating history, it has become a mode of conceptualizing the historical artefact, expressive of a certain kind of heritage fetishization. The example of the Duchess of Northumberland's musaeum at Alnwick Castle, was one of the most compelling examples of this particular mode: Gothick inflected with Gothic. It is a mode that is implied in those currently popular terms 'curious' and 'cabinet' (not to mention 'Musaeum'). The popularity of this mode is one of the reasons for the appeal of such acts as Tranzient Gallery's 'Palace of Curiosities' to heritage organizations.[9]

There has been a recent critical emphasis on the pseudo-histories of Gothic. Jerrold E. Hogle's influential article, 'The Gothic Ghost of the Counterfeit and the Progress of Abjection' has neatly drawn the attention of scholars in recent years to the issue of inauthenticity, pointing out that 'the modern "Gothic" as we know it has been grounded in fakery.'[10] Lucie Armitt, writing of Gothic at Alton Towers, pointing out that Gothicization has characterized the estate past and present, states 'Gothic sells, and the phonier it is the better.'[11] Yet, as this study has shown, the question of 'authenticity' in relation to Gothic tourism is complicated, and has been ever since Walpole positioned real relics in his mocked-up castle. Much Gothic tourism happily sits within authentic buildings. The 'fakery' of Madame Tussaud's is grounded in history. It is notable that some of the most interesting effects in Gothic tourism are achieved by positioning the authentic besides the fake; examples from Madame Tussaud's to Severs' House derive their effects precisely

from experimenting with the relation between the two. Tussaud's wax-work displays, with their incorporated relics, and transported murder-witness furniture would, arguably, have been less effective without the element of mock-up incorporated: it is the blend of the authentic and the fake that presses the spectator to muse upon Gothic psychologies, and to interrogate the Gothic object.

In the present day, much Gothic tourism attempts to draw upon the premium accorded to the 'authentic' in contemporary culture. Over the door of the Clink, for example, is a sign stating:

YOU ARE ENTERING THE ORIGINAL SITE OF THE CLINK

THE PRISON THAT GAVE ITS NAME TO ALL OTHERS.

Despite these protestations of authenticity, only a fraction of the present-day attraction is actually positioned on the former site and the building is all too manifestly a mock-up. Yet, there is a strange way in which the inauthenticity of the Clink, and that of many other Gothic tourist attractions, becomes a form of authenticity. The well-known tropes and technologies that populate such attractions – waxworks, Hammer theatricality, ghost-train rides – constitute a kind of heritage in themselves.

Merlin was the company that made the most frequent appearances in this book; from the Dungeons, to Alton Towers, Warwick Castle and Tussaud's.[12] Not only does Merlin have all-year-round Gothic attrac-tions, it also goes in for Gothic accessorization when the season is right. In 2013, London Sea Life put the limelight on '"halloweeny" sounding sea creatures – from Blood Shrimps to Bat Fish and Spider Crabs' and featured a 'Fish Witch' in a 'Spooky Rainforest'.[13] The dominance of Gothic within the Merlin Group is unsurprising when one considers that Merlin bought out the Tussaud's Group (which also owned Alton Towers) in 2007.[14] Gothic is not only the business of very large corpo-rations, however. At the other end of the scale, Gothic is embedded in English culture at grass roots level – in oral and performative traditions. That this has been going on for a long time, is evident in the case of Berry Pomeroy, that picturesque ruin beloved of antiquarians in the late eighteenth century, which had become, for some, by the mid-twentieth century, a ghost-infested site of horror.

Berry Pomeroy's transformation resulted from a combination of factors: the changing look of the castle and its surroundings, the national (and international) popularity of the ghost story, an obscure

nineteenth-century novel, the after-effects of a piece of tourist marketing – and the fecundity and willingness of the public imagination. As a case history, it illustrates nicely not only the importance of a range of media in the lifecycle of a ghost reputation – amongst them novels, newspapers, and guidebooks – but also the close relation between Gothic literature, folklore and tourism. Notably, Berry Pomeroy's Gothicization was not the result of a marketing ploy, a decision to 'sell' the building by local business interests. Instead it was the result of a more protracted and communal process. In the case of Berry Pomeroy, it is possible to see folklore in the making – and the extent to which Gothic narratives are dominant within folklore. The ghost walks too demonstrated the extent to which Gothic has become a part of contemporary folklore. As could be seen on the Exeter and Bath walks, the patterns of telling, the relation of people to place, the nature of the teller and their relation to their audience, the ambience and desired frisson, all these were characteristic of the classic ghost story – those of M R James in particular. As at Berry Pomeroy, the process of folklore-making involved not only literary texts, but also arcane collections of folklore, as well as oral sources.

The connection between the tourist, heritage and ghost industries has been noted many a time. Carrie Clanton argues that 'ghosts are utilised in a secular way by the British tourist and heritage industries, supporting claims of historical authenticity and the right to heritage status'.[15] Inglis and Holmes claim that 'the industry pledges the present of the specter as a way of luring tourists and their spending-power *in* to a particular locale'.[16] Ghost walks, however, are not merely the slaves of commercial interests. Some of them, indeed, operate with little or no direct financial reward to those who run them. Ghost walks are, of course, linked to the heritage industry, but they also can, and often do, give expression to popular voice. They provide potent ways of talking about place. They can be expressive about experiences of change, loss and passing. They can be a celebration of people's sense of the identity of a town, village or city. The ghost walk is an event of imagination and possibility. It is a theatre of the streets – and a crucible where contemporary folklore is made and rehearsed.

The ghost tour may also be a site of resistance. In the introduction, I referred to some of the problems of Romania's Dracula tourism. As Duncan Light put it, in 2007, 'Dracula tourism can be identified as a site of struggle between the West's assertion of Romania as Other and the country's efforts to define itself in its own way and on its own terms.'[17] More recently, Tuomas Hovi in *Heritage through Fiction: Dracula Tourism in Romania*, discusses how Romanian guides have been fashioning

Dracula tours so that they separate 'fictional and foreign elements from the history and the culture of the country'. Hovi concludes that, through their tours, the guides ultimately manage to:

> control the image of their country against a (presupposed) outsider view of Romania. It is clear that the tour agencies are constructing a deliberate social and cultural construction of Romania through Dracula tourism that fits their own ideas and conceptions of Romania.[18]

In Hong Kong, Mak Tak-ching leads ghost walks through the Wan Chai district. Mak draws tourists' attention to the older buildings and talks about the communities who once lived in them. As he pointed out in a recent interview for the BBC:

> You can see those historic spots that I bring people to are disappearing, or rapidly changing. One haunted house could eventually become a restaurant.[19]

Mak's ghost tour, he hopes, could work at a variety of levels, helping to change sensibilities ('Hong Kongers have to feel that we should stop this trend to demolish old buildings'), and to protect what Mak calls a 'labour right' – that of 'people's right to live in their community'.

Throughout the book, my vocabulary in relation to the 'paranormal' has been one of non-belief. In this I don't feel that I have done the material a disservice. The very existence of the term 'paranormal' as a description of some of Gothic tourism, alerts us to the fact that much 'ghost' tourism isn't particularly interested in the paranormal. The fact remains, however, that Gothic tourism is not closed to the possibility of supernatural apparitions and events. And it is not only the tourists who entertain this possibility. As one ghost walk leader said to me, recounting the story of another guide who had encountered a ghost whilst leading a walk: 'If it does happen, I'd probably panic. I'm not going to lie.'

Notes

Introduction

1. http://www.atmosfearuk.com/scare-attractions.html.
2. http://www.pasajedelterror.com/ (accessed 10 November 2014).
3. Catherine Spooner, *Contemporary Gothic* (London: Reaktion Books, 2006), page 8.
4. Letter to George Montagu, 2 February 1762. The letter may be found at http://images.library.yale.edu/hwcorrespondence/
5. E. J. Clery, *The Rise of Supernatural Fiction, 1762–1800* (Cambridge: Cambridge University Press, 1995), pages 17–18.
6. Ibid., page 17.
7. Eve Kosofsky Sedgwick, *The Coherence of Gothic Conventions* (New York: Arno Press, 1980), page 10.
8. Eve Kosofsky Sedgwick, 'The Character in the Veil: Imagery of the Surface in the Gothic Novel', *PMLA*, Vol. 96, No. 2 (March 1981), pages 255–270, page 268, fn.14.
9. Eve Kosofsky Sedgwick, *The Coherence of Gothic Conventions* (New York: Arno Press, 1980), page 13.
10. I am using the term 'affect' as a noun, as it is defined in the Oxford English Dictionary. 'A feeling or subjective experience accompanying a thought or action or occurring in response to a stimulus; an emotion, a mood.'
11. This list, of course, is not exhaustive.
12. Chris Baldick, *The Oxford Book of Gothic Tales* (Oxford: Oxford University Press, 1992), page xxi.
13. See the introduction to Robert Mighall's *A Geography of Victorian Gothic Fiction: Mapping History's Nightmares* (Oxford: Oxford University Press, 1999).
14. Chris Baldick, *The Oxford Book of Gothic Tales* (Oxford: Oxford University Press, 1992), page xix.
15. Dale Townshend and Glennis Byron (eds), *The Gothic World* (Abingdon: Routledge, 2013), page xli.
16. http://www.bodminjail.org/ (accessed 10 January 2015).
17. Owen Davies, *The Haunted: A Social History of Ghosts* (Basingstoke: Palgrave Macmillan, 2007), page 64.
18. P. R. Stone, '"It's a Bloody Guide": Fun, Fear and a Lighter Side of Dark Tourism at the Dungeon Visitor Attractions, UK', in R. Sharpley and P. R. Stone (eds), *The Darker Side of Travel: The Theory and Practice of Dark Tourism* (Bristol: Channel View Publications, 2009), pages 167–185, page 181.
19. http://www.bodminjail.org/ (accessed 10 January 2015).
20. http://www.theforbiddencorner.co.uk/ (accessed 10 January 2015).
21. David Inglis and Mary Holmes, 'Highland and Other Haunts – Ghosts in Scottish Tourism', *Annals of Tourism Research*, Vol. 30, No. 1 (2003), pages 50–63, page 56.

22. https://rosehall.com/tours/ (accessed 27 February 2015).
23. http://www.hauntedtokyotours.com/ (accessed 6 March 2015).
24. Glennis Byron (ed.), *Globalgothic* (Manchester: Manchester University Press, 2013), page 1.
25. Ibid., page 1.
26. Ibid., passim.
27. From correspondence with the author, November 2013.
28. http://www.glastonburyfestivals.co.uk/worthy-causes/ (accessed 31 March 2015).
29. http://www.showzam.co.uk (accessed 1 April 2015).
30. The phrase is used to describe Stuff and Things' 'head-turning comedy walkabout show' 'The Lost Funeral' See http://www.stuffandthings.co.uk/futter.htm (accessed 19 December 2014).

1 Strawberry Hill: Performed Architecture, Houses of Fiction and the Gothic Aesthetic

1. The Treaty of Hubertusburg was the other. The signatories to the Treaty of Hubertusburg were Prussia and Austria as well as Britain.
2. To George Montagu, 11 June 1753. All the letters I refer to may be found on Yale University's website, which hosts the electronic version of *The Yale Edition of Horace Walpole's Correspondence* (New Haven: Yale University Press, 1937–1983). It may be found at http://images.library.yale.edu/hwcorrespondence/ (accessed 30 April 2015).
3. Nivernais wrote fables and light verse and had become a member of the Académie Française in 1742 at the age of 27. At this point in time, Walpole was known for his *Fugitive Pieces in Verse and Prose* (1758) and the first volumes of his *Anecdotes of Painting in England* (1762) both of which he had published at his own printing press in the grounds of Strawberry Hill.
4. To George Montagu, letter dated 17 May 1763; this passage is in the second section dated 19 May.
5. To Horace Mann, 30 April 1763.
6. From *A Description of the Villa of Horace Walpole, Youngest Son of Sir Robert Walpole Earl of Orford, at Strawberry-Hill, Near Twickenham: With an Inventory of the Furniture, Pictures, Curiosities, &c* (1774) available online at http://archive.org/details/descriptionofvil00walp page 76 (accessed 30 April 2015).
7. Ibid., page 76.
8. Ibid., page 77.
9. Ibid., page 78.
10. Ibid., page 87.
11. Ibid., page 80.
12. Ibid., page 86.
13. To Horace Mann, 30 April 1763.
14. To Horace Mann, 8 July 1759.
15. Quoted in W. S. Lewis' *Horace Walpole* (The A. W. Mellon Lectures in the Fine Arts, 1960) (London: printed in U.S.A.: Rupert Hart-Davis, 1961), page 5. Lewis gives the origin of the quotation as *Walpoliana*, edited by John Pinkerton (London: R. Phillips, 1799).

16. To Horace Mann, 30 April 1763.
17. To Henry Seymour Conway, 8 June 1747 OS.
18. To Horace Mann, 5 June 1747 OS.
19. Michael Snodin 'Going to Strawberry Hill' in Michael Snodin ed. *Horace Walpole's Strawberry Hill* (New Haven, Conn.; London: Yale University Press and Yale Center for British Art, 2009), pages 15–57, page 20. Walpole later acquired another nine acres of land for his grounds.
20. To Henry Seymour Conway, 8 June 1747 OS.
21. *A Description of the Villa of Horace Walpole, Youngest Son of Sir Robert Walpole Earl of Orford, at Strawberry-Hill, Near Twickenham: With an Inventory of the Furniture, Pictures, Curiosities, &c* (1774) page 1.
22. Both quotations are from a letter to George Montagu dated 18 June 1764.
23. To Richard Bentley, 3 November 1754.
24. To Horace Mann, 29 April 1748.
25. To Horace Mann, 10 January 1750 OS.
26. *A Description of the Villa of Horace Walpole, Youngest Son of Sir Robert Walpole Earl of Orford, at Strawberry-Hill, Near Twickenham: With an Inventory of the Furniture, Pictures, Curiosities, &c* (1774) page 41.
27. Ibid., page 64.
28. Ibid., page 43.
29. To Henry Seymour Conway, 9 August 1763. Walpole is quoting Cibber, a former Strawberry resident.
30. To George Montagu, 3 September 1763.
31. Both quotations are from a letter to Richard Bentley dated 10 June 1755.
32. Robert Wyndham Ketton-Cremer, (1940) *Horace Walpole: A biography* (third edition) (London: Methuen & Co., 1964), page 135.
33. Ibid.
34. It is, I think, significant that Walpole also used the phrase 'puppet-show' in relation to the Cock Lane phenomenon. See his letter to George Montagu, 2 February 1762.
35. To George Montagu, 17 May 1763.
36. To Horace Mann, 27 April 1753.
37. To George Montagu, 17 May 1763.
38. See Footnote 9 of letter to George Montagu, 17 May 1763, in the Yale edition of Walpole's Correspondence.
39. See, for example, the letter to Horace Mann, 27 April 1753.
40. This passage and that quoted above, are from a letter to Horace Mann, 20 December 1764.
41. Quoted in 'Strawberry Hill: from the Letters of the Hon. Horace Walpole' in the *Gentleman's Magazine*, June 1842, volume 172, pages 571–91, page 587 (footnote).
42. To Horace Mann, 20 December 1764.
43. The term is taken from a letter to Mann, dated 24 October 1758. In it, Walpole refers to a monument he and Bentley had worked on to their friend, and Mann's brother, Galfridus Mann. Walpole considered it to unite the 'grace of Grecian architecture and the irregular lightness and solemnity of Gothic.'
44. Michael Snodin 'Going to Strawberry Hill' in Michael Snodin ed. *Horace Walpole's Strawberry Hill* (New Haven, Conn.; London: Yale University Press and Yale Center for British Art, 2009), pages 15–57, page 16.

45. To Horace Mann, 24 October 1758.
46. Quoted in Robert Wyndham Ketton-Cremer (1940) *Horace Walpole: A biography* (third edition) (London: Methuen & Co., 1964), page 122.
47. Marion Harney *Place-Making for the Imagination: Horace Walpole and Strawberry Hill* (Farnham: Ashgate, 2011), page 133.
48. In the Tribune, for example, the 'grated door' was designed by Thomas Pitt, and the carpet was of contemporary design and echoed the patterns of the windows and the 'star' in the ceiling. See Walpole's *Description* (1774), page 77.
49. Kevin Rogers 'Walpole's Gothic: Creating a Fictive History', in Michael Snodin ed. *Horace Walpole's Strawberry Hill* (New Haven, Conn.; London: Yale University Press and Yale Center for British Art, 2009), pages 59–73, page 62.
50. The quotations are taken from *A Description of the Villa of Horace Walpole, Youngest Son of Sir Robert Walpole Earl of Orford, at Strawberry-Hill, Near Twickenham: With an Inventory of the Furniture, Pictures, Curiosities, &c* (1774), pages 76, 80 and 86 respectively.
51. Strawberry straddled the disciplines of antiquarianism and design in a way that not only French visitors of the mid-century found uncomfortable. When, by the closing years of the century, a fashion for greater historical verisimilitude had set in, Walpole had to justify Strawberry anew. He wrote to his friend, Mary Berry, in a letter dated 17 October 1794, of his designs at Strawberry: 'every true Goth must perceive that they are more the works of fancy than of imitation.'
52. To Horace Mann, 20 December 1764.
53. Ibid.
54. To Horace Mann, 27 April 1753.
55. To Horace Mann, 25 February 1750 OS.
56. Robert Miles 'Eighteenth-century Gothic' in Catherine Spooner and Emma McEvoy (eds), *Routledge Companion to Gothic* (Basingstoke: Routledge, 2007), pages 10–18, page 16.
57. *The World*, by Adam Fitz-Adam (London: R. and J. Dodsley, 1753). No. XII, 22 March 1753, pages 67–72, page 69.
58. To Horace Mann, 25 February 1750 OS.
59. David Porter *The Chinese Taste in Eighteenth-Century England* (Cambridge: Cambridge University Press, 2010), page 122.
60. To Horace Mann, 27 January 1761.
61. To Horace Mann, 12 June 1753.
62. *A description of the villa of Mr. Horace Walpole, youngest son of Sir Robert Walpole Earl of Orford, at Strawberry-Hill near Twickenham, Middlesex. With an inventory of the furniture, pictures, curiosities, &c* (Twickenham: Strawberry Hill, 1784), page iii. Available at https://archive.org/details/descriptionofvil00walp_0.
63. To Horace Mann, 12 June 1753.
64. To Horace Mann, 5 June 1747.
65. To Horace Mann, 4 March 1753.
66. Catherine Spooner 'Gothic Lifestyle' in Glennis Byron and Dale Townshend (eds), *The Gothic World* (London: Routledge, 2014), pages 441–53, page 445.
67. This statement is to be found in the preface to the second edition of the *Description*, (Twickenham: Strawberry Hill, 1784), page iv.
68. Michael Snodin 'Going to Strawberry Hill' in Michael Snodin ed. *Horace Walpole's Strawberry Hill* (New Haven, Conn.; London: Yale University Press and Yale Center for British Art, 2009), pages 15–57, page 16.

69. To George Montagu, 17 May 1763.
70. To Horace Mann, 30 April 1763.
71. John Dixon Hunt and Peter Willis *The Genius of the Place: The English Landscape Garden, 1620–1820* (London: Paul Elek Ltd., 1975), page 1.
72. Interestingly enough, considering the number of Gothic gardens and landscapes that abound in our age, Walpole didn't consider that gardens could be Gothicized, commenting to Mann 'one's garden on the contrary is to be nothing but *riant*, and the gaiety of nature' (27 April 1753).
73. Marion Harney *Place-Making for the Imagination: Horace Walpole and Strawberry Hill* (Farnham: Ashgate 2014), page xiv.
74. Ibid., page 250.
75. Used by Horace in his *Ars Poetica*.
76. Manuscript annotation to William Mason's Satirical Poems, quoted in John Dixon Hunt, 'Emblem and Expression in the Eighteenth-Century Landscape Garden' *Eighteenth-Century Studies* 4 iii pages 294–317, Spring 1971, page 294.
77. Horace Walpole *Essay on Modern Gardening*, bilingual edition (Twickenham: Strawberry Hill, 1785), page 87.
78. John Dixon Hunt and Peter Willis (eds) *The Genius of the Place: the English Landscape Garden, 1620–1820* (London: Paul Elek Ltd., 1975), page 14.
79. Horace Walpole, *Essay on Modern Gardening*, page 83.
80. See, for example, John Dixon Hunt and Peter Willis', *The Genius of the place: the English Landscape Garden, 1620–1820* (London: Paul Elek Ltd., 1975) or John Barrell's *The Idea of Landscape and the Sense of Place: An Approach to the Poetry of John Clare* (Cambridge: Cambridge University Press, 1972) or his *The Dark Side of the Landscape: The Rural Poor in English Painting, 1730–1840* (Cambridge: Cambridge University Press, 1980).
81. The play was an adaptation of Molière's *Les Femmes Savantes* (1672).
82. Kenneth Clark (1928) *The Gothic Revival: An Essay in the History of Taste* (London: John Murray, 1962), third edition, page 56.
83. See chapter III, 'Ruins and Rococo: Strawberry Hill' where Clark writes: 'Strawberry was not built to satisfy a literary mood, and reflects but indirectly the fashion for sentimental Gothic.' Kenneth Clark (1928) *The Gothic Revival: An Essay in the History of Taste* (London: John Murray, 1962), third edition, page 58.
84. *A Description of the Villa of Horace Walpole, Youngest Son of Sir Robert Walpole Earl of Orford, at Strawberry-Hill, Near Twickenham: With an Inventory of the Furniture, Pictures, Curiosities, &c* (Twickenham: Strawberry, 1774), page 97.
85. Ibid.
86. To Horace Mann, 27 April 1753.
87. The poem was published anonymously and without Gray's permission.
88. To George Montagu, 11 May 1769.
89. Ibid.
90. To Henry Seymour Conway, 8 June 1747 OS.
91. Michael Snodin 'Going to Strawberry Hill', in Michael Snodin ed. *Horace Walpole's Strawberry Hill* (New Haven, Conn.; London: Yale University Press and Yale Center for British Art, 2009), pages 15–57, page 17.

92. |Stephen Bann, 'Historicizing Horace' in Michael Snodin ed. *Horace Walpole's Strawberry Hill* (New Haven, Conn.; London: Yale University Press and Yale Center for British Art, 2009), pages 117–33, page 130.

93. Kevin Rogers 'Walpole's Gothic: Creating a Fictive History', in Michael Snodin ed. *Horace Walpole's Strawberry Hill* (New Haven, Conn.; London: Yale University Press and Yale Center for British Art, 2009), pages 59–73, page 63.

94. Ibid., page 63.

95. To Conway, 12 February 1756.

96. To Horace Mann, 12 June 1753.

97. To Horace Mann, 18 October 1750 OS.

98. Thomas Babington Macaulay, 'Walpole's Letters to Horace Mann' (first published in the *Edinburgh Review* 1833), reprinted in *Macaulay Essays* (Philadelphia: Carey and Hart, 1841), volume II, page 220.

99. Alicia Weisberg-Roberts, 'Singular Objects and Multiple Meanings', in Michael Snodin ed. *Horace Walpole's Strawberry Hill* (New Haven, Conn.; London: Yale University Press and Yale Center for British Art, 2009), pages 87–105, page 89.

100. Frances Burney. *Memoirs of Doctor Burney: Arranged from his own Manuscripts, from Family Papers, and from Personal Recollections, by his Daughter, Madame d'Arblay* (London: Edward Moxon, 1832), volume III, pages 67–8.

101. This description may be found in the Appendix to the 1774 edition of the *Description*, page 140.

102. 'Caleb D'anvers' 'Merlin's Prophecy with an Interpretation' (from *The Craftsman* No. 491), *The Gentleman's Magazine: or, Monthly Intelligencer*, volume 5, September 1735, pages 532–5, page 533.

103. These phrases, and those in the previous sentence, are all from a letter to Horace Mann, dated 12 June 1753.

104. To Horace Mann, 9 September 1758.

105. To Horace Mann, 12 June 1753.

106. Judith Chalcraft and Anna Viscardi 'Visiting Strawberry Hill: An Analysis of the Eton Copy of the Description of the Villa' (published by Chalcraft and Viscardi, produced by Aquatintbsc, Wimbledon, 2009), page 28.

107. Ibid, pages 22–3.

108. Ibid., page 23.

109. To Richard West, 27 February 1740 NS.

110. All quotations relating to this anecdote are from the letter to Horace Mann, dated 13 February 1743 OS.

111. Michael Snodin 'Going to Strawberry Hill' in Michael Snodin ed. *Horace Walpole's Strawberry Hill* (New Haven, Conn.; London: Yale University Press and Yale Center for British Art, 2009), pages 15–57, page 16.

112. Ibid., page 17.

113. To George Montagu, 11 May 1769.

114. For more details about Fonthill Abbey past and present, see Rictor Norton's webpage 'A Visit to Fonthill' at http://www.rictornorton.co.uk/beckfor3. htm (accessed 5 March 2015).

115. See Lewis Melville *The Life and Letters of William Beckford of Fonthill* (London: William Heinemann, 1910), page 299.

116. Ibid., page 299. Lewis Melville recounts, at the end of a chapter on 'Beckford the Collector', a conversation Beckford had with Cyrus Redding

'[t]wo score years' after Walpole's death, in which Beckford disparages Walpole's collection in these words.

117. The account is presented anonymously. Some of the wording, however, is suggestive of Beckford's style and interests – particularly of the work *Dreams, Waking Thoughts and Incidents* (1783). I think it is possible, even probable, that Beckford wrote the account himself.

118. *Gentleman's Magazine*, 1801, 'Letter from a Gentleman, present at the Festivities at FONTHILL, to a Correspondent in Town', Anonymous, pages 206–8 and 297–8. This phrase occurs on page 207. Note that the original spelling is retained in all quotations from this letter. A facsimile may be found online at http://beckford.c18.net/wbgentmag.html (accessed 30 April 2015).

119. Ibid., page 297.

120. Ibid.

121. Ibid.

122. Ibid.

123. Ibid.

124. Ibid.

125. Ibid.

126. Ibid.

127. Ibid.

128. Ibid.

129. Ibid., page 298.

130. Ibid.

131. Ibid.

132. To George Montagu, 11 May 1769.

133. *Gentleman's Magazine*, 1801, 'Letter from a Gentleman, present at the Festivities at FONTHILL, to a Correspondent in Town', Anonymous, pages 206–8 and 297–8, page 297.

134. It is worth noting here that Walpole's inner circle, the few people who had been allowed to read *The Mysterious Mother*, would have been encountering Strawberry Hill through this text as well. In terms of a wider public, however, *Otranto* was the defining text.

135. To William Cole, 9 March 1765.

136. *A Description of the Villa of Horace Walpole* (Twickenham: Strawberry, 1784), page iv.

137. Ibid., page 51.

138. See Wilmarth Sheldon Lewis, 'The Genesis of Strawberry Hill' in *Metropolitan Museum Studies*, V i June 1934, pages 57–92.

139. Robert Wyndham Ketton-Cremer (1940) *Horace Walpole: A biography* (third edition) (London : Methuen & Co., 1964), page 193.

140. Burney mistakes the date of the visit. She gives it as 1786. See Yale University's podcast about the Burney visit available at http://www.library.yale.edu/walpole/collections/digital_collection.html. (accessed 30 April 2015).

141. Frances Burney, *Memoirs of Doctor Burney: Arranged from his own Manuscripts, from Family Papers, and from Personal Recollections, by his Daughter, Madame d'Arblay* (London: Edward Moxon, 1832), volume III, page 65.

142. Ibid., volume III, page 65.

143. Ibid., volume III, pages 65–6.

144. Ibid., volume III, page 66.

145. Ibid., volume III, page 69.
146. Ibid.
147. Ibid., volume III, page 68.
148. Ibid.
149. Written on the ticket granting entrance to Strawberry Hill. An image of one of these tickets may be seen at http://images.library.yale.edu/strawberryhill/tour_home.html (accessed 30 April 2015).
150. Both these phrases come from the ticket granting entrance to Strawberry Hill.
151. To Mary Berry, 14 June 1791.
152. Mervyn Heard, *Phantasmagoria: The Secret Life of the Magic Lantern* (Hastings: The Projection Box, 2006), pages 94–5.
153. David J. Jones, *Gothic Machine: Textualities, Pre-cinematic Media and Film in Popular Visual Culture, 1670–1910* (Cardiff: University of Wales Press, 2011), page 58.
154. Ibid., page 65.
155. Ibid., page 59.
156. Ibid., page 61.
157. Ibid., page 68.
158. Ibid., page 64.
159. Robertson's phrase is 'monotonie du son'. E. G. Robertson, *Mémoires Récréatifs, Scientifiques et Anecdotiques* (Paris: chez l'auteur et à la librairie de Wurtz, 1831), volume I, page 358.
160. As Jones argues, the Fantasmagorie was also highly influential on literary Gothic texts. Nowhere, I think, is this more so than in the case of Robertson's Gothicization of scientific experimentation.
161. David J. Jones, *Gothic Machine: Textualities, Pre-cinematic Media and Film in Popular Visual Culture, 1670–1910* (Cardiff: University of Wales Press, 2011), pages 60–1.
162. Ibid., page 69.
163. Ibid., page 56.
164. Preface to the first edition of Horace Walpole's *The Castle of Otranto*. In *Three Gothic Novels* edited by Peter Fairclough, Penguin Classics (1968) (Penguin, Harmondsworth, 1986), page 42.
165. See the letter to Madame du Deffand, dated 27 January 1775. The passage runs: 'je me trouvais précisément dans la cour de mon château ... Les tours, les portes, la chapelle, la grande salle, tout y répondait avec la plus grande exactitude ... je croyais entrer tout de bon dans celui d'Otrante—'
166. Alicia Weisberg-Roberts, 'Singular Objects and Multiple Meanings' in Michael Snodin ed. *Horace Walpole's Strawberry Hill* (New Haven, Conn.; London: Yale University Press and Yale Center for British Art, 2009), pages 87–105, page 89.
167. For more on frames and framing at Strawberry, and some interesting parallels with *Otranto*, see Alicia Weisberg-Roberts' 'Singular Objects and Multiple Meanings', in Michael Snodin ed. *Horace Walpole's Strawberry Hill* (New Haven, Conn.; London: Yale University Press and Yale Center for British Art, 2009), pages 87–105. Weisberg-Roberts notes that 'the objects in Walpole's collection were not always securely fixed, physically or conceptually, within their frames and containers; they could be taken out and worn, like the gloves of James I, or they might escape their frames through representation, like the *Portrait of Lord Falkland*, or quotation, as in Eccardt's *Portrait of Sir Robert Walpole and Catherine Shorter*' (page 101).

2 Madame Tussaud's Chamber of Horrors: Wounded Spectators, Perverse Appetites and Gothic History

1. Tussaud's today goes without the apostrophe. I am, however, using the form Tussaud's (derived from Madame Tussaud's), as using the new form, particularly in the context of possessives, would be confusing and misleading.
2. See Eve Kosofsky Sedgwick's *The Coherence of Gothic Conventions* (New York: Arno Press, 1980) and 'The Character in the Veil: Imagery of the Surface in the Gothic Novel' *PMLA*, Vol. 96, No. 2 (Mar., 1981), pp. 255–270.
3. http://www.madametussauds.com/london/# (accessed 19 November 2013).
4. Charles Maturin, *Melmoth the Wanderer* (1820) (Oxford: Oxford University Press, 1989), page 256.
5. Ibid., page 256.
6. Ibid., page 257.
7. http://www.madametussauds.com/london/planyourvisit/explore/scream/default.aspx (accessed 24 November 2014).
8. Sigmund Freud, 'The "Uncanny"' (1919) (translated by Joan Riviere) in *Collected Papers*, vol. 4 (London: The Hogarth Press, 1956), pages 368–407, page 378.
9. See Chapter 1 'The Origins of Wax Modelling' (pages 1–16) of Pamela Pilbeam's, *Madame Tussaud and the History of Waxworks* (Hambledon and London: London 2003).
10. A copy of the poster may be seen at http://mappingbirmingham.blogspot.co.uk/2013/02/ephemera-2-curtiuss-grand-cabinet-of.html (accessed 14 December 2014).
11. Pilbeam, *Madame Tussaud and the History of Waxworks*, page 32.
12. See Chapter 1 'The Origins of Wax Modelling' (pages 1–16) of Pilbeam's, *Madame Tussaud and the History of Waxworks*.
13. See Chapter 2 'The Wax Salon' (pages 17–36) of Pilbeam's, *Madame Tussaud and the History of Waxworks*.
14. Pilbeam's, *Madame Tussaud and the History of Waxworks*, page 42.
15. Ibid., page 49.
16. It is said that the Sleeping Beauty at present-day Tussaud's is this figure.
17. François stayed in France with Tussaud's husband, and was only permanently settled in England in 1822, at the age of 21.
18. Mervyn Heard notes that Philidor was an influence on Robertson (of the Fantasmagorie), though Robertson 'later refuses to acknowledge' it. Mervyn Heard, *Phantasmagoria: The Secret Life of the Magic Lantern* (Hastings: The Projection Box, 2006), page 87.
19. Some of the heads, however, had been seen in England before, because Philip Astley commissioned some from Curtius and Tussaud before he left France.
20. Lela Graybill, 'A Proximate Violence: Madame Tussaud's Chamber of Horrors' *Nineteenth-Century Art Worldwide*, Vol. 9, No. 2 (Autumn 2010). The article may be found at http://www.19thc-artworldwide.org/autumn10/a-proximate-violence (accessed 30 January 2015). The pages in the online version are unnumbered.

21. Ibid.
22. These heads weren't exhibited until after Marie Tussaud's death.
23. A reproduction of this poster, which advertises the exhibition when it appeared at the Reindeer Inn, Hull, February 1812, may be found in Pilbeam's, *Madame Tussaud and the History of Waxworks*, page 70.
24. The term first appeared in the Tussaud's catalogue and was taken up by *Punch*, three years later, in an article that popularized the term.
25. Percival Leigh, 'Mr Pips his Diary Wednesday September 5th 1849' (accompanying text to Richard Doyle's 'Manner and Customs of ye Englyshe in 1849 no. 27: Madame Tussaud her Wax-Werkes ye Chamber of Horrors!!'), *Punch*, vol. 17 (1849), page 112.
26. 'Our Eye-Witness in Great Company' by Charles Allston Collins in *All the Year Round*, Volume II, Magazine No. 37, 7 January 1860, pages 249–253, page 252.
27. Ibid.
28. See Eve Kosofsky Sedgwick 'The Character in the Veil: Imagery of the Surface in the Gothic Novel', *PMLA*, Vol. 96, No. 2 (March, 1981), pages 255–270.
29. 'Our Eye-Witness in Baker-Street' by Charles Allston Collins in *All the Year Round*, Volume II, Magazine No. 36 (31 December 1859), pages 233–236, page 236.
30. 'Our Eye-Witness in Great Company' by Charles Allston Collins in *All the Year Round*, Volume II, Magazine No. 37 (7 January 1860), pages 249–253, page 252.
31. Ibid., page 253.
32. The meat of Mrs Lovett's pies is, of course, human flesh.
33. John Theodore Tussaud (1919) *The Romance of Madame Tussaud's* (London: Odham's Press, 1921), page 218.
34. Ibid., page 220.
35. Ibid., pages 263–4.
36. Ibid., page 264.
37. Ibid.
38. John Theodore Tussaud discusses the 'popular delusion that Madame Tussaud's will pay a sum of money to any person who spends a night alone with the criminals' (page 260) in the Chamber. Significantly, he traces the rumour back to 'a story told long ago by one "Dagonet"' (261) (i.e. G R Sims). Tussaud suggests that the story gained currency by means of a scene, set in the Chamber of Horrors, in a play called *The Whip*, performed at Drury Lane in 1909. *The Romance of Madame Tussaud's* (London: Odham's Press, 1921), page 261.
39. Nesbit's story is actually set in the Musée de Grévin, but its basic premise is the challenge of staying the night in a waxworks exhibition, and this challenge was specifically associated with Tussaud's Chamber of Horrors. Notably, in Nesbit's story, the horror of the Chamber is countered, for one of its characters, by the influence of a (very Grévin) tableau depicting the early Christian martyrs.
40. The exceptions are the serial killers Dennis Nilsen and Donald Neilson.
41. *Mme Tussaud's Exhibition Guide* (London: Printed by Bruton and Co., undated, British Library catalogue suggests 1917), page 66. Pilbeam notes that Tussaud's took the idea for the series of tableaux from the Musée de Grévin, Paris.
42. Pilbeam, *Madame Tussaud and the History of Waxworks*, page 108.
43. Lela Graybill, 'A Proximate Violence: Madame Tussaud's Chamber of Horrors', *Nineteenth-Century Art Worldwide*, Vol. 9, No. 2 (Autumn 2010). The

article may be found at http://www.19thc-artworldwide.org/autumn10/a-proximate-violence (accessed 30 January 2015). The pages in the online version are unnumbered.

44. Ibid.
45. Ibid.
46. Ibid.
47. See Richard Doyle's 'Manner and Customs of ye Englyshe in 1849 no. 27: Madame Tussaud her Wax-Werkes ye Chamber of Horrors!!', *Punch*, vol. 17 (1849), page 112.
48. John Theodore Tussaud (1919) *The Romance of Madame Tussaud's* (London: Odham's Press, 1921), page 251.
49. Numerically, but not proportionately, the tableaux in the rest of the exhibition outnumbered those in the Chamber.
50 'Our Eye-Witness in Great Company' by Charles Allston Collins in *All the Year Round*, Volume II, Magazine No. 37, (7 January 1860), pages 249–253, page 250.
51. Ibid., page 249.
52. As Louise Baker, archivist of Madame Tussaud's, points out, Tussaud's has always been interested in the 'key moment', the 'evocative moment of a person's fame' (or notoriety). Referring to the difference between the approaches of Tussaud's and the Musée Grévin, Baker notes 'if we freeze time, they tell the story'. (Conversation with the author, 2 April 2015.)
53. *Mme Tussaud's Exhibition Guide* (London: Printed by Bruton and Co., undated, British Library catalogue suggests 1917), page 75.
54. Many of the items recorded as belonging in the 1890s exhibition are not in the 1950s display. The staging at Tussaud's is, and always has been, highly adaptable. When tableaux became less popular they were removed, or diminished. The alcoves in the 1950s image were created in the twentieth century.
55. *Mme Tussaud's Exhibition Guide*, page 62.
56. The room also contained Wellington relics.
57. *Mme Tussaud's Exhibition Guide*, page 60.
58. Ibid., page 69.
59. Ibid., page 70.
60. Ibid.
61. Pilbeam, *Madame Tussaud and the History of Waxworks*, page 108.
62. Pauline Chapman, *Madame Tussaud's Chamber of Horrors: Two Hundred Years of Crime* (London: Constable, 1984).
63. *Mme Tussaud's Exhibition Guide*, page 75.
64. Ibid., page 74.
65. Mark B. Sandberg, *Living Pictures, Missing Persons: Mannequins, Museums, and Modernity* (Princeton, NJ: Princeton University Press, 2003), page 47.
66. Percival Leigh, 'Mr Pips his Diary Wednesday September 5th 1849' (accompanying text to Richard Doyle's 'Manner and Customs of ye Englyshe in 1849 no. 27: Madame Tussaud her Wax-Werkes ye Chamber of Horrors!!'), *Punch*, vol. 17 (1849), page 112.
67. The three rooms were to be considered together. This is borne out by the fact that, when, in 1843, the exhibition was re-jigged, and the two Napoleon Rooms set up, the extra sixpence demanded for the 'Separate Room' covered them too.
68. 'Our Eye-Witness in Great Company' by Charles Allston Collins in *All the Year Round*, Volume II, Magazine No. 37 (7 January 1860), pages 249–253, page 250.

69. Pamela Pilbeam, drawing on the work of Richard D. Altick, points out that Tussaud's 'seem to have invented the promenade concert'. Pilbeam's *Madame Tussaud and the History of Waxworks*, page 93.
70. I would like to thank Louise Baker, archivist of Madame Tussaud's, for drawing my attention to the significance of the move and management by the sons.
71. Eve Kosofsky Sedgwick, *The Coherence of Gothic Conventions* (New York: Arno Press, 1980), page 37.
72. Kelly Hager, *Dickens and the Rise of Divorce: The Failed-Marriage Plot and the Novel Tradition* (Farnham: Ashgate, 2010), page 79.
73. Ibid. See Chapter 2 'Monstrous Marriage in Early Dickens'.
74. The waxwork exhibition has also been a popular subject for film.
75. W. L. George, 'Waxworks: A Mystery', *The Strand Magazine*, July 1922, 58–64, page 59.
76. Ibid., page 60.
77. Ibid.
78. Ibid.
79. Ibid., page 62.
80. Ibid.
81. Ibid.
82. Ibid.
83. Ibid.
84. Significantly, the two distinct policemen are merged into one representative character by the end of the story.
85. George, 'Waxworks: A Mystery', pages 58–64, page 64.
86. Introductory essay by George-Augustus Sala (1892) reprinted in *Mme Tussaud's Exhibition Guide*, page 9.
87. Ibid., page 10.
88. Ibid., page 11
89. Ronald Paulson *Representations of Revolution (1789–1820)* (New Haven, CT and London: Yale University Press, 1983), page 220.
90. Ibid., page 218.
91. Ibid.
92. Charles Maturin *Melmoth the Wanderer* (1820) (Oxford: Oxford University Press, 1989), page 256.
93. Ibid., page 255.
94. It's interesting to note here, Freud's statement about the uncanniness of 'Dismembered limbs, a severed head'. Freud 'The "Uncanny"' (1919), pages 368–407, page 397.
95. Pilbeam's *Madame Tussaud and the History of Waxworks*, page 46.
96. Quoted in Lela Graybill, 'A Proximate Violence: Madame Tussaud's Chamber of Horrors' *Nineteenth-Century Art Worldwide*, Vol. 9, No. 2 (Autumn 2010). The article may be found at http://www.19thc-artworldwide.org/autumn10/a-proximate-violence (accessed 30 January 2015). The pages of the online version are unnumbered.
97. See Pilbeam's *Madame Tussaud and the History of Waxworks*, page 127.
98. David Brett, *The Construction of Heritage* (Cork: Cork University Press, 1996), page 85.
99. 'Our Eye-Witness in Great Company' by Charles Allston Collins in *All the Year Round*, Volume II, Magazine No. 37, (7 January 1860), pages 249–253, page 250.

100. See Avril Horner and Sue Zlosnik, *Gothic and the Comic Turn* (Basingstoke: Palgrave Macmillan, 2004), page 3 and passim.
101. Richmal Crompton, 'William and the Waxwork Prince', Chapter 4 of *William* (London: George Newnes, 1929), page 101.
102. John Theodore Tussaud (1919), *The Romance of Madame Tussaud's* (London: Odham's Press, 1921), page 219.
103. *Carry on Screaming* refers back to the 1953 horror film *House of Wax* (directed by Andre De Toth).

3 London's Gothic Tourism: West End Ghosts, Southwark Horrors and an Unheimlich Home

1. http://www.houseofmagic.co.uk/home.html (accessed 30 November 2009).
2. These words are taken from the handout that all visitors are given on entering Severs' House. The handout is also transcribed (though the division into paragraphs is different) on the website of the house http://www.dennissevershouse.co.uk on the page named 'The Tour'.
3. I am grateful to Mick Pedroli for many interesting conversations, over the years, about the house, its creator and its admirers.
4. From the Severs' House handout.
5. That is according to the Radio 4 documentary (details given in the following note). According to another version of the legend of the house's construction, Dan Cruickshank's, the plastic fruit was purchased from Tesco on the Bethnal Green Road. (From the BBC Four documentary 'Dan Cruickshank and the House that Wouldn't Die', broadcast on 8 December 2003.)
6. My source for this detail was the 2001 Radio 4 programme, 'You Either See It Or You Don't: The Story Of 18 Folgate Street, Spitalfields', introduced by Vicky Licorish and produced by Jane Greenwood. The programme was broadcast 15 November 2001.
7. Raphael Samuel (1994), *Theatres of Memory vol. I: Past and Present in Contemporary Culture* (London: Verso, 1996), page 114.
8. http://www.timeout.com/london/museums-attractions/event/2158/dennis-severs-house (accessed 5 October 2010).
9. From the Severs' House handout.
10. Ibid.
11. Dennis Severs, *18 Folgate Street: The Tale of a House in Spitalfields* (London: Chatto and Windus and Vintage 2002), page 155.
12. Sigmund Freud 'The "Uncanny"' (1919) (translated by Joan Riviere) in *Collected Papers*, vol. 4, (London: The Hogarth Press, 1956), pages 368–407, page 377.
13. Anthony Vidler, *The Architectural Uncanny: Essays in the Modern Unhomely* (Cambridge, MA: The MIT Press, 1992), page 4.
14. Ibid., page 3.
15. Ibid., page 11.
16. Ibid.
17. See Freud 'The "Uncanny"' (1919), pages 368–407, page 393 and elsewhere.
18. Dennis Severs, *18 Folgate Street*, page 49.
19. Ibid., page 173.

20. Ibid., page174.
21. 'Jentsch has taken as a very good instance "doubts whether an apparently animate being is really alive; or conversely, whether a lifeless object might not be in fact animate";' Freud 'The "Uncanny"' (1919), pages 368–407, page 378.
22. Iain Sinclair, in Rachel Lichtenstein and Iain Sinclair *Rodinsky's Room* (London: Granta, 1999), page 11.
23. Ibid., page 8.
24. From the Severs' House handout.
25. Iain Sinclair in Iain Sinclair and Rachel Lichtenstein, *Rodinsky's Room*, page 8.
26. Samuel (1994) *Theatres of Memory Vol. I*, page 114. Raphael Samuel was also a resident of Spitalfields.
27. Susan Stewart, *On Longing: Narratives of the Miniature, the Gigantic, the Souvenir, the Collection* (Durham, NC and London: Duke University Press, 1993), page 150. For Stewart, the 'chief subject [of the imaginary context of origin] is a projection of the possessor's childhood' (page 150).
28. Ibid., page 138.
29. Caroline Evans, *Fashion at the Edge: Spectacle, Modernity and Deathliness* (New Haven, CT: Yale University Press, 2003), page 12.
30. Spitalfields, however, is represented by Prague in the film.
31. Patrick Wright, *A Journey Through Ruins: a Keyhole Portrait of British Postwar Life and Culture* (London: Flamingo, 1993), page 139.
32. David I. Cunningham, 'Living in the Slashing Grounds: Jack the Ripper, Monopoly Rent and the New Heritage', in Alexandra Warwick and Martin Willis (eds.) *Jack the Ripper: Media, Culture, History* (Manchester: Manchester University Press, 2007), pages 159–175, page 173.
33. Ibid., page 171.
34. Ibid., page 172.
35. Since the 1970s, the Spitalfields Trust have purchased, occupied and squatted in Spitalfields' houses, determined to save them from development.
36. See Robert Mighall's, *A Geography of Victorian Gothic Fiction: Mapping History's Nightmares* (Oxford: Oxford University Press, 1999), passim.
37. Theatre Royal, Drury Lane's promotional leaflet for 'Through the Stage Door'.
38. http://www.londontheatre.co.uk/lashmars/backstagetour/index.html (accessed 4 August 2009).
39. http://www.theatreroyaldrurylane.co.uk/theatre-history.htm (accessed 4 August 2009).
40. Mighall, *A Geography of Victorian Gothic Fiction*, page 21.
41. http://www.walks.com/Homepage/Thursdays_Walks/default.aspx#12882 (accessed 5 August 2009).
42. E J Burford, *A Short History of The Clink Prison* (no publisher or place of Publication, 1989), unnumbered page.
43. E J Burford, *A Short History of The Clink Prison* (no publisher or place of publication, 1989), page 12.
44. Ibid., page 4.
45. The notable exception is, of course, 'Scream'.
46. Anonymous, *The Dungeons: Rogues Gallery: The Photographs* (Poole: Merlin Entertainments, undated, but post-2013).

47. The quote is from the guidebook relating to Dungeon when it was at Tooley Street, London Bridge (the site was moved in February 2013). Anon, *The London Dungeon* (guide book). (Poole: Merlin Entertainments, undated, but pre-2013).
48. Ibid. The quotation is from the Time Line inside the front cover.
49. http://www.thedungeons.com/london/en/explore-the-dungeon/the-tyrant-boat-ride.aspx (accessed 14 December 2014).
50. http://www.thedungeons.com/london/en/explore-the-dungeon/drop-dead.aspx (accessed 14 December 2014).
51. http://www.theghostbustours.com/history.html (accessed 30 January 2015).
52. Ibid.
53. http://www.theghostbustours.com/london.html (accessed 30 January 2015).
54. http://www.dennissevershouse.co.uk/ accessed (20 October 2010).
55. Having seen many tearful children in such attractions, I'm not convinced.
56. From the Severs' House handout.
57. It is actually two houses made into one.
58. Nicole Reynolds, *Building Romanticism: Literature and Architecture in Nineteenth-Century Britain* (Ann Arbor, MI: University of Michigan Press, 2010), page 116.
59. See Flecky Bennett's, 'London's Highgate Ghost and Vampire Walk' at http://www.ghostwalklondon.co.uk/ (accessed 27 February 2015). Bennett now takes private bookings only.
60. Audrey Niffenegger, *Her Fearful Symmetry* (Bath: Windsor/Paragon, 2010).

4 Ghost Walking

1. http://www.walks.com/London_Walks_Home/Heres_Why/default.aspx (accessed 10 January 2015).
2. http://www.walks.com/London_Walks_Home/London_Ghost_Walks/default.aspx (accessed 11 January 2015).
3. Catherine Spooner, '"That Eventless Realm": Hilary Mantel's *Beyond Black* and the Ghosts of the M25', in Lawrence Phillips and Anne Witchard (eds), *London Gothic: Place, Space and the Gothic Imagination* (London: Continuum, 2010), pages 80–90, page 82.
4. http://www.independent.co.uk/news/uk/home-news/almost-30-pubs-close-every-week-9165968.html (accessed 5 March 2014).
5. See, for example, http://www.mirror.co.uk/news/uk-news/ghost-caught-cctv-ye-olde-3155330 (accessed 15 January 2015).
6. Surprising in that, as Owen Davies points out in *The Haunted* (2007), there has not been much of a tradition of child ghosts in England (as compared to Scandinavia, for example).
7. Promotional leaflet for 'Ghost Walks of Bath'.
8. Time Team was a series featuring archaeological excavations, which ran on Channel 4, 1994–2013.
9. Avery Gordon, *Ghostly Matters: Haunting and the Sociological Imagination* (Minneapolis, MN and London: University of Minnesota Press, 1997), page 63.
10. Owen Davies, *The Haunted: A Social History of Ghosts* (Basingstoke: Palgrave Macmillan 2007), Chapter 2, 'The Geography of Haunting', pp. 45–64.

11. Pike and Shot 'Organise and Manage Historical Events, Living History Interpretation Displays, Historical Markets and Tours' http://www.pikeandshot.com/ (accessed 9 January 2013).
12. Alex Woodward, *Haunted Weymouth* (Stroud: The History Press, 2011), page 30.
13. The 'skeleton' actually consists of the remains of more than one person.
14. http://www.britishlistedbuildings.co.uk/en-104236-the-town-pump-dorchester-dorset (accessed 26 April 2013).
15. The words are written on the shop front, below the windows.
16. Nicola J. Watson, *The Literary Tourist: Readers and Places in Romantic and Victorian Britain* (Basingstoke: Palgrave Macmillan, 2006), page 177.
17. Dorchester has no separate theatre now, though it has an Arts Centre.
18. The series, which ran from 1979–1988 on ITV, featured dramatizations of short stories by Roald Dahl, and, later, episodes by other writers.
19. The actual quotation runs: 'All tribal myths are true, for a given value of "true".' Terry Pratchett's, *The Last Continent* (London: Doubleday, 1998), see page 10. Thanks to Rowan Lee McEvoy for finding the quotation.
20. Kristine Keller (2010) 'Ghost Tours as a Form of Alternative Tourism'. http://csun.academia.edu/KristineKeller/Papers/968554/Ghost_Tours_as_A_Form_of_Alternative_Tourism (accessed 14 October, 2012), page 2.
21. Owen Davies, *The Haunted: A Social History of Ghosts* (Basingstoke: Palgrave Macmillan 2007), page 42.
22. Ibid., page 41.
23. Ibid., page 40.
24. Davies uses the term on page 8 and in a number of other places in the book.
25. Theo Brown, *The Fate of the Dead: A Study in Folk-Eschatology in the West Country After the Reformation* (Ipswich and Cambridge: D. S. Brewer and Rowman and Littlefield, 1979), page 24. See Chapter 3 'The Folk Ghost'.
26. The first of the BBC's *A Ghost Story for Christmas* adaptations ran between 1971 and 1978. The series was revived (on BBC Four) in 2005.
27. David Lodge, *Paradise News* (1991) (Penguin: London, 1992), page 75.
28. Julian Holloway, 'Legend-tripping in Spooky Spaces: Ghost Tourism and Infrastructures of Enchantment', *Environment and Planning D: Society and Space* Vol. 28 (2010), pages 618–637, page 622.

5 Becoming a Haunted Castle: Literature, Tourism and Folklore at Berry Pomeroy

1. Reverend John Swete, page 110 of *Devon Tour*, 1793, manuscript in Devon Archives and Local Studies Service, ref. 564M/F5. All quotations from Swete in this chapter are given as they occur in his journals. I have not corrected any spelling or punctuation, neither have I used 'sic' to indicate supposedly incorrect usage. Swete's journals are held in the Devon Archives and Local Studies Service, Sowton, Exeter.
2. Robert Graves, 'The Devil at Berry Pomeroy', from BBC broadcast recording 27 September 1953, BBC Archive 19500, side 2 of 4.
3. http://www.english-heritage.org.uk/daysout/properties/berry-pomeroy-castle/ (accessed Tuesday 8 October 2013).
4. William George Maton, illustrations by the Rev. J. Rackett, 'Dorsetshire Devonshire and Cornwall' 1794, page 66 in *Tour in the Western Counties 1794 and 1796*, manuscript volume in Devon Archives and Local Studies Service,

ref Z19/2/10a-b. This quotation and the next were not incorporated into the published version that appeared in 1797.

5. Ibid., page 69.
6. Keith Poole, *Britain's Haunted Heritage* (London: Robert Hale, 1988), page 138.
7. Google search undertaken 25 June 2013.
8. Deryck Seymour, *The Ghosts of Berry Pomeroy Castle* (Exeter: Obelisk Publications, 1990), pages 3–4.
9. Reverend John Swete, *Devon Tour*, 1793, page 109.
10. Ibid., page 110.
11. From a famous passage in Lucan's *Civil War* IX: 969, describing Caesar's visit to the remains of Troy. I am grateful to Chris Baldick for identifying, and providing translations for, Swete's Latin quotations.
12. Reverend John Swete *Sketches in Devon*, 1788, page 1. The manuscript is held by Devon Archives and Local Studies Service, ref. Z.19/2-12.
13. Ibid., page 2.
14. Ibid., page 3.
15. There is also a sketch in another of Swete's volumes which, though unlabelled, seems to me to be of Berry Pomeroy. A further volume of Swete's travels in Devon, which also included accounts of Berry Pomeroy, was destroyed during the Exeter Blitz.
16. William George Maton, illustrations by the Rev. J. Rackett, *Observations Relative Chiefly to the Natural History, Picturesque Scenery and Antiquities of the Western Counties of England, made in the Years 1794 and 1796* (Salisbury: J. Eaton, 1797), page 112.
17. Richard Warner, *A Walk Through Some of the Western Counties of England* (London: G. G. and J. Robinson, 1800), page 192.
18. Ibid., pages 192–3.
19. Edward Montague, *The Castle of Berry Pomeroy* (1806) ed. James D. Jenkins (Richmond, Virginia: Valancourt Books, 2007), page 3.
20. Ibid., pages 2–3.
21. Ibid., page 2.
22. Sam Smiles and Michael Pidgley, *The Perfection of England: Artist Visitors to Devon c. 1750–1870* (Exeter: Royal Albert Memorial Museum and Djanogly Art Gallery, University of Nottingham, 1995), page 74.
23. See for example, William Marshall Craig's 'Berry Pomeroy', engraved by William Hawkins, in *The Beauties of England and Wales*, vol. IV *Devonshire and Dorsetshire* (London: Vernor and Hood, 1803).
24. See, for example, Westall's 'Berry-Pomeroy Castle', engraved by E. Finden and published by C. Tilt of London in 1829.
25. See, for example, some of the lithographs by Gauci, taken from images by C. F. Williams, and published by P. Hannaford of Exeter in the 1840s. The images entitled 'The State Rooms' and 'In the Guard Room' are particularly good examples of this tendency.
26. Anonymous, *Guide to the Watering Places Between the Exe and the Dart Including Teignmouth, Dawlish and Torquay* (Teignmouth: Printed and sold by E. Croydon, public library, 1817), part the third: page 48.
27. Ibid., part the third: page 49.
28. The *Description of the County of Devonshire* (c. 1825), for example, plagiarizes from *The Beauties of England and Wales* (1803) and even the Mortimer Brothers' guidebook (publication dates 1876–1940s) discussed later in the chapter, though usually good at attributing quotations, plagiarizes Maton's text of 1797.

29. *Black's Guide to the South-Western Counties of England. Dorsetshire, Devon, and Cornwall* (Edinburgh: Adam and Charles Black, 1862). Route VIII is on pages 254–272, the references to Berry Pomeroy are on pages 269–270.
30. Ibid. See page 114.
31. R. N. Worth (1878) *Tourist's Guide to South Devon: Rail, Road, River, Coast, and Moor* (Edward Stanford: London 1880) (second edition), page 56.
32. 'Through Devonshire and Cornwall to the Scilly Isles: Part 1' in *Bentley's Miscellany*, vol. 61 (1867), pages 316–330, page 321.
33. Ibid., page 322.
34. Reverend John Swete, *Devon Tour*, 1793, page 106 leading to page 109.
35. The other vignettes on the hotel notepaper in the archive include a second view of Berry Pomeroy Castle, and a bathing cove in Torquay.
36. From 1845–1846, Longman, Brown, Green and Longmans issued the collection *The Novels and Romances of Anna Eliza Bray*. A new and revised edition of *Mrs Bray's Novels and Romances* was published by Chapman and Hall in 1884 (Bray died in 1883).
37. Anna Bray, *Henry de Pomeroy; or, the Eve of St. John, a Legend of Cornwall and Devon* (London: Richard Bentley, 1842) volume I, pages 10–11.
38. Ibid., volume I, page 7.
39. Ibid., volume I, page 19.
40. William George Maton, illustrations by the Rev. J. Rackett, *Observations Relative Chiefly to the Natural History* etc., page 112.
41. *Black's Guide to the South-Western Counties of England. Dorsetshire, Devon, and Cornwall* (Edinburgh: Adam and Charles Black, 1862), page 254.
42. Anna Bray, *Henry de Pomeroy*, volume III, page 221.
43. There is the possibility that this lithograph, if it was indeed published in 1840 (the date is estimated), was known to Bray.
44. Bray, *Henry de Pomeroy*, page 266–267.
45. Elizabeth Goudge, *The Castle on the Hill* (London: Gerald Duckworth and Co., 1949), pages 53–54. Curiously in Goudge's description the orientation of the castle is reversed: north is south, east is west.
46. Ibid., page 53.
47. Ibid.
48. Ibid., page 54.
49. Ibid.
50. Ibid., page 57.
51. All these issues are to be found in the novels by Bray and Goudge.
52. Deryck Seymour, *The Ghosts of Berry Pomeroy Castle* (Exeter: Obelisk Publications, 1990), page 31.
53. Ibid., page 12.
54. Charles Kightly, *Berry Pomeroy Castle* (London: English Heritage, 2011), pages 5–6.
55. Ibid., page 38. The discoveries haven't really harmed the castle's reputation as a haunted locale. For Bob Mann, *A Most Haunting Castle: Writings from the Ruins at Berry Pomeroy* (Totnes: Longmarsh Press, 2012), the ghost stories are particular cultural expressions of the bad presences that are to be felt at the castle. Indeed, for Mann, the fundamentally story-less nature of the ghosts becomes testimony to their existence.
56. Kightly, *Berry Pomeroy Castle*, page 39.
57. Ibid., page 38.

58. Ibid., page 39.
59. Ibid., page 38.
60. James D. Jenkins, introduction to *The Castle of Berry Pomeroy* (Richmond, Virginia: Valancourt Books, 2007), page viii.
61. Ibid., page viii. Jenkins also notes 'the mysterious change in De Clifford's name from Thomas to Henry'.
62. On page 218 of the modern edition, Laura complains of two attempts on her life, when there have been three.
63. Edward Montague, *The Castle of Berry Pomeroy* (1806) ed. James D. Jenkins (Richmond, Virginia: Valancourt Books, 2007), page 1.
64. The name was to change more than once. Matilda was not considered an attractive name for much of the twentieth century. In the Mortimer brothers' guidebook, it is Elinor who is confined by Matilda.
65. Bob Mann (ed.), *A Most Haunting Castle*, page 27.
66. Ibid., page 27.
67. Murray's *A Handbook for Travellers in Devon and Cornwall* (London: John Murray, 1851), page 42.
68. Swete's phrase 'opacum frigus' is adapted by omission/transposition from Virgil's First Eclogue, circa line 55, where the original wording is 'frigus captabis opacum'. Literally it means 'shaded coolness', but in English idiom that comes out simply as 'cool shade'.
69. Reverend John Swete, *Devon Tour*, 1793, page 106.
70. The 'national' landscape of these texts, however, takes many of its cues from the landscapes of German Gothic and Romantic texts.
71. Kightly, *Farleigh Hungerford Castle*, page 3.
72. 'Through Devonshire and Cornwall to the Scilly Isles: Part 1' in *Bentley's Miscellany*, vol. 61 (1867), pages 316–330, page 322.
73. As Bob Mann notes: 'Nothing here, you'll notice, about her being imprisoned'. *A Most Haunting Castle: Writings from the Ruins at Berry Pomeroy*, page 17.
74. Nicola J. Watson in Chapter 4 'Ladies and Lakes' of *The Literary Tourist: Readers and Places in Romantic and Victorian Britain* (Basingstoke: Palgrave Macmillan, 2006), page 137.
75. T. and A. Mortimore, *Berry Pomeroy Castle: An Historical and Descriptive Sketch* (Totnes: printed at the 'Times' and 'Western Guardian' Offices, by T. & A. Mortimore, 1876), page iv.
76. Ibid., page xxxvii.
77. It is interesting to note that the story (with further name confusion) is taken up by a London-published guide, Worth's *Tourist's Guide to South Devon*, two years later (1878). (See R. N. Worth, *Tourist's Guide to South Devon: Rail, Road, River, Coast and Moor* (London: Edward Stanford, 1878). Worth's *Guide* refers to 'Ellen de Pomeroy' 'confined by her sister through jealousy' (page 57).
78. I have not found this serialization, but the Mortimers state this to have been the case in the 1906 edition of the novel.
79. The fact that the Mortimers number their editions in terms of their history of publishing the novel doesn't help. Thus their "SECOND EDITION" is actually the third edition of the work (the first being the 1806 edition). Likewise the Mortimer Brothers' 'THIRD EDITION' is actually the fourth. Though the fact isn't remarked upon, their 1906 edition marked the centenary of the novel.

80. It is possible that other colours were available but I have only seen these two copies.
81. Preface to Edward Montague's, *The Castle of Berry-Pomeroy: A Novel* (Totnes: printed at the 'Times' and 'Western Guardian' Offices, by T. & A. Mortimer, 1906), this page is not numbered.
82. This preface of this edition is rather more subdued than that of the second.
83. The Preface to the second edition runs in full: 'Few Places in the West of England possess such historic associations as those clustering around the ancient and majestic ruins of 'BERRY-POMEROY CASTLE,' once the stately residence of the lordly Pomeroys, who joined William the Conqueror in the invasion of this country, and who estimated their power as little less than regal. Situate within comparatively easy walking distance (2½ miles) of the picturesque and ancient town of Totnes, accounted the oldest borough in the kingdom, and only about six miles from the delightful 'Queen of Watering Places,' Torquay, the newest corporate borough, it is no wonder that Berry Pomeroy Castle should prove so great an object of interest to the intelligent traveller. Teeming as the spot does with tragic incident and legendary lore, throwing quite a mystic spell over the scene, it is but natural that a variety of tales should be associated therewith, but the most interesting and exhaustive, and perhaps the most thrilling, is the story written long years ago by EDWARD MONTAGUE, ESQ., and which appeared in the columns of The Western Guardian, and was subsequently repinted in book form. The whole of the first edition having been disposed of a SECOND EDITION has now been called for'. Preface to *The Castle of Berry-Pomeroy: A Novel* (Totnes: printed at the 'Times' and 'Western Guardian' Offices, by T. & A. Mortimer, 1892) no page number.
84. Ibid., page 6.
85. T, and A. Mortimore, *Berry Pomeroy Castle* (1876), page xxxvii.
86. T. and A. Mortimore, *Berry Pomeroy Castle: An Historical and Descriptive Sketch* (Totnes: printed at the 'Times' and 'Western Guardian' Offices, by T. & A. Mortimer, undated, but probably 1930s, the British Library catalogue suggests 1933), page 43.
87. Ibid., page 42.
88. Certain copies of the book of course did survive, but faced with the co-existence of a literary text and folklore most people (myself included) usually prefer to believe that the literary text post-dates the folklore.
89. Richard Harold St Maur, *Annals of the Seymours* (London: K. Paul, Trench, Trübner & Co., 1902), page 444.
90. The story is to be found in note 98, which runs from page 443 to page 445.
91. John H. Ingram (1884), *The Haunted Homes and Family Traditions of Great Britain* (London: Gibbings and Co., 1897). The account of Berry Pomeroy is on pages 336–341. This quotation is to be found on page 341.
92. 'But how much is it to be regretted, that the example of Sydenham, the faithful and accurate recorder of nature, is not followed by succeeding physicians. The experience of a Farquhar committed to writing, would be of more value to the profession, than a hundred volumes of the *closet* speculator' (pages 419–420) in 'Sir Walter Farquhar, Bart. Licenciate of the Royal College of Physicians, and Physician to the Prince Regent' *The New Monthly Magazine*, Vol. 4, No. 19 (December 1815), pages 417–420, page 420.

93. 'Article XXII – *Whychote [sic] of St John's; or, the Camp, the Cloister, and the Quarter-deck'* [NB The title is given wrongly.] in the *Monthly Review: New and Improved Series*, Vol. 1, No. iv (1833), pages 607–608, page 607.
94. Erskine Neal, *Whychcotte of St John's; or, the Court, the Camp, the Quarter-deck, and the Cloister* (London: E. Wilson, 1833), page 50.
95. Ibid., page 59.
96. Ibid., page 61.
97. Mann provides an entertaining example of the literary progress and reuse of an account of a visit to Berry Pomeroy in his introduction to *A Most Haunting Castle* (pages 1–4). An account of the family's 1968 visit, and the children's reactions, was written by his mother, a journalist. It was to be cited and changed many a time in subsequent ghost accounts.
98. Owen Davies, *The Haunted: A Social History of Ghosts* (Basingstoke: Palgrave Macmillan 2007), page 8.
99. Mann (ed.), *A Most Haunting Castle*, page 44.
100. Jenkins, introduction to *The Castle of Berry Pomeroy*, page vii.
101. Ibid., page vii.
102. Ibid.
103. *The Castle of Berry-Pomeroy: A Novel* (Totnes: printed at the 'Times' and 'Western Guardian' Offices, by T. & A. Mortimer, 1892), page 2. This is the second Mortimer brothers edition.
104. There is a Forde Abbey, which, though it was part of Devon at the time, is part of Dorset now. It, however, is too distant to be the building referred to in the novel. And it is nowhere near the Teign.

6 A Tale of Three Castles: Gothic and Heritage Management

1. Since the time of writing, English Heritage has been divided into two organizations. As of April 2015, the part of it responsible for the national heritage collection operates as a charitable trust. 'Historic England' is the name for the other part of the organization, which 'champions the nation's wider heritage, running the listing system, dealing with planning matters and giving grants.' http://www.english-heritage.org.uk/about-us/our-history/ (accessed 16 July 2015).
2. Charles Kightly, 'Interpretation, Entertainment, Involvement: Historic Site Presentation c. 1983–2008 in English Heritages', *Conservation Bulletin* issue 58, summer 2008, pages 25–27, page 25. Available online at http://www.english-heritage.org.uk/publications/conservation-bulletin-58/con-bull-58-pp25-40-web.pdf (accessed 4 March 2015).
3. Ibid., page 26.
4. Robert, Mighall, *A Geography of Victorian Gothic Fiction: Mapping History's Nightmares* (Oxford: Oxford University Press, 1999, page xviii.
5. http://www.warwick-castle.com/ (accessed 9 July 2013).
6. http://www.warwick-castle.com/explore-castle/history-and-restoration.aspx (accessed 9 July 2013).
7. The other three are 'The Highwayman's Supper' and 'The Kingmaker's Mediaeval Banquet' and the 'Dine Through Time Banquet'. See https://www.warwick-castle.com/events/dinners-and-banquets.aspx (accessed 17 March 2015).

8. All quotations relating to the Haunted Castle in this paragraph are drawn from http://www.warwick-castle.com/whats-on/halloween/halloween-events.aspx (accessed 26 November 2013).
9. For a review and fuller description of 'The Haunted Castle' 2013 see http://www.scaretouruk.com/review---warwick-castle-2013.html (accessed 26 March 2014).
10. http://www.warwick-castle.com/explore-castle/map-and-overview.aspx (accessed 10 July 2013).
11. *Horrible Histories* is a transmedial phenomenon that encompasses books and magazines, a highly popular television series that has been running on CBBC since 2009, and stage adaptations.
12. *Merlin* ran between 2008 and 2012 on BBC One. It was written by Julian Jones, Jake Michie, Julian Murphy and Johnny Capps.
13. http://www.alnwickcastle.com (accessed 8 February 2014). The duke's welcoming words have since been changed.
14. As from 2015, the presentation also draws on ITV's *Downton Abbey*, some of which was filmed at Alnwick. As the website has it: 'We are delighted to announce that Alnwick Castle stars as a brand new location, Brancaster Castle, in the Downton Abbey 2014 Christmas special.' http://www.alnwick-castle.com/explore/downton-abbey (accessed 26 March 2015).
15. All quotations from Catherine Neil are from a telephone interview conducted on 15 November, 2013.
16. The Laidly Worm is the subject of a celebrated Northumbrian ballad.
17. Neil's background is in film and theatre.
18. With one exception (a story inspired by the collection of decoy figures) the dramatized stories do not relate to the castle but to its environs.
19. The One Show episode featuring the Poison Garden was broadcast on 10/08/2010. The Poison Garden has featured on 'Woman's Hour' many times, including 17/03/2005, 11/05/2006 and 31/05/2010.
20. Though there is a garden of poisonous plants in the botanical gardens of Kirstenbosch, Cape Town, South Africa, for example, it is not Gothicized as Alnwick's is.
21. The recently opened 'Poison Garden' at Blarney Castle, Ireland, is perhaps one such example.
22. http://www.amazon.co.uk/The-Poison-Diaries-Duchess-Northumberland/dp/1862057311 (accessed 12 February 2013).
23. Richard Lomas, *A Power in the Land: The Percys* (East Linton: Tuckwell Press, 1999), pages 171–172.
24. Entry for 23 July 1760, quoted in *The Diaries of a Duchess: Extracts from the Diaries of the First Duchess of Northumberland* (1716–1776) edited by James Greig, with a foreword by the Duke of Northumberland (London: Hodder and Stoughton, 1926), page 13.
25. Richard Lomas, *A Power in the Land*, page 172.
26. http://www.oxforddnb.com/templates/article.jsp?articleid=21943&back= (accessed 28 February 28 2014).
27. From the foreword of *The Diaries of a Duchess: Extracts from the Diaries of the First Duchess of Northumberland* (1716–1776) edited by James Greig, with a foreword by the Duke of Northumberland (London: Hodder and Stoughton, 1926), page v.
28. Richard Lomas, *A Power in the Land*. See Chapter 12 'Attaining a Dukedom'.

29. This required a special remainder which was granted by George II in 1748.
30. Richard Lomas, *A Power in the Land*, page 171.
31. Colin Shrimpton, *Alnwick Castle* (Derby: English Life, c. 1999), page 15. Algernon employed Anthony Salvin, an architect who specialized in medieval restoration and design, accessed 9 July 2015.
32. Ibid., page 14.
33. Ibid., page 15.
34. Ibid., page 53.
35. Laura Mayer's, '"Junketacious" Gothick: Elizabeth Percy's Patronage of Alnwick Castle, Northumberland' in Maria Purves (ed.) *Women and Gothic* (Newcastle Upon Tyne: Cambridge Scholars Publishing, 2014), pages 25–38, page 32.
36. Ibid., page 30.
37. Percy, who was from Shropshire, does not seem to have been a direct relation of the family. He became their family chaplain at their London residence – Northumberland House.
38. The poem was later incorporated into Goldsmith's novel *The Vicar of Wakefield* as 'A Ballad' sung by Mr Burchell in Chapter 8.
39. Anonymous, *Dellingborough Castle, or, The Mysterious Recluse: A Novel* (London: Minerva Press, 1806), page 2.
40. The exception is the chapel constructed in the garden, in the early 1770s.
41. Horace Walpole Letter to Horace Mann, 27 April 1753. The letter may be found at http://images.library.yale.edu/hwcorrespondence/.
42. Quoted in Mayer's, '"Junketacious" Gothick', pages 25–38, page 27.
43. http://www.alnwickcastle.com/explore/whats-here/1st-duchess (accessed 13 February 2015).
44. This Duke of Somerset is from a different branch of the family from the eighteenth-century Somersets discussed in the context of Alnwick castle. They shared a common ancestor, however, in Edward Seymour (brother of Jane Seymour, third wife of Henry VIII) who bought Berry Pomeroy Castle, in 1547, from Sir Thomas Pomeroy.
45. http://www.english-heritage.org.uk/daysout/properties/berry-pomeroy-castle/history-and-research/history/ (accessed 13 June 2013).
46. Extravagant building works at the turn of the seventeenth century had long been known about through the writing of a local historian of 1700, John Prince, but the building he was referring to had been assumed by many to be the Elizabethan Wing, much of which is still standing.
47. Charles Kightly, *Berry Pomeroy Castle* (London: English Heritage, 2011) page 21. Note that the caryatids and the plasterwork are not now visible on site.
48. Ibid., page 18.
49. From a conversation with the author. Both informants have been anonymized.
50. This conversation was held at Easter 2013. There is now a new site manager at the castle.
51. Kate Ellis, *The Contested Castle: Gothic Novels and the Subversion of Domestic Ideology* (Chicago: University of Illinois Press, 1989).
52. On the entrance sign, the castle is also described as 'picturesque'. All quotations from the audio guide are taken from the transcription I made at the time of the visit referred to in this chapter.
53. The wording found in the *Whychcotte/Annals of the Seymours* passage was also consciously stylized in its own day.

54. The exception is, of course, the exhibition devoted to Elizabeth Percy's Musaeum.
55. By contrast, English Heritage has been less keen on exploiting the figure of the ghost. As of July 2014, 11 examples are to be found on the Trust's 'Ghostly encounters' page, but English Heritage's 'Ghostly Adventures' page lists only five. Significantly Berry Pomeroy is not amongst them: after all, this is marketing, not an invitation to hold a seance.
56. http://www.nationaltrust.org.uk/article-1356402321704/ (accessed 13 September, 2013).
57. From the BBC Four documentary 'Dan Cruickshank and the House that Wouldn't Die', broadcast on 8 December 2003.
58. http://www.nationaltrust.org.uk/dunster-castle/things-to-see-and-do/crypt/ (accessed 16 September 2013).
59. Charles Kightly, 'Interpretation, Entertainment, Involvement: Historic Site Presentation c 1983–2008' in English Heritages', *Conservation Bulletin*, No. 58 (Summer 2008), pages 25–27, page 27. Available online at http://www.english-heritage.org.uk/publications/conservation-bulletin-58/con-bull-58-pp25-40-web.pdf (accessed 4 March 2015).
60. *Conservation Principles, Policies and Guidance for the Sustainable Management of the Historic Environment* English Heritage April 2008. Available online at http://www.english-heritage.org.uk/publications/conservation-principles-sustainable-management-historic-environment/conservationprinciples policiesguidanceapr08web.pdf (accessed March 4 2015).
61. See http://www.enamecharter.org/downloads/ICOMOS_Interpretation_Charter_EN_10-04-07.pdf page 7, (accessed 13 February 2013).
62. Ibid.

7 '"Boo" to Taboo': Cultural Tourism and the Gothic

I've taken the phrase '"boo" to taboo' from Robert Eke's description of the walkabout act 'The Lost Funeral' on Stuff and Things' website www.stuffandthings.co.uk/funeral.htm (accessed 19 December 2014).

1. http://www.showzam.co.uk/ (accessed 22 July 2011).
2. http://www.glastonburyfestivals.co.uk/ (accessed 22 July 2011).
3. http://www.nnfestival.org.uk/UserData/root/Files/2010AnnualReportlowres.pdf page 3 (accessed 22 July 2011).
4. Ibid.
5. http://nnf11.nnfestival.org.uk/programme/detail/the_wolves (accessed 22 July 2011).
6. http://www.periplum.co.uk/company/index.php (accessed 19 December 2014).
7. http://www.heritagecity.org/projects/museums-at-night.htm (accessed 22 July 2011).
8. http://nnf11.nnfestival.org.uk/programme/detail/museums_at_night (accessed 22 July 2011).
9. Ibid.
10. Ibid.
11. Ibid.
12. The trailer may be seen at http://www.culture24.org.uk/places+to+go/museums+at+night/art354814 (accessed 19 December 2014). All subsequent references to the trailer refer to this site.

13. All the ellipses in the quotations derive from the trailer itself.
14. This quote and all further quotes relating to Futter's Child from http://www. stuffandthings.co.uk/futter.htm (accessed 19 December 2014).
15. Bert Eke has not been performing Futter's Child since 2012. The page, however, may still be found at http://www.stuffandthings.co.uk/futter.htm (accessed 19 December 2014).
16. This quote and all further quotes relating to 'The Lost Funeral' from http:// www.stuffandthings.co.uk/funeral.htm (accessed 18 December 2014).
17. http://www.stuffandthings.co.uk/futter.htm (accessed 19 December 2014).
18. http://www.nnfestival.org.uk/UserData/root/Files/2010AnnualReportlowres. pdf Annual Report for 2010 festival page 3 (accessed 22 July 2011).
19. http://www.independent.co.uk/news/education/higher/ride-of-a-lifetime-from-the-fairground-to-a-university-career-850595.html (accessed 22 July 2011).
20. http://www.visitblackpool.com/site/home/latest-news/2011/3/14/black-pool-s-showzam-proves-to-be-tourism-tonic-for-resort-a385 accessed (22 July 2011).
21. Ibid.
22. Blackpool's 'regeneration' seems to be on track. Certainly, it is regaining ground as a popular holiday resort. A recent survey by Tripadvisor (March 2015) put it as number 6 in the 'Top 10 Travellers' Choice Destinations in the UK'. See http://www.tripadvisor.co.uk/PressCenter-i7183-c1-Press_Releases. html (accessed 31 March 2015).
23. http://www.showzam.co.uk/ (accessed 22 July 2011).
24. http://www.showzam.co.uk/latest/newfoshowzamcentral (accessed 22 July 2011).
25. For information on the original Tom Norman and the performances with which he was associated see 'It was not the show it was the tale that you told': The Life and Legend of Tom Norman, the Silver King' on the University of Sheffield's National Fairground Archive website.
26. http://www.philandgarth.com/jon/shows.html (accessed 28 July 2011).
27. It should be noted that NNF's Museums at Night events also had regeneration funding.
28. http://www.admissionallclasses.com/about.php (accessed 22 July 2011).
29. Phrase used on a publicity poster that can be found at http://www. horrorinthehammer.ca/2013/04/full-list-of-parties-and-screenings-at.html (accessed 19 December 2014).
30. Catherine Spooner, *Contemporary Gothic* (London; Reaktion, 2006), page 127.
31. For further discussion of the issue of 'free space' and the one-way system at Glastonbury, see Jonathan Croose's 'What does Glastonbury do?' at https:// jurassicresearch.wordpress.com/2011/11/28/59/.
32. This programme may be found online at http://cdn.glastonburyfestivals. co.uk/wp-content/uploads/pdf/2014programme.pdf (accessed 19 December 2014). These quotations may be found on page 87.
33. http://www.glastonburyfestivals.co.uk/areas/shangri-la/ (accessed 18 December 2014).
34. Ibid.
35. http://cdn.glastonburyfestivals.co.uk/wp-content/uploads/pdf/2014programme. pdf (accessed 19 December 2014), page 94.
36. Ibid., page 88.
37. Ibid.

38. http://cdn.glastonburyfestivals.co.uk/wp-content/uploads/pdf/2014programme. pdf (accessed 19 December 2014), page 96.
39. Glastonbury 2011 official programme, page 66.
40. http://cdn.glastonburyfestivals.co.uk/wp-content/uploads/pdf/2014programme. pdf (accessed 19 December 2014), page 99.
41. Ibid., page 99.
42. Details of all these acts may be found in the 2011 official programme.
43. http://cdn.glastonburyfestivals.co.uk/wp-content/uploads/pdf/2014programme. pdf (accessed 19 December 2014), page 98.
44. The performers were: Matt Barnard and Gareth Jones of Slightly Fat Features; Peewee Murray, Joanna Kessell and Emma Lloyd of Stickleback Plasticus; and Petra Massey of Spymonkey.
45. http://artsbournemouth.org.uk/arts-bournemouth/arts-by-the-sea/event/ resurrection-of-the-sea-brides/ (accessed 19 December 2014).
46. Ibid.
47. Sooty was created by Harry Corbett in 1948 and has, since the 1950s, been the star of many children's TV shows. The latest, *Sooty*, has been running on CITV since 2011.
48. http://www.palaceofcuriosities.com/ (accessed 17 December 2014).
49. http://www.thetranzientgallery.co.uk/events-and-exhibitions.html (accessed 18 December 2014).
50. http://www.palaceofcuriosities.com/events-shows.html (accessed 17 December 2014).
51. http://cdn.glastonburyfestivals.co.uk/wp-content/uploads/pdf/2014programme. pdf (accessed 19 December 2014), page 15.
52. Ibid., page 98.
53. For more on the story of Archaos see http://archaos.info/pages/?id=14 (accessed 5 March 2015).
54. http://www.carneskysghosttrain.com/ (accessed 22 July 2011).
55. http://carnesky.com/ghosttrain/ (accessed 17 December 2014).
56. Ibid.
57. Ibid.
58. http://www.carneskysghosttrain.com/ (accessed 22 July 2011).
59. http://www.carnesky.com/productions.html (accessed 22 July 2011).
60. http://carnesky.com/ghosttrain/ (accessed 17 December 2014).
61. At Glastonbury 2011, for example, Medécins sans Frontières were involved in Zona Bassline in the Common. The charitable foundation for medical research, the Wellcome Trust, set up a decontamination unit at Shangri-La in the same year.

Conclusion

1. At the time of going to press, I also became aware of the existence of Michele Hanks's, *Haunted Heritage: The Cultural Politics of Ghost Tourism, Populism, and the Past* (Walnut Creek: Left Coast Press, 2015).
2. John R. Gold and Margaret M. Gold, *Imagining Scotland: Tradition, Representation and Promotion in Scottish Tourism Since 1750* (Aldershot: Scolar Press, 1995).
3. P. R. Stone, 'A Dark Tourism Spectrum: Towards a Typology of Death and Macabre Related Tourist Sites, Attractions and Exhibitions', *Tourism: An Interdisciplinary International Journal*, Vol. 54, No. 2 (2006), pages 145–160, page 157.

4. Ibid., page 152.
5. Madelon Hoedt, *Acting Out: the Pleasures of Performance Horror* unpublished PhD thesis, submitted July 2014, University of South Wales, UK, page 164.
6. See, for example, Tim Edensor's, 'Performing Tourism, Staging Tourism: (Re) producing Tourist Space and Practice', *Tourist Studies*, Vol. 1, No. 1 (2001), pages 59–81.
7. Jerome de Groot, *Consuming History: Historians and Heritage in Contemporary Popular Culture* (London: Routledge, 2009), page 4.
8. It is interesting to note that Gothic is used as a strategy in the marketing of science museums too. The Natural History Museum's 2013 sleepover for adults, featured the telling of ghost stories. See http://www.independent.co.uk/news/uk/this-britain/a-night-at-the-natural-history-museum--just-dont-try-doing-what-comes-naturally-at-this-sleepover-for-grownups-9029363.html (accessed 31 March 2015).
9. As regards the relation between history, popular culture and Gothic, it is worth noting that Dennis Severs' House was the subject of the very first programme of a tv series on museums, presented by historian Ronald Hutton. The series is entitled *Professor Hutton's Curiosities*, and it was first broadcast on UKTV's Yesterday channel in 2013.
10. Jerrold E. Hogle, 'The Gothic Ghost of the Counterfeit and the Progress of Abjection', in David Punter (ed.) *A Companion to the Gothic* (Oxford: Blackwell, 2000), pages 293–304, page 293.
11. Lucie Armitt, *Twentieth-Century Gothic* (Cardiff: University of Wales Press, 2010), page 5.
12. It is interesting to note that Merlin has a significant presence in Blackpool now too. Not only has Merlin bought Louis Tussaud's waxworks, bringing it under the umbrella of Madame Tussaud's, but, since 2010, when Blackpool Council bought Blackpool Tower, it has managed that attraction – and has installed a Dungeon there.
13. https://www.visitsealife.com/london/newsandevents/halloween/ (accessed 28 February 2015).
14. The freeholds of many of the attractions, however, including that of Madame Tussaud's, are owned by Nick Leslau.
15. Carrie Clanton, '"Living" History: Ghost Tourism in the UK', paper presented at ASA Conference 2007: Thinking Through Tourism (Sacred Landscapes, Esoteric Journeys Panel) London, April 2007. http://www.mecon.nomadit.co.uk/pub/conference_epaper_download.php5?PaperID=1391&MIMEType=application/pdf (accessed 9 October 2012), page 1.
16. D. Inglis and M. Holmes, 'Highland and Other Haunts – Ghosts in Scottish Tourism', *Annals of Tourism Research*, Vol. 30, No. 1 (2003), pages 50–63, page 57.
17. Duncan Light, 'Dracula Tourism in Romania Cultural Identity and the State', *Annals of Tourism Research*, Vol. 34, No. 3 (2007), pages 746–765, page 761.
18. Tuomas Hovi, 'Heritage through Fiction: Dracula Tourism in Romania,' Doctoral Dissertation, supervised and submitted at University of Turku, Finland, page 109.
19. All quotations from the article by Martin Yip available at http://www.bbc.co.uk/news/world-asia-china-24302108 (accessed 6 March 2015).

Bibliography

Anonymous, 'Article XXII – *Whychote [sic] of St John's; or, the Camp, the Cloister, and the Quarter-deck'* [NB The title is given wrongly.] in the *Monthly Review: New and Improved Series*, Vol. 1, No. iv (1833), pages 607–608.

Anonymous, *Dellingborough Castle, or, The Mysterious Recluse: A Novel* (London: Minerva Press, 1806).

Anonymous, *Guide to the Watering Places Between the Exe and the Dart Including Teignmouth, Dawlish and Torquay* (Teignmouth: Printed and sold by E. Croydon, public library, 1817).

Anonymous, 'Letter from a Gentleman, present at the Festivities at FONTHILL, to a correspondent in Town' dated December 28th 1800 in *The Gentleman's Magazine and Historical Chronicle*, Vol. 71 (March and April 1801), pages 206–208 and 297–298.

Anonymous, 'Sir Walter Farquhar, Bart. Licenciate of the Royal College of Physicians, and Physician to the Prince Regent' in *The New Monthly Magazine*, Vol. 4, No. 19 (December 1815), pages 417–420.

Anonymous, 'Strawberry Hill: From the Letters of the Hon. Horace Walpole', *Gentleman's Magazine*, Vol. 172 (June 1842), pages 571–591.

Anonymous, *The Dungeons: Rogues Gallery: The Photographs* (Poole: Merlin Entertainments, undated, but post-2013).

Anonymous, *The London Dungeon* (guide book). (Poole: Merlin Entertainments, undated, but pre-2013).

Anonymous, *The World*, by Adam Fitz-Adam (London: R. and J. Dodsley, 1753). No. XII, 22 March 1753, pages 67–72.

Anonymous, 'Through Devonshire and Cornwall to the Scilly Isles: Part 1', *Bentley's Miscellany*, Vol. 61 (1867), pages 316–330.

Armitt, Lucie, *Twentieth-Century Gothic* (Cardiff: University of Wales Press, 2010).

Baldick, Chris, *The Oxford Book of Gothic Tales* (Oxford: Oxford University Press, 1992).

Bann, Stephen, 'Historicizing Horace' in Michael Snodin (ed.) *Horace Walpole's Strawberry Hill* (New Haven, Conn.; London: Yale University Press and Yale Center for British Art, 2009), pages 117–133.

Barrell, John, *The Dark Side of the Landscape: The Rural Poor in English Painting, 1730–1840* (Cambridge: Cambridge University Press, 1980).

Barrell, John, *The Idea of Landscape and the Sense of Place: An Approach to the Poetry of John Clare* (Cambridge: Cambridge University Press, 1972).

Black, Adam and Charles, *Black's Guide to the South-Western Counties of England. Dorsetshire, Devon, and Cornwall* (Edinburgh: Adam and Charles Black, 1862).

Bray, Anna, *Henry de Pomeroy; or, the Eve of St. John, a Legend of Cornwall and Devon* (London: Richard Bentley: New Burlington Street, 1842).

Brett, David, *The Construction of Heritage* (Cork: Cork University Press, 1996).

Brown, Theo, *The Fate of the Dead: A Study in Folk-Eschatology in the West Country After the Reformation* (Ipswich and Cambridge: D. S. Brewer and Rowman and Littlefield for the Folklore Society, 1979).

Burford, E. J., *A Short History of The Clink Prison* (no publisher or place of Publication, 1989).

Burney, Frances, *Memoirs of Doctor Burney: Arranged from his Own Manuscripts, from Family Papers, and from Personal Recollections, by his Daughter, Madame d'Arblay* (London: Edward Moxon, 1832).

Byron, Glennis (ed.), *Globalgothic* (Manchester: Manchester University Press, 2013).

Byron, Glennis and Townshend, Dale (eds.), *The Gothic World* (London: Routledge, 2014).

Chalcraft, Judith and Viscardi, Anna, 'Visiting Strawberry Hill: An Analysis of the Eton Copy of the Description of the Villa' (published by Chalcraft and Viscardi, produced by Aquatintbsc, Wimbledon, 2009).

Chapman, Pauline, *Madame Tussaud's Chamber of Horrors: Two Hundred Years of Crime* (London: Constable, 1984).

Clanton, Carrie, '"Living" History: Ghost Tourism in the UK' Paper Presented at ASA Conference 2007: Thinking Through Tourism (Sacred Landscapes, Esoteric Journeys Panel) London, April 2007. www.mecon.nomadit.co.uk/pub/conference_epaper_download.php5?PaperID=1391&MIMEType=application/pdf accessed 9 October 2012.

Clark, Kenneth (1928), *The Gothic Revival: An Essay in the History of Taste* (London: John Murray, 1962), third edition.

Clery, E. J., *The Rise of Supernatural Fiction, 1762–1800* (Cambridge: Cambridge University Press, 1995).

Collins, Charles Allston, 'Our Eye-Witness in Baker-Street', *All the Year Round*, Vol. II, No. 36 (31 December 1859), pages 233–236.

Collins, Charles Allston 'Our Eye-Witness in Great Company', *All the Year Round*, Vol. I I, No. 37 (7 January 1860), pages 249–253.

Combes, Luke M., *Berry Pomeroy: A Poem* (Torquay: E. Cockrem, 1872).

Crompton, Richmal, *William* (London: George Newnes, 1929).

Croose, Jonathan (2011), 'What Does Glastonbury Do?' at blogs.exeter.ac.uk/jurassicresearch/blog/2011/11/28/59/ accessed 9 July 2015.

Cunningham, David I., 'Living in the Slashing Grounds: Jack the Ripper, Monopoly Rent and the New Heritage' in Alexandra Warwick and Martin Willis (eds.) *Jack the Ripper: Media, Culture, History* (Manchester: Manchester University Press, 2007), pages 159–175.

D'anvers, Caleb, 'Merlin's Prophecy with an Interpretation' (from *The Craftsman* No. 491), *The Gentleman's Magazine: or, Monthly Intelligencer*, Vol. 5 (September 1735), pages 532–535.

Davies, Owen, *The Haunted: A Social History of Ghosts* (Basingstoke: Palgrave Macmillan, 2007).

Doyle, Richard 'Manner and Customs of ye Englyshe in 1849 no. 27: Madame Tussaud her Wax-Werkes ye Chamber of Horrors!!', *Punch*, vol. 17 (1849), page 112.

Edensor, Tim, 'Performing Tourism, Staging Tourism: (Re)producing Tourist Space and Practice', *Tourist Studies*, Vol. 1, No. 1 (2001), pages 59–81.

Ellis, Kate, *The Contested Castle: Gothic Novels and the Subversion of Domestic Ideology* (Chicago: University of Illinois Press, 1989).

Ellis, S. M., *Ghosts and Legends of Berry Pomeroy Castle* (Totnes: Sawtell & Nielsen, undated).

Evans, Caroline, *Fashion at the Edge: Spectacle, Modernity and Deathliness* (New Haven, Conn.; London: Yale University Press, 2003).

Freud, Sigmund, 'The "uncanny"' (1919) (translated by Joan Riviere) *Collected Papers*, Vol. 4 (London: The Hogarth Press, 1956), pages 368–407.

George, W. L., 'Waxworks: A Mystery', *The Strand Magazine* (July 1922), pages 58–64.

Gold, John R. and Margaret M., *Imagining Scotland: Tradition, Representation and Promotion in Scottish Tourism Since 1750* (Aldershot: Scolar Press, 1995).

Gordon, Avery, *Ghostly Matters: Haunting and the Sociological Imagination* (Minneapolis, MN; London: University of Minnesota Press, 1997).

Goudge, Elizabeth (1942), *The Castle on the Hill* (London: Gerald Duckworth and Co.,1949).

Graves, Robert, 'The Devil at Berry Pomeroy', from BBC Broadcast Recording 27 September 1953, BBC Archive 19500, side 2 of 4.

Graybill, Lela, 'A Proximate Violence: Madame Tussaud's Chamber of Horrors', *Nineteenth-Century Art Worldwide*, Vol. 9, No. 2 (Autumn 2010). www.19thc-artworldwide.org/autumn10/a-proximate-violence accessed 30 January 2015.

Groot, Jerome de, *Consuming History: Historians and Heritage in Contemporary Popular Culture* (London: Routledge, 2009)

Hager, Kelly, *Dickens and the Rise of Divorce: The Failed-Marriage Plot and the Novel Tradition* (Farnham: Ashgate, 2010).

Harney, Marion, *Place-Making for the Imagination: Horace Walpole and Strawberry Hill* (Farnham: Ashgate, 2014).

Heard, Mervyn, *Phantasmagoria: The Secret Life of the Magic Lantern* (Hastings: The Projection Box, 2006).

Hoedt, Madelon, *Acting Out: the Pleasures of Performance Horror* unpublished Ph.D thesis, submitted July 2014, University of South Wales, UK.

Hogle, Jerrold E., 'The Gothic Ghost of the Counterfeit and the Progress of Abjection' in David Punter (ed.) *A Companion to the Gothic* (Oxford: Blackwell, 2000), pages 293–304.

Holloway, Julian, 'Legend-tripping in Spooky Spaces: Ghost Tourism and Infrastructures of Enchantment', *Environment and Planning D: Society and Space*, Vol. 28 (2010), pages 618–637.

Horner, Avril and Zlosnik, Sue, *Gothic and the Comic Turn* (Basingstoke: Palgrave Macmillan, 2004).

Hovi, Tuomas, *Heritage Through Fiction: Dracula Tourism in Romania*. Doctoral Dissertation supervised and submitted at University of Turku, Finland. August, 2014.

Hunt, John Dixon, '*Emblem and Expression* in the Eighteenth-Century Landscape Garden', *Eighteenth-Century Studies*, Vol. 4, No. iii (Spring 1971), pages 294–317.

Hunt, John Dixon, and Willis, Peter, *The Genius of the Place: The English Landscape Garden, 1620–1820* (London: Paul Elek Ltd., 1975).

Inglis D. and Holmes M. (2003), 'Highland and Other Haunts – Ghosts in Scottish Tourism', *Annals of Tourism Research*, Vol. 30, No. 1, pages 50–63.

Ingram, John H. (1884), *The Haunted Homes and Family Traditions of Great Britain* (London: Gibbings and Co., 1897).

Jones, David J., *Gothic Machine: Textualities, Pre-cinematic Media and Film in Popular Visual Culture, 1670–1910* (Cardiff: University of Wales Press, 2011).

Keller, Kristine (2010), 'Ghost Tours as a Form of Alternative Tourism'. www.academia.edu/932118/Ghost_Tours_as_A_Form_of_Alternative_Tourism accessed 14 October, 2012.

Ketton-Cremer, Robert Wyndham (1940), *Horace Walpole: A Biography* (London: Methuen & Co., 1964) Third edition.

Kightly, Charles, *Berry Pomeroy Castle* (London: English Heritage, 2011).

Kightly, Charles, *Farleigh Hungerford Castle* (London: English Heritage, 2012). Revised reprint.

Kightly, Charles, 'Interpretation, Entertainment, Involvement: Historic Site Presentation c 1983–2008', *Conservation Bulletin*, No. 58 (Summer 2008), page 25. at www.english-heritage.org.uk/publications/conservation-bulletin-58/con-bull-58-pp25-40-web.pdf accessed 4 March 2015.

Lees-Milne, James, *William Beckford* (Tisbury: Compton Russell, 1976).

Lennon, J. and Foley, M., *Dark Tourism: The Attraction of Death and Disaster* (London: Continuum, 2007).

Lewis, W. S., 'The Genesis of Strawberry Hill', *Metropolitan Museum Studies*, Vol. i (June 1934), pages 57–92.

Lewis, W. S., *Horace Walpole* (The A. W. Mellon Lectures in the Fine Arts, 1960) (London: printed in USA Rupert Hart-Davis, 1961).

Lichtenstein, Rachel and Sinclair, Iain, *Rodinsky's Room* (London: Granta, 1999).

Light, Duncan, 'Dracula Tourism in Romania Cultural Identity and the State', *Annals of Tourism Research*, Vol. 34, No. 3 (2007), pages 746–765.

Light, Duncan, 'Gazing on Communism: Heritage Tourism and Post-communist Identities in Germany, Hungary and Romania', *Tourism Geographies*, Vol. 2, No. 2, pages 157–176.

Light, Duncan, 'Performing Transylvania: Tourism, Fantasy and Play in a Liminal Place', *Tourist Studies*, Vol. 9, No. 3, pages 240–258.

Lodge, David, *Paradise News* (1991) (Penguin: London, 1992).

Lomas, Richard, *A Power in the Land: the Percys* (East Linton: Tuckwell, 1999).

Macaulay, Thomas Babington, 'Walpole's Letters to Horace Mann' (First published in the *Edinburgh Review* 1833), reprinted in volume II of *Macaulay Essays* (Philadelphia: Carey and Hart, 1841).

Mann, Bob (ed.), *A Most Haunting Castle: Writings from the Ruins at Berry Pomeroy* (Totnes: Longmarsh Press, 2012).

Maton, William George, illustrations by rev. J. Rackett, 'Dorsetshire Devonshire and Cornwall' 1794 in *Tour in the Western Counties 1794 and 1796*, manuscript volume in Devon Archives and Local Studies Service, ref Z19/2/10a-b.

Maton, William George, illustrations by rev. J. Rackett, *Observations Relative Chiefly to the Natural History, Picturesque Scenery and Antiquities of the Western Counties of England, Made in the Years 1794 and 1796* (Salisbury: J. Eaton, 1797).

Maturin, Charles, *Melmoth the Wanderer* (1820) ed. Douglas Grant, introduced by Chris Baldick (Oxford: Oxford University Press, 1989).

Mayer, Laura, '"Junketacious" Gothick: Elizabeth Percy's Patronage of Alnwick Castle, Northumberland' in Maria Purves (ed.) *Women and Gothic* (Newcastle Upon Tyne: Cambridge Scholars Publishing, 2014), pages 25–38.

Melville, Lewis, *The Life and Letters of William Beckford* (London: William Heinemann, 1910).

Mighall, Robert, *A Geography of Victorian Gothic Fiction: Mapping History's Nightmares* (Oxford: Oxford University Press, 1999).

Miles, Robert, 'Eighteenth-century Gothic' in Catherine Spooner and Emma McEvoy (eds.) *Routledge Companion to Gothic* (London: Routledge, 2007), pages 10–18.

Miles, Robert, *Gothic Writing 1750–1820: A Genealogy* (London: Routledge, 1993).

Montague, Edward, *The Castle of Berry Pomeroy* (London: Minerva Press, 1806)

Montague, Edward (1806), *The Castle of Berry-Pomeroy: A Novel* (Totnes: printed at the 'Times' and 'Western Guardian' Offices, by T. & A. Mortimer, 1892) First Mortimer edition.

Montague, Edward (1806), *The Castle of Berry-Pomeroy: A Novel* (Totnes: printed at the 'Times' and 'Western Guardian' Offices, by T. & A. Mortimer, 1892) Second Mortimer edition.

Montague, Edward (1806), *The Castle of Berry-Pomeroy: A Novel* (Totnes: printed at the 'Times' and 'Western Guardian' Offices, by T. & A. Mortimer, 1906) Third Mortimer edition.

Montague, Edward, *The Castle of Berry Pomeroy* (1806) ed. James D. Jenkins (Richmond, Virginia: Valancourt Books, 2007).

Mortimore, T. and A., *Berry Pomeroy Castle: An Historical and Descriptive Sketch* (Totnes: printed at the 'Times' and 'Western Guardian' Offices, by T. & A. Mortimer, 1876).

Mortimore, T. and A., *Berry Pomeroy Castle: An Historical and Descriptive Sketch* (Totnes: printed at the 'Times' and 'Western Guardian' Offices, by T. & A. Mortimer, 1930s).

Murray, John, *A Hand-Book for Travellers in Devon & Cornwall. With Maps.* (London: John Murray, 1851).

Neal, Erskine, *Whychcotte of St John's; or, the Court, the Camp, the Quarter-deck, and the Cloister* (London: E. Wilson, 1833).

Niffenegger, Audrey, *Her Fearful Symmetry* (Bath: Windsor/Paragon, 2010).

Norton, Rictor 'A Visit to Fonthill'. www.rictornorton.co.uk/beckfor3.htm accessed 5 March 2015.

Paulson, Ronald, *Representations of Revolution (1789–1820)* (New Haven and London: Yale University Press, 1983).

Leigh, Percival 'Mr Pips his Diary Wednesday September 5th 1849' (accompanying text to Richard Doyle's 'Manner and Customs of ye Englyshe in 1849 no. 27: Madame Tussaud her Wax-Werkes ye Chamber of Horrors!!'), *Punch*, vol. 17 (1849), page 112

Percy, Elizabeth, First Duchess of Northumberland, *The Diaries of a Duchess: Extracts from the Diaries of the First Duchess of Northumberland (1716–1776)*, ed. James Greig, with a foreword by the Duke of Northumberland (London: Hodder and Stoughton, 1926).

Pilbeam, Pamela, *Madame Tussaud and the History of Waxworks* (Hambledon and London: London, 2003).

Poole, Keith, *Britain's Haunted Heritage* (London: Robert Hale, 1988)

Porter, David, *The Chinese Taste in Eighteenth-Century England* (Cambridge: Cambridge University Press, 2010).

Pratchett, Terry, *The Last Continent* (London: Doubleday, 1998).

Reynolds, Nicole, *Building Romanticism: Literature and Architecture in Nineteenth-Century Britain* (Ann Arbor: University of Michigan Press, 2010).

Robertson, E. G., *Mémoires Récréatifs, Scientifiques et Anecdotiques* (Paris: chez l'auteur et à la librairie de Wurtz, 1831).

Rogers, Kevin, 'Walpole's Gothic: Creating a Fictive History' in Michael Snodin (ed.) *Horace Walpole's Strawberry Hill* (New Haven, Conn.; London: Yale University Press and Yale Center for British Art, 2009), pages 59–73.

Sala, George-Augustus (1892), Introductory essay in *Mme Tussaud's Exhibition Guide* (London: Printed by Bruton and Co., undated, British Library catalogue suggests 1917).

Samuel, Raphael (1994), *Theatres of Memory Vol. I Past and Present in Contemporary Culture* (London: Verso, 1996).

Sandberg, Mark B., *Living Pictures, Missing Persons: Mannequins, Museums, and Modernity* (Princeton: Princeton University Press, 2003).

Sedgwick, Eve Kosofsky, 'The Character in the Veil: Imagery of the Surface in the Gothic Novel', *PMLA*, Vol. 96, No. 2 (March 1981), pp. 255–270.

Sedgwick, Eve Kosofsky, *The Coherence of Gothic Conventions* (New York: Arno Press, 1980).

Severs, Dennis, *18 Folgate Street: The Tale of a House in Spitalfields* with an introduction by Peter Ackroyd (London: Chatto and Windus and Vintage 2002).

Seymour, Deryck, *The Ghosts of Berry Pomeroy Castle* (Exeter: Obelisk Publications, 1990).

Shrimpton, Colin, *Alnwick Castle* (Derby, English Life, c. 1999).

Sinclair, Iain, *Lud Heat and Suicide Bridge*, with an introduction by Michael Moorcock (London: Granta, 1998).

Sinclair, Iain and Lichtenstein, Rachel, *Rodinsky's Room* (London: Granta, 1999).

Smiles, Sam and Pidgley Michael, *The Perfection of England: Artist Visitors to Devon c. 1750–1870* (Exeter: Royal Albert Memorial Museum and Djanogly Art Gallery, University of Nottingham, 1995).

Snodin, Michael, 'Going to Strawberry Hill' in Michael Snodin (ed.), *Horace Walpole's Strawberry Hill* (New Haven, Conn.; London: Yale University Press and Yale Center for British Art, 2009).

Snodin, Michael (ed.), *Horace Walpole's Strawberry Hill* (New Haven, Conn.; London: Yale University Press and Yale Center for British Art, 2009).

Snodin Michael, 'Representing Rooms: Plans and Other Drawings' in Jeremy Aynsley and Charlotte Grant (eds.) *Imagined Interiors: Representing the Domestic Interior Since the Renaissance* (London: V and A Publications, 2006), pages 128–129.

Stewart, Susan, *On Longing: Narratives of the Miniature, the Gigantic, the Souvenir, the Collection* (Durham and London: Duke University Press, 1993)

Spooner, Catherine, *Contemporary Gothic* (London: Reaktion Books, 2006).

Spooner, Catherine, 'Gothic Lifestyle' in Byron and Townshend (eds.) *The Gothic World* (London: Routledge, 2014), pages 441–453.

Spooner, Catherine, '"That Eventless Realm": Hilary Mantel's *Beyond Black* and the Ghosts of the M25' in Lawrence Phillips and Anne Witchard (eds.) *London Gothic: Place, Space and the Gothic Imagination* (London: Continuum, 2010), pages 80–90.

St. Maur, Richard Harold, *Annals of the Seymours* (London: K. Paul, Trench, Trübner & Co., 1902).

Stone, P. R., 'A Dark Tourism Spectrum: Towards a Typology of Death and Macabre Related Tourist Sites, Attractions and Exhibitions', *Tourism: An Interdisciplinary International Journal*, Vol. 54, No. 2 (2006), pages 145–160.

Stone, P. R., '"It's a Bloody Guide": Fun, Fear and a Lighter Side of Dark Tourism at the Dungeon Visitor Attractions, UK' in R. Sharpley and P. R. Stone (eds.) *The Darker Side of Travel: The Theory and Practice of Dark Tourism* (Bristol: Channel View Publications, 2009), pages 167–185.

Swete, Reverend John, *Devon Tour*, 1793. Manuscript in Devon Archives and Local Studies Service. Ref. 564M/F5.

Swete, Reverend John, *Sketches in Devon*, 1788. Manuscript in Devon Archives and Local Studies Service. Ref. Z.19/2-12.

Tussaud, John Theodore (1919), *The Romance of Madame Tussaud's* (London: Odhams Press, 1921). Second edition.

Tussaud, Marie, *Memoirs and reminiscences of France: forming an abridged history of the French Revolution*, ed. F. Hervé (London: Sauders and Otley, 1838).

Vidler, Anthony, *The Architectural Uncanny: Essays in the Modern Unhomely* (Cambridge Mass: The MIT Press, 1992).

Walpole, Horace, *A Description of the Villa of Horace Walpole, Youngest Son of Sir Robert Walpole Earl of Oxford, at Strawberry-Hill, Near Twickenham: With an Inventory of the Furniture, Pictures, Curiosities, &c* (1774). archive.org/details/descriptionofvil00walp accessed 30 April 2015.

Walpole, Horace, *A Description of the Villa of Horace Walpole, Youngest Son of Sir Robert Walpole Earl of Orford, at Strawberry-Hill, Near Twickenham, Middlesex: With an Inventory of the Furniture, Pictures, Curiosities, &c* (Twickenham: Strawberry Hill, 1784). archive.org/details/descriptionofvil00walp_0 accessed 30 April 2015.

Walpole, Horace, 'Essay on Modern Gardening' bilingual edition, traduit en François par M. le Duc de Nivernois (Strawberry Hill, 1785).

Walpole, Horace (1764), *The Castle of Otranto* in Peter Fairclough (ed.) *Three Gothic Novels* (Harmondsworth: Penguin, 1986), pages 37–148.

Walpole, Horace, *The Yale Edition of Horace Walpole's Correspondence* (New Haven: Yale University Press, 1937–1983). images.library.yale.edu/hwcorrespondence accessed 30 April 2015.

Warner, Richard, *A Walk Through Some of the Western Counties of England* (London: G G and J Robinson, 1800).

Watson, Nicola J., *The Literary Tourist: Readers and Places in Romantic and Victorian Britain* (Basingstoke: Palgrave Macmillan, 2006).

Weisberg-Roberts, Alicia, 'Singular Objects and Multiple Meanings' in Michael Snodin (ed.) *Horace Walpole's Strawberry Hill* (New Haven, Conn.; London: Yale University Press and Yale Center for British Art, 2009), pages 87–105.

Whishaw, Frederick J., *A Secret of Berry Pomeroy* (London: Griffith, Farran Browne and Co., 1902).

Whitcombe, Henry Pennell, *Bygone Days in Devonshire and Cornwall* (London: Richard Bentley and son, 1874).

Woodward, Alex, *Haunted Weymouth* (Stroud: The History Press, 2011)

Worth, R. N. (1878), *Tourist's Guide to South Devon: Rail, Road, River, Coast, and Moor* (London: Edward Stanford, 1880).

Wright, Patrick, *A Journey Through Ruins: A Keyhole Portrait of British Postwar Life and Culture* (London: Flamingo, 1993).

Wright, W. H. K. (ed.), *West Country Poets: their Lives and Their Works* (London: Elliot Stock 1896).

Yip, Martin 'Ghostly journey through Hong Kong's old Wan Chai district'.www.bbc.co.uk/news/world-asia-china-24302108 accessed 6 March 2015.

Electronic resources

Conservation Principles, Policies and Guidance for the Sustainable Management of the Historic Environment English Heritage April 2008.Available online at www.english-heritage.org.uk/publications/conservation-principles-sustainable-management-historic-environment/conservationprinciplespoliciesguidanceapr08web.pdf accessed 4 March 2015

www.admissionallclasses.com/about.php accessed 22 July 2011
www.ahrc.ac.uk/FundingOpportunities/Documents/admissionallclasses.pdf
www.amazon.co.uk/The-Poison-Diaries-Duchess-Northumberland/
dp/1862057311 accessed 12 February 2013
www.archaos.info/pages/?id=14 accessed 5 March 2015
www.artsbournemouth.org.uk/arts-bournemouth/arts-by-the-sea/event/resurrec-
tion-of-the-sea-brides/ accessed 19 December 2014
www.atmosfearuk.com accessed 27 July 2012
www.bodminjail.org/ accessed 10 January 2015
www.bramstokerfilmfestival.com/thursday accessed 31 March 2015
www.britishlistedbuildings.co.uk/en-104236-the-town-pump-dorchester-dorset
accessed 26 April 2013
www.carnesky.com/productions.html accessed 22 July 201
www.carneskysghosttrain.com/ accessed 22 July 2011
www.culture24.org.uk/places+to+go/museums+at+night/art354814 accessed
December 19 2014.
www.dennissevershouse.co.uk accessed 20 October 2010
www.easternstate.org/Halloween accessed 21 September 2012.
www.enamecharter.org/downloads/ICOMOS_Interpretation_Charter_EN_10-04-07.
pdf accessed 13 February 2013
www.english-heritage.org.uk/daysout/properties/berry-pomeroy-castle/ accessed
8 October 2013
www.english-heritage.org.uk/daysout/properties/berry-pomeroy-castle/history-
and-research/history/ accessed 8 October 2013
www.ghostwalklondon.co.uk/ accessed 27 February 2015.
www.glastonburyfestivals.co.uk/ accessed 22 July 2011
www.glastonburyfestivals.co.uk/wp-content/uploads/pdf/2014programme.pdf
accessed 19 December 2014
www.hauntedtokyotours.com/ accessed 6 March 2015
www.heritagecity.org/projects/museums-at-night.htm accessed 22 July 2011
www.horrorinthehammer.ca/2013/04/full-list-of-parties-and-screenings-at.html
accessed 19 December 2014.
www.independent.co.uk/news/education/higher/ride-of-a-lifetime-from-the-fair-
ground-to-a-university-career-850595.html accessed 22 July 2011
www.independent.co.uk/news/uk/home-news/almost-30-pubs-close-every-
week-9165968.html accessed March 5 2014
www.jamaicainn.co.uk/ghosts accessed 1 October 2012.
www.londontheatre.co.uk/lashmars/backstagetour/index.html accessed 4 August 2009
www.madametussauds.com/london/planyourvisit/explore/scream/default.aspx
accessed 24 November 2014
www.mappingbirmingham.blogspot.co.uk/2013/02/ephemera-2-curtiuss-grand-
cabinet-of.html accessed 14 December 14 2014
www.merlinentertainments.biz/en/brands/cwoa.aspx accessed 16 July 2012
www.mirror.co.uk/news/uk-news/ghost-caught-cctv-ye-olde-3155330 accessed
15 January 2015
www.nationaltrust.org.uk/article-1356402321704/ accessed 13 September 2013
www.nationaltrust.org.uk/dunster-castle/things-to-see-and-do/crypt/ accessed 16
September 2013
www.nnfestival.org.uk/UserData/root/Files/2010AnnualReportlowres.pdf
accessed 22 July 2011

www.nnf11.nnfestival.org.uk/programme/detail/the_wolves accessed 22 July 2011

www.oxforddnb.com/templates/article.jsp?articleid=21943&back= accessed 28 February 2014

www.palaceofcuriosities.com/ accessed 17 December 2014

www.pasajedelterror.com/ accessed 10 November 2014

www.periplum.co.uk/company/index.php accessed 19 December 2014

www.philandgarth.com/jon/shows.html accessed 28 July 2011

www.pikeandshot.com/ accessed 9 January 2013

www.rosehall.com/tours/ accessed 27 February 2015

www.showzam.co.uk/ accessed 22 July 2011

www.stuffandthings.co.uk/funeral.htm accessed 19 December 2014

www.stuffandthings.co.uk/futter.htm accessed 19 December 2014

www.theatreroyaldrurylane.co.uk/theatre-history.htm, accessed 4 August 2009

www.thedungeons.com/london/en/explore-the-dungeon/drop-dead.aspx accessed 14 December 2014

www.thedungeons.com/london/en/explore-the-dungeon/the-tyrant-boat-ride. aspx accessed 14 December 2014

www.theforbiddencorner.co.uk/ accessed 10 January 2015

www.theghostbustours.com/history.html accessed 30 January 2015

www.theghostbustours.com/testimonials.html accessed 14 October 2012

www.themeparks-uk.com/alton-towers-guide/events/alton-towers-halloween-scarefest.html accessed 16 July 2012

www.thetranzientgallery.co.uk/events-and-exhibitions.html accessed 18 December 2014

www.timeout.com/london/museums-attractions/event/2158/dennis-severs-house accessed 5 October 2010

www.tripadvisor.co.uk/PressCenter-i7183-c1-Press_Releases.html accessed 31 March 2015.

www.visitblackpool.com/site/home/latest-news/2011/3/14/blackpool-s-showzam-proves-to-be-tourism-tonic-for-resort-a385 accessed 22 July 2011

www.visitsealife.com/london/newsandevents/halloween/ accessed 28 February 2015

www.walks.com/Homepage/Thursdays_Walks/default.aspx#12882 accessed August 5 2009

www.walks.com/London_Walks_Home/Heres_Why/default.aspx accessed 10 January 2015

www.walks.com/London_Walks_Home/London_Ghost_Walks/default.aspx accessed 11 January 2015

www.warwick-castle.com/ accessed 18 July 2012

Radio programmes

'You Either See It Or You Don't: The Story of 18 Folgate Street, Spitalfields' introduced by Vicky Licorish and produced by Jane Greenwood. The programme was broadcast 15 November 2001 on Radio 4.

'Dan Cruickshank and the House that Wouldn't Die', introduced by Dan Cruickshank, broadcast on 8th December 2003 on Radio 4.

Index